THE ART OF

TO
MO
RR
OW

THE ART OF

TOMORROW

EDITED BY
LAURA HOPTMAN
YILMAZ DZIEWIOR
UTA GROSENICK

DISTANZ

Impressum / **Imprint**

Herausgeber / **Editors**
Laura Hoptman, Yilmaz Dziewior, Uta Grosenick

Texte / **Texts**
Jens Asthoff, Sven Beckstette, Kirsty Bell, Michael Connor,
Lauren Cornell, Silke Hohmann, Anthony Huberman, Rita Kersting,
Oliver Koerner von Gustorf, Matthias Mühling, Lauren O'Neill-Butler,
David Riedel, Dieter Roelstraete, André Rottmann, Chris Sharp,
Ali Subotnick, Ossian Ward, Astrid Wege

Redaktion und Koordination / **Managing Editor**
Sabine Bleßmann

Lektorat / **Copy Editing**
Cordelia Marten, Gerrit Jackson

Übersetzung / **Translation**
Barbara Hess (deutsch / **German**), Gerrit Jackson (englisch / **English**)

Grafische Gestaltung / **Design**
BOROS, Mathias-Kim Beyer

Produktionskoordination / **Production Management**
Nicole Rankers

Gesamtherstellung / **Production**
Optimal Media Production GmbH, Röbel/Müritz

© 2010 DISTANZ Verlag GmbH
© 2010 VG Bild-Kunst, Bonn für / **for** Michael Sailstorfer

Vertrieb / **Distribution**
GESTALTEN, Berlin
www.gestalten.com

ISBN 978-3-89955-406-9

Printed in Germany

Erschienen im / **Published by**
DISTANZ Verlag, Berlin
www.distanz.de

VORWORT

„Die reizvolle Spannung, die von moderner Kunst ausgelöst wird, ist wie eine Sucht", schrieb der Kunsthistoriker Leo Steinberg 1960, als Innovation, wie schmerzhaft sie auch sein mochte, Fortschritt bedeutete. Die Idee, dass Kultur sich im Vergleich zum Vorangegangenen unaufhaltsam auf etwas unweigerlich Besseres zubewegt, hat ihren Ursprung in den wissenschaftlichen Anschauungen der Aufklärung und erlebte ihre Blüte im 20. Jahrhundert. In der ersten Dekade des 21. Jahrhunderts, einer Zeit, in der wir nostalgisch auf die Moderne zurückschauen, haben wir immer noch den romantischen Hang zum Neuen und sind gleichzeitig voller Ungeduld, zu erfahren, was als nächstes passieren wird.

Daher ist es wichtig, auf die zwei bedeutendsten Charakteristika der internationalen zeitgenössischen Kunst in den letzten beiden Jahrzehnten hinzuweisen: Ein überwältigender und nie dagewesener Pluralismus an Form und Inhalt und der gleichzeitige Blick auf historische Vorläufer stehen im Widerspruch zu unseren positivistischen Erwartungen, enttäuschen unsere Sehnsucht nach Klassifizierung, Kategorisierung und zeitlicher Einordnung.

Wie die Auswahl der Künstler in THE ART OF TOMORROW zeigt, ist die einflussreichste Kunst im Moment auf provozierende Weise eklektisch. Alle Arten von Abstraktion stehen neben Figuration, Konzeptualismus, Relational Art und Mischformen wie narrativer Konzeptkunst. Die beständige Wiederkehr der Malerei ist ebenso zu beobachten wie eine Renaissance von Performance-Kunst; monumentale Skulpturen erfreuen sich großer Beliebtheit, während gleichzeitig entschieden „unmonumentale" Tendenzen von Assemblage, Collage und Montage allgegenwärtig sind. Dokumentarische Filme und Videos florieren in unerwartetem Ausmaß, Künstler drehen Spielfilme und errichten raffinierte Pavillons, in denen Arbeiten, die neue Medien verwenden, betrachtet werden können, parallel dazu erlebt das Objekt eine Verklärung: eine kleinformatige Leinwand, eine Skulptur von geringer Größe. In der Zusammenschau ergeben all diese Arbeiten das Bild einer Ära von simultaner Verfügbarkeit und Relevanz. Die Fortschreibung der Kunstgeschichte ist nicht an ihr Ende gekommen, aber sie entwickelt sich nicht mehr nur nach oben, einer einzigen Sonne entgegen wie ein Weinstock oder eine Treibhauspflanze, sondern eher in alle Richtungen wie ein Gewirr grüner Gräser.

Die „reizvolle Spannung", über die Steinberg in der Begegnung mit moderner Kunst schrieb, könnte auch beim Lesen der vorliegenden Kompilation auftreten, aber sie wird wahrscheinlich eher durch das Moment der Wiedererkennung als durch die Überraschung des Neuen ausgelöst. Wie unsere Auswahl eindeutig zeigt, erinnert sich „die Kunst von morgen" an die Kunst von gestern und kommentiert sie. Die Künstler lassen sich von allen Genres und Strömungen der Kunstgeschichte inspirieren, machen Anleihen bei ihnen oder zeigen ihre Vorlieben. In diesem Buch kann man ebenso Beispiele für Albertis Perspektive und kubistische Raumwahrnehmung finden wie betont Konkrete Kunst, Bezüge zum Klassizismus und Konstruktivismus, Expressionismus und Realismus wie zum Duchamp'schen Readymade.

Auch wenn viele Arbeiten formal auf Werken vergangener Epochen gründen, wiederholt sich die Kunstgeschichte doch nicht, weil bekannte Formen in unbekannten Zusammenhängen auftauchen oder in frischen Kontexten gebraucht werden. Auf diese Weise werden sie transformiert und behalten nur eine pseudomorphe Beziehung zu ihren früheren Vorbildern zurück. Man begreift so die Geschichte der bildenden Kunst unhierarchisch als eine Art unbegrenztes Feld künstlerischer Möglichkeiten, das zeitgenössische Künstler mit einem immensen künstlerischen Vokabular bespielen. Ihre Arbeiten reflektieren profunde Kenntnis der Kunstgeschichte und großen Respekt vor ihr, die sie verstärkt als international weitreichend und als einflussreich begreifen. Die ironische Aneignung des letzten Jahrhunderts ist der Hommage und dem engagierten Neumachen gewichen.

Die Theorie vom „Long Tail" mag aus dem Marketing kommen, aber die generelle Beobachtung, dass die Zahl der meinungsbildenden Gruppen im Internetzeitalter stark steigt und dass das Erkennen von weltweiten kulturellen Trends durch individuelle Trendsetter obsolet geworden ist, hat nachhaltige Resonanz in der Wahrnehmung von zeitgenössischer Kunst und ihren vielfältigen Konfigurationen ausgelöst. Die Antwort auf die Frage „Wie sieht die Kunst von morgen aus?" wird vor allem von Vorlieben des Betrachters abhängen. Heute sind wir mit der Fähigkeit gesegnet oder gestraft, nur die Kultur, die wir uns aussuchen, zu konsumieren. Am Ende kann jeder seine persönlichen Entwicklungsprozesse auf der Basis seiner Wahlfreiheit ohne die Zuhilfenahme von Ratschlägen oder Fachwissen kultivieren.

THE ART OF TOMORROW schlägt eine Schneise in den üppigen, manchmal undurchdringlichen Dschungel der aktuellen Kunst der letzten fünf Jahre. Es stellt eine repräsentative, mit Bedacht ausgewählte Anzahl internationaler Künstler am Beginn ihrer Karriere vor. Der Weg, den sie mit ihren Arbeiten vorgeben, führt nicht in eine Richtung, sondern in viele, was mit Sicherheit die Qualität der weitläufigen Landschaft unserer kulturellen Zukunft ausmacht.

Als wir mit der Arbeit an THE ART OF TOMORROW begannen, haben wir uns gefragt, warum und für wen wir dieses Buch machen. Wer wird sich dafür interessieren, an wen richtet es sich? Es gab schon ähnliche Publikationen, die den zeitgenössischen Kunstbetrieb dokumentierten und festhielten, was zum Zeitpunkt ihres Erscheinens vor sich ging. Unsere Absicht ist eine andere: Wir beobachten nicht nur, was gerade geschieht, sondern werfen einen Blick auf die nächste maßgebliche Generation. Die Künstler in diesem Buch – davon sind wir überzeugt – geben nicht nur dem jetzigen Diskurs der bildenden Kunst wichtige Impulse, sondern haben das Potenzial, in den kommenden Jahren noch einflussreicher zu werden.

Mit dieser Absicht ist THE ART OF TOMORROW entstanden, für Künstler, Theoretiker, Autoren, Galeristen und Kuratoren, die sich die Tendenzen der kommenden Jahre vergegenwärtigen und gleichzeitig einen umfassenden Einblick in die derzeitige internationale junge Künstler-szene bekommen wollen. Das Buch möchte aber auch das Interesse eines weniger speziali-sierten Publikums wecken, das hin und wieder Ausstellungen besucht und sich über aktuelle und zukünftige Trends, die mit aller Wahrscheinlichkeit in der nahen Zukunft noch mehr Auf-merksamkeit erregen werden, informieren will. Daher war es für uns wichtig, nicht nur kurze aussagekräftige Texte von internationalen Verfassern, sondern auch eindrucksvolle Bilder im Buch zu versammeln, die die gezeigten Positionen visuell verständlich machen.

Wie alle Unternehmungen in der zeitgenössischen Kunst ist auch THE ART OF TOMORROW sub-jektiv und gibt die Sichtweisen der Personen wieder, die an dem Projekt mitgewirkt haben. Da aber so zahlreiche Stimmen – der Herausgeber, der Autoren und der Künstler – vertreten sind, glauben wir, eine große Bandbreite der Kunst von heute und morgen vorzustellen.

Danken möchten wir allen Beteiligten, die an THE ART OF TOMORROW mitgearbeitet haben:

- den gezeigten Künstlern, den Galeristen und deren Mitarbeitern, die diese Künstler vertreten, sowie den Fotografen, die ihre Arbeiten dokumentiert haben
- den Autoren Jens Asthoff, Sven Beckstette, Kirsty Bell, Michael Connor, Lauren Cornell, Silke Hohmann, Anthony Huberman, Rita Kersting, Oliver Koerner von Gustorf, Matthias Mühling, Lauren O'Neill-Butler, David Riedel, Dieter Roelstraete, André Rottmann, Chris Sharp, Ali Subotnick, Ossian Ward und Astrid Wege
- der Redakteurin Sabine Bleßmann
- den Lektoren Cordelia Marten und Gerrit Jackson
- den Übersetzern Barbara Hess und Gerrit Jackson
- dem Grafikdesigner Mathias-Kim Beyer

Laura Hoptman, Yilmaz Dziewior, Uta Grosenick
September 2010

PREFACE

'The thrill of pain caused by modern art is like an addiction', wrote the art historian Leo Steinberg in 1960, when newness, however wrenching, connoted progress. The idea that culture was moving towards something inevitably better than what came before has its roots in the scientific teleologies of the Enlightenment and its flower in the twentieth century. In the first decade of the twenty-first, at a time when we view the modern nostalgically, we still retain the historically Romantic attraction to newness and are at once eager to see what is coming next.

It is important, then, to point out the two key characteristics of the last two decades of international contemporary art: an overwhelming and unprecedented pluralism of form and content and a synchronic view of historical precedents. Both work against our positivist expectations, frustrating our desire to rank, label, or periodise.

As the selection of artists in this volume of THE ART OF TOMORROW attests, the most influential art of the moment is defiantly eclectic. Abstraction of all kinds co-exists with figuration, Conceptualism, Relational Art, and hybrids like narrative Conceptualism. The perennial return of painting is welcomed alongside a renaissance of performance-based initiatives; monumental sculpture enjoys a revival, while the decidedly 'unmonumental' tendencies of assemblage, collage, and montage have gained ubiquity. Time-based film and video flourish on an unprecedented scale, with artists creating feature films and erecting elaborate pavilions in which to view new media works. There is also a transfiguration of the object like a small canvas, or a table-top sculpture. Our survey brings together a group of works that create a picture of an age of simultaneous availability, simultaneous relevance. The story of art history has not stopped, but it is not growing up and towards a single sun, like a vine or a hothouse flower, but rather in all directions like a tangle of verdant weeds.

In addition, while that 'thrill of pain' Steinberg wrote about when confronted with modern art might still occur when perusing this compilation, it might as easily be caused by the shock of recognition as the shock of the new. As our examples show unequivocally, 'the art of tomorrow' recalls and comments upon the art of yesterday. Artists are inspired by, borrow from, or share affinities with all periods of the history of art. In this book one can find examples of Albertian perspective, cubist notions of space, as well as emphatic Concretism; references to Classicism and Constructivism, Expressionism, Realism, and the Duchampian Readymade.

Although most works have a formal basis in the art of earlier eras, history is not repeating itself exactly, because familiar forms are put to unfamiliar uses or deployed in fresh contexts. In this way, they are transformed, and retain only a pseudomorphic relationship to their earlier incarnations. Apprehending the history of visual culture non-hierarchically, as a kind of infinite plane of artistic choices, contemporary artists construct rich artistic vocabularies. Their works reflect deep knowledge of, and respect for, a broad, international, and cumulative notion of art history. Ironic, fin-de-siècle appropriation is replaced by homage and can-do reconstruction.

The theory of the 'long tail' might have originated in marketing, but the general observation remains true that communities of opinion have proliferated so widely in the Internet age that the notion of worldwide cultural trends spotted by individual arbiters of opinion has become obsolete. This has deep resonance with the reception of contemporary visual art in its myriad configurations. The answer to the question 'what does the art of tomorrow look like?' might well depend, first and foremost, on the proclivities of the beholder. Today we are graced or cursed with the ability to consume only the culture we choose to consume. In the end, everyone can cultivate his or her own personal teleology on the strength of his or her own choices and without the benefit of advice or expertise.

THE ART OF TOMORROW cuts a path through the rich but dense growth of the contemporary visual art of the past five years. It features a representative, deliberately chosen group of international artists at the beginning of their careers. The trajectories their works describe lead not in a single direction but in many, which is surely the hallmark of the vast landscape of our cultural future.

Working on a publication like THE ART OF TOMORROW, we had to ask ourselves why and for whom we are doing this. Who will be interested in this book? Whom do we address? There have been similar publications that documented the numerous contemporary art scenes, focussing on what was going on at the moment of their publication. Our aim is different insofar as we look not only at what is going on now but also at what we believe will be the next relevant generation. The artists in this book, we are convinced, are not only making important contributions to the contemporary discourse in the visual arts now but also have the potential to be influential in the future.

In this context, THE ART OF TOMORROW is made for artists, theorists, writers, gallerists, and curators who want to envision future trends and also receive more insight into the current generation's art scene on an international level. The book also aims to awaken the interest of a less specialised audience: people who may visit exhibitions from time to time and like to be informed about current and future trends that will likely receive attention going forward. That is why it was important to us to include in the book not only highly informative brief essays by international authors but also visual material that is as accessible as it is impactful. Like all endeavours in contemporary art, THE ART OF TOMORROW is biased and the views represented in it are those of the people involved in the project. But having included many voices, ranging from editors to writers to the artists themselves, we hope to offer a thorough sample of the art of today and tomorrow.

We would like to thank everyone who contributed to THE ART OF TOMORROW:

· all the artists presented, the gallery owners and their associates who represent them, and the photographers who have documented their work
· the authors, Jens Asthoff, Sven Beckstette, Kirsty Bell, Michael Connor, Lauren Cornell, Silke Hohmann, Anthony Huberman, Rita Kersting, Oliver Koerner von Gustorf, Matthias Mühling, Lauren O'Neill-Butler, David Riedel, Dieter Roelstraete, André Rottmann, Chris Sharp, Ali Subotnick, Ossian Ward, and Astrid Wege
· the managing editor, Sabine Bleßmann
· the copy editors, Cordelia Marten and Gerrit Jackson
· the translators, Barbara Hess and Gerrit Jackson
· the graphic designer, Mathias-Kim Beyer

Laura Hoptman, Yilmaz Dziewior, Uta Grosenick
September 2010

ACKNOWLEDGMENTS

DISTANZ und die Herausgeber bedanken sich bei den folgenden Galerien und Studios der Künstler und ihren Mitarbeitern für die großzügige Bereitstellung von Bildmaterial und Informationen für THE ART OF TOMORROW:

DISTANZ and the editors would like to thank the following galleries and artists' studios and their associates for generously providing photographic material and information for THE ART OF TOMORROW:

Alexander and Bonin, New York, Oliver Newton – Andersen's Contemporary, Copenhagen/
Berlin, Leonie von Gadow, Christina Kohorst – Ei Arakawa Studio – Balice Hertling, Paris,
Alexander Hertling – Barbican Art Gallery, London, Alex Cattell – Walead Beshty Studio,
John Ryan Moore – Johanna Billing Studio – Alexandra Bircken Studio – Peter Blum Gallery,
New York, Simone Subal – Isabella Bortolozzi, Berlin, Andrew Cannon, Marta Lusena – Bose
Pacia, Brooklyn, Sadia Rehman – Carol Bove Studio, Gordon Terry – BQ, Berlin, Jörn Bötnagel,
Anna Grande, Ann Kristin Kreisel – Kerstin Brätsch Studio – Broadway 1602, New York, Aniko
Erdosi – Galerie Daniel Buchholz, Cologne/Berlin, Katharina Forero, Christopher Müller, Julia
Schneider – Bugada & Cargnel, Paris, Claudia Cargnel – Mircea Cantor Studio, Gabriela Vanga –
Galerie Gisela Capitain, Cologne, Regina Fioroto, Dorothee Sorge – Capitain Petzel, Berlin,
Marta Fontolan, Dan Gunn – Peter Coffin Studio, Joshua Smith – Sadie Coles HQ, London,
James Cahill, Katy Morgan – Paula Cooper Gallery, New York, Davina Semo – Pilar Corrias Ltd,
London, Isabella Maidment, Lorena Muñoz-Alonso – Corvi-Mora, London, Tabitha Langton-
Lockton – Galerie Chantal Crousel, Paris, Philippe Manzone, Karen Tanguy – Jason Dodge
Studio – Foksal Gallery Foundation, Warsaw, Joanna Diem, Aleksandra Sciegienna – gb agency,
Paris, Solène Guillier, Magalie Meunier, Elodie Royer – c/o Gerhardsen Gerner, Berlin, Maike
Fries – Gladstone Gallery, New York/Brussels, Sascha Crasnow, Daniel Feinberg – Greene
Naftali, New York, Anna Fisher, Annie Ochmanek, Rachel Tomlinson – Herald St, London,
Samara Aster – Hollybush Gardens, London, Malin Stahl – Xavier Hufkens, Brussels, Mathieu
Paris – Taka Ishii Gallery, Tokyo/Kyoto, Takayuki Mashiyama, Jeffrey Ian Rosen – Luis Jacob
Studio – Galerie Martin Janda, Vienna, Eva Lahnsteiner – Catriona Jeffries, Vancouver, Anne
Low – Johnen Galerie, Berlin, Cornelia Tischmacher – Casey Kaplan Gallery, New York, Jessica
Lally, Loring Randolph – Georg Kargl, Vienna, Doris Richter – Galerie Ben Kaufmann, Berlin,
Henri Dietz – Galerie Peter Kilchmann, Zurich, Annemarie Reichen – Johann König, Berlin,
Edwige Cochois, Tien Nguyen The – David Kordansky Gallery, Los Angeles, Melissa Tolar –
Andrew Kreps Gallery, New York, Phil Birch – Kukje Gallery, Seoul, Bella Jung – kurimanzutto,
Mexico City, Amelia Hinojosa – Galerie Yvon Lambert, Paris/New York, Didier Barroso – Tanya
Leighton, Berlin, Robert Fitzpatrick – Daniel Lergon Studio – Michael Lett, Auckland, Sarah
Hopkinson – David Lieske Studio – Lisson Gallery, London, Rute Ventura – Lombard-Freid
Projects, New York, Jessica Eisenthal – Lüttgenmeijer, Berlin, Robert Meijer – Maccarone,
New York, Daphné Valroff – Gió Marconi, Milan, Esther Quiroga – Mary Mary, Glasgow, Hannah
Robinson – Galerie Meyer Kainer, Vienna, Isabella Ritter – Jan Mot, Brussels, Pieter Demeyere,
Amadeo Tuskany – Galerie Christian Nagel, Cologne/Berlin, Daniel Patrick Müller, Andrea Zech –
Galerie Neu, Berlin, Magnus Schäfer – Galerie Giti Nourbakhsch, Berlin – Maureen Paley,
London, Patrick Shier – Galerie Emmanuel Perrotin, Paris/Miami, Héloïse Le Carvennec, Clara
Ustinov – Friedrich Petzel Gallery, New York, Vera Alemani, Sam Tsao – Galerie Francesca Pia,
Zurich, Stefanie Little – Postmasters, New York, Magdalena Sawon – Galerie Eva Presenhuber,
Zurich, Melanie Bidmon, Kristina von Bülow – RaebervonStenglin, Zurich, Beat Raeber – Raqs
Media Collective, New York, Monica Narula – Galerie Almine Rech, Brussels/Paris, Sibylle du
Roy – Sterling Ruby Studio, Natasha Garcia Lomas, Devon Oder – Michael Sailstorfer Studio –
Tomás Saraceno Studio, Emek Uluray – Scai the Bathhouse, Tokyo, Fumiko Nagayoshi –
Markus Schinwald Studio – Galerie Rüdiger Schöttle, Munich, Susanne Spieler – Galerie Micky
Schubert, Berlin, Oriane Durand – ShanghART, Shanghai, Helen Zhu – Stuart Shave/Modern
Art, London, Ryan Moore – Sies + Höke, Düsseldorf, Diana Hunnewinkel, Julia Köhler – Sommer
Contemporary Art, Tel Aviv, Silvan Raveh – Sprüth Magers, Berlin/London, Jochen Arentzen,
Ruth Kißling, Jan Salewski, Andrew Silewicz – Galerie Barbara Thumm, Berlin, Judith Manzoni –
Van Horn, Düsseldorf, Daniela Steinfeld – Vitamine Creative Space, Guangzhou, He Cong –
Danh Vo Studio – Kelley Walker Studio, Neal Curley, Allison Kave – Galerie Barbara Weiss,
Berlin, Charlotte von Carmer – Andro Wekua Studio, Roseline Rannoch – Galerie Fons Welters,
Amsterdam, Laurie Cluitmans, Laura van Grinsven – White Cube, London, Alex Bradley, Sara
Macdonald – Galerie Michael Wiesehöfer, Cologne, Sabine Jenske – Galleri Christina Wilson,
Copenhagen, Katrine Jørgensen, Janna Lund – Xu Zhen Studio, Renee Xue – Zach Feuer Gallery,
New York, Grace Evans – Zero..., Milan, Alice Conconi, Anna Cuomo

THE ART OF TOMORROW

JENNIFER ALLORA
& GUILLERMO CALZADILLA

Jennifer Allora
1974 geboren in Philadelphia, PA, USA
1974 born in Philadelphia, PA, USA

Guillermo Calzadilla
1971 geboren in Havanna, Kuba
1971 born in Havana, Cuba

Live and work in New York, NY, USA,
and San Juan, Puerto Rico
Leben und arbeiten in New York, NY, USA
und San Juan, Puerto Rico

2010 29th Bienal de São Paulo – *Há
sempre um copo de mar para o homem
navegar / There is always a cup of sea
to sail in*
2008 16th Biennale of Sydney –
Revolutions – Forms That Turn
2008 7th Gwangju Biennale – *Annual
Report: A Year in Exhibitions*
2007 9th Biennale de Lyon – *00s.
The history of a decade that has not
yet been named*
2007 10th International Istanbul
Biennial – *Not Only Possible,
But Also Necessary: Optimism
in the Age of Global War*
2005 51st International Art Exhibition /
La Biennale di Venezia – *The Experience
of Art; Always a Little Further*

www.alloracalzadilla.com

www.crousel.com
www.gladstonegallery.com
www.lissongallery.com

Compass, 2009
Plywood, tap dancer
(Hiroki Mano, depicted
in the photograph)
2133 × 3048 cm
Installation view,
Temporäre Kunsthalle Berlin

Welche Spuren und Sedimente hinterlässt die Zeit, hinterlassen wir selbst? Dieser Frage gehen Jennifer Allora und Guillermo Calzadilla nach. Das Künstlerduo versteht beide Begriffe dabei im wortwörtlichen wie übertragenen Sinne. Für ihren Beitrag zur Biennale in Venedig 2005 wühlten sie beispielsweise im Schlamm des Canal Grande. Nicht die glorreiche Vergangenheit der Lagunenstadt, an die zahlreiche heroische Reiterstandbilder erinnern, förderten sie zu Tage, sondern die Abfallprodukte, aus denen sie ein dösendes Flusspferd formten. *Hope Hippo* war jedoch nicht einfach ein Anti-Monument auf jegliches historisches Pathos. Vielmehr banden Allora und Calzadilla ihre Skulptur an die unmittelbare Gegenwart an. Auf den Rücken des Tieres setzten sie einen Zeitungsleser, der immer dann in eine Trillerpfeife blasen sollte, wenn ihm eine Meldung unglaubwürdig erschien: Ein Signal, dass der Müllberg, auch der geistige, täglich munter weiter wächst.

Die Folgen dieser Ablagerungen zeigte das amerikanisch-kubanische Paar in der Performance *Stop, Repair, Prepare: Variationen zur Ode „An die Freude" für ein präpariertes Klavier* (2008) auf. Wie der Titel bereits besagt, bezieht sich die Arbeit auf den Schlusssatz von Beethovens unverwüstlicher 9. Symphonie. Allora und Calzadilla sägten ein Loch in den Rumpf eines Flügels und schalteten so zwei Oktaven des Instruments aus. Die Öffnung gab einer Pianistin Platz, die nun die Tastatur von Innen heraus betätigen und sich dabei zugleich frei im Raum bewegen konnte. Durch den Eingriff wurden die Melodiebögen und Akkordfolgen von Beethovens Stück ähnlich beschädigt, wie das Werk durch seine wechselvolle Geschichte eigentlich längst korrumpiert sein müsste. Zugleich verhandeln Allora und Calzadilla auch aktuelle gesellschaftspolitische Anliegen. So engagierten sie sich etwa beim Protest gegen eine US-amerikanische Militärbasis auf Puerto Rico, der die Armee 2003 schließlich zum Rückzug zwang. Bei *Land Mark (Foot Prints)* (2001–2002) verteilten sie Schuhsohlen mit Slogans an die Demonstranten, um die Bandbreite des Widerstands festzuhalten: „Wir hatten nach einem Mittel gesucht, um die Vielfältigkeit dieser Gruppe auf den Fotos sichtbar zu machen, so wie das auch die Spuren im Sand aufzeigten, die in alle Himmelsrichtungen auseinanderstrebten und sich gegenseitig auslöschten, indem neue Spuren die bestehenden verwischen."

What traces and sediments does time, do we ourselves leave behind? That is a question Jennifer Allora and Guillermo Calzadilla explore. The artists' couple takes both of these concepts in a literal as well as a figural sense. For their contribution to the 2005 Biennale di Venezia, for instance, they dredged up the silt at the bottom of the Grand Canal. What they brought back to light was not the glorious past of the Queen of the Adriatic, commemorated by numerous historic equestrian statues, but the city's waste, out of which they shaped a dozing hippopotamus. Yet *Hope Hippo* was not a simple anti-monument denouncing all historical pathos; Allora and Calzadilla tied their sculpture to the immediate present, seating a newspaper reader on the animal's back with the assignment to blow his whistle whenever a report seemed implausible to him: a signal that the trash, including intellectual trash, is merrily piling up day after day.

In 2008, the American-Cuban duo illustrated the consequences of such accretion with the performance *Stop, Repair, Prepare: Variations on 'Ode to Joy' for a Prepared Piano*. As the title indicates, the work refers to the final movement of Beethoven's indestructible Ninth Symphony. Allora and Calzadilla bored a hole through the centre of a grand piano, taking two octaves of the instrument's range out of commission. The opening allowed a pianist to enter the instrument and work its keys from inside while also freely moving about the exhibition space. The intervention damaged the melodic arcs and chord sequences of Beethoven's piece in ways resembling the corruption that the vicissitudes of its history should long have inflicted on it. Allora and Calzadilla also work on current social and political causes. For instance, they contributed to the protests against a US military base on Puerto Rico, which eventually forced the army to retreat in 2003. For *Land Mark (Foot Prints)* (2001–2002), they distributed soles featuring slogans to the protestors in order to document the bandwidth of the resistance: 'We wanted to find a way to convey the diversity of this group in the photographs, as shown through the actual marks being produced in the sand – going in so many different directions, cancelling each other out as one footprint replaced the one that was made before.'

Sven Beckstette

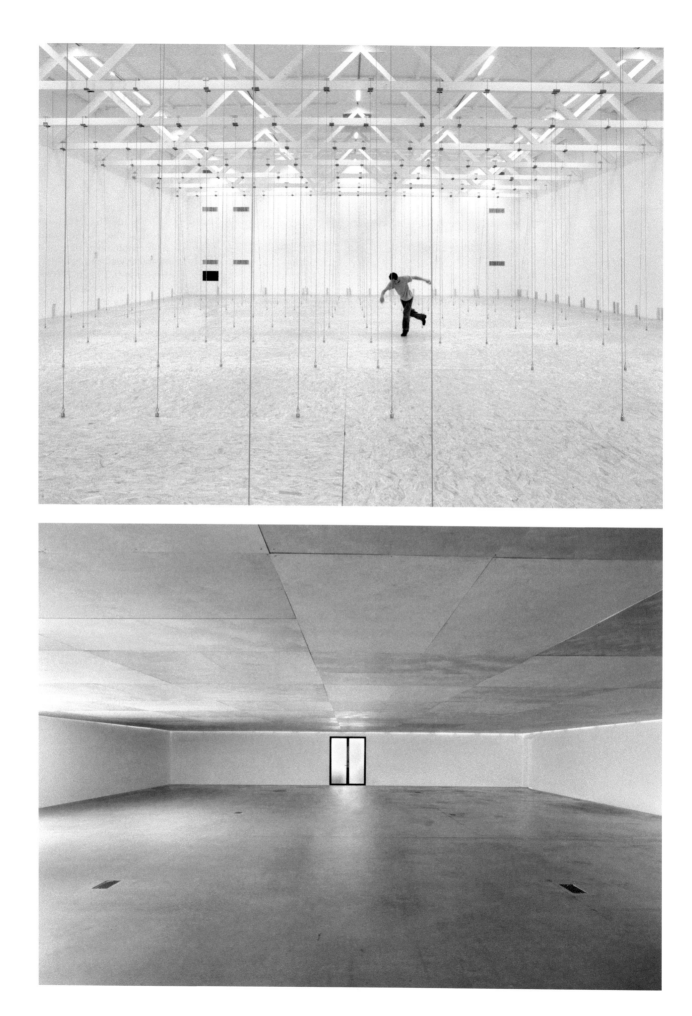

*Stop, Repair, Prepare: Variations
on 'Ode to Joy' for a Prepared Piano*, 2008
Prepared Bechstein piano, pianist
(Andrea Giehl, depicted in the photograph)
Length: 205 cm
Installation view, Haus der Kunst, Munich

Hope Hippo, 2005
Mud, whistle, daily newspaper, reader
489 × 183 × 152 cm
Installation view, 51st International Art
Exhibition / La Biennale di Venezia

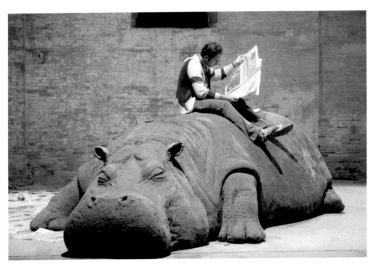

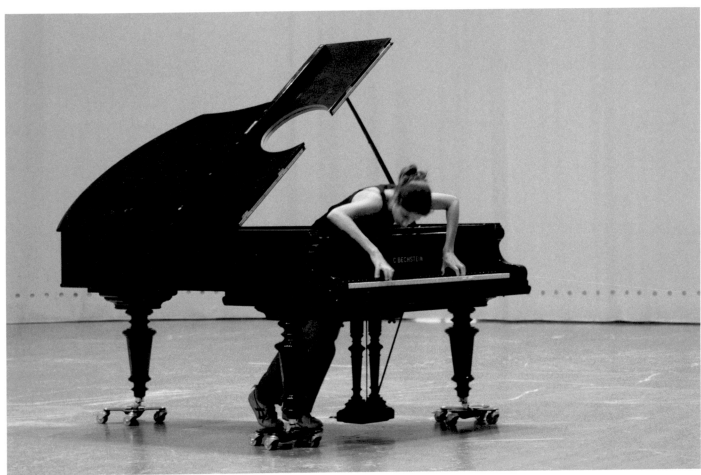

How to Appear Invisible, 2009
Super 16mm film transferred to HDV,
colour, sound
21:26 min

EI ARAKAWA

1977 geboren in Iwakawa, Japan, lebt
und arbeitet in New York, NY, USA
**1977 born in Iwakawa, Japan, lives and
works in New York, NY, USA**

2007 9th Biennale de Lyon – 00s.
*The history of a decade that has not
yet been named*

www.takaishiigallery.com

Der Werdegang von Ei Arakawa ist vielfältig: Ursprünglich wollte er Bühnenbeleuchtung studieren, verfügte aber nach eigener Aussage nicht über das notwendige mathematische Talent. Deshalb schrieb er sich an der New Yorker School of Visual Arts ein, an der er zunächst Kurse in Design und Comiczeichnen besuchte, um schließlich zur Freien Kunst zu wechseln. Später befasste er sich am Bard College mit Film und Video. Dieser knappe Überblick deutet auf den Charakter seiner Arbeiten hin, die er als Spektakel inszeniert. Das Interesse am Theater hat sich Arakawa in seinen installativen Performances bewahrt, in denen außerdem angewandte Kunstpraktiken und Multimediatechnik aufeinandertreffen.
Auf den ersten Blick geht es bei Arakawas Aufführungen um die Mechanismen der Produktion, Rezeption und Distribution von Kunst. Unter dem Motto *BYOF – Bring Your Own Flowers* lud er zusammen mit seiner Lehrerin, der Malerin Amy Sillman, 2007 zu einer Performance in New York ein. Tatsächlich verstanden einige Besucher den Titel als Aufforderung und brachten Blumensträuße mit, die prompt eingesammelt und als Malmaterial zweckentfremdet wurden. Und damit war das Publikum bereits mittendrin in einem Programm, bei dem Gemälde durch die Gegend getragen wurden, während gleichzeitig eine Lattenkonstruktion entstand sowie Lesungen und Vorträge zu hören waren. Dazu gab es Musik und Getränke. Zu guter Letzt wurde die architektonische Struktur wieder abgebaut, wobei herumstehende Zuschauer zur tatkräftigen Mitarbeit aufgefordert wurden. Mehrere Video- und Fotokameras hielten das bunte Treiben fest. Außer Texten und Bildern der Performance, die zum Ende verteilt wurden, erinnerte nichts mehr an den Abend, an dem das Publikum aktiv miterleben konnte, wie ein Kunstwerk entsteht und betrachtet, dokumentiert und abgebaut wird. Arakawa legt jedoch nicht nur die Abläufe im Kunstbetrieb offen. Ausgangspunkt der Performances sind zumeist gesellschaftspolitische Themen und Ereignisse wie Migration oder die Akzeptanz von Homosexualität, mit der er sich etwa in der achttägigen Veranstaltung *Riot the Bar* (2005) auseinandergesetzt hat. Allerdings bleiben die Verweise selbst für Eingeweihte und Freunde häufig erratisch. Vielmehr geht es Arakawa darum, wie Wissen und subjektive Identifikation in Körperlichkeit und Bewegung umgesetzt werden können. In seinen Arbeiten bringt Arakawa also buchstäblich die Verhältnisse zum Tanzen – sowohl in der Kunst wie auch im Leben.

Ei Arakawa has a colourful professional background: initially he wanted to study stage lighting, but, he says, he lacked the required mathematical talent. So he registered at New York's School of Visual Arts, attending classes in design and cartooning before switching to fine arts. Later on, at Bard College, he studied film and video. This brief biographical sketch already suggests the character of his works, which he stages as spectacles. Arakawa's original interest in the theatre is still evident in his installational performances, which also combine practices from the applied arts with multimedia technology.
At first glance, Arakawa's acts seem to be about the mechanisms of the production, reception, and distribution of art. In 2007, he and his teacher, the painter Amy Sillman, sent out invitations to a performance in New York under the heading *BYOF – Bring Your Own Flowers*. Some attendees actually read the title as a request and brought bouquets, which the artists promptly collected and repurposed into a painting material. And so the audience already found itself in the middle of a programme that featured paintings being carried around while a lath structure arose and readings and lectures could be heard. Music played, and drinks were served. Finally the architectonic structure was taken down again; members of the audience who watched the proceedings were invited to lend a hand. Several video and photo cameras documented the colourful goings-on. Apart from the texts and images of the performance that were distributed in the end, nothing remained of the evening, during which the audience was able to watch, and participate in, the creation, examination, documentation, and dismantling of a work of art.
Yet Arakawa's art is not limited to revealing how the art world operates. The point of departure for most of his performances are socio-political issues and events such as migration or the acceptance of homosexuality, a theme he explored, for instance, in the event *Riot the Bar* (2005), which ran for eight days. Many references, however, remain erratic even in the eyes of initiates and friends. Still, Arakawa's main interest is in how knowledge and subjective identification can be translated into physicality and movement. And so his works literally make the conditions dance – in art as well as in life.

Sven Beckstette

I am an Employee of UNITED, 2010
Performance, Galerie Neu, Berlin

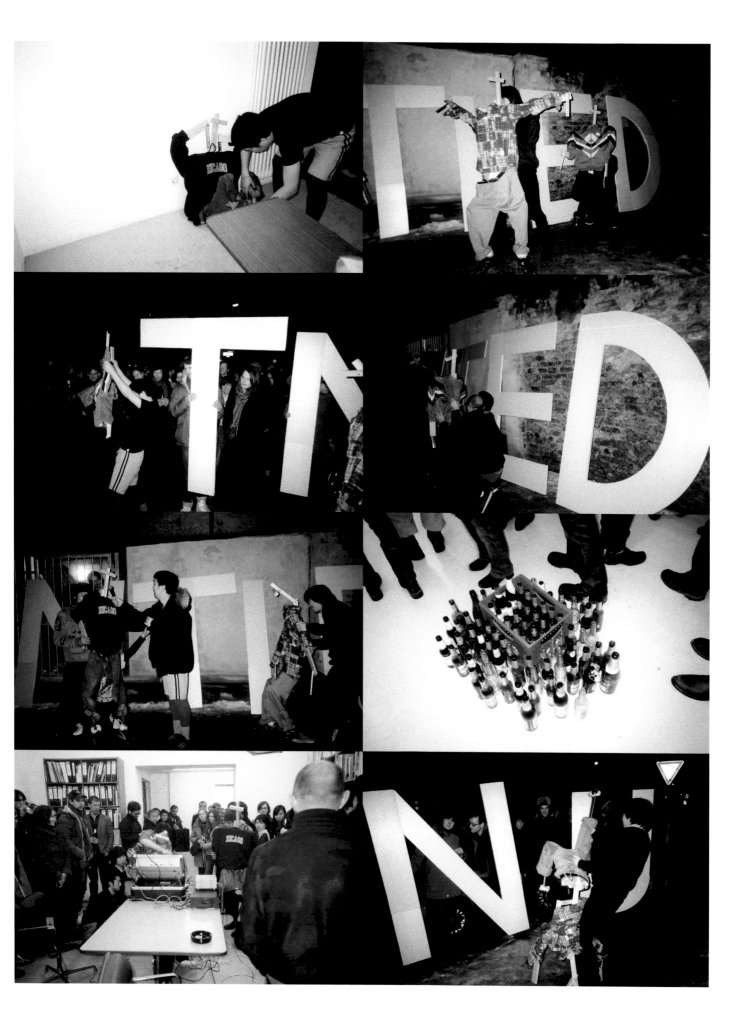

Ei Arakawa and Amy Sillman
BYOF – Bring Your Own Flowers, 2007
Performance, Performa07 at Japan
Society, New York

*Liaison, a Naïve Pacifist (BAYSIDE
YOKOHAMA Tickets)*, 2009
Offset print
46.5 × 23 cm

*Liaison, a Naïve Pacifist (with Paintings
by Silke Otto-Knapp)*, 2009
Performance, Taka Ishii Gallery, Kyoto

FIKRET ATAY

1976 geboren in Batman, Türkei,
lebt und arbeitet in Batman
**1976 born in Batman, Turkey,
lives and works in Batman**

2009 10th Biennale de Lyon –
Le spectacle du quotidien
2007 10th International Istanbul
Biennial – *Not Only Possible, But Also
Necessary: Optimism in the Age of
Global War*
2006 15th Biennale of Sydney –
Zones of Contact
2004 Busan Biennale – *Chasm*
2003 8th Istanbul Biennial –
Poetic Justice

www.crousel.com

„Ich lebe in einer Stadt, in der es praktisch unmöglich ist, Kunst zu produzieren" – diese Selbstverortung von Fikret Atay gehört zu seinen am häufigsten zitierten Äußerungen. Veröffentlicht ist sie im Katalog der Istanbul Biennial 2003, durch die er zu internationaler Bekanntheit gelangte. Der Alltag in seiner überwiegend von Kurden bewohnten Heimatstadt Batman nahe der Grenze zu Syrien und dem Irak ist Hintergrund und Thema seiner Videoarbeiten.

Meist mit einer Handkamera bei natürlichem Licht gefilmt, halten Atays kurze Videos in unprätentiöser Bildsprache improvisierte Situationen fest, in denen tradierte Kulturformen – Tänze, Lieder, Feste etc. – auf moderne westliche Einflüsse treffen. So singen zwei Jungen in *Rebels of the Dance* (2002) im kalten Licht des Vorraums einer Bank zu kurdischen Melodien Reime in einer verschlüsselten Sprache: Manifestation des Lokalen und zugleich Ausdruck einer Art Selbstzensur, da kurdisch in der Türkei bis in die 1990er Jahre verboten war. In *Any Time Prime Time* (2004) kontrastiert die archaisch anmutende Darstellung einer volkstümlichen Geschichte mit dem Titel, der das Geschehen in der medialen Aufmerksamkeitshierarchie der „Hauptsendezeit" zuordnet. Und in *Gooaall!!* (2009) definiert eine Asphaltstraße in karger Berglandschaft das Spielfeld einer Gruppe Fußball spielender Kinder, die schließlich von einem alten Mann abgelöst wird.

Atays Protagonisten sind meist Kinder und Jugendliche, gezeigt in Situationen, die die Welt der Erwachsenen widerspiegeln. Die von Kindern gespielte Schießerei in *Bang! Bang!* (2003) wird durch den Einsatz einer unruhigen Handkamera und suggestive Einstellungen mit den formalen Konventionen von Videospiel und Kriegsreportage kurzgeschlossen. Die Gemeinschaft der Tänzer in *Fast & Best* (2002), von denen die Kamera nur die Beine erfasst, wird durch fast militärisch wirkenden Gleichschritt zusammengeschweißt. Entindividualisiert erscheinen auch die Schüler einer Koranschule in *Theorists* (2008), die laut rezitierend im Raum herumgehen.

In *Tinica* (2004) hingegen spielt ein junger Mann versunken und mit Bravour auf einem selbst gebauten Schlagzeug aus leeren Blechdosen und Plastikeimern auf einer Anhöhe vor Batman. Am Ende seiner Aufführung kickt er die Einzelteile des Schlagzeugs den Hang hinunter – und verleiht dieser mittlerweile klassischen Geste der Rebellion bemerkenswerte Nonchalance.

'I live in a town where it is practically impossible to produce art' – this stark characterisation of his own situation is among the statements Fikret Atay is most often quoted with. It was printed in the catalogue of the 2003 Istanbul Biennial, in which he participated to international acclaim. Everyday life in his predominantly Kurdish hometown of Batman, near the Syrian and Iraqi borders forms the backdrop and subject of his video works.

Shot, in most cases, with a hand-held camera and in natural lighting, Atay's short videos use unpretentious images to record situations in which traditional cultural forms – dances, songs, festivals, etc. – clash with modern Western influences. In *Rebels of the Dance* (2002), for instance, two boys, standing in the cold light of a bank lobby, sing Kurdish melodies with rhyming lyrics in an encoded language: a manifestation of the local and at once the expression of a sort of self-censorship, since the use of Kurdish was forbidden in Turkey well into the 1990s. In *Any Time Prime Time* (2004), the seemingly archaic enactment of a folkloristic tale stands in contrast with the title, which assigns what is going on to a 'prime-time slot' in the hierarchical distribution of media attention. And in *Gooaall!!* (2009), an asphalt road amid arid mountains serves a group of children as a football field; finally, an old man appears in their stead.

Most of Atay's protagonists are children and teenagers, whom he shows in situations that reflect the world of grown-ups. In *Bang! Bang!* (2003), children play-act a shooting; the use of an unsteady hand-held camera and suggestive shots short-circuits their play with the formal conventions of video games and war reporting. The community of dancers in *Fast & Best* (2003) – the camera captures only their legs – is united by an almost military lockstep movement. The students at a Qur'an school in *Theorists* (2008), loudly reciting as they walk about the room, similarly appear to have been stripped of their individuality.

In *Tinica* (2004), by contrast, a young man, seated on a hill outside Batman, is immersed in playing with great virtuosity on a drum set he has built from empty tin cans and plastic buckets. At the end of his performance, he kicks the individual parts of the drum set down the hillside – imbuing what is by now a classical gesture of rebellion with remarkable nonchalance.

Astrid Wege

Tinica, 2004
Video, colour, sound
7:32 min

Rebels of the Dance, 2002
Video, colour, sound
10:52 min

Bang! Bang!, 2003
Video, colour, sound
2:17 min

Gooaall!!!, 2009
Video, colour, sound
4 min

NAIRY BAGHRAMIAN

1971 geboren in Isfahan, Iran,
lebt und arbeitet in Berlin, Deutschland
**1971 born in Isfahan, Iran,
lives and works in Berlin, Germany**

2008 5th berlin biennial for
contemporary art – *When things
cast no shadow*
2007 skulptur projekte münster 07

www.galeriebuchholz.de

*Portrait (The Concept-Artist
Smoking Head)*, 2008
b/w print, metal artist's frame, glass
125 × 123 × 3 cm

Klassentreffen (Class Reunion), 2008
Coloured epoxy resin, coloured
cast rubber, painted metal
Dimensions variable
Installation view,
Serpentine Gallery, London

Die Beziehung zwischen Interieur und Exterieur, ja das Dazwischen selbst, spielt eine zentrale Rolle im Werk von Nairy Baghramian. Am deutlichsten wird das in Installationen wie *Es ist außer Haus* (2006), *Entr'acte* (2007), *Ein semiotisches Haus, das nie gebaut wurde, La colonne cassée* oder *The Walker's Day Off* (alle 2008). Die Balance von Gebäuden und Körpern ist labil, ebenso ihre Trennung von Innen und Außen, die durch (Stell-)Wände, Fenster oder auch Gehhilfen vermittelt wird. Baghramians elegante Skulpturen aus lackiertem Metall, Messing, Papier, Stoff oder Porzellan erinnern häufig an Möbel der 1950er Jahre. Manche Arbeiten Baghramians haben darüber hinaus einen anthropomorphen Charakter und erscheinen als Porträts – ganz offensichtlich z. B. bei *Trennwände mit Ohrringen (Anna, Martha, Varthui)* (2005), in dem drei Schwestern aus Isfahan, die als emanzipatorische Vorbilder für Baghramian und ihre Freundinnen fungierten, als scharfkantige, mit weicher Stoffoberfläche konturierte abstrakte weiße Skulpturen auftauchen – widerständige allegorische Erscheinungen mit Körpern wie Schultafeln oder Projektionsflächen. Mit Interieur ist auch Seele, Mythos, Intellekt, das individuell Menschliche gemeint, das in Beziehung zum Exterieur, zur Öffentlichkeit, zu Politik und Geschichte steht.

So zeigte Baghramian die Arbeiten der fast vergessenen, 1909 geborenen feministischen Designerin und Künstlerin Janette Laverrière, oder sie eröffnete eine Ausstellung in London mit einer Fotografie des Hutes von *Mr. Keuner* (Herr K.), wobei Bertolt Brechts Protagonist für das Politische im Privaten steht. Die im Ausstellungsraum zentral aufgestellte hybride Skulptur *Butcher, Barber, Angler & others* (2009), eine utopische Dreifaltigkeit, war zurückzuführen auf eine von Marx und Engels vorgestellte Arbeitsteilung, die nicht zu Entfremdung, sondern zu Universalismus führen sollte: Der Mensch übt mehrere Berufe aus. Die Künstlerin stellt diese Theorie humorvoll als zeitgleiche Teilung des Individuums in Metzger, Frisör und Angler dar und verbindet die stilisierten Attribute Trockenhaube und Angelrute durch einen überlangen Metallbogen miteinander – ein manierierter Körper zwischen Kopf und Rumpf. Der Schinken auf dem wie ein lebenswichtiges Organ platzierten Tisch, von dem außerdem Würste herabhängen, ist Repräsentant des Metzgerberufs. In diese metaphernreiche Konstellation schreibt sich Baghramian vielleicht selbst ein: Man kann die Installation als ein Künstlerselbstporträt lesen.

The relation between interior and exterior, and indeed this in-between itself, plays a central role in Nairy Baghramian's work. That is most evident in installations such as *Es ist außer Haus* (2006), *Entr'acte* (2007), *Ein semiotisches Haus, das nie gebaut wurde, La colonne cassée,* or *The Walker's Day Off* (all 2008). The balance of buildings and bodies is unstable, as is their separation of inside and outside, mediated by (movable) walls, windows, or even, say, walking aids. Made of lacquered metal, brass, paper, fabric, or porcelain, Baghramian's elegant sculptures frequently recall furniture of the 1950s. Some of Baghramian's works also evince anthropomorphism, suggesting portraits; that is quite obvious, for instance, in *Trennwände mit Ohrringen (Anna, Martha, Varthui)* (2005), where three sisters from Isfahan, whose example Baghramian and her friends followed in their own process of emancipation, appear as sharply edged abstract white sculptures, their contours emphasised by soft fabric surfaces – refractory allegorical figures with bodies like school blackboards or projection screens. Interior: that also means the soul, myth, the intellect, the individually human, which relates to an exterior, to the public sphere, to politics and history.

For example, Baghramian showed works by Janette Laverrière (b. 1909), a virtually forgotten feminist designer and artist; or she opened a show in London with a photograph of the hat worn by *Mr. Keuner* (Herr K.); Brecht's protagonist represented the political within the private sphere. The hybrid sculpture installed at the centre of the exhibition space, *Butcher, Barber, Angler & others* (2009), a utopian Trinity, derived from a division of labour imagined by Marx and Engels that was supposed to lead not to alienation but to universalism: man working in several professions. With subtle humour, the artist represents this theory as a simultaneous subdivision of the individual into a butcher, a barber, and an angler, joining the stylised attributes of the drying hood and the fishing rod with an extra-long metal arc – a mannerist body between head and torso. The ham on the table installed like a vital organ – there are also sausage links hanging down from it – represents the butcher's trade. Perhaps Baghramian inscribes herself in this highly metaphorical constellation: we may read the installation as a self-portrait of the artist.

Rita Kersting

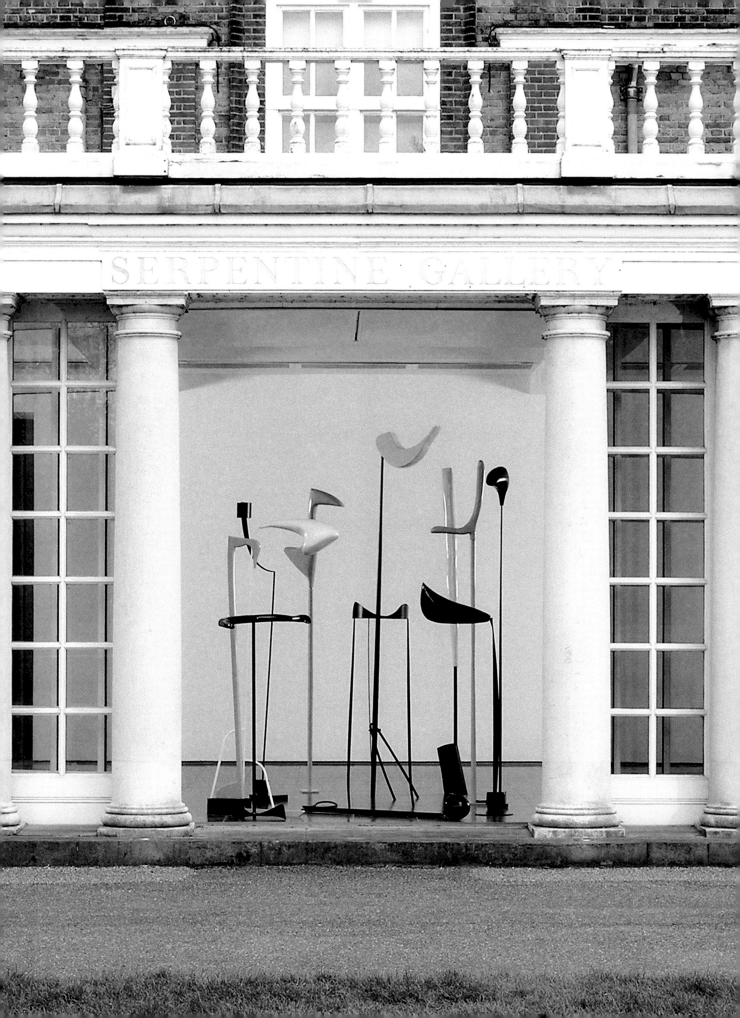

Eule, 2007
Wood, paint, epoxy resin
35 × 100 × 42 cm

Butcher, Barber, Angler & others,
2009
Painted metal and fibreglass,
wire mesh and rubber
Dimensions variable
Installation view, Studio Voltaire,
London

La colonne cassée, 1871, 2008
Two parts, painted steel
245 × 190 × 140 cm (each)
Installation view, 5th berlin biennial for
contemporary art, Neue Nationalgalerie

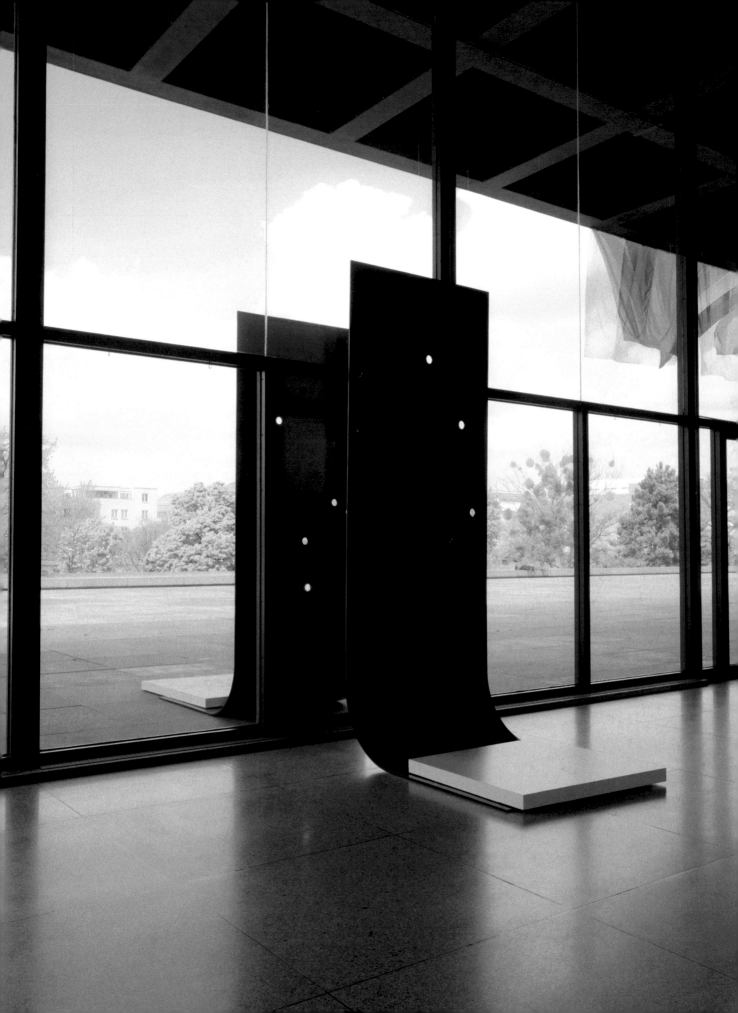

YAEL BARTANA

1970 geboren in Kfar Yehezkel, Israel,
lebt und arbeitet in Tel Aviv, Israel, und
Amsterdam, Niederlande
**1970 born in Kfar Yehezkel, Israel,
lives and works in Tel Aviv, Israel,
and Amsterdam, The Netherlands**

2010 29th Bienal de São Paulo – *Há
sempre um copo de mar para o homem
navegar / There is always a cup of sea
to sail in*
2007 documenta 12, Kassel
2006 27th Bienal de São Paulo – *Como
viver junto / How to Live Together*
2005 9th Istanbul Biennial – *Istanbul*
2004 Liverpool Biennial of
Contemporary Art
2002 Manifesta 4, European Biennial
of Contemporary Art, Frankfurt / Main

www.annetgelink.nl
www.sommergallery.com

A Declaration, 2006
Mini DV and DVD, colour, sound
7 min

A Declaration (2006): ein Mann in einem Ruderboot, im Hintergrund die Silhouette Jaffas. Er hält auf einen Felsen im Meer zu, auf dem die israelische Flagge weht, und tauscht sie gegen einen Olivenbaum aus. Ikonische Bilder, kollektive Zeremonien und alltägliche Rituale im Dienste nationaler und kultureller Identitätsbildung spielen eine zentrale Rolle in den Filmen von Yael Bartana. *Trembling Time* (2001) etwa zeigt einen Moment kollektiven Innehaltens am Jom haZikaron (Gedenktag an die gefallenen jüdischen Soldaten und Opfer des Terrorismus). *When Adar Enters* (2003) fängt Straßenszenen einer aufgekratzten Jugend im orthodoxen Jerusalem während des Purim-Festes ein, das an die Errettung des jüdischen Volkes in der Diaspora erinnert, doch die subtile Montage von Bild und Ton verleiht der Szenerie etwas latent Bedrohliches.
Eine solche Ambivalenz ist charakteristisch für Bartanas Werk. So ist der über Grenzen schwebende Zeppelin in *Freedom Border (Blimp)* (2003) mit einer Überwachungskamera ausgestattet. Die spielerische Besetzung von Sanddünen mithilfe massiger Geländewagen gewinnt in *Kings of the Hill* (2003) vor dem Hintergrund israelischer Siedlungspolitik politische Relevanz. Zunehmend fokussiert Bartana Formen individuellen Widerstands, etwa wenn Musiker auf das in Israel allgegenwärtige Sirenengeheul mit musikalischer Kakophonie antworten (*Sirens' Songs,* 2005) oder israelische Aktivisten die Evakuierung der Gilad-Kolonie in der Westbank nachstellen (*Wild Seeds,* 2005).
So wie *Summer Camp* auf *Avodah* (1935) verweist, einen Film über zionistische Siedler, spielen auch *Mary Koszmary* (Träume Albträume, 2007) und *Mur i Wieża* (Mauer und Turm, 2009) mit Elementen propagandistischer Ästhetik der 1930er Jahre. In *Mary Koszmary* umschmeichelt die Kamera einen jungen polnischen Redner, der für die Rückkehr der Juden plädiert, die das kommunistische Polen verlassen haben – unter Berufung auf die von den Nationalsozialisten ermordeten polnischen Juden.
Die Errichtung eines temporären Kibbuz im Stil der 1930er Jahre auf dem Gebiet des ehemaligen Warschauer Ghettos in *Mur i Wieża* wiederum ist mit Insignien kolonialer Expansion oder Reklamation ausgestattet. Schutz und Abgrenzung in einem, bietet das stacheldrahtbewehrte Camp ein doppeldeutiges Bild, das gängige Überzeugungen zu Antisemitismus, Xenophobie, Migration und nationaler Identität gegen den Strich bürstet: ein eindrücklicher Denkanstoß weit über die israelische und polnische Wirklichkeit hinaus.

A Declaration (2006): a man in a rowboat, the skyline of Jaffa in the background. He steers toward a rock in the sea on which the Israeli flag waves, and replaces it with an olive tree. Iconic images, collective ceremonies, and everyday rituals serving the formation of national and cultural identities play a central role in Yael Bartana's films. *Trembling Time* (2001), for instance, shows the beginning of Soldiers Memorial Day, when Israelis collectively stop in silence. *When Adar Enters* (2003) captures scenes of teenagers in an Orthodox neighbourhood of Jerusalem cheerfully celebrating Purim, which commemorates the rescue of the Jewish people during the Diaspora; but the subtle editing of images and sounds lends an atmosphere of latent menace to the scene.
This sort of ambivalence is characteristic of Bartana's work. The dirigible floating across borders in *Freedom Border (Blimp)* (2003), for example, is equipped with a surveillance camera. The playful occupation of sand dunes with massive all-terrain vehicles in *Kings of the Hill* (2003) speaks to a contentious political issue: Israeli settlement policy. Bartana increasingly focuses on forms of individual resistance, thus when musicians respond to the wailing of sirens, omnipresent in Israel, with a musical cacophony (*Sirens' Songs*, 2005); or when Israeli activists reenact the evacuation of Havat Gilad, a colony in the West Bank (*Wild Seeds,* 2005).
Summer Camp refers to *Avodah* (1935), a film about Zionist settlers; *Mary Koszmary* (Dreams Nightmares, 2007) and *Mur i Wieża* (Wall and Tower, 2009) similarly play with elements of 1930s propaganda aesthetics. In *Mary Koszmary,* the camera adoringly encircles a young Polish speaker as he makes the case for the return of the Jews who left Poland during the communist era – invoking the Polish Jews who were murdered by the Nazis.
By contrast, the creation of a temporary 1930s-style kibbutz on the territory of the former Warsaw ghetto in *Mur i Wieża* is furnished with the signature marks of colonial expansion or reclamation. Protection and segregation at once, the camp, surrounded by barbed wire, presents an ambiguous picture, going against the grain of widespread ideas about anti-Semitism, xenophobia, migration, and national identity: plenty of food for thought far beyond current Israeli and Polish realities.

Astrid Wege

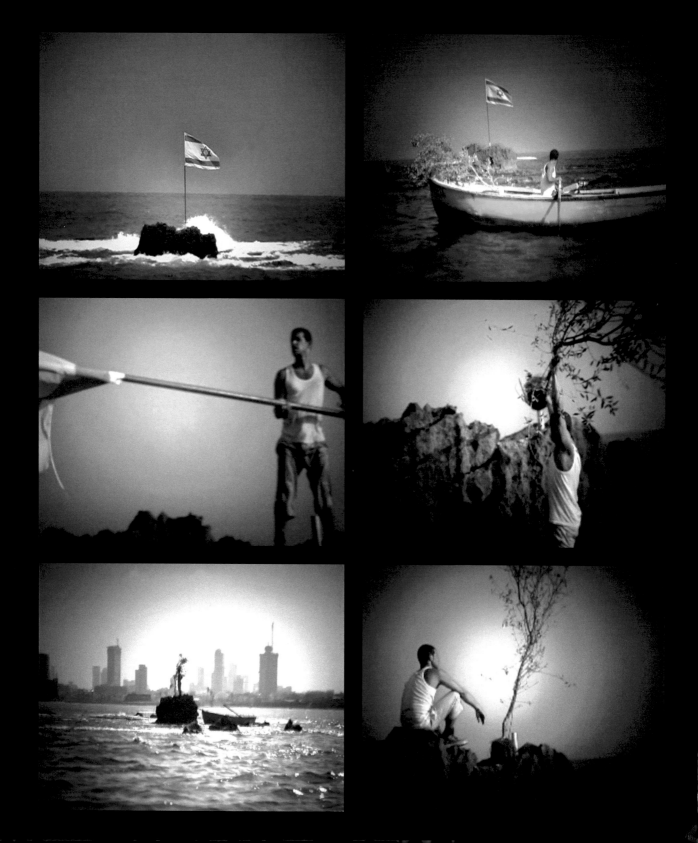

Mary Koszmary, 2007
Super 16mm film transferred to DVD,
colour, sound
10:50 min

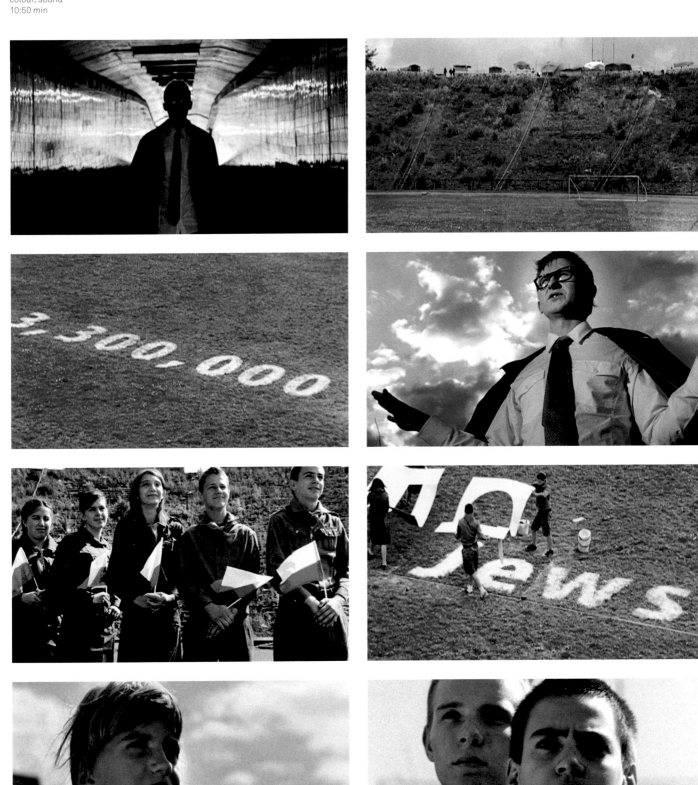

Mur i Wieża, 2009
HDV, colour, sound
13 min

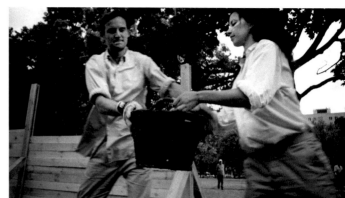
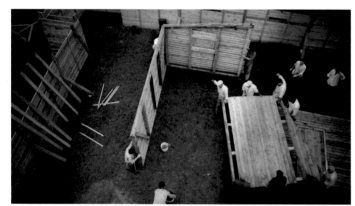
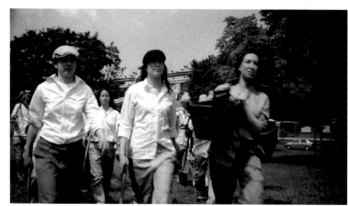

WALEAD BESHTY

1976 geboren in London, Großbritannien,
lebt und arbeitet in Los Angeles, CA, USA
**1976 born in London, Great Britain,
lives and works in Los Angeles, CA, USA**

2009 The Tate Triennial –
Altermodern, London
2008 Whitney Biennial, New York

www.galerierodolphejanssen.com
www.regenprojects.com
www.thomasdane.com
www.wallspacegallery.com

Vor allem die überdimensionalen Fotogramme von Walead Beshty werden im Zusammenhang mit neuen Tendenzen zur Abstraktion in der Fotografie diskutiert. Allerdings ist sein Werk vielgestaltig und keinesfalls formal, sondern kunst- und medienreflexiv angelegt. „Die Reflexivität meiner Arbeit bezog sich eigentlich nie auf ‚die Fotografie'", so Beshty, „sondern verstand sich als Reaktion auf spezifische Bedingungen ihrer Verwendung." Er arbeitet stets mit konzeptuellen, prozessgebundenen Verfahren. Auch als Autor ist er einflussreich, u. a. schreibt er für „Texte zur Kunst".

Beshty, so Kurator Shamim Momin, sei „eher daran interessiert, abstrakt mit Bildern umzugehen, als abstrakte Inhalte zu produzieren", und diese Reflexion eint ganz unterschiedliche Werkformen. So zeigte er in *Popular Mechanics,* einer Einzelschau 2009 bei Wallspace in New York, in einer irritierenden Konfrontation abstrakte, farbig-opulente Fotogramme der *Three Color Curl*-Serie zusammen mit kleinen Schwarz-Weiß-Fotos, auf denen Kuratoren, Galeristen, Helfer, Sammler, sogar Ansichten des Druckers und des Farbprozessors zu sehen waren. Er stellte also alle technischen und personellen Voraussetzungen ebenso wie die Produktions- und Distributionsbedingungen der farbigen Großformate aus. Wie schon bei László Moholy-Nagy oder Man Ray sind Beshtys Abstraktionen Fotografien ohne Kamera, ein Produkt der Dunkelkammer, das die materiellen Bedingungen des fotografischen Bildes thematisiert. Beshty konstruiert seine Bilder aus nichts als Licht, Filtern, Fotopapieren und den Möglichkeiten moderner Hightech-Printer. So war *Popular Mechanics* die Verflechtung zweier selbstreflexiver Bilddiskurse über Repräsentation und Referentialität des fotografischen Bildes. Auch jenseits der Fotografie findet Beshty Wege „prozessualer" Abstraktion, etwa mit den *FedEx®*-Arbeiten (2008): Kubische Glasskulpturen, passgenau nach FedEx-Standard-Verpackung gefertigt, lässt er via FedEx weltweit auf Ausstellungen schicken, präsentiert sie samt Karton und den beim Transport erlittenen Sprüngen, um sie später auf gleichem Wege weiterzuversenden. Der minimalistische Kubus, idealtypische Verkörperung ästhetischer Selbstbezüglichkeit, wird auf seine materiellen Rahmenbedingungen zurückgeworfen.

Among Walead Beshty's works, it is primarily the oversized photograms that critics interested in new tendencies toward abstraction in photography discuss. Yet his oeuvre is multifaceted; its roots, far from formalism, lie in a reflection on art and its media: 'The reflexivity of my work has never really been "about photography"', Beshty says, 'but a response to the specific conditions related to [its] use.' He always works with conceptual and process-bound methods. He is also an influential author, writing for 'Texte zur Kunst' and other publications.

Beshty, curator Shamim Momin says, 'is interested in treating the image abstractly rather than the content being abstract', and this reflection unites very different forms of works. In *Popular Mechanics,* for instance, a solo exhibition at New York's Wallspace in 2009, he displayed abstract and opulently colourful photograms from the *Three Color Curl* series in irritating confrontation with small black-and-white photographs showing curators, gallerists, assistants, collectors, even shots of the printer and the colour processor; that is to say, he exhibited all the technological and personal prerequisites underpinning the multi-coloured large formats as well as the conditions of their production and distribution. As in László Moholy-Nagy or Man Ray before him, Beshty's abstractions are photographs without a camera, a product of the darkroom that examines the material conditions of the photographic image. Beshty constructs his pictures out of nothing but light, filters, photographic paper, and the possibilities offered by modern high-tech printers. *Popular Mechanics* thus interwove two self-reflexive pictorial discourses about representation and the referentiality of the photographic image. Beyond the bounds of photography, too, Beshty finds ways to implement 'processual' abstraction, thus in the *FedEx®* pieces (2008): he has FedEx ship cubic glass sculptures, made to fit exactly into a standard FedEx package, to exhibitions around the world, presenting them with the box and the cracks they have suffered during transportation, and later sending them onward by the same method. The minimalist cube, the ideal-typical embodiment of aesthetic self-reference, is cast back upon the material conditions that make it possible.

Jens Asthoff

Passages, 2009
Exhibition view,
LAXART, Los Angeles

Production Stills, 2009
Exhibition view,
Thomas Dane Gallery, London

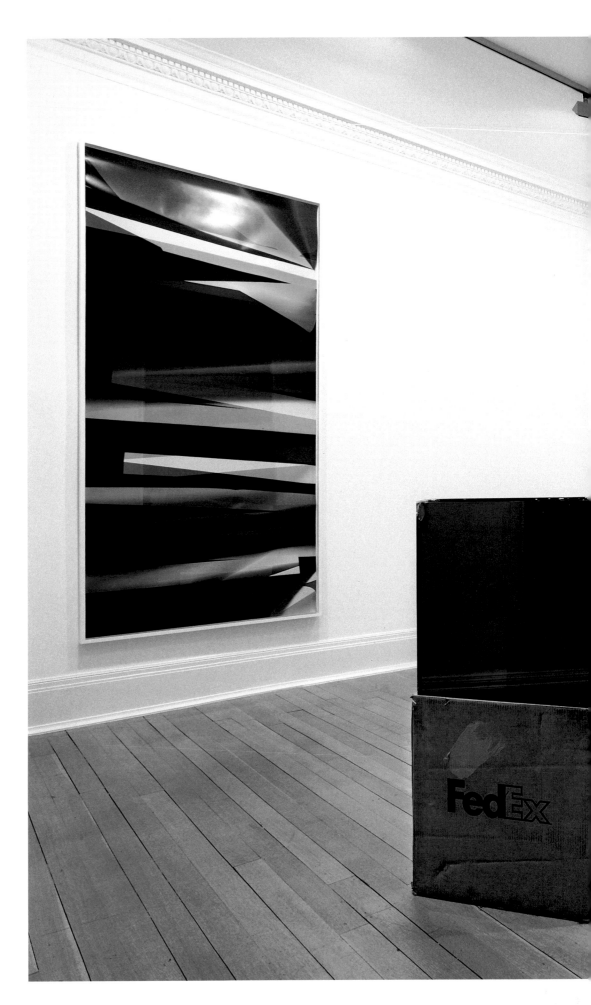

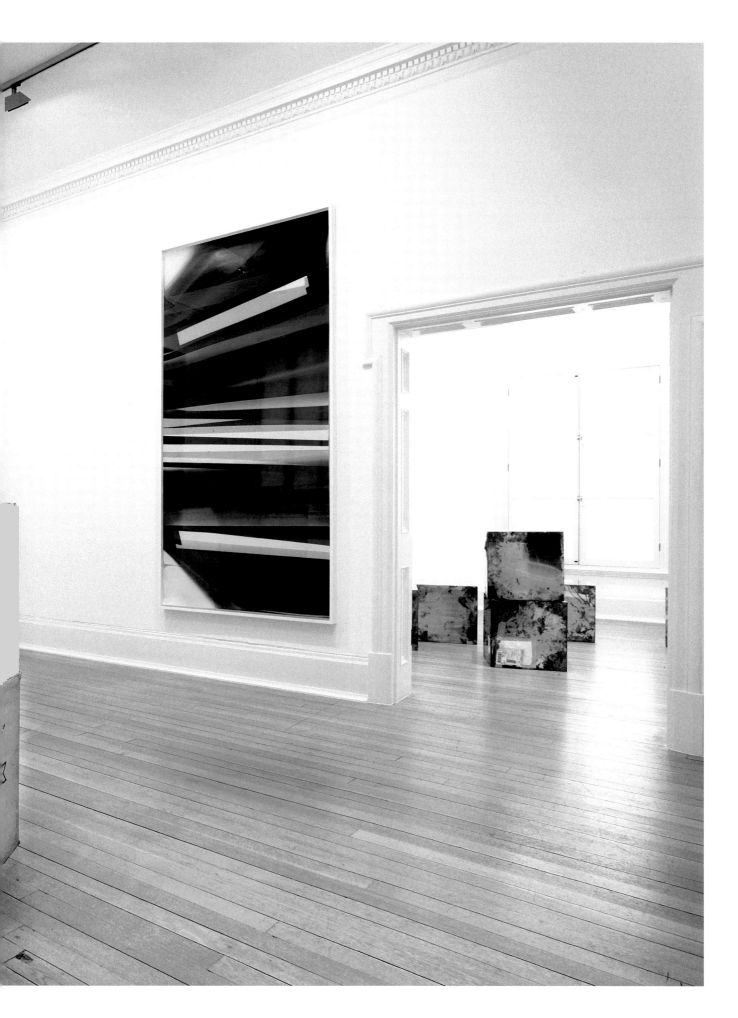

JOHANNA BILLING

1973 geboren in Jönköping, Schweden,
lebt und arbeitet in Stockholm,
Schweden
**1973 born in Jönköping, Sweden,
lives and works in Stockholm, Sweden**

2007 documenta 12, Kassel
2005 9th Istanbul Biennial – *Istanbul*
2005 1st Moscow Biennale of Contemporary Art – *Dialectics of Hope*
2003 50th International Art Exhibition /
La Biennale di Venezia – *Delays and Revolutions*
2002 4th Gwangju Biennale –
P_A_U_S_E

www.makeithappen.org

www.hollybushgardens.co.uk
www.kavigupta.com

„Einer der Gründe, weshalb ich beschlossen habe, mit dem Medium Film zu arbeiten", so Johanna Billing in einem Gespräch mit Philipp Kaiser, „lag in der einfachen Tatsache, dass der Ton die Hälfte seines Wesens ausmacht." Tatsächlich ist Musik ein zentrales Element in den Videos der schwedischen Künstlerin, die zwischen Dokumentation, Fiktion, Performance, Mise en scène, Musikvideo und Choreografie angesiedelt sind und oft heterogene Gruppen von Menschen einbeziehen.
In *I'm Lost Without Your Rhythm* (2009) und *Graduate Show* (1999) ist Musik das strukturierende Moment zweier Amateur-Tanzperformances. In *Magical World* (2005) und *Another Album* (2006), beide in Kroatien entstanden, wird Musikmachen zu einer Selbstvergewisserung in unsicherer Gegenwart; zu einem Prozess reflexiver Wiederaneignung der Vergangenheit: wenn Kinder in einem Kulturzentrum in einem Vorort Zagrebs ein Stück der Chicagoer Band „Rotary Connection" von 1968 einüben oder eine Gruppe junger Leute Songs der jugoslawischen New-Wave-Bewegung der 1970er und 1980er Jahre singt. „Magical World", ein persönliches Lied von Sidney Barnes, 1968 geschrieben in einer Zeit politischer Umwälzungen, wird nun von Kindern in einer ihnen nicht vertrauten Sprache vorgetragen, in einem Land, das sich selbst in einer Phase gesellschaftlichen Umbruchs befindet und dessen Situation keineswegs „magisch" wirkt.
Häufig sind Musikstücke und eine mit ihnen assoziierte Emotion titelgebend. In *This Is How We Walk on the Moon* (2007) verbindet Billing Arthur Russells gleichnamigen Song mit dem Versuch, sich auf unbekanntes Terrain vorzuwagen und schickt eine Gruppe seeunerfahrener schottischer Musiker auf einen Segeltörn; *Magic & Loss* (2005) – ein Umzugsteam verpackt in Abwesenheit der Bewohner eine Wohnungseinrichtung – nimmt Bezug auf ein Album von Lou Reed, das vom Verlust ihm naher Menschen handelt. *You Don't Love Me Yet* (2003) schließlich nimmt den gleichnamigen Song Roky Ericksons zum Anlass einer Coversong-Tournee durch mehrere europäische Länder mit inzwischen Hunderten Versionen dieses Stücks. Billings Filme sind hochkomplexe Arrangements mit ständig wechselndem Fokus zwischen Innen- und Außenraum, Vorder- und Hintergrund, Nahansicht und Totale. Sie halten die Spannung zwischen Einzelaktion und Gruppendynamik, Teilhabe und Beobachten, Handeln und Nicht-Handeln und schaffen einen „Raum in der Zeit", einen Zwischenraum, der offen ist für Neues, Unerwartetes.

'One of the reasons why I decided to start working with film as a medium', Johanna Billing said in a conversation with Philipp Kaiser, 'was the simple fact that sound is half of its consistency'. Music is indeed a central element in the videos made by this Swedish artist, which mark positions between documentary, fiction, performance, mise-enscène, music video, and choreography, often involving heterogeneous groups of people.
In *I'm Lost Without Your Rhythm* (2009) and *Graduate Show* (1999), music is the element that lends structure to two amateur dance performances. In *Magical World* (2005) and *Another Album* (2006), both shot in Croatia, making music becomes a process serving self-reassurance in an uncertain present and a reflective re-appropriation of the past: children in an arts centre in a suburb of Zagreb rehearse a 1968 song by the Chicago-based band 'Rotary Connection', and a group of young people sings tunes from the Yugoslav New Wave movement of the 1970s and 1980s. 'Magical World', a very personal song by Sidney Barnes, written in 1968, at a time of political upheaval, is now performed by children in a language they are not familiar with, and in a country that has likewise entered a period of social transformation – creating a situation that is far from 'magical'. Many of Billing's works take their titles from pieces of music and an emotion associated with them. In *This Is How We Walk on the Moon* (2007), she associates Arthur Russell's song of the same title with a daring venture into uncharted terrain, sending a group of Scottish musicians and landlubbers on a sailing trip; *Magic & Loss* (2005) – a team of movers packs up the furnishings of an apartment, the residents are absent – makes reference to an album by Lou Reed that is about losing people he was close to. In *You Don't Love Me Yet* (2003), finally, Roky Erickson's song of the same title becomes the occasion for a tour of cover songs through several European countries; by now, Billing has recorded hundreds of versions of the piece.
Billing's films are highly complex arrangements, with the focus constantly moving between interior and exterior spaces, foreground and background, close-up and long shot. They sustain the tension between individual action and group dynamics, between participation and observation, between action and inaction, creating a 'space in time', an in-between space that is open to the new and unexpected.

Astrid Wege

This Is How We Walk on the Moon, 2007
DVD, colour, sound
27:20 min

I'm Lost Without Your Rhythm
(production stills), 2009
HDV, colour, sound
13:29 min

Project for a Revolution
(production stills), 2000
DVD, colour, sound
3:14 min

ALEXANDRA BIRCKEN

1967 geboren in Köln, Deutschland,
lebt und arbeitet in Köln
**1967 born in Cologne, Germany,
lives and works in Cologne**

2008 Brussels Biennial 1 – *Show me,
don't tell me*

www.bqberlin.de
www.heraldst.com

In den betont handwerklichen Arbeiten von Alexandra Bircken verfangen sich scheinbar zufällige Dinge: Werkzeuge, mit denen man verbindet, wie Klammern und Heftbänder, Drähte, Schlingen oder Schraubzwingen, die als Readymades die virtuosen, zeitlosen Gebilde Birckens aus Zweigen und Wolle in der Gegenwart erden. Die Verbindungen sind das Schönste an Birckens Arbeit, nicht nur die fetischhaft verknoteten Schlaufen, mit denen das offene, scheinbar wachsende Kunstwerk an die Wirklichkeit andockt, an ein Standbein, einen Sockel, einen Rahmen, manchmal bildet auch ein Bürostuhl den vermittelnden Übergang – Anfang und Ende einer installativen Landschaft im Ausstellungsraum (*Alles muss raus!*, 2009).

Strukturiert und zugleich mit einer grenzenlosen Offenheit werden Objekte und Materialien aus unterschiedlichen Sphären, zum Beispiel aus Natur, Popkultur oder dem Alltag in Beziehung gesetzt und auf die Möglichkeit des Miteinanders überprüft. Dabei ist die Dinghaftigkeit der Arbeiten anders als bei den Objets trouvés in Werken der 1920er oder 1960er Jahre kein radikales Statement für die Autonomie des Künstlers, der jede Sache zu Kunst machen kann, sondern ein Verweis auf den Kern des Menschlichen in einer zunehmend immateriellen Welt.

Birckens Akkumulationen und Montagen schwanken dabei zwischen präziser modellhafter Wissenschaft und bühnenhafter Figuration des Wahnsinns. Manchmal dient dazu eine scheinbar neutrale Aufreihung und Egalisierung von so unterschiedlichen Dingen wie Reißverschluss, Pampelmuse, Heftpflaster, Silikon und zahlreichen anderen gefundenen Objekten in setzkastenhafter Anordnung (*Muschi Collection,* 2009). Ein andermal eine eher dramatische Verknüpfung: Der zentrale, zerschnittene Rock nimmt als integraler Teil von *Netz mit Maria* (2008) mit einem Einkaufsnetz, einem Federball und einer Schlägerbespannung verblüffende formale Verbindungen auf. Inhaltliche Beziehungen folgen, wenn die weibliche Körperlichkeit, die in Birckens Arbeit eine wichtige Rolle spielt, in den Fokus rückt. Auf diesen gesellschaftlich konditionierten Blick hin ausgerichtet, spielt das Werk der Künstlerin mit weiblicher Identität zwischen Abhängigkeit und Freiheit. Dieses Thema ist ebenso ein Baustein im verketteten Gebilde des Werks wie viele andere, etwa wesentliche Fragen der Bildhauerei nach Volumen, Masse und Oberfläche, die Bedeutung von Konstruktion oder Vergänglichkeit, die Beziehung von Alltag und Kunst oder das Erzählen von Geschichten.

Seemingly random objects get caught up in Alexandra Bircken's emphatically artisanal works: tools used to connect such as staples and strips of adhesive tape, wires, nooses, or bar clamps, which serve as readymades grounding Bircken's timeless and virtuosic structures made of twigs and wool in the present. The connections are the most beautiful aspect of Bircken's work, not only the fetish-like knotted loops that dock the open and, it appears, growing work of art to reality, to a leg on the ground, a pedestal, a frame; sometimes it is even an office chair that constitutes this mediating transition – the beginning and end of an installation landscape in the exhibition room (*Alles muss raus!,* 2009).

Structured and yet limitlessly open, her works place objects and materials from a variety of spheres including nature, pop culture, and everyday life in interrelation, testing their ability to coexist. Unlike the objet trouvé in works from the 1920s or the 1960s, the objecthood of Bircken's works represents not a radical statement affirming the artist's autonomy, which enables him to turn anything into art, but rather a gesture pointing toward the core of what is human in an increasingly immaterial world.

Bircken's accumulations and montages balance between precise exemplary science and theatrical figurations of insanity. Sometimes, she pursues this aim by what seems like a neutral and equalising sequence of objects as diverse as a zipper, a grapefruit, an adhesive plaster, silicone, and numerous other found objects in an arrangement suggesting a letter case (*Muschi Collection,* 2009). In other cases, the conjunction is fairly dramatic: the cut-up skirt at the centre is an integral part of *Netz mit Maria* (2008), entering into striking formal correspondence with a string bag, a shuttlecock, and the strings of a racket. References on the level of content follow when female physicality, which plays an important role in Bircken's works, comes into focus. Seeking to engage this socially conditioned perspective, the artist's work plays with female identity between dependency and freedom. This set of issues is one building-block among many in the concatenated structure of the work: others include essential questions of sculpture regarding volume, mass, and surface; the signification of construction or transience; the relationship between everyday life and art; and storytelling.

Rita Kersting

Units, Docking Station, 2008
Exhibition view, Stedelijk Museum,
Amsterdam

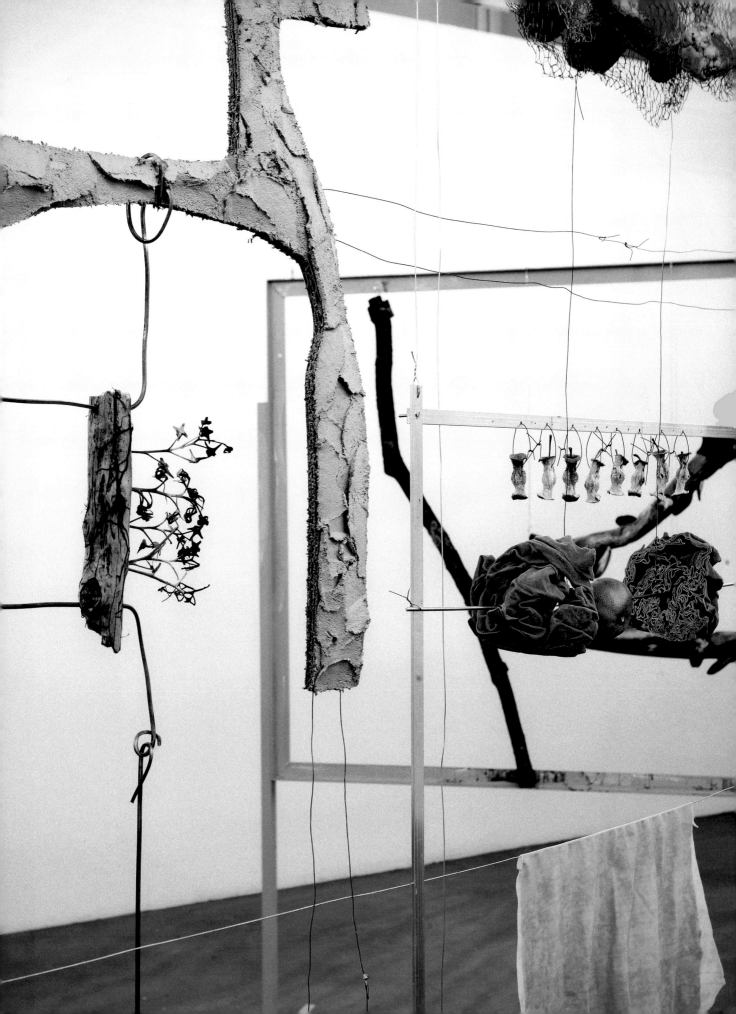

Pferdchen, 2008
Rocking horse (wood),
branches, screws, wool
137.5 × 88.5 × 36 cm

Not Ikea, 2009
Rattan, wood, acrylic, wool, wire,
varnish, glass, wax-soaked cloth,
plaster, soap, cooling pad, photos,
advertising poster, gold jewellery,
ear stud, hair, tree bark, sand, apple
cores, sausage casing, bread, Nutella,
chocolate wrapping, grape branch,
hot glue, plastics
240 × 55 × 47 cm

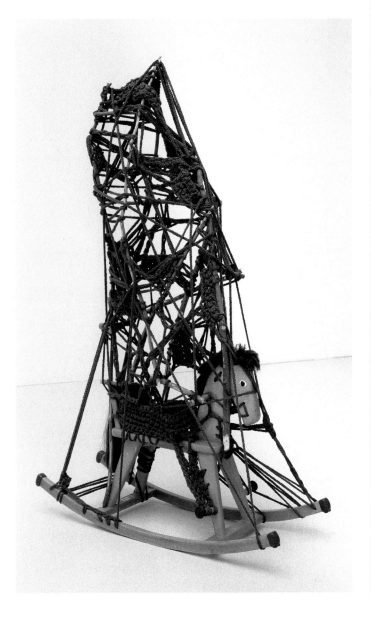

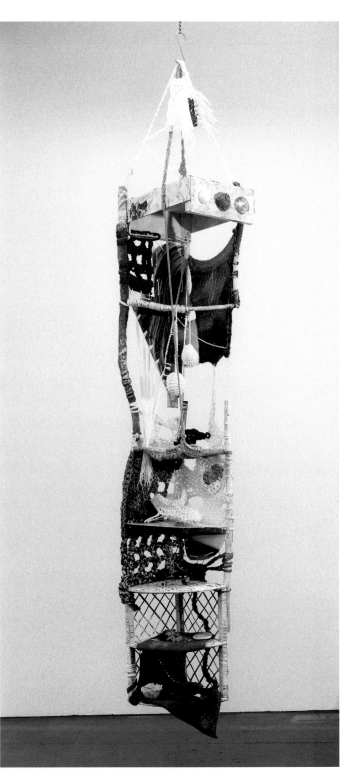

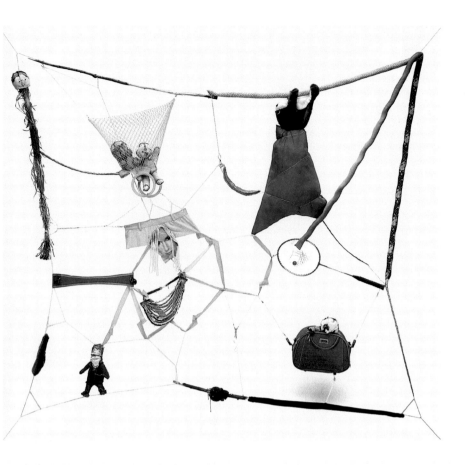

Netz mit Maria, 2008
Wool, branches, cloth, polyester
padding, wire, bags, soft toys,
wax-coated plaster, shuttlecock,
badminton racket, dried grass,
jeans necklace, paper, pearls,
nylon threads
212 × 88.5 × 23 cm

Muschi Collection I, 2009
Zipper, nutshell, photos, bread,
plaster, stone, bottle cap, wire,
handbag, doll, leather, pins, skin
of a grapefruit, silicone, mirror,
cloth, thread, varnish, varnished
wood, glass
44 × 64 × 13 cm

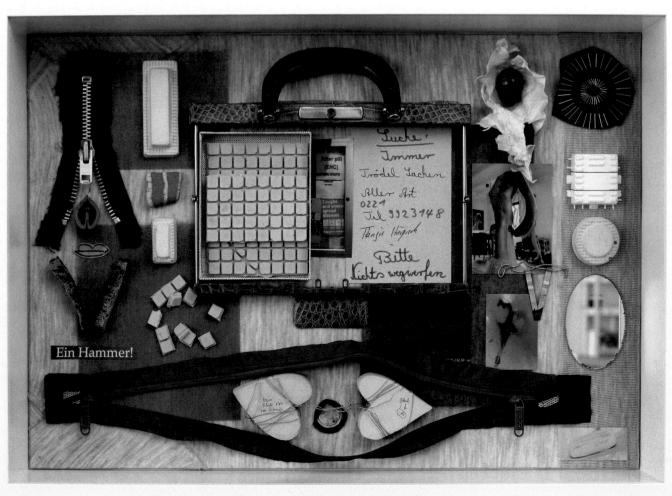

KARLA BLACK

1972 geboren in Alexandria, Groß-
britannien, lebt und arbeitet in Glasgow,
Großbritannien
**1972 born in Alexandria, Great Britain,
lives and works in Glasgow, Great
Britain**

2011 54th International Art Exhibition /
La Biennale di Venezia, Scottish Pavilion
2008 Brussels Biennial 1 – *Show me,
don't tell me*

www.galerie-capitain.com
www.marymarygallery.co.uk

Alex Frost
Untitled (Karla), 2003
Framed pencil on graph paper
107 × 92 cm

Principles of Admitting (detail), 2009
Plaster powder, powder paint,
sugar paper, spray tan, chalk,
concealer stick
20 × 2770 × 1025 cm
Installation view, migros museum
für gegenwartskunst, Zurich

Die auf dem Boden ausgebreiteten Arbeiten und die hängenden Skulpturen von Karla Black bestehen aus verschiedenen Kosmetik-produkten – von Lippenstift und Nagellack bis zu Selbstbräuner-Spray und Bodylotion – sowie aus konventionelleren Kunstmateria-lien wie Gips, Zellophan und Farbe. Kritiker haben ihr Werk mit dem Hinweis auf ihre pastellfarbene Palette und ihre Materialien als „feminin" und „häuslich" klassifiziert, wo-rauf Black in einem Interview mit der Verfas-serin antwortete: „Warum ist nur die Kunst von Frauen durch ihr soziales Geschlecht geprägt? Neulich fragte mich jemand: ‚Wie sähe Ihr Werk aus, wenn Sie ein Mann wären?' Käme irgendjemand auf die Idee, einen Mann zu fragen: ‚Wie sähe Ihr Werk aus, wenn Sie eine Frau wären?'"
Ihre aktuelle Produktion ist von solchen Fragen geprägt. In ihrer Ausstellung im Mo-dern Art Oxford war unter anderem *Made to Wait* (2009) zu sehen, eine riesige von der Decke hängende Folie aus durchsichtigem Zellophan mit malerischen Pinselstrichen aus Zahnpasta und Haargel sowie weiteren Substanzen, die an ihrer Unterkante eine unregelmäßige rosafarbene Linie bilden. Wer sich eingehend mit Blacks Arbeiten be-schäftigt, stellt sich womöglich die Frage nach ihrer Auseinandersetzung mit formalen Problemen – tatsächlich beurteilt sie ihre Skulpturen so, als handele es sich um Male-rei – sowie mit Semiotik und Psychoanalyse. Black ist zutiefst inspiriert von den Schriften der Theoretikerin Melanie Klein, insbesonde-re von ihren Überlegungen zur frühkindlichen Entwicklung. Das Misstrauen der Künstlerin gegenüber der Sprache wird deutlich, wenn sie ihr Werk gleichzeitig als Kompromiss und Protest bezeichnet: Aufgrund seiner Emp-findlichkeit muss es in einem institutionel-len Raum existieren; trotzdem, bemerkt sie, „versucht es, die Anforderungen an seine Dauerhaftigkeit zu demontieren". Die Kunst von Black inszeniert das folgende Paradox: Mit ihrer Üppigkeit zieht sie die Betrachter an, muss sie jedoch zugleich auf Abstand halten. Auf diese Weise bringt die Künst-lerin auch eine durchaus humorvolle Haltung gegenüber Geschlechterrollen und Pflicht-erfüllung ins Spiel.

Karla Black's expansive floor-based works and hanging sculptures are made with an assortment of cosmetic products – from lipstick and nail polish to spray-on tanning and body lotion – and more ordinary art sub-stances such as plaster, cellophane, and paint. Emphasising her pastel palette and materials, critics have classified her work as 'feminine' and 'domestic', to which Black responded in an interview with this author, 'Why is it only women's art that is gendered? I was recently asked, "How do you think your work would differ if you were a man?" Would anyone ever ask a man, "What would your work look like if you were a woman?"'
Her recent output is riddled with such ques-tions. An exhibition at Modern Art Oxford in-cluded *Made to Wait* (2009), a massive sheet of clear cellophane hanging from the ceil-ing with painterly strokes of toothpaste and hair gel among other substances that form an uneven pink line along its bottom edge. Those who spend time with Black's works might wonder about the artist's en-gagement with formal issues – indeed, she judges her sculpture as if it were paint-ing – as well as semiotics and psychoanaly-sis. Black is deeply inspired by the writings of Melanie Klein, particularly the theorist's ideas on pre-linguistic development. The artist's suspicion of language is clear when she speaks of her work as both a compro-mise and protest – it must exist in an insti-tutional space, because of its vulnerability, and yet it 'tries to dismantle the demands of being permanent', as she notes. Black's art turns on this paradox: it lures viewers in through a lushness but must push them away, and therein the artist allows a little humour about gender roles and perform-ance to slip in.

Lauren O'Neill-Butler

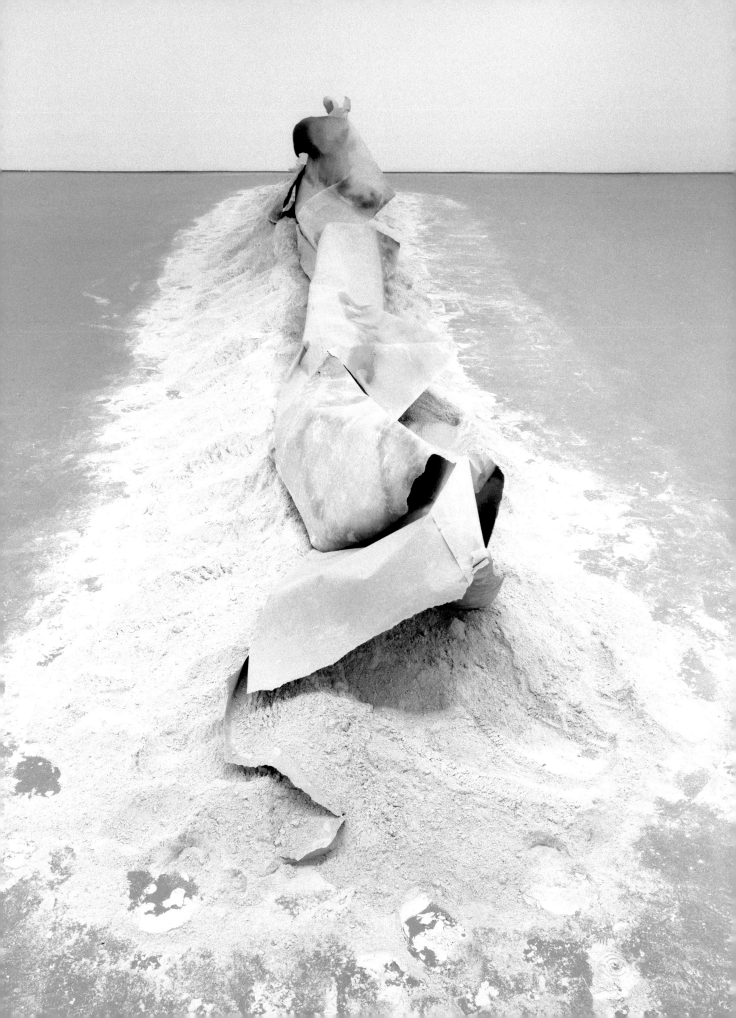

Platonic Solid, 2009
Plaster powder, powder
paint, sugar paper, chalk,
lipstick
70 × 1600 × 1040 cm
Nothing Is a Must, 2009
Sugar paper, chalk, ribbon,
lipstick, glitter hairspray
312 × 300 × 182 cm
Installation view,
Modern Art Oxford

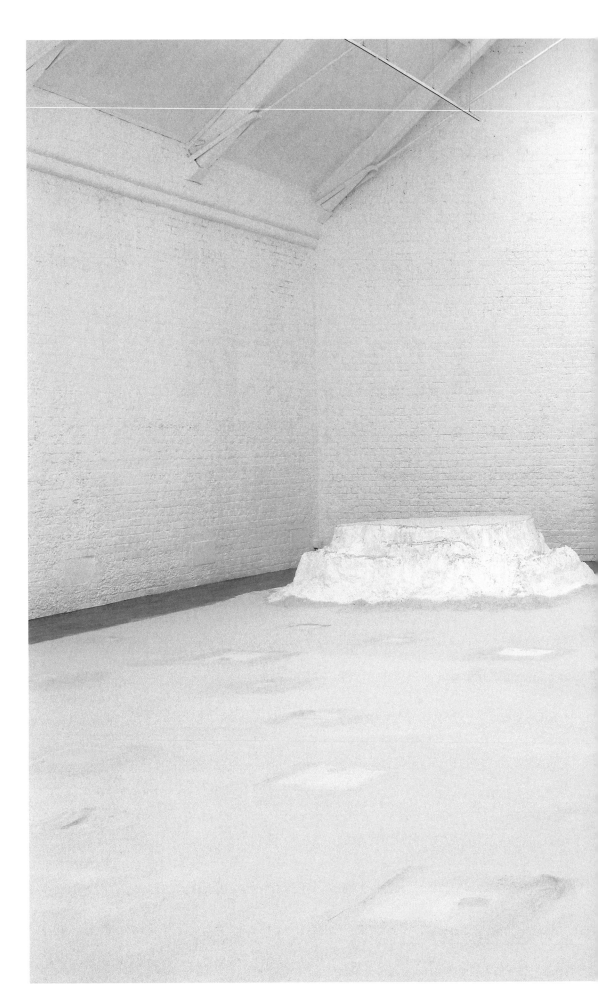

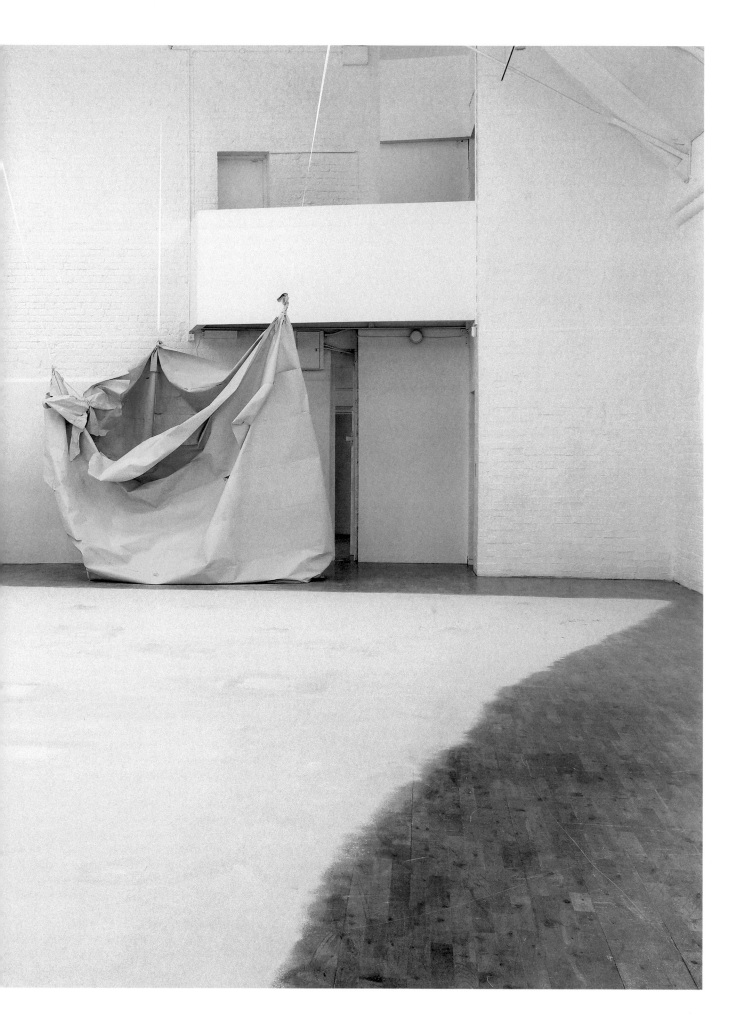

CAROL BOVE

1971 geboren in Genf, Schweiz,
lebt und arbeitet in New York, NY, USA
1971 born in Geneva, Switzerland,
lives and works in New York, NY, USA

2008 Whitney Biennial, New York

www.georgkargl.com
www.kimmerich.com
www.maccarone.net

Seit Beginn des neuen Millenniums hat Carol Bove elegante Skulpturen, Assemblagen und Installationen unter zeitgenössischem Blickwinkel, dem Konzept des „period eye", entwickelt. Mit diesem Ansatz untersuchte die Künstlerin, wie spezielle Looks, geschmackliche und intellektuelle Vorstellungen einen gegebenen historischen Moment prägen und warum manche Farben, Gestalten und Formen mit bestimmten Bereichen verknüpft zu sein scheinen. Boves Arbeiten strahlen oft eine meditative Ruhe aus, und ihre größeren Environments oder „Settings" vermitteln eine uneingeschränkte Coolness. In ihren frühen Arbeiten verwendete die Künstlerin Holzregale und -tische der 1960er und 1970er Jahre als Träger für gefundene Gegenstände, Bücher und Fotografien aus den – von der heutigen Kunst so geschätzten – 1960er Jahren und erforschte das gesellschaftliche, kulturelle und intellektuelle Gewicht jener Zeit mit einer nahezu archivarischen Herangehensweise. So besteht beispielsweise *At Home in the Universe* (2001) aus zwei Regalböden mit Büchern wie „Soul on Ice", „Our Bodies Ourselves", „The Writings of Robert Smithson" und „Walden", Bänden von Aldous Huxley und R. Buckminster Fuller sowie einer Doppelseite aus einem Buch über Freikörperkultur.
Während des gesamten Jahrzehnts hielt Bove die Bedeutung ihrer stimmigen Produktion gelungen in der Schwebe, frei von Nostalgie und Sentimentalität. Ihre jüngsten, hinreißenden Konstruktionen verbinden verschiedene natürliche Materialien – wie etwa Pfauenfedern, Treibholz und Irismuscheln – mit glänzenden Stahlträgern und -sockeln, die ebenso anziehend und geheimnisvoll sind wie die gefundenen Objekte. Mit ihrer einzigartigen Ästhetik, einer sensiblen Note und einem ausgeprägten Formgefühl kann Bove zu den wichtigsten und experimentierfreudigsten Künstlern dieser Tage gezählt werden. Im Unterschied zu vielen Kollegen ihrer Generation hat sie jedoch zunehmend auch die Mechanismen der Schönheit und ihre formalen und metaphorischen Möglichkeiten erforscht. Dies ist ein seltenes Vergnügen und eine begrüßenswerte Entwicklung ihrer feinsinnigen künstlerischen Praxis.

Since the early 2000s, Carol Bove has developed her elegant sculptures, assemblages, and installations through her concept of the 'period eye'. Under this rubric, the artist has examined how certain looks, tastes, and intellectual ideas come to define a moment, as well as why some colours, shapes, and forms seem connected to particular eras. Bove's works often radiate a quiet and meditative calm, and her larger environments or 'settings' impart an unfettered coolness. The artist's early works used century-style wooden shelves and tables as supports for found objects, books, and photographs from the 1960s – a moment much cherished in today's art – and mined the sociopolitical, cultural, and intellectual heft of the time through a nearly archival approach. *At Home in the Universe* (2001), for instance, offers a pair of shelves with books such as 'Soul on Ice', 'Our Bodies Ourselves', 'The Writings of Robert Smithson', and 'Walden', as well as tomes by Aldous Huxley and R. Buckminster Fuller and a spread from a book about nudism.
Throughout this decade, Bove's harmonious output has remained blissfully circuitous in meaning and has smartly eschewed nostalgia and sentimentalism. Her latest entrancing constructions combine a range of natural materials – such as peacock feathers, driftwood, and abalone shells – with radiant steel supports and bases, which are just as attractive and mysterious as the found objects. With a singular aesthetic, a delicate touch, and a keen sensitivity to form, Bove should be counted among the most important and experimental artists working right now. Unlike many of her peers, however, she has increasingly explored the mechanics of beauty and its formal and metaphorical possibilities. This is a rare treat and welcome development in her fine-tuned practice.

Lauren O'Neill-Butler

The Night Sky over New York,
October 21, 2007 at 9 pm, 2007
Approx. 470 bronze rods,
wire mesh base
Dimensions variable
Installation view, Maccarone, New York

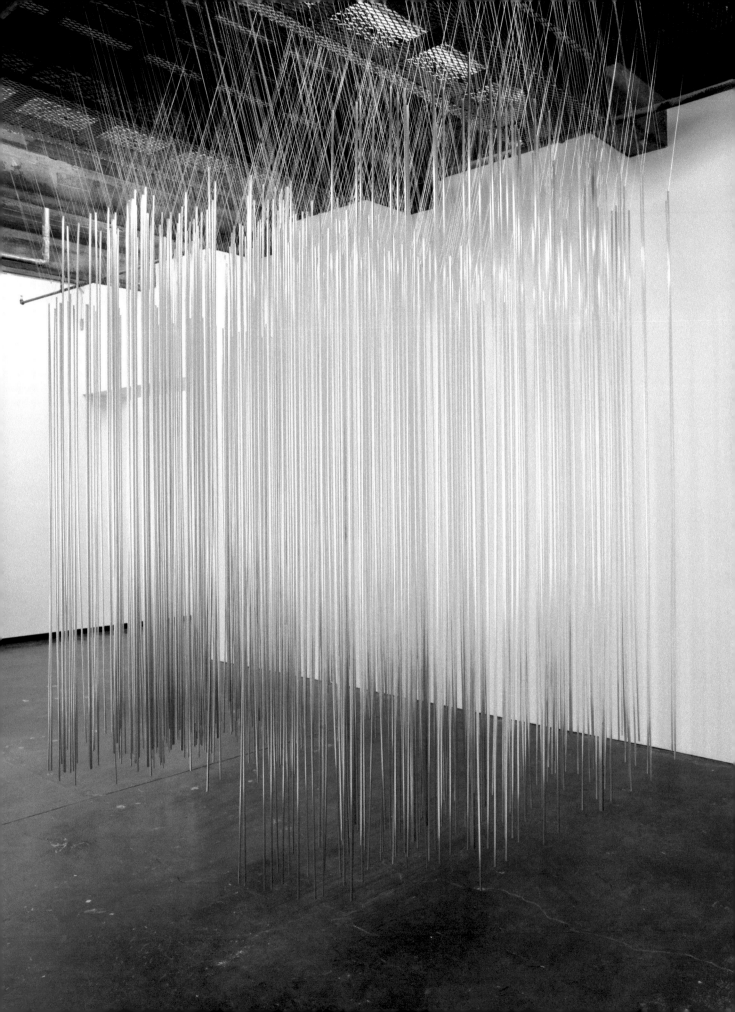

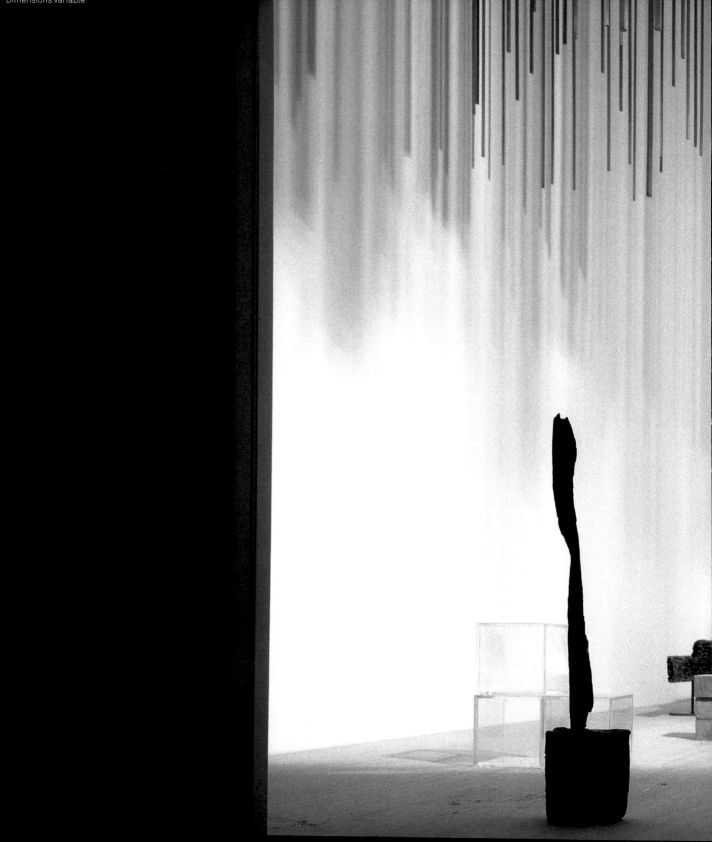

Dimensions variable

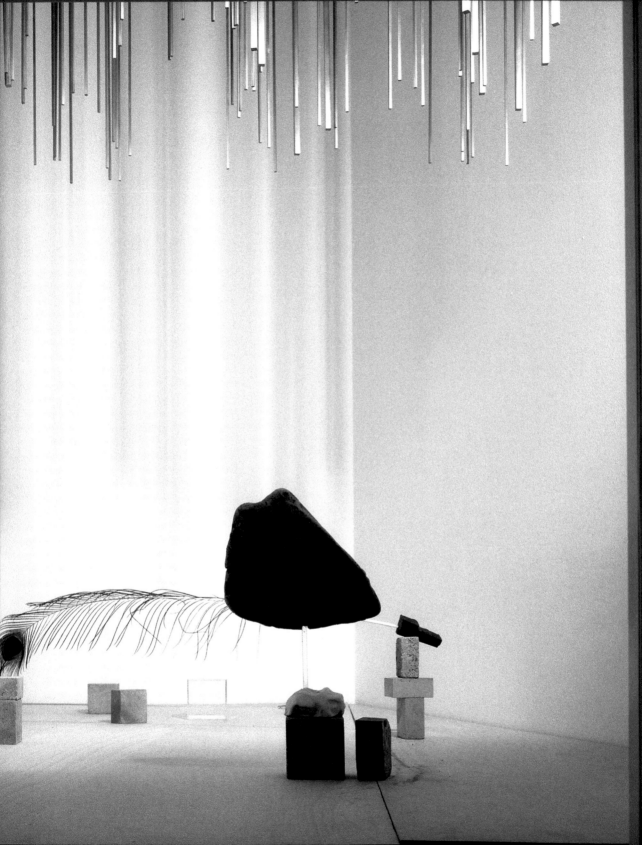

KERSTIN BRÄTSCH

1979 geboren in Hamburg, Deutschland,
lebt und arbeitet in New York, NY, USA,
und Berlin, Deutschland
1979 born in Hamburg, Germany, lives
and works in New York, NY, USA, and
Berlin, Germany

2010 8th Gwangju Biennale –
10.000 Lives

www.balicehertling.com

*My Life as Frau Cow Will Show You How
to Chew the Left over Grass on the
Fields,* from the *FürstFürst Series* –
Kerstin Brätsch for DAS INSTITUT, 2009
Oil and mixed media on paper
180 × 260 cm
Installation view, Balice Hertling, Paris

Das Medium von Kerstin Brätsch ist die Malerei, und darin baut sie einen ausufernden abstrakten Bilderkosmos auf. Die Vielfalt ihrer formalen Erfindungen, der improvisierende Zug, mit dem sie mal leichthändig, mal brachial gesetzte Farbgesten moduliert oder mit post-minimalistischen Mustern kreuzt – all das übertrumpft sich in ihren Bildern fortlaufend selbst. Und so wie die Verfügbarkeit von Bildvorräten für ihre Künstlergeneration längst kein Thema mehr, sondern natürlicher Zustand geworden ist, klinkt sich Brätsch in diverse popkulturelle und kunsthistorische Zeichenflüsse ein – und mischt sie in der Aneignung von Grund auf neu. Wenn sie die Bildfläche dichtgefügt mit unregelmäßigen Farbbahnen in Op-Art-Manier überzieht (*Mr. Eye Gives You a Deal,* 2008) oder dunkel-informelle Farbanhäufungen anlegt (*Good Mourning* oder *Pretrospective,* beide 2009), dann wieder brüchig verschränkte Farbfelder aus sich überlagernden Schichten von Taches und Drippings collagiert (*Cool by Gang and Heart,* 2009) – dann geht es nicht mehr bloß um eine weitere Transformation tradierter Sprachen à la Pollock, Kline & Co. Brätsch eignet sich den Gestus nicht mehr über den Ausdruck, sondern in seiner entleerten Zeichenhaftigkeit an und macht ihn zum Material einer unendlichen Kombinatorik der Effekte. Ihre Malerei zielt klar auf Inszenierung ab. Dazu gehört, dass Brätsch sie stets im Rahmen „eines größeren Bezugssystems" präsentiert, „sei es in Form gemalter Serien, durch Bezug zu eigens von mir hergestellten Magazinen oder durch kollaborative Projekte". Fragen der Präsentation, der Distribution und der Zuschreibung von Bedeutung versteht sie „als Erweiterung meines Malprozesses". Mit der Ausstellung *Buybrätschwörst* (2009) hat sie dieses Prinzip von Komposition durch Kombinatorik zugespitzt, die Werke nahmen dabei wechselnde Rollen ein. Von 18 großformatigen Arbeiten, Gemälde auf Papier, wurden rotierend täglich drei gezeigt – eines im Schaufenster, eines als Raumteiler und eines traditionell an der Wand. Jedes dieser Bilder wurde von einem Poster begleitet (produziert von DAS INSTITUT, einer Kooperation mit Adele Röder), mit Aufschriften wie *Heavy Mädel* oder *Come Bye.* Zudem gab es täglich eines von 18 „Commercials" der Filmemacherin Jane Jo zu sehen, in denen Brätsch die eigene Malerei bewirbt, dazu jede Menge Drucksachen. Brätsch arbeitet an einer künstlerischen Praxis, die das abstrakte Bild von einstiger Autonomie in multiple Ursprungslosigkeit hinein auflöst.

Kerstin Brätsch's paintings form a sprawling cosmos of abstract imagery. The variety of her formal inventions, the improvising touch with which she modulates gestures of colour, placing them now with a light hand, now with brute force, sometimes crossing them with post-minimalist patterns – all these features constantly outdo one another in her pictures. For artists of her generation, the availability of stores of images has long stopped being an issue and become a natural state of affairs, and so Brätsch appropriates various pop-cultural and art-historical streams of signifiers – and thoroughly remixes them. When she places irregular Op-Art-style bands of paint in dense juxtaposition (*Mr. Eye Gives You a Deal,* 2008), arranges darkly Informel agglomerations of colours (*Good Mourning* or *Pretrospective,* both 2009), or collages interlaced brittle colour fields out of superimposed layers of taches and drippings (*Cool by Gang and Heart,* 2009), more is at stake than merely yet another transformation of traditional languages à la Pollock, Kline, and Co. Brätsch appropriates the gesture, no longer a mode of expression but an empty signifier, as the material of an infinite combinatorics of effects. Her painting aims at theatricality, and so she always presents her works within the framework of a 'larger system of reference, be it in the form of painted series, by means of references to magazines I create specifically for this purpose, or through collaborative projects'. Questions of presentation, distribution, and the attribution of meaning, she believes, are 'extensions of the process of my painting'. In the exhibition *Buybrätschwörst* (2009), she took this principle of compositional combinatorics to another level; the works themselves played a variety of roles. Of eighteen large-format paintings on paper, a different set of three was shown every day – one in the shop window, one as a room divider, one, traditionally, on the wall, each accompanied by a poster (produced by DAS INSTITUT, a collaboration with Adele Röder) bearing an inscription such as *Heavy Mädel* or *Come Bye.* One of eighteen 'Commercials' by the artist Jane Jo was shown every day in which Brätsch advertises her own paintings, as well as lots of printed matter. Brätsch works on an artistic practice that dissolves the abstract painting from its erstwhile autonomy into a diversified lack of origin.

Jens Asthoff

Cc. Corp Ab – DAS INSTITUT, 2010
Eight customised men's shirts from the
Comcor Röder Series (Adele Roder for DAS
INSTITUT) and sixteen titleposters for the
*BroadwayBrätsch / Corporate Abstraction
Series* (DAS INSTITUT)
Dimensions variable
Installation view, Art 41 Basel,
Art Statements

*THUS! Unit #1, #2 and #3 (La Technique
De Brätsch & Comcor Röder Desert
Capes)* – DAS INSTITUT, 2010
Oil on Mylar (Kerstin Brätsch for DAS
INSTITUT), digital print on silk (Adele
Röder for DAS INSTITUT),
wood construction, magnets
Dimensions variable
Installation view, New Jerseyy, Basel

Non Solo Non Group Show, 2009
Exhibition view, Kunsthalle Zürich, Zurich

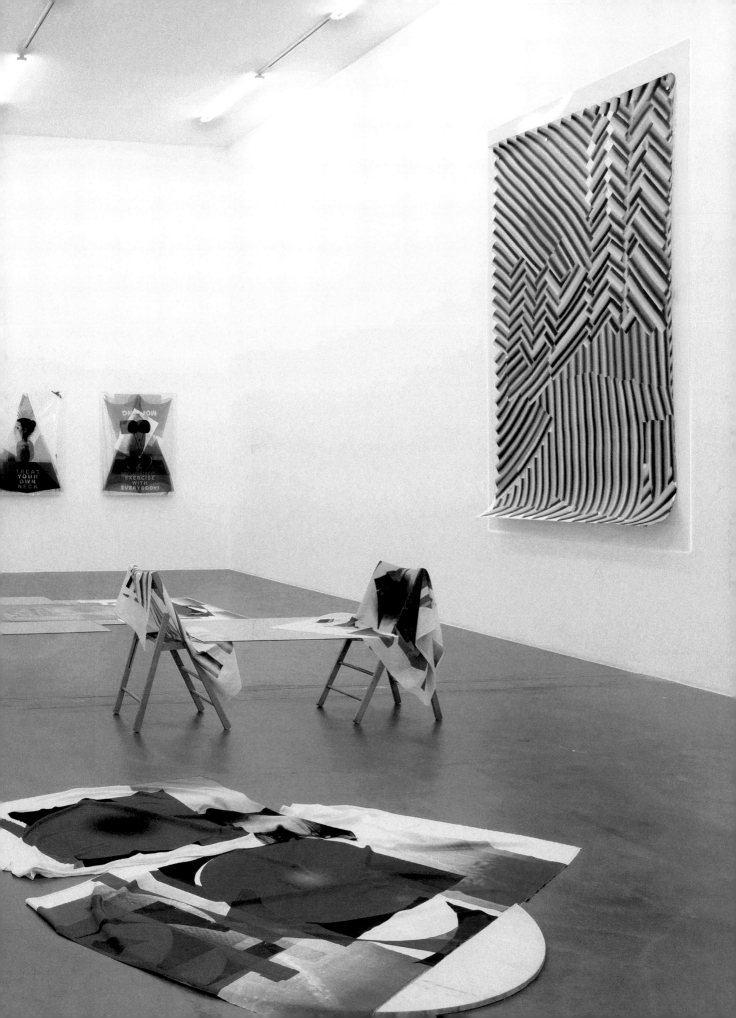

FERNANDO BRYCE

1965 geboren in Lima, Peru, lebt und arbeitet in Berlin, Deutschland
1965 born in Lima, Peru, lives and works in Berlin, Germany

2009 53rd International Art Exhibition / La Biennale di Venezia – *The Fear Society*
2008 28th Bienal de São Paulo – *In Living Contact*
2006 Whitney Biennial – *Day for Night, New York*
2004 3rd berlin biennial for contemporary art
2003 50th International Art Exhibition / La Biennale di Venezia, Latin American Pavilion

www.alexanderandbonin.com
www.bthumm.de
www.galeriajoanprats.com

Die Welt, 2008
Series of 195 drawings
Ink on paper
Dimensions variable
Installation view, 53rd International Art Exhibition / La Biennale di Venezia
Work located in the foreground:
Jota Castro, *Shanghai 2,* 2009

Fernando Bryce war noch ein Kind, als er in seiner Heimatstadt Lima einem Schild mit der Aufschrift „Museo Hawaii" folgte und eine faszinierende Entdeckung machte: In einem Hinterhof standen Vitrinen voller anatomischer Präparate und Kuriositäten und Wachsfiguren, die Diktatoren und Gangstern wie Hitler, Mussolini und Al Capone nachempfunden waren. Als Bryce am nächsten Tag mit einem Freund zurückkehrte, war die obskure Sammlung verschwunden. Sie gehörte einem Wandermuseum, das unter dem Deckmantel von Wissenschaft und Aufklärung nichts anderes beabsichtigte, als die Leute zum Staunen zu bringen. In den Quechua-Sprachen bedeutet „Hawaii" so viel wie „bestaunen" oder „blicken". Fast scheint es, als hätte diese Erfahrung den Grundstein zu seinem eigenen, imaginären Museum gelegt, das den Blick selbst zum Gegenstand hat.

Seit Mitte der 1990er Jahre zeichnet Bryce Zeitungsausschnitte, Dokumentarfotos, Broschüren, Illustrationen und Texte ab, die er zuvor in Archiven recherchiert hat, und baut seine Zeichnungen zu enzyklopädischen Installationen aus. Bryce nähert sich auf diese Weise historischen und politischen Momenten in der Geschichte Lateinamerikas oder der deutschen Kolonialzeit an: So thematisiert seine aus 195 Tuschezeichnungen bestehende Arbeit *Die Welt* (2008) den Imperialismus um 1900. Seiten der „Deutsch-Ostafrika Zeitung" berichten über Prügelstrafen für „Eingeborene", Artikel anderer Blätter dokumentieren die Herrschafts- und Gebietsansprüche der europäischen Kolonialmächte.

Bryce macht keinen Unterschied zwischen vermeintlich Nebensächlichem und geschichtlich Bedeutsamem. Alle Motive werden in derselben comicartigen Manier abgezeichnet. Das Prinzip der Recherche, der Auswahl und des Abzeichnens nennt Bryce „mimetische Analyse". Wenn er Dokumente der kubanischen Revolution, des Kalten Krieges oder der südamerikanischen Nachkriegsmoderne in Hunderten von Zeichnungen nachempfindet, geht es ihm nicht um Reproduktion oder Rekonstruktion, sondern um das Freilegen von ideologischen und politischen Machtstrukturen, die sich im Blick der unterschiedlichsten Medien niederschlagen. Das geschieht nicht ohne Ironie: Die Welt, wie Bryce sie zeichnet, gleicht gelegentlich einer ebenso makabren wie obskuren Wunderkammer.

Fernando Bryce was still a child when, in his hometown of Lima, he followed a sign promising a 'Museo Hawaii' and made a fascinating discovery: in a backyard stood glass cases crowded with anatomical specimens and curiosities as well as wax figures resembling dictators and gangsters including Hitler, Mussolini, and Al Capone. When Bryce returned with a friend the next day, the obscure collection had disappeared. It belonged to a travelling museum whose true aim, under the pretence of a scientific and educational mission, was to amaze. In the Quechua languages, 'hawaii' means 'to admire' or 'to gaze at'. It is almost as though this experience laid the cornerstone for what would later become Bryce's own imaginary museum, whose object is the gaze itself.

Since the mid-1990s, Bryce has drawn copies of newspaper clippings, documentary photographs, brochures, illustrations, and texts he has gleaned from archives after detailed research; he then builds his drawings into encyclopaedic installations. In this fashion, Bryce approaches historically and politically important moments in the history of Latin America or of the German colonial era: his work *Die Welt* (2008), for instance, examines imperialism around 1900 in 195 ink drawings. Pages from the 'Deutsch-Ostafrika Zeitung' (a newspaper in German East Africa) contain reports of corporeal punishment inflicted upon 'natives'; articles in other papers document the claims to sovereignty and territorial demands of the European colonial powers.

Bryce does not distinguish between what is ostensibly marginal and what is historically significant. His drawings copy all motifs in the same manner suggestive of a comic strip. The principle governing the process of research, selection, and copying, he says, is one of 'mimetic analysis'. When he creates hundreds of drawings based on documents from the Cuban revolution, the Cold War, or South American post-war modernism, the aim is not to reproduce or to reconstruct, but rather to uncover the ideological and political structures of power that inform the gaze of the most diverse media. And Bryce's museum is not without its irony: the world as drawn by the artist sometimes resembles a cabinet of curiosities that is as macabre as it is obscure.

Oliver Koerner von Gustorf

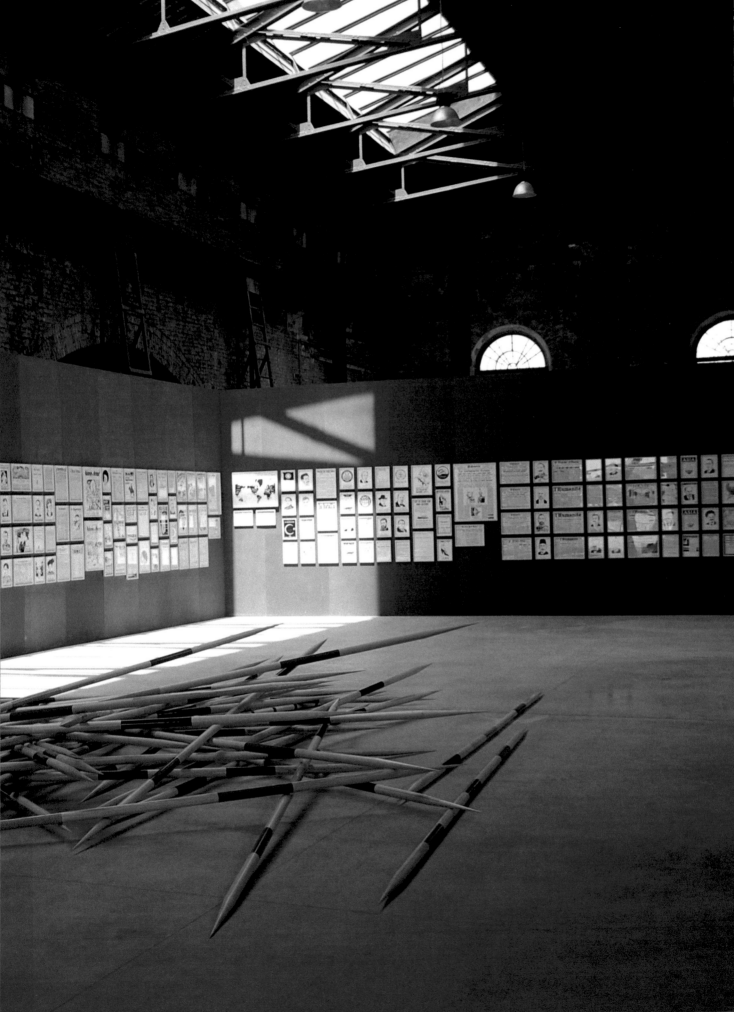

Die Welt, 2008
Series of 195 drawings
Ink on paper
Dimensions variable

THE NEW YORK TIMES SUNDAY JANUARY 14 1912.
R. W. BABSON ON CHINA SITUATION AND WORLD'S TRADE
Statistician Gives Results of His Examination of the Oriental Rebellion and Reviews Business
and Financial Conditions in Europe, Canada and South America.

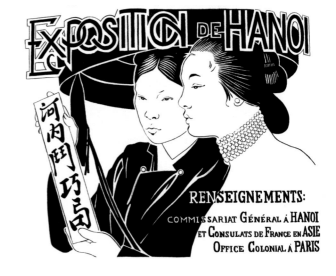

EMILIANO ZAPATA : ¡TIERRA Y LIBERTAD!

EMPRESS DOWAGER CI XI

"Gewalt mit krassem Terrorismus und selbst mit Grausamkeit auszuüben war und ist
meine Politik. Ich vernichte die aufständischen Stämme mit Strömen von Blut
und Strömen von Geld. Nur auf dieser Aussaat kann etwas neues entstehen."
GENERAL LOTHAR von TROTHA

JOHN D. ROCKEFELLER

Tsar Nicholas II

KARL KAUTSKY
Theoretician of the German and International social democracy

KARL LIEBKNECHT
Left-wing Social-democrat. Co Founder of the Spartacist Lea-
gue and the Communist Party of Germany. Leader of
The November revolution 1918.

MATA HARI

Die deutsche Industrie und der deutsche Handel sprechen viel von einer „amerikanischen Gefahr" im wirtschaftlichen Sinne, selbst Professoren der Nationalökonomie reden und Fasein davon, dass der riesige Ausfuhrüberschuss der Union uns mit ernster Besorgnis erfüllen müsse; alles, was das internationale Wirtschaftsleben verfolgt, steht unter dem Drucke der enormen Ziffern der amerikanischen amtlichen Statistik und räumt dem Lande der unbegrenzten Möglichkeiten, grund der Ja. auf dem Papiere unträglich Schwarz auf weiss stehenden – Steigerung der „Manufakturenausfuhr", die industrielle und kommerzielle Vormacht unter den Welthandelsstaaten in be-

1895, Onkel Sam ein nur „guter Kunde", so ist er schon fünf Jahre später, und ganz besonders jetzt „ein „bestgehasster Konkurrent". Dieser Wandel deutschen Empfindens für den Mann übern grossen Teich liegt zugrunde dessen nicht antastbarer, erstaunlicher Siegeszug auf dem Weltmarkte seit 1898–1901? „Damals schwoll nicht nur der landwirtschaftliche Export der Union gewaltig an; auch der Manufakturenexport, ich sage absichtlich Manufakturen-statt Fabrikenexport, stieg in einem so raschen Tempo, erreichte solche Dimensionen, wie niemals zuvor. Damals begannen unsere Industriellen auch vor der AmerikageFahr zu zittern. Damals ward hüben

THE STORY OF THE PHILIPPINES AND OUR NEW POSSESSIONS
INCLUDING THE LADRONES, HAWAII, CUBA AND PUERTO RICO

GEORGE V, KING OF THE UNITED KINGDOM AND EMPEROR OF INDIA

LIBERATOR
JANUARY 1919 20 CENTS

NIKOLAI LENIN –

Afghani's Arabic book on Afghanistan Cairo 1901

Five ó ClockTea

Buy It Because It's a Better Car
Model T Touring Car f.o.b. Detroit **$550**

Get particulars from Ford Motor Company, 1723 Broadway; also Jackson Avenue and Honeywell St. Long Island City.

ANDREAS BUNTE

1970 geboren in Mettmann, Deutschland,
lebt und arbeitet in Berlin, Deutschland
**1970 born in Mettmann, Germany,
lives and works in Berlin, Germany**

www.benkaufmann.com

Wem gehört die Stadt?, 2006
Letraset letters, linocut, and
photocopies on magazine page
31.5 × 23 cm
Part of the installation *Die letzten
Tage der Gegenwart,* 2006
Two 16mm films, plasterboard walls,
collages
Dimensions variable

Wenn der Unterschied zwischen Geschichte und Geschichten verwischt, dann wird das eine erst durch das andere lebendig. Die Filme von Andreas Bunte schlagen ebenso gekonnte wie elegante Bögen zwischen Fiktion und Überlieferung. Thematisch beschäftigt er sich mit menschlichen Errungenschaften oder Ideologien: Im Mittelpunkt seiner Filme können die einsame Waldhütte als Hort subversiver Ideen, die Erfindung des elektrischen Lichts oder die künstlerisch-philosophische Weltgestaltung eines Landschaftsarchitekten stehen. Aus gefundenem und erfundenem Material collagiert Bunte filmische Dramaturgien, die weniger auf eine Rekonstruktion der Ereignisse als vielmehr auf eine subjektive, manchmal suggestive Erzählung hinauslaufen.

Die einsame Waldhütte zum Beispiel ist ein hochgradig bemerkenswerter Ort. Henry David Thoreau kam hier auf die Idee, Steuerzahlungen zu verweigern und verfasste nach einer Nacht im Gefängnis „Über die Pflicht zum Ungehorsam gegen den Staat". Der Architekt Frank Lloyd Wright lebte als Selbstversorger abgeschieden in einer selbst entworfenen Behausung, und nicht zuletzt verbrachte Ted Kaczynski, der „Unabomber", 27 Jahre in einer Hütte. Im Zentrum des 16-mm-Films *May the Circle Remain Unbroken* (2005) von Bunte steht die Waldhütte als repräsentativer Rückzugsort für Gegner der Gesellschaft. Bunte schneidet Elemente aus den Manifesten der drei ungleichen Aussteiger Thoreau, Lloyd Wright und Kaczynski in Ton und Bild zusammen, sodass eine eigene, einleuchtende Narration entsteht. Wie in seinem Film *La Fée Électricité* (2007), einer fingierten Chronik über die Anfänge des elektrischen Lichts, mischt Bunte historisches mit nachgedrehtem Material, greift auf Originaltexte zurück und erfindet Figuren, die es genau so hätte geben können.

Buntes Filmen gehen immer ausgiebige Recherchen voraus, doch es ist nicht nur geschichtliches Interesse, das ihn antreibt. Eine wichtige Rolle spielt auch die von ihm jeweils sorgsam entwickelte visuelle Sprache, die sein Gespür für die Ästhetik der jeweiligen Zeit zeigt. So erzeugt er gewissermaßen eine historische Wahrheit höheren Grades. Mit künstlerischen Mitteln beschwört er seinerseits auf beeindruckende Weise die Kraft der Utopie.

Only when the distinction between history and stories becomes blurred does the one begin to bring the other to life. Andreas Bunte's films build bridges, as clever as they are elegant, between fiction and tradition. In thematic terms, he examines human accomplishments or ideologies: the object at the centre of one of his films may be the isolated forest cabin as a home for subversive ideas, the invention of electric light, or a landscape architect's artistic-philosophical design of the world. Making collages out of found and invented materials, Bunte creates filmic dramaturgies that add up not so much to a reconstruction of events but rather to a subjective and sometimes suggestive narrative.

The isolated forest cabin, for instance, is a highly remarkable place. It inspired Henry David Thoreau to refuse to pay his taxes; after a night in prison, he wrote 'On the Duty of Civil Disobedience'. The architect Frank Lloyd Wright lived as a self-sufficient farmer in a secluded home he had designed for himself. Last but not least, Ted Kaczynski, the 'Unabomber', spent twenty-seven years in a cabin. At the centre of Bunte's 16mm film *May the Circle Remain Unbroken* (2005) stands the forest cabin as a representative refuge for society's antagonists. Onscreen and on the soundtrack, Bunte presents a compilation from the manifestos written by the three unequal dropouts Thoreau, Lloyd Wright, and Kaczynski, creating a persuasive narrative of his own. As in his film *La Fée Électricité* (2007), a fictional chronicle of the early years of electric light, Bunte mixes historic footage with newly recorded material, drawing on original writings and inventing characters that might well have existed exactly as he describes them.

Bunte's films are always based on extensive research, but what drives his work is not just a historian's interest. Another important component is the visual language he carefully develops for each project, which evinces his keen sense for the particular aesthetic of the era he is working on. The result is the creation of something like a higher-order historical truth. Using the means of art, he invokes, in his own impressive way, the power of utopia.

Silke Hohmann

DER HIMMEL HERRSCHT IHM BEUGT SICH ALLES DEM EINFALLS WINKEL DER SONNE WIE DEM FAHLEN LICHT DER STERNE BIS DAS ELEKTRISCHE LICHT DAS ENDE DER TAGE AUS DEN STÄDTEN VERTRIEBEN HAT

5
6
7

May the Circle Remain Unbroken, 2005
16mm film projection, wooden walls,
radio, maps, print
Dimensions variable
Installation view, Adeline Morlon, Düsseldorf

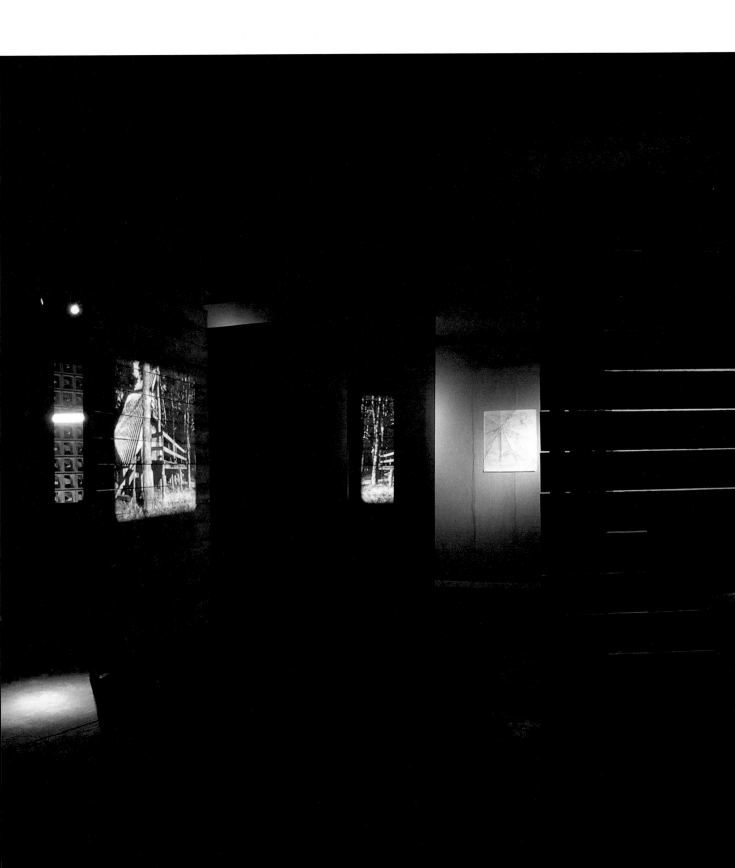

Autonomous Units, 2005
Map, ink, letraset type
54 × 58 cm
Part of the installation *May the Circle
Remain Unbroken*, 2005

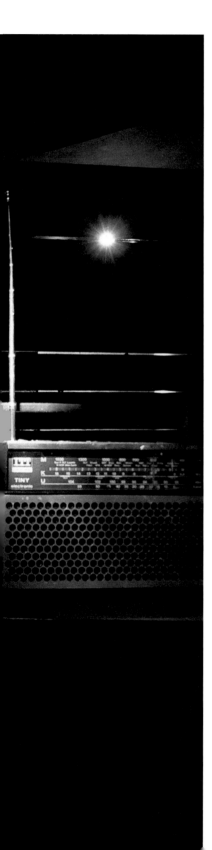

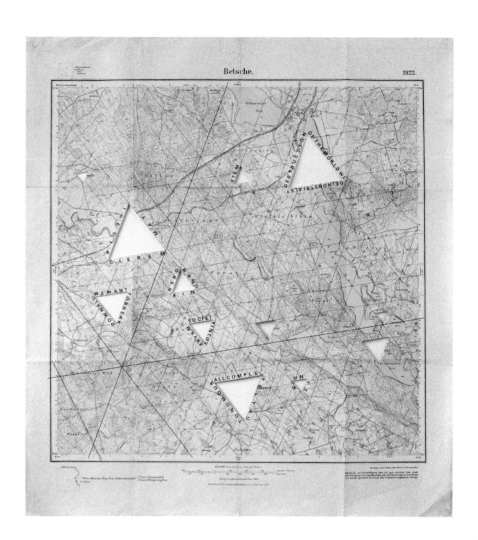

MIRCEA CANTOR

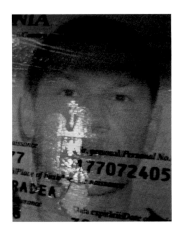

1977 geboren in Oradea, Rumänien,
lebt und arbeitet auf der Erde
**1977 born in Oradea, Romania,
lives and works on the Earth**

2008 28th Bienal de São Paulo –
In Living Contact
2006 4th berlin biennial for contempo-
rary art – *Of Mice and Men*
2006 Busan Biennale – *Everywhere*
2003 50th International Art Exhibition /
La Biennale di Venezia – *Dreams and
Conflicts. The Dictatorship of the Viewer*

www.mirceacantor.ro

www.dvirgallery.com
www.magazzinoartemoderna.com
www.yvon-lambert.com

Mircea Cantor thematisiert in seinen Videos, Fotografien und Installationen gesellschaftliche und politische Veränderungen – häufig vor dem Hintergrund der Globalisierung. Nach dem Studium geht Cantor nach Paris. In seinem Video *All the Directions* (2000) greift er das Thema Migration auf und konfrontiert als Tramper Autofahrer mit einem Reisewunsch, seine Papptafeln verraten jedoch keinerlei Zielort: der Künstler als sinn- und zielsuchender Nomade. Cantor richtet seinen Blick weiter auf die rumänische Heimat: In *The Silence of the Lambs* (2007) beschäftigt er sich anhand des Schächtens auf einem rumänischen Wochenmarkt exemplarisch mit dem der europäischen Marktwirtschaft geschuldeten Wandel. Cantor vermeidet doktrinäre Stellungnahmen und setzt sich in einer subtilen, poetischen Sprache mit Wesen und Wirkungen von Ideologien und Macht auseinander.
Ganz im Sinne von Marcel Broodthaers, der eine politische Weltkarte durch einen winzigen Eingriff in eine „Carte du Monde Poétique" (1968) verwandelte, nimmt Cantor eine optimistisch-integrative Veränderung an westlichen Leitmedien vor: *Les Mondes* (2005) und *The New Times* (2009). Sinnliche Kraft entfalten auch die *Seven Future Gifts* (2008). Auf Geschenkband und Schleife reduziert, entwickeln die monumentalen Pakete eine fragile, zeichnerische Leichtigkeit. Seine Skepsis gegenüber Versprechungen und Erwartungen drückt Cantor mit der für ihn typischen Ökonomie der Mittel auch in *Chaplet* (2007) aus: Was zunächst als Stacheldrahtzaun an den Wänden des Ausstellungsraums wahrgenommen wird, entpuppt sich bei näherer Betrachtung als Aneinanderreihung von Fingerabdrücken – im Zeitalter der Erhebung biometrischer Daten und sich auflösender Staaten eine ambivalente Metapher. *Rosace* (2007) bildet eine ornamentale Form aus zu Aschenbechern verarbeiteten Getränkedosen, Readymades zwischen lapidarer Handarbeit und industrieller Massenfertigung. Das für Cantor wichtige Motiv der Unsicherheit taucht im Video *Deeparture* (2005) auf, das einen Wolf und ein Reh in den leeren Räumen einer Galerie zeigt. Eine ähnlich allegorisch-traumhafte Stille vermittelt das Video *Tracking Happiness* (2009), in dem sieben junge Frauen im Kreis die Fußabdrücke der jeweils vorangehenden mit einem Besen im weißen Sand verwischen. In einer kreisenden, unendlichen Bewegung entsteht eine märchenhaft schöne Metapher auf die Kunst von Cantor, die Spuren legt, ohne dem Betrachter den eindeutigen Weg aufzuzeigen.

Mircea Cantor's videos, photographs, and installations examine social and political transformations – often before the backdrop of globalisation. After finishing his university studies, Cantor moves to Paris. In his video *All the Directions* (2000), he takes up the subject of migration: posing as a hitchhiker, he confronts drivers with his desire to travel, but his cardboard signs do not say where he wants to go – the artist as a nomad in search of meaning and a destination. Cantor continues to look toward his native Romania: in *The Silence of the Lambs* (2007), he uses the example of Jewish ritual slaughter performed at a Romanian farmer's market to examine the transformations brought on by the European market economy. Cantor avoids taking doctrinaire positions, employing a subtle and poetic language to study the nature and effects of ideologies and power. Following in the footsteps of Marcel Broodthaers, who transformed a political map of the world by means of a tiny intervention into a 'Carte du Monde Poétique' (1968), Cantor makes optimistic-integrative alterations in leading media of the West: *Les Mondes* (2005) and *The New Times* (2009). Of similar sensual power are the *Seven Future Gifts* (2008). Reduced to ribbons and bows, the monumental packages unfold a fragile and graphical lightness. With his signature economy of means, Cantor expresses his scepticism regarding promises and expectations in *Chaplet* (2007): what we initially perceive as a barbed-wire fence along the walls of the exhibition room turns out, upon closer inspection, to be a chain of fingerprints – an ambivalent metaphor in an era defined by the collection of biometric data and the dissolution of the nation-state. *Rosace* (2007) creates an ornamental shape out of soft-drink cans turned into ashtrays, readymades between laconic manual production and industrial mass manufacturing. Insecurity, an important motif in Cantor, appears in the video *Deeparture* (2005), which shows a wolf and a deer in the empty rooms of a gallery. A similar allegorical-dreamlike silence is conveyed by the video *Tracking Happiness* (2009), in which each of seven young women, walking in a circle, uses a broom to efface the footprints left in the white sand by the woman in front of her. In this infinite circular movement, a metaphor of fairy-tale-like beauty emerges, a metaphor for Cantor's art, which lays traces without pointing out an unambiguous path for the beholder.

David Riedel

Deeparture, 2005
16mm film transferred to BETA digital,
colour, no sound
2:43 min

Rosace, 2007
Drink cans, plexiglass, aluminum
⌀ 400 cm

Seven Future Gifts, 2008
Concrete, iron
Dimensions variable
Installation view, Mücsarnok Kunsthalle, Budapest

Tracking Happiness, 2009
16mm transferred to HDV, colour, sound
11 min

Arch of Triumph, 2008
Oak, 24-carat gold
640 × 416 × 130 cm

CAO FEI

1978 geboren in Guangzhou, China,
lebt und arbeitet in Peking, China
**1978 born in Guangzhou, China,
lives and works in Beijing, China**

2010 29th Bienal de São Paulo – *Há
sempre um copo de mar para o homem
navegar / There is always a cup of sea
to sail in*
2007 52nd International Art Exhibition /
La Biennale di Venezia, China Tracy
Pavilion
2007 9th Biennale de Lyon –
*00s. The history of a decade that
has not yet been named*
2007 10th International Istanbul
Biennial – *Not Only Possible, But Also
Necessary: Optimism in the
Age of Global War*
2006 15th Biennale of Sydney –
Zones of Contact

www.caofei.com

www.lombard-freid.com
www.vitamincreativespace.com

UNCosplayers–hello!Kitty, 2006
Photograph
90 × 120 cm

UNCosplayers–A Hutong War, 2006
Photograph
90 × 120 cm

Aufgewachsen im Spannungsfeld zwischen kommunistischen Traditionen und globaler Popkultur, repräsentiert Cao Fei die Generation der Xin Xin Ren Lei. Die Sehnsüchte und Lebensentwürfe dieser „brandneuen Menschen" stehen im Zentrum ihrer Video- und Fotoarbeiten. Als Tochter eines Staatskünstlers wächst Cao in einem der Epizentren des chinesischen Wirtschaftswachstums auf – dem Delta des Perlflusses, wo die massiven sozialen und kulturellen Umbrüche unübersehbar zu Tage treten, besonders in einer Großstadt wie Guangzhou. Sie dient als Setting für Caos Video *COSplayers* (2004) über jugendliche Manga-Fans. In den fantastischen Kostümen ihrer Superhelden posieren sie vor gesichtslosen Hochhäusern und sitzen zum Schluss wie Aliens neben ihren Eltern. In *Whose Utopia* (2006) kontrastiert Cao Lebenswirklichkeit und Wunschträume junger Fabrikarbeiter: Szenen des eintönigen Arbeitsablaufs werden von Sequenzen unterbrochen, in denen sie inmitten der Fabrikhallen als Gitarristen oder Breakdancer posieren. So persönlich ihre Sehnsüchte sind, basieren sie doch gleichzeitig auf den global verfügbaren Klischeebildern der westlichen Massenkultur.

Virtuelle Wunschwelten sondiert Cao in ihren „Second Life"-Projekten. Hier können Millionen User miteinander kommunizieren, spielen oder für ihre Avatare ein neues Styling erwerben. Den Kommerzkosmos hat Cao erstmals 2007 mit ihrem Avatar China Tracy erkundet. Seit 2008 kreisen die „Second Life"-Arbeiten um die von ihr kreierte Stadt RMB City. Hier präsentiert ihr Alter Ego in der Fotoserie *The Fashions of China Tracy* (2009) Mode von Avantgarde-Designern wie Martin Margiela vor surrealen Kulissen. Das Video *The Birth of RMB City* (2009) schildert die Entstehung dieser Stadt, die ihren Namen der Abkürzung für die chinesische Währung Renminbi verdankt: Futuristische Wolkenkratzer, Einkaufszentren und Autobahnen schießen in Sekundenschnelle aus dem Boden. Die Bauwerke zitieren die Wahrzeichen des alten und neuen China: Tiananmen-Platz, Mao-Denkmäler, das Olympiastadion von Herzog & de Meuron. Unaufhaltsam wuchern die hybriden Architekturen, um am Ende wieder zusammenzufallen – eine beständig mutierende Konsumgesellschaft, die sich selbst nach ihrer Zerstörung sofort wieder neu formieren kann.

Having grown up amid the tensions between communist traditions and the global pop culture, Cao Fei is a representative of the generation called xin xin ren lei. The longings and ambitions of these 'brand-new people' stand at the centre of Cao's videos and photographs. The daughter of a state artist, she is brought up in an epicentre of the Chinese economic expansion, the Pearl River Delta, where the country's rapid social and cultural transformation is strikingly evident, especially in major cities like Guangzhou. The latter is the backdrop for Cao's video *COSplayers* (2004), about teenage manga fans. Wearing the fantastic costumes of their superheroes, they pose before featureless high-rises; in the end, they sit next to their parents, looking like extraterrestrials. In *Whose Utopia* (2006), Cao contrasts the reality of the lives of young factory workers with their daydreams: scenes of their monotonous work are interrupted by sequences in which they pose, in the middle of the factory floor, as guitarists or breakdancers. Personal though their yearnings are, they are nonetheless based on globally circulating stereotypical images produced by western mass culture.

Virtual fantasy worlds are something Cao probes in her 'Second Life' projects. The software lets millions of users communicate with one another, play, or buy new trimmings for their avatars. Cao began exploring the commercial universe in 2007 with her avatar China Tracy. Since 2008, her 'Second Life' works have revolved around RMB City, a metropolis of her own creation, where her alter ego presents fashions by avant-garde designers such as Martin Margiela before surreal backdrops (in the photo series *The Fashions of China Tracy,* 2009). The video *The Birth of RMB City* (2009) tells the story of how this city, which owes its name to the abbreviation for the Chinese currency, the renminbi, came into being: futuristic skyscrapers, malls, and highways spring up like mushrooms in mere seconds. The buildings quote the landmarks of the old and the new China: Tiananmen Square, monuments to Mao, Herzog & de Meuron's Olympic stadium. The hybrid architectures proliferate inexorably, only to collapse in the end – a permanently mutating consumerist society that can form afresh immediately after its destruction.

Oliver Koerner von Gustorf

RMB City, 2008
Exhibition view,
Lombard-Freid Projects, New York

The Birth of RMB City, 2009
Single-channel video, colour, sound
10:30 min

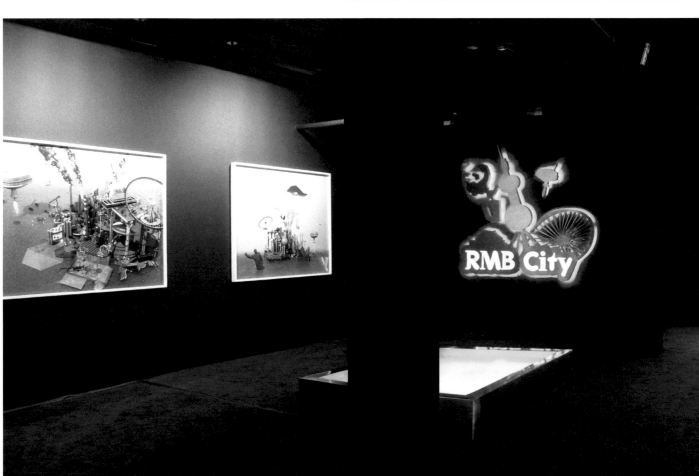

Living in RMB City, 2009
Single-channel video, colour, sound
25 min

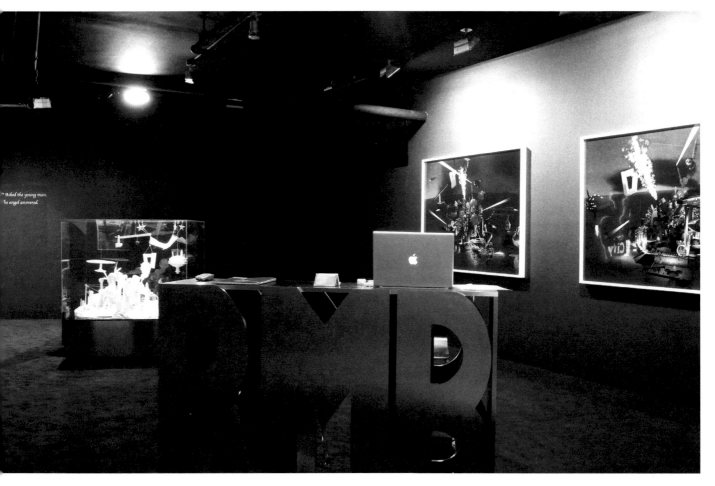

PAUL CHAN

1973 geboren in Hongkong, Britische
Kronkolonie, lebt und arbeitet in New
York, NY, USA
**1973 born in Hong Kong, British Crown
Colony, lives and works in New York,
NY, USA**

2009 53rd International Art Exhibition /
La Biennale di Venezia – *Fare Mondi /
Making Worlds*
2008 16th Biennale of Sydney –
Revolutions – Forms That Turn
2007 9th Biennale de Lyon – *00s.
The history of a decade that has not
yet been named*
2007 10th International Istanbul
Biennial – *Not Only Possible, But Also
Necessary: Optimism in the Age of
Global War*
2006 Whitney Biennial – *Day for Night*,
New York

www.nationalphilistine.com

www.greenenaftaligallery.com

In seinem Zyklus *7 Lights* (2005–2008) verbindet Paul Chan Anleihen aus der klassischen Mythologie mit Bildern der zeitgenössischen Medien- und Popkultur sowie Motiven der Kunst-, Religions- und Philosophiegeschichte. Er lässt digital animierte Silhouetten – Menschen, Vogelschwärme, Bäume, Äpfel und alltägliche Konsumobjekte – langsam über leuchtende Farbfelder treiben. Auf den Boden von Ausstellungsräumen projiziert, changieren die im freien Fall oder schwebendem Aufstieg begriffenen Schatten zwischen Apokalypse und Apotheose.

Chan, der auch als theoretisch versierter Autor und politischer Aktivist auftritt, organisiert seine Arbeiten oftmals in Werkgruppen. Gemeinsam ist ihnen die Reflexion des Verhältnisses von Ästhetik und Politik, von Engagement und Autonomie, von Referenz und Abstraktion. Doch löst Chan diese die Praxis moderner Avantgarden und den avancierten kunstkritischen Diskurs der Gegenwart strukturierenden Gegensätze nicht künstlerisch auf, sondern hält sie bewusst in Spannung. Wenn etwa in *3rd Light* (2006) die Schatten fallender Körper auftauchen, sind die Bilder des 11. September ebenso mitgedacht wie Assoziationen mit religiös konnotierten Topoi der ästhetischen Theorie der Moderne, etwa Walter Benjamins Überlegungen zum messianischen Ereignis, das dem Lauf einer Trümmer auf Trümmer häufenden Geschichte im Lichte einer Utopie der Versöhnung Einhalt zu gebieten verspricht.

Auch *Sade for Sade's Sake* (2009) verknüpft Verweise auf die moderne Kunstgeschichte mit Fragen der philosophischen Ästhetik und politisch aktuellen Ereignissen. An die Wand werden lebensgroße Schattenfiguren geworfen, die es in einer Manier, die an die Schriften des libertinen Marquis erinnern, fast sechs Stunden lang brutal miteinander treiben. Abstrakte schwarze Quadrate ziehen über dieses pornografische Schattentheater perverser Grausamkeiten. Die berüchtigten Fotos aus Abu Ghuraib verbinden sich mit Referenzen auf Bruce Naumans Neonarbeiten, Jean Arps Collagen und Pier Paolo Pasolinis „Salò" ebenso wie auf das Kant'sche Axiom der zwecklosen Zweckmäßigkeit des Kunstobjekts, das die Autonomieästhetik begründet. In programmatischer Weise ist Kunst bei Chan ein Medium der aufgeklärten Reflexion, das die zeitgenössische Lebenswelt in der ästhetischen Erfahrung distanziert – im Wissen darum, dass es mehr als der Kunst bedarf, damit politisches Engagement sich konkretisiert.

In his cycle *7 Lights* (2005–2008), Paul Chan fuses borrowings from classical mythology with the imagery of today's media and pop culture and motifs from the histories of art, religion, and philosophy. Digitally animated silhouettes – people, flocks of birds, trees, apples, and mundane consumer goods – slowly drift across fields of luminescent colour. Projected onto the floor of an exhibition space, these shades now seem to be in free fall, now appear to be floating upward, suspended between apocalypse and apotheosis. Chan, who is also a writer well versed in theory as well as a political activist, often organises his works in groups. Common to these larger sets is the reflection on the relationship between aesthetics and politics, between commitment and autonomy, between reference and abstraction. Yet Chan does not offer an artistic resolution of these oppositions, which structure the practice of the modern avant-gardes and the advanced contemporary art-critical discourse; to the contrary, he deliberately keeps the tensions within them alive. The shadows of falling bodies that appear in *3rd Light* (2006), for instance, implicitly refer to the images of September 11, but also associate ideas in the aesthetic theory of modernism with religious connotations, such as Walter Benjamin's meditations about the messianic event that, in the radiant light of a utopian vision of reconciliation, promises to put a halt to a history that has piled debris upon debris.

Sade for Sade's Sake (2009), similarly combines references to the history of modern art with questions of philosophical aesthetics and current political events. The artist projects life-sized silhouettes onto a wall; for almost six hours, they get it on with each other with a brutality that recalls the writings of the libertine marquis. Abstract black squares move across this pornographic shadow-theatre of cruel perversion. The work draws connections between the infamous photographs from Abu Ghraib and Bruce Nauman's neon pieces, Jean Arp's collages, and Pier Paolo Pasolini's 'Salò' as well as Kant's axiom of the art object's purposiveness without purpose, the foundation of the theory of aesthetic autonomy. Chan programmatically employs art as a medium of enlightened reflection that constitutes aesthetic experience as a distancing of the contemporary life-world – fully aware that it takes more than art for political commitment to take concrete form.

André Rottmann

The Body of Oh Boy (TrueType Font), 2008
Ink on paper, mixed media
231 × 149 cm

*Untitled (after Lacan's
Last Laugh)*, 2008
Two-channel video projection
30 min
Installation view,
Torino Triennale

Sade for Sade's Sake, 2009
Digital projection
5:45 h
Installation view,
Greene Naftali, New York

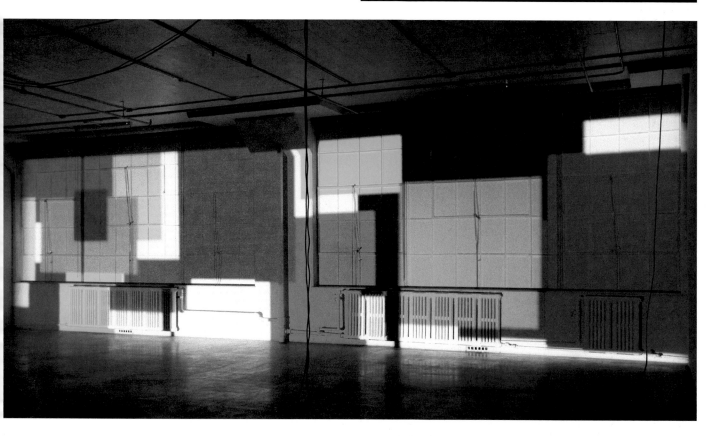

CLAIRE FONTAINE

2004 gegründet in Paris, Frankreich, lebt und arbeitet in Paris
2004 founded in Paris, France, lives and works in Paris

2008 16th Biennale of Sydney – *Revolutions – Forms That Turn*
2008 Manifesta 7, European Biennial of Contemporary Art, Trentino-Alto Adige
2007 9th Biennale de Lyon – *00s. The history of a decade that has not yet been named*
2007 10th International Istanbul Biennial – *Not Only Possible, But Also Necessary: Optimism in the Age of Global War*

www.clairefontaine.ws

www.airdeparis.com
www.crousel.com
www.galerieneu.net
www.reenaspaulings.com
www.t293.it

In der Selbstbeschreibung definiert sich Claire Fontaine im Singular: „Nachdem Claire Fontaine ihren Namen einer beliebten Marke von Schulheften entlehnt hatte, erklärte sie sich selbst zum ‚Readymade-Künstler' und begann ihre eigene Version neo-konzeptueller Kunst, die häufig wie das Werk anderer Künstler aussieht, zu entwickeln." Bei ihrer Arbeit agiert sie jedoch im Plural. Damit beziehen sich die Künstler auf die utopische Idee des Kollektivs, in dem eine reflektierte Form der Verbindung von Arbeit, Kreativität und politischem Kommentar erst durch das Zusammenspiel Vieler entsteht.

Die Ideen von Claire Fontaine begeben sich in eine intelligente Konstellation des „post" zu bereits erfolgreich eingeführten Strategien ästhetischer Produktion der letzten Jahrzehnte: Autorschaft, kollektive Herstellung, Singularität, Konzeptkunst, selbst Appropriation sind für Claire Fontaine Verfahren, die nur noch als Ruinen – einer wie auch immer zu beschreibenden Postmoderne – distanziert beobachtet werden können.

In dieser Gemengelage aus scharfer theoretischer Reflexion, engagiertem politischem Willen und radikaler Einverleibung ästhetischen Vokabulars entstehen Arbeiten, deren vordergründige Einfachheit zugleich komplexe Beschreibungen politischer Konstruktionen und Realitäten ermöglicht. Zum Beispiel die Neonarbeit *ARBEIT MACHT KAPITAL* (2004): In der Wahl des Materials, industriell hergestellte Leuchtstoffröhren, knüpft Claire Fontaine an eine Tradition von Leuchtschriften der Konzeptkunst an, die jedoch auch dem Format gewöhnlicher Leuchtreklame entsprechen. Die drei Wörter „ARBEIT MACHT KAPITAL" sind zum einen als Substantive zu verstehen, das Wort „MACHT" kann jedoch auch als Verb aufgefasst werden. Einerseits beschreiben die Benennungen Bereiche des gesellschaftlichen und ökonomischen Zusammenlebens, andererseits thematisieren sie auf einer zweiten Ebene auch das Verhältnis zwischen diesen Feldern. In einer dritten Ebene klingt sehr deutlich eine ähnliche historische Formulierung an, die die Nationalsozialisten am Tor des Konzentrationslagers Auschwitz angebracht haben. Den darin ausgedrückten menschenverachtenden Zynismus vergleicht Claire Fontaine mit den Bedingungen des Kapitalgewinns und hinterfragt sowohl die Organisation des auf permanente Wertschöpfung basierenden, kapitalistischen Kunstsystems als auch die des Gesellschaftssystems.

In her self-description, Claire Fontaine speaks about herself in the singular: 'After lifting her name from a popular brand of school notebooks, Claire Fontaine declared herself a "readymade artist" and began to elaborate a version of neo-Conceptual Art that often looks like other people's work.' In her art, however, Claire Fontaine acts in the plural. The artists gesture toward the utopian idea of the collective in which a reflected form of the fusion of work, creativity, and political commentary is genuinely a product of the interplay between multiple participants. Claire Fontaine's ideas enter into an intelligent constellation of 'post'-ness in relation to established strategies of aesthetic production that were successful in recent decades: authorship, collective production, singularity, Conceptual Art, and even appropriation are modes that Claire Fontaine can only observe from a distance as the ruinous vestiges of a post-modernity, however the latter must be described.

This multifaceted interplay of keen theoretical reflection, intentional political commitment, and the radical incorporation of aesthetic vocabularies gives rise to works whose superficial simplicity at once enables complex descriptions of political constructions and realities. Take, for instance, the neon piece *ARBEIT MACHT KAPITAL* (2004): in choosing the material, industrially manufactured fluorescent tubes, Claire Fontaine takes up a tradition of neon lettering in Conceptual Art while also conforming to the conventional format of illuminated advertising. The three words 'ARBEIT MACHT KAPITAL' can be read as nouns – 'WORK POWER CAPITAL' – but the word 'MACHT' can also be taken to be a verb – 'WORK MAKES CAPITAL'. As nouns, the terms describe areas of social and economic coexistence; on a second level, they also address the interrelation between these fields. On a third level, the words quite clearly allude to a similar phrase from history: the Nazis inscribed it above the gate leading to the Auschwitz concentration camp. Claire Fontaine compares the inhuman cynicism expressed in that phrase to the conditions of the accumulation of capital, questioning the organisation of a capitalist art world that operates on the basis of the constant creation of value as well as that of the social system.

Matthias Mühling

You Pay, 2007
Smoke on ceiling
⌀ 80 cm

YOU PAY FOR YOUR PLEASURE

*Instructions for the Sharing of Private
Property,* 2006
Digital video, colour, sound,
Sony monitor, plinth
45:23 min

PETER COFFIN

Peter Coffin macht oftmals unwahrscheinliche Ideen zum Ausgangspunkt einer Untersuchung. So versucht Coffin in *Untitled (Greenhouse)* (2002), die Verständigung zwischen Menschen und Pflanzen zu verbessern. Im Ausstellungsraum wird ein mit Pflanzen und Musikinstrumenten gefülltes Gewächshaus installiert, und Musiker wie Besucher sind eingeladen, vor diesem belaubten Publikum zu spielen.

Der Versuch, die Welt mit neuen Augen zu betrachten, charakterisiert auch Projekte wie *Untitled (Rainbow)* (2005). Die Arbeit basiert auf gefundenen Fotografien mit Regenbogen-Motiven. Coffin verband die Bilder miteinander, um daraus einen einzigen Mega-Regenbogen in Form einer Nauman'schen Spirale an der Wand zu schaffen. *Untitled (Designs for Colby Poster Company)* (2008) besteht aus handelsüblichen Farbverläufen, die für eine kalifornische Druckerei mit Kultstatus hergestellt wurden. Normalerweise dienen diese Farbverläufe als Hintergrund für schwarz gedruckte Ankündigungen für eine Kirmes oder eine Rock-'n'-Roll-Show; in dieser Arbeit wird der Hintergrund selbst zum Inhalt.

Ein ähnlicher Versuch, einen neuen Blick auf das Vertraute zu erfinden, kennzeichnet Coffins Projekt *Untitled (Tate Britain)* (2009); dafür kuratierte er Werke aus der ständigen Sammlung der Tate in einer Ausstellung, begleitet von einem audiovisuellen Spektakel. Auf jedes Werk wurden in einer vorprogrammierten Reihenfolge Videos projiziert: Bienen schwärmten über einen goldfarbenen Druck von Josef Albers; Regen fiel vom Himmel einer apokalyptischen Szene von Samuel Colman; Licht spielte auf den Linien einer Arbeit von Francis Picabia wie auf den Saiten einer Harfe. Coffins Werk beruht auf der Vorstellung, dass unser reglementierter Blick und unser reguliertes Vorstellungsvermögen unsere Fähigkeiten einschränken, die Welt so zu sehen, wie sie – in ihrer ganzen Magie – tatsächlich ist. Coffin versucht beharrlich, durch die Überprüfung seltsamer Hypothesen oder durch neue Betrachtungsweisen vertrauter Bilder die Definition des Möglichen zu erweitern.

Peter Coffin's work often takes implausible ideas as a starting point for investigation. In *Untitled (Greenhouse)* (2002), for example, Coffin attempts to facilitate communication between plants and humans. A greenhouse filled with plants and musical instruments is installed in the gallery, and musicians as well as members of the public are invited to serenade this leafy audience.

An effort to look at the world through new eyes also characterises projects such as *Untitled (Rainbow)* (2005). This work uses found photographs depicting rainbows as its source material. Coffin linked the images together to create a single mega-rainbow in the form of a Naumanesque spiral on the wall. *Untitled (Designs for Colby Poster Company)* (2008) consists of custom colour gradients created for an iconic commercial printer in California. These gradients normally serve as the backdrop for rows of black letterpress text announcing a county fair or rock 'n' roll show; in this work, the background itself becomes the subject.

A similar effort to invent new ways of seeing the familiar can be found in Coffin's project *Untitled (Tate Britain)* (2009), for which he curated works from Tate's permanent collection in an exhibition accompanied by an audiovisual spectacle. Videos were projected onto each work in a pre-programmed sequence: bees swarmed across a golden Josef Albers print; rain poured from the sky of an apocalyptic Samuel Colman scene; light played across the lines of a work by Francis Picabia as if plucking the strings of a harp. Coffin's work stems from the idea that our regimented vision and imagination limit our ability to see the world as it is, in its true magic. Whether testing outlandish hypotheses or finding new ways to see familiar images, Coffin consistently seeks to expand the definition of the possible.

Michael Connor

1972 geboren in Berkeley, CA, USA,
lebt und arbeitet in New York, NY, USA
1972 born in Berkeley, CA, USA,
lives and works in New York, NY, USA

2008 Manifesta 7, European Biennial of
Contemporary Art, Trentino-Alto Adige
2007 2nd Moscow Biennale of Contemporary Art – *Footnotes on Geopolitics, Market and Amnesia*
2004 Liverpool Biennial of
Contemporary Art
2002 Manifesta 4, European Biennial
of Contemporary Art, Frankfurt/Main

www.galleriafonti.it
www.perrotin.com
www.heraldst.com

Untitled (Designs for Colby Poster Company), 2008
Eighty posters, letterpress ink on cardstock
Dimensions variable
Installation view, Aspen Art Museum

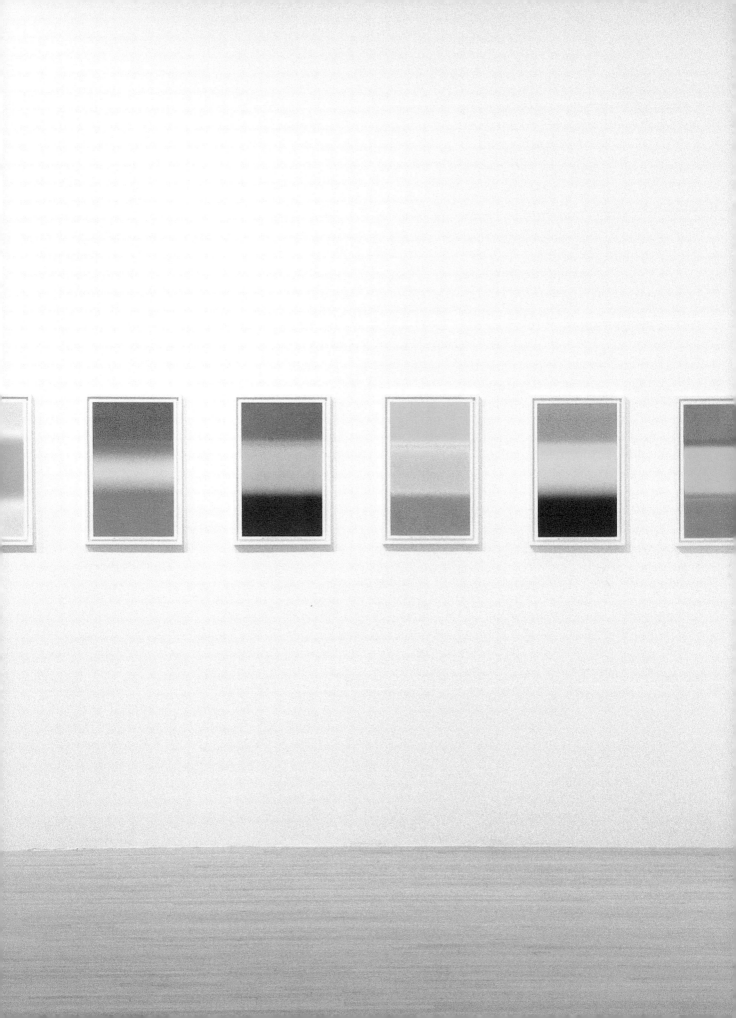

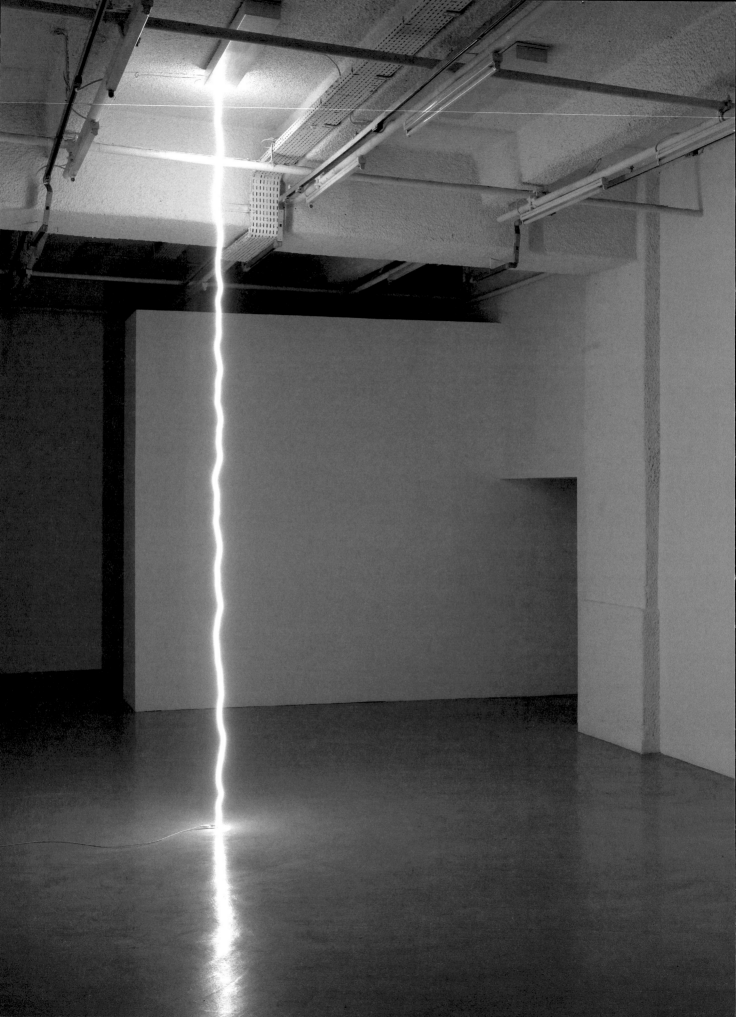

Untitled (Line), 2010
Neon
Dimensions variable
Installation view, Centre d'art
contemporain d'Ivry – le Crédac,
Ivry-sur-Seine

Untitled (RGB), 2008
CRT projector, DVD
Dimensions variable
Installation view, FRI ART Kunsthalle,
Fribourg

MINERVA CUEVAS

1975 geboren in Mexiko-Stadt, Mexiko,
lebt und arbeitet in Mexiko-Stadt
**1975 born in Mexico City, Mexico,
lives and works in Mexico City**

2010 6th Berlin Biennale for Contem-
porary Art – *what is waiting out there*
2010 Liverpool Biennial of Contemporary
Art
2007 9th Biennale de Lyon – *00s.
The history of a decade that has not
yet been named*
2006 27th Bienal de São Paulo –
Como viver junto / How to Live Together
2004 Biennale of Sydney – *On Reason
and Emotion*
2003 8th International Istanbul
Biennial – *Poetic Justice*

www.irational.org/minerva/
resume.html

www.kurimanzutto.com

La venganza del elefante
(from the series *hidrocarburos*), 2007
Four piled tanks
88 × 63 cm
Installation view,
kurimanzutto, Mexico City

Minerva Cuevas nutzt künstlerische Kontex-
te und Strategien, um spürbare gesellschaft-
liche Veränderungen zu bewirken. Dieses
Interesse steht im Mittelpunkt ihres Lang-
zeitprojekts Mejor Vida Corporation (MVC),
dessen Titel ausdrücklich ein „besseres
Leben" verspricht. MVC wurde 1998 gegrün-
det und bietet jedem Interessenten seine
kostenlosen Produkte und Dienstleistungen
an. Besucher der Firmenwebsite sind einge-
laden, sich Studentenausweise mit Fotos zu
bestellen, mit denen man beispielsweise gra-
tis oder zu reduzierten Preisen ein Museum
besichtigen, ins Kino gehen oder öffentliche
Verkehrsmittel nutzen kann. Es lassen sich
auch Strichcodes herunterladen und ausdru-
cken, die man in großen Supermarktketten
heimlich auf bestimmte Lebensmittel kleben
kann, um den Originalpreis zu reduzieren.
Viele der von Cuevas im öffentlichen Raum
durchgeführten Interventionen sind geprägt
von humanistischen Ideen und schelmischem
Humor. In *Dodgem* (2000) platzierte sie Logos
von großen Ölkonzernen auf den Autoscoo-
tern in einem Freizeitpark in Mexiko-Stadt
und transformierte sie dadurch in politisches
Slapstick-Theater. Für *Concert for Lavapiés*
(2003) lud Cuevas alle möglichen Musiker in
ein Madrider Stadtviertel ein, um dort zu-
sammen zu spielen. Es erschienen ungefähr
fünfzig Personen, und obwohl es weder ein
abgesprochenes Programm noch einen Diri-
genten oder eine Partitur gab, war das Ergeb-
nis überraschend harmonisch.
Cuevas entwickelt auch Installationen für
Galerieräume, darunter mehrkanalige Video-
arbeiten und skulpturale Objekte wie die
Autoscooter aus *Dodgem*. Ein beispielhaftes
Projekt für das Zusammenspiel zwischen In-
nenraum und Außenraum der „weißen Zelle"
war *S.COOP* (2009), das im Auftrag der Lon-
doner Whitechapel Gallery entstand. Cuevas
schuf eine neue Währung, den S.COOP, der
auf einem örtlichen Markt an die Händler
ausgegeben wurde. Die Münzen im Wert von
£1.20 konnten in einer von der Künstlerin ge-
stalteten Eisdiele in der Nachbarschaft gegen
Naturalien eingetauscht werden. Eine Aus-
stellung in der nahe gelegenen Whitechapel
Gallery untersuchte die bedeutende Ge-
schichte der Genossenschaftsbewegung in
London. Für Cuevas ist der Ausstellungsraum
ein wichtiger Ort für die Verbreitung von Ideen,
doch müssen diese auch auf die Straße ge-
tragen werden.

Minerva Cuevas uses artistic contexts and
strategies to produce tangible social change.
This agenda is at the fore of Cuevas's long-
running project Mejor Vida Corporation (MVC)
(Better Life Corporation), whose title explic-
itly promises a 'better life'. Launched in 1998,
MVC offers its products and services for free
to any and all who request them. Visitors to
the company's website are invited to order
student ID cards, complete with photo, which
can be used to obtain free or reduced admis-
sion to museums, movies, public transport,
and so on. They can also download and print
bar codes which can be furtively placed on
selected food items in large supermarket
chains to reduce the sticker price.
Mischievous humour and an underlying hu-
manism characterise many of Cuevas's pub-
lic space interventions. In *Dodgem* (2000),
she placed the logos of major oil companies
onto the bumper cars at a Mexico City amuse-
ment park, transforming it into slapstick
political theatre. For *Concert for Lavapiés*
(2003), Cuevas invited any and all musicians
to a Madrid neighbourhood to play together.
About fifty turned up, and despite the lack of
any pre-agreed plan, conductor, or score, the
result was surprisingly harmonious.
Cuevas's work also takes the form of gallery
installations, including multi-channel vide-
os and sculptural objects such as the cars
from *Dodgem.* One project that exemplified
the interplay between the interior and ex-
terior of the white cube was *S.COOP* (2009),
commissioned by London's Whitechapel
Gallery. Cuevas created a new currency,
the S.COOP, which was distributed to ven-
dors in a local market. Valued at £1.20, the
coins could be exchanged for an ice cream at
a nearby parlour designed by the artist. An
exhibition at the nearby Whitechapel Gallery
explored the rich history of the co-operative
movement in London. For Cuevas, the gallery
is an important place for the propagation of
ideas, but the ideas must also spill out into
the street.

Michael Connor

S.COOP (project), 2009
Five wooden showcases, ice cream, 2000
coins exchanged in the Petticoat Lane Mar-
ket area, photographs, vintage cooperative
tokens, posters and leaflets
Dimensions variable
Installation view,
Monochrome, Toynbee Street, London

S.COOP (monochrome project), 2009
Wooden box with one S.COOP coin, four
wooden showcases including posters,
leaflets, books, postcards, tokens and
magnifying glass
Dimensions variable
Wooden box: 5.5 × 24 × 18 cm
Each showcase: 8 × 90 × 68 cm

AARON CURRY

1972 geboren in San Antonio, TX, USA,
lebt und arbeitet in Los Angeles, CA, USA
**1972 born in San Antonio, TX, USA,
lives and works in Los Angeles, CA, USA**

www.davidkordanskygallery.com
www.galeriebuchholz.de
www.michaelwerner.com

Mit Collagen, Gemälden und Zeichnungen, vor allem aber mit großformatigen Skulpturen schafft Aaron Curry eine Bühne für die gezielte Konfusion ästhetischer Codes, indem er kunsthistorisch altbekannte mit popkulturellen und auch unkonventionelleren Referenzen neu zusammenführt. Curry gräbt sich durch den Steinbruch der Avantgarden des 20. Jahrhunderts, greift Formen auf von Künstlern wie Calder, Picasso, Arp, Moore oder Noguchi – durchweg solche, die vermeintliche „Primitivismen" gesampelt und daraus zu ihrer Zeit frische Bildsprachen zwischen Abstraktion und Figuration entwickelten. Currys Zugriff kreiert ein ironisches Spiel um gefälschte, missverstandene oder obsessiv herbeifantasierte Authentizität des künstlerischen Ausdrucks. Er nutzt jene vordergründigen Versprechungen „ursprünglicher" Formen, um sie mit Versatzstücken heutiger Popkultur zu re-inszenieren – und so ihre ureigene Hybridität auf die Spitze zu treiben. Bildwelten aus Computerspielen, Comics, amerikanischer Folklore, Mode und Graffiti werden hineinverflochten. Zudem nennt Curry selbst so eigenwillige Künstler wie H. C. Westermann, Ivan Albright, Karl Wirsum und seinen Lehrer Richard Hawkins als wichtige Anreger.

Wenn Curry den Trash und die tradierte Form neu aufmischt, geht es ihm nicht bloß um ästhetisches Recycling. Er betreibt die postdigitale Rückübersetzung einer scheinbar unbegrenzten Stil-Verfügbarkeit und setzt dieses im rauen Umgang mit dem Material um: *Face Face Socialite (Harlequin in Grisaille)* (2009) etwa, eine abstrakte, übermannshohe Figur à la Dubuffet oder Picasso, ist betont lässig aus flachen Holzelementen montiert, weiß grundiert und großflächig grob mit dem konturauflösenden Tarnmuster Razzle Dazzle überzogen. Schon das ist ein Cross-over: Solche Oberflächen, militärisch zur Camouflage von Schiffen und Kriegsgerät eingesetzt, sind nah an kubistischer und vortizistischer Formensprache. Auch in anderen Arbeiten, etwa *Ohnedaruth* oder *Danny Skullface Sky Boat (Reclining)* (beide 2009), schließt Curry Raum- und Flächeneindruck kurz: Durch ihre Konstruktion aus flachen Holz- oder Alu-Elementen sieht man die Skulpturen je nach Standpunkt als Kontur oder Volumen. So fordern die Arbeiten den beweglichen Blick – und inszenieren disparate ästhetische Benutzeroberflächen.

In his collages, paintings, and drawings, but most importantly his large-format sculptures, Aaron Curry creates a stage for the deliberate confusion of aesthetic codes, blending references to the standards of art history with pop-cultural as well as more remote sources in new ways. Curry digs his way through the quarry of the avant-gardes of the twentieth century, taking up forms created by people such as Calder, Picasso, Arp, Moore, or Noguchi – all of them artists who sampled alleged 'primitivisms' and developed them into what were at their time fresh visual languages between abstraction and figuration. Curry's take on his sources creates an ironic game around the faked, misperceived, or obsessively imagined authenticity of artistic expression. He uses the superficial aura of promise that surrounds 'aboriginal' forms in order to re-stage them with set pieces from today's pop culture, taking the hybridity that has always defined them at their core to new extremes. Imagery from computer games, comic strips, American folklore, fashion, and graffiti are woven into his art. Among his major inspirations, Curry himself names idiosyncratic artists such as H. C. Westermann, Ivan Albright, Karl Wirsum, and not least importantly his teacher Richard Hawkins.

Curry's remixing of trash and traditional form aims not just at aesthetic recycling. He conducts a post-digital re-translation of what seems an unlimited availability of styles, a project reflected also in the rough use he makes of his materials: *Face Face Socialite (Harlequin in Grisaille)* (2009), for instance, an abstract larger-than-life figure in the style of Dubuffet or Picasso, is a demonstratively casual montage of wooden elements, coated with white primer and then generously and coarsely covered with the contour-dissolving camouflage pattern Razzle Dazzle. Therein already lies a form of crossover: this sort of surface design – its military purpose was to confuse observers of ships and other equipment – is not far away from the formal vocabularies of Cubism or Vorticism. In other works such as *Ohnedaruth* and *Danny Skullface Sky Boat (Reclining)* (both 2009), Curry similarly short-circuits spatial and surface perception: because of the way they are built from flat wooden or aluminium elements, the sculptures appear as contours or volumes, depending on the beholder's vantage point. The works thus call for an agile eye – and stage disparate aesthetic user interfaces.

Algebra Headdress, 2009
Unique silkscreen and gouache on paper
287 × 216 cm

Jens Asthoff

Face Face Socialite
(Harlequin in Grisaille), 2009
Painted wood
255 × 74 × 99 cm

Idea without Idea, 2009
Painted wood
274 × 91 × 61 cm

The Scarecrow's Wife, 2009
Silkscreen on wood, steel
293 × 150 × 102 cm

KEREN CYTTER

1977 geboren in Tel Aviv, Israel,
lebt und arbeitet in Berlin, Deutschland
**1977 born in Tel Aviv, Israel,
lives and works in Berlin, Germany**

2010 8th Gwangju Biennale –
10.000 Lives
2009 53rd International Art Exhibition /
La Biennale di Venezia – *Fare Mondi /
Making Worlds*
2008 Manifesta 7, European Biennial of
Contemporary Art, Trentino-Alto Adige
2007 9th Biennale de Lyon – *00s.
The history of a decade that has not
yet been named*

www.galerie-nagel.de
www.pilarcorrias.com
www.schauort.com

*History in the Making or The Secret
Diary of Linda Schultz*, 2009
Live theatre piece
Stage view, Tate Modern,
Turbine Hall, London

In einem Film von Keren Cytter möchte man bestimmt nicht aufwachen. Es schneit in der Wohnung, ein Plattenspieler fängt Feuer, Kunstblut spritzt, Menschen werden erschossen oder in den Selbstmord getrieben. Zwischendurch masturbiert jemand. Die Schauspieler wirken seltsam fremdbestimmt und scheinen ihre Sätze mehr abzulesen als sie wirklich aus freien Stücken vorzutragen. Sie stolpern durch eine Handlung, die zwar erzählerische Momente enthält, aber viel zu fahrig ist, als dass sie einer inneren Logik folgen könnte. Darüber hinaus sind die Charaktere häufig in Schleifen ohne Anfang und Ende gefangen, aus denen es kein Entrinnen gibt. Die Produktion ist denkbar einfach; ein paar Freunde als Darsteller genügen. Gedreht wird in der Küche, die Effekte sind hausgemacht, in wenigen Tagen ist das Werk vollendet. Auf diese Weise hat Cytter seit 2001 schon über vierzig Videos mit Leichtigkeit produziert. Kurz: Gegen *Les Ruissellements du Diable* (2008) oder *Four Seasons* (2009) wirkt Luis Buñuels surrealistisches Opus „Ein andalusischer Hund" wie ein geradlinig verlaufender Hollywood-Blockbuster.

Wie bei Buñuel geht es bei Cytter auch um das Geflecht zwischenmenschlicher Beziehungen. Allerdings interessiert sie nicht so sehr die Psychologie von Liebe und Zuneigung, sondern vielmehr, wie sehr unsere Gefühlsregungen medial geprägt sind. *The Victim* (2006) könnte gleichermaßen griechische Tragödie wie Seifenoper sein. Eine Frau muss sich für ihren Liebhaber oder ihren Sohn entscheiden, die beide von derselben Person gespielt werden. Ein Chor und der Regisseur des Dramas kommentieren die Szenen. Das Skript, dessen Dialoge nur so vor Klischees strotzen, liegt auf dem Tisch.

Seit Neuestem widmet sich Cytter, die außerdem noch zeichnet und Romane schreibt, dem Tanztheater. Hierfür hat sie ihre eigene Kompanie gegründet, deren Name D.I.E. Now (als Abkürzung für Dance International Europe Now) wie der Titel eines Horrorfilms klingt. Bei ihren Aufführungen geht es erwartungsgemäß drunter und drüber. In dem Stück *The True Story of John Webber and His Endless Struggle with the Table of Content* (2010) etwa bezieht sich Cytter auf so unterschiedliche Vorbilder wie Pina Bausch und „Disney on Ice", Michael Jackson und Samuel Beckett. Im Zentrum stehen der politische Aktivist John Webber und die Grafikdesignerin Linda Schultz. Als sich beide ineinander verlieben, müssen sie am nächsten Morgen feststellen, dass sich ihre Geschlechter vertauscht haben. Es kommt zur Revolution ... natürlich!

A film by Keren Cytter is surely not a place anyone would want to wake up in. Snow is falling in the apartment, a record player catches fire, fake blood spatters, people are shot or driven to suicide. In between, someone masturbates. The actors appear strangely remote-controlled, seeming to read their lines rather than performing them of their own free will. They stumble through an action that, though it contains narrative moments, is far too erratic to be obeying an internal logic. The characters, moreover, are frequently caught up in loops without beginning or end from which there is no escape. The production is as simple as can be imagined; a few friends are good enough as actors. The films are shot in the kitchen, the effects are homemade, the work is finished in no more than a few days. Since 2001, Cytter has produced more than forty videos in this fashion with great ease. In short: in comparison with *Les Ruissellements du Diable* (2008) or *Four Seasons* (2009), Luis Buñuel's Surrealist opus 'An Andalusian Dog' looks like a straightforwardly plotted Hollywood blockbuster.

Like Buñuel, Cytter is also interested in the web of interpersonal relationships. Her focus, however, is not so much on the psychology of love and affection but rather on how and to what extent media shape our emotions. *The Victim* (2006) might equally well be a Greek tragedy or a soap opera. A woman must decide between her lover and her son, both of whom are played by the same person. A chorus and the drama's director comment on the scenes. The script, whose dialogues are studded with clichés, rests on the table.

Recently, Cytter, who also draws and writes novels, has devoted herself to dance theatre, founding her own company, whose name, D.I.E. Now (the abbreviation for Dance International Europe Now) sounds like the title of a horror film. As the viewer familiar with her work would expect, the company's performances are a big mess. In *The True Story of John Webber and His Endless Struggle with the Table of Content* (2010), for instance, Cytter makes reference to models as diverse as Pina Bausch and 'Disney on Ice', Michael Jackson and Samuel Beckett. The piece revolves around the political activist John Webber and the graphic designer Linda Schultz. The two fall in love; the next morning, they find to their surprise that they have switched genders. Revolution ensues ... of course!

Sven Beckstette

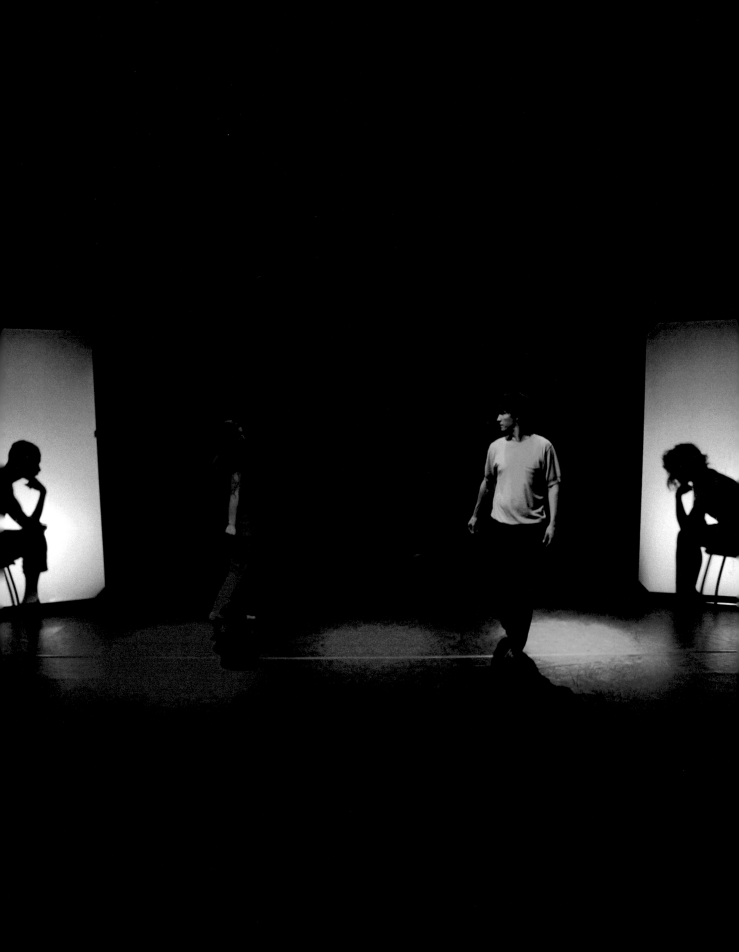

Untitled, 2009
DVD, colour, sound
9 min

I know you ar... ome

So what do you want me to do?

I said I'm sorry.

You can't smoke here

ENRICO DAVID

1966 geboren in Ancona, Italien, lebt und
arbeitet in London, Großbritannien
**1966 born in Ancona, Italy, lives and
works in London, Great Britain**

2006 The Tate Triennial – *New British Art*,
London
2003 50th International Art Exhibition /
La Biennale di Venezia – *Dreams and
Conflicts. The Dictatorship of the Viewer*

www.galeriebuchholz.de

Bulbous Marauder, 2008
Gouache on paper
116 × 83 cm

>>
Turner Prize 09, 2009
Exhibition view, Tate Britain,
London

Ornament sei barbarisch, Kindern oder Natur-
völkern angemessen, aber beim modernen
Menschen Ausdruck kultureller Degeneration,
postulierte der Architekt Adolf Loos 1908 in
seiner berühmten Streitschrift „Ornament und
Verbrechen". Eine wesentliche Rolle spielte für
ihn dabei der erotische Aspekt des Ornaments:
„der mensch unserer zeit, der aus innerem
drange die wände mit erotischen symbolen
beschmiert, ist ein verbrecher oder ein dege-
nerierter." Schnell wurde jedoch deutlich, dass
sich auch auf den funktionalen Oberflächen
der Moderne Ornamente bildeten, unter deren
vermeintlicher Neutralität sich Gewalt und se-
xuelle Phantasien ablesen lassen.
Enrico David dechiffriert und „missbraucht"
dieses ambivalente ästhetische Vokabular
der Moderne, um daraus eine eigene, queere
Sprache zu entwickeln. Bekannt wurde der
Central-Saint-Martins-Absolvent mit Serien
von Stickereien, auf denen tanzende, merk-
würdig bedrohliche Harlekine zu sehen sind,
deren Körper sich in ornamentalen Symme-
trien auflösen: „A Clockwork Orange" trifft auf
Aubrey Beardsley und das Bauhaus. Diesen
theatralischen Ansatz führte er mit autobio-
grafisch aufgeladenen Installationen weiter,
die wie Bühnen für Mysterienspiele wirkten –
etwa mit *Ultra Paste* in seiner ersten großen
Museumsausstellung im Londoner ICA (2007).
In dieser raumfüllenden Arbeit verband David
die Architektur des Jugendzimmers, das sein
früh verstorbener Vater in den 1970er Jahren
für ihn entworfen hatte, mit Elementen einer
1935 entstandenen Collage von Dora Maar,
die einen kleinen Jungen zeigt, der sich an
einer matronenhaften Figur reibt. In Davids
Version ist er es selbst, der sich mit herun-
tergelassenen Hosen an einer maskierten
Puppe erregt, quasi das Andenken an seinen
Vater schändet und die Grenzen von Privatem
und Öffentlichem durchbricht. Anspielungen
auf die moderne Kunstgeschichte verbin-
den sich in seinem Werk mit Kindheitstrau-
mata, Überwachung, Strafe und Lust. Der
Körper wird amputiert, designt, zum Orna-
ment transformiert, wie zum Beispiel in den
hodensackartigen Papierlaternen, die er in
seiner Ausstellung *Bulbous Marauder* (2008)
von abstrahierten Menschenfiguren baumeln
ließ. So zeigte er auch 2009 in seinen Instal-
lationen zum Turner Prize und für *How Do You
Love Dzzzt by Mammy?* im Basler Museum für
Gegenwartskunst riesige, eierförmige Wipp-
figuren, die einem Spielzeugentwurf für die
Wiener Werkstätten um 1910 nachempfunden
waren: monströse schwankende Kind-Mann-
Wesen, die das Psychodrama der Moderne als
das eigene durchleben.

Ornamentation, the architect Adolf Loos
postulated in his famous 1908 polemic 'Or-
nament and Crime', is barbaric, appropriate
for children or primitive peoples; in modern
man, he wrote, it is an expression of cultural
degeneration. A central part of the problem
was the erotic aspect of ornamentation: 'the
man of our time who daubs the walls with
erotic symbols to satisfy an inner urge', he
wrote, 'is a criminal or a degenerate'. It soon
became apparent, however, that ornaments
formed even on the functional surfaces of
modernism, beneath whose alleged neutral-
ity we can thus discern the marks of violence
and sexual fantasy.
Enrico David decodes and 'abuses' this am-
bivalent aesthetic vocabulary of modernism
in order to develop it into his own queer lan-
guage. The artist, who graduated from Cen-
tral Saint Martins, rose to fame with series
of embroidered works showing dancing and
strangely menacing harlequins whose bod-
ies dissolve into ornamental symmetries: 'A
Clockwork Orange' meets Aubrey Beardsley
and the Bauhaus. He took this theatrical ap-
proach one step further in autobiographi-
cally charged installations that looked like
stages set for mystery plays, such as *Ultra
Paste*, created for his show at London's ICA
(2007), his first large-scale show at a muse-
um. In this expansive work, David fused the
architecture of the childhood room his fa-
ther, who died early, had designed for him in
the 1970s with elements from a 1935 collage
by Dora Maar that shows a little boy rubbing
up against a matronly figure. In David's ver-
sion, it is he himself who has dropped his
pants and is masturbating using a masked
doll, defiling, as it were, his father's mem-
ory and breaching the boundary between
the private and public spheres. His works
blend allusions to the history of modern art
with childhood traumata, surveillance, pun-
ishment, and sexual pleasure. The body is
amputated, designed, transformed into an
ornament, thus in the scrotum-like paper
lanterns dangling from abstract human fig-
ures in his show *Bulbous Marauder* (2008).
In his 2009 installations for the Turner Prize
and in *How Do You Love Dzzzt by Mammy?* at
the Basel Museum of Contemporary Art, he
showed gigantic egg-shaped seesaw figures
loosely based on a ca. 1910 toy design for
the Wiener Werkstätten: monstrous teeter-
ing hybrid creatures between child and man
living through the psychodrama of modern-
ism as though it were their own.

Oliver Koerner von Gustorf

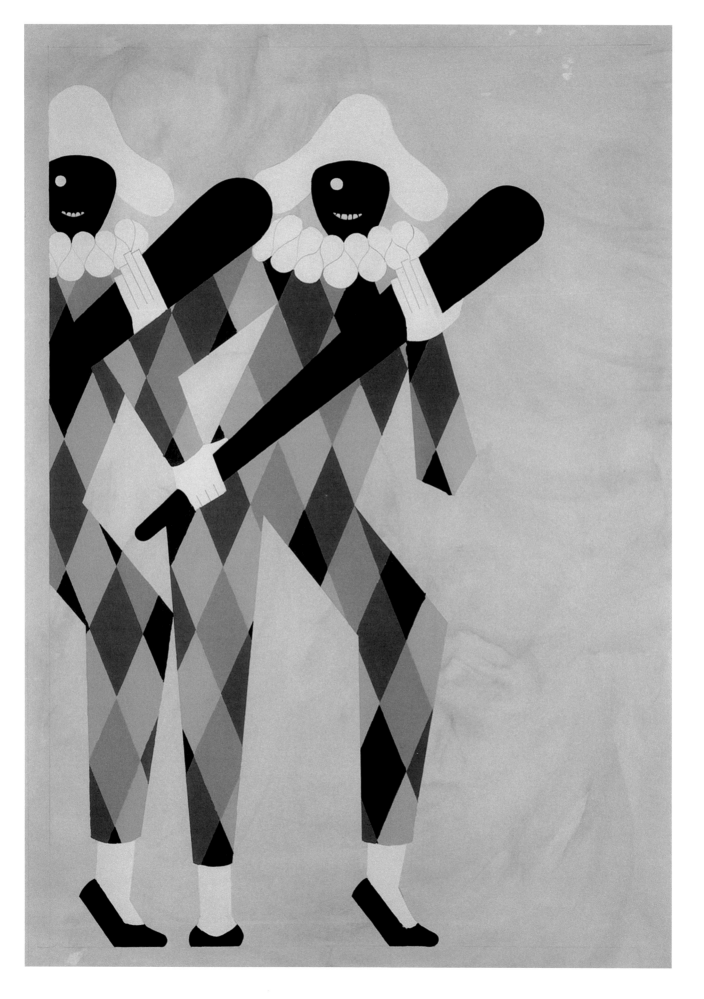

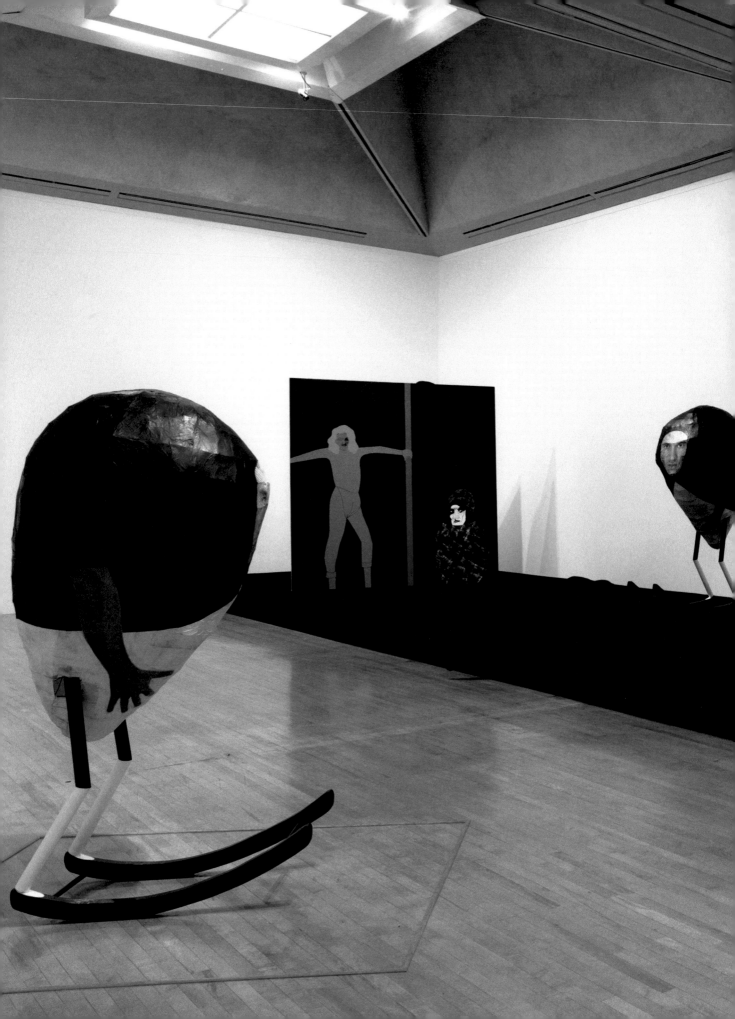

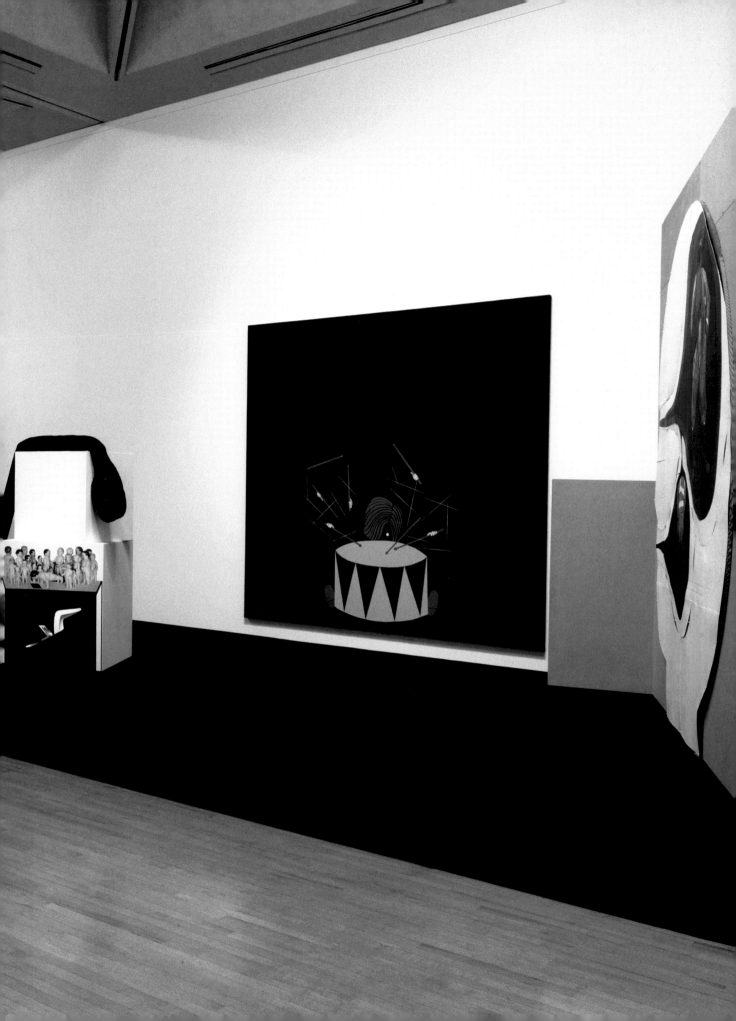

SIMON DENNY

1982 geboren in Auckland, Neuseeland, lebt und arbeitet in Auckland und Köln, Deutschland
1982 born in Auckland, New Zealand, lives and works in Auckland and Cologne, Germany

2008 16th Biennale of Sydney – *Revolutions – Forms That Turn*
2008 Brussels Biennial 1 – *Show me, don't tell me*

www.galeriebuchholz.de
www.michaellett.com

Simon Denny hat eine Vorliebe dafür, kulturelle Signifikanten buchstäblich und symbolisch zu verflachen, während er ihre flüchtige und prekäre Wirkung im Raum erforscht. Bekanntlich zitiert der Künstler popkulturelle Figuren wie den „Prinz von Bel-Air" und verschiedene Kitsch-Phänomene und zeigt wenig oder gar keinen Respekt vor überlebten oder traditionellen Hierarchien künstlerischer Materialien. Er wird einen Druck ebenso gerne auf einem Badehandtuch wie auf einer Leinwand ausführen. Seine Arbeiten sind oft von einer provisorischen Ad-hoc-Ästhetik geprägt, die nicht ungewöhnlich für seine Heimat Auckland ist und die beispielsweise auch die Skulpturen von Isa Genzken kennzeichnet, die billige und schlecht produzierte Materialien und Produkte wegen ihres zerbrechlichen, flüchtigen Charakters bevorzugt. Daher ist sein Werk auf sensible Weise trashig und offenkundig den gleichen Gesetzen des Veraltens unterworfen wie ein großer Teil von Dennys popkulturellem Bezugsrahmen.

Dies lässt sich auch an der aktuellen, andauernden Untersuchung des Künstlers zu der überholten Form kastenartiger Fernsehgeräte und ihrer komplexen Beziehung zum Raum ablesen. In den vergangenen zwei Jahren beschäftigte sich Denny ausführlich mit diesem technologischen Motiv und erforschte es gründlich in einer Reihe von Einzelausstellungen. *7 Drunken Videos* (2009) war ein Versuch, sieben Stadien der Trunkenheit anhand von Aluminiumgehäusen mit Plexiglas-Deckeln darzustellen. Die Gehäuse fungierten zugleich als nostalgische Fernsehapparate und unwahrscheinliche Aquarien mit Plastikfischen und setzten die beiden Objekte und ihre Fähigkeiten gleich, (berauschende?) Welten zu enthalten sowie den Raum zu repräsentieren und einzunehmen. In den darauffolgenden Ausstellungen wurde das Motiv in der Mitte durchgesägt wie ein totes anatomisches Objekt und mit Pfeilen durchbohrt, als sollten diese angezogene Blicke darstellen; es erschien auch in einer zusammenhängenden Serie von Bildern mit vertrauten Unterwasserszenen, die in einer Achse auf Sockeln arrangiert wurden wie ein horizontales Totem oder ein symbolisches Riff. Dennys anhaltende Auseinandersetzung mit diesem Motiv scheint darauf abzuzielen, die innere Spannung dieses Sujets so umfassend wie möglich zu untersuchen und es als Ausgangspunkt zu nutzen, um die Grenzen zwischen Bild, Objekt und Malerei formal und fließend auszuloten.

Simon Denny has a penchant for literally and symbolically flattening out cultural signifiers while exploring their fleeting and tenuous purchase on space. Known to reference such pop-cultural figures as 'The Fresh Prince of Bel-Air' and a variety of kitsch, the artist has little or no respect for any outmoded or traditional hierarchies of artistic materials. He'll just as happily do a print on a beach towel as he will make a print on canvas. The work is often suffused with a provisional, ad-hoc aesthetic not foreign to his native Auckland or, say, the sculpture of Isa Genzken, in which cheap, badly made materials and products are used, their fragile, ephemeral character privileged. Thus is the work invested with a delicate trashiness, apparently vulnerable to the same laws of obsolescence as much of Denny's pop-cultural frame of reference.

This much can be seen in the artist's recent, ongoing research into the obsolescent form of box TV sets and their complex relationship with space. The past two years have seen Denny particularly preoccupied with this technological motif, exploring it extensively in a series of solo exhibitions. *7 Drunken Videos* (2009) sought to represent seven states of inebriation with aluminium casings with plexiglass covers. The casings doubled as wistful TV sets and improbable fishtanks, replete with fake, plastic fish inside, equating the two objects and their ability to contain (inebriating) worlds, represent and occupy space. In subsequent exhibitions, the motif was sawed in half, like a deceased, anatomical specimen, and pierced with arrows, as if to represent a captive gaze, or incarnated on a series of conjoined canvases bearing generic, subaquatic scenes, which were then arranged in a linear axis on pedestals, like a horizontal totem or a symbolic underwater reef. Denny's ongoing treatment of the motif seems determined to examine the inherent tension of the subject as exhaustively as possible while exploiting it as a point of departure to formally and fluidly test the boundaries between image, object, and painting.

Chris Sharp

Underberg Drawing Samsung, 2009
Xerox on paper (actor's handwritten notes for *Deep Sea Vaudeo* script, technical data sheet)
128 × 91 cm

Die Geräte der LED TV Serie 6 zählen zu den schmalsten, robustesten und am nahtlos gearbeiteten Fernsehern weltweit. Der einzigartige, transparente Fuß eines jeden Samsung LED TV rundet das Design ab. Dafür findet sich in jedem Zimmer ein geeigneter Platz.

Erfahren Sie mehr +

Eine Schraube genügt, um die erstaunlich schmale LED TV Serie 6 aufzuhängen, ähnlich wie einen Bilderrahmen. Nur dass Sie sich hier einen echten Crystal TV™ an die Wand hängen. Ein Blick auf die abgerundeten Ecken reicht aus, um zu begreifen, dass es sich hierbei nicht um einen profanen Fernseher handelt, sondern vielmehr um ein echtes Kunstwerk. Die Geräte der LED TV Serie 6 sind sehr schmal, robust und außerdem nahtlos hergestellt. Der einzigartige transparente Fuß eines jeden Samsung LED TVs rundet das Design ab. Dafür findet sich in jedem Zimmer ein geeigneter Platz.

Erfahren Sie mehr +

Grün passt in jeden Raum.

Der recycelbare Rahmen der LED TV Serie 6 enthält keinerlei flüchtige organische Verbindungen. Die Hintegrundbeleuchtung beinhaltet kein Quecksilber. Außerdem enthalten Samsung LED TVs im Lötmittel kein Blei, und während des Herstellungsprozesses der Fernsehrahmen werden keine VOCs ausgestoßen. Deshalb können Sie getrost die Füße hochlegen und sich vor Ihrem umweltfreundlichen Fernseher erholen.

Erfahren Sie mehr +

0%

Paint Spray

40%

Low Power

0%

Mercury

Mega Dynamic Contrast

Früher konnte man realitätsgetreue Bilder nur im Kino erleben. Mit Mega Dynamic Contrast ist die gleiche Schärfe jedoch auch mit LED-Bildschirmen möglich. Jeder Frame hat volle, satte Farbtöne. Dunkle Farbtöne erscheinen voller, und helle unglaublich rein. Der einzige Unterschied zum Kino ist, dass niemand vor Ihnen sitzt und Ihnen die Sicht blockiert.

Von Experten getestet

100Hz Motion Plus

Noch nie wurden schnelle Animationen oder Spezialeffekte in Filmen fließender wiedergegeben als mit der 100Hz Motion Plus Technologie. Durch das Analysieren und Erweitern von Action-Frames sorgt 100Hz Motion Plus dafür, dass nichts verschwimmt. Stattdessen werden Spezialeffekte schärfer wiedergegeben. Animationen wirken geschmeidiger. Sportszenen erscheinen schärfer. Und der Zuschauer ist noch gebannter.

Ihre Bildergalerie ist jetzt geöffnet

Hantarex Monitor Promotional Image, 2009
Digital colour photograph on card of
Hantarex monitor displaying Hantarex
promotional image
19 × 15 cm

Flatscreen Video Aquarium 1, 2008
Found plinth, television casing, cardboard,
polystyrene, mdf, aluminium, plexiglass
with protective plastic, screen print,
coffee beans, dirty rag, stains
75 × 100 × 20 cm

Euphoria, 2009
Television casing, wax, plaster, aquarium lamp,
plastic backdrop, aluminium casing, plexiglass,
screen print, wood, found vitrine
258 × 100 × 50 cm
Installation view, Lüttgenmeijer, Berlin

Deep Sea Vaudeo, 2009
Exhibition view with monitors arranged in
order of depth, Galerie Daniel Buchholz,
Cologne

Contradiction, 2010
Inkjet on canvas, metal fittings
66 × 100 × 74 cm
Installation view, Artspace, Sydney

NATHALIE DJURBERG

1978 geboren in Lysekil, Schweden,
lebt und arbeitet in Berlin, Deutschland
**1978 geboren in Lysekil, Sweden,
lives and works in Berlin, Germany**

2009 53rd International Art Exhibition /
La Biennale di Venezia – *Fare Mondi /
Making Worlds*
2007 2nd Moscow Biennale of Contemporary Art – *Footnotes on Geopolitics,
Market and Amnesia*
2006 4th berlin biennial for contemporary art – *Of Mice and Men*

www.giomarconi.com
www.zachfeuer.com

Portrait: Hans Berg
and Nathalie Djurberg

The Experiment, 2009
Three digital claymation videos, multiple
sculptures, mixed media
Dimensions variable
Installation view, 53rd International Art
Exhibition / La Biennale di Venezia

Die Stop-Motion-Animationen von Nathalie Djurberg (zumeist mit Tonfiguren und handgefertigten Requisiten, manchmal aber auch mit einfachen Kohlezeichnungen produziert) sind wie ein süßliches Märchen, in dem alles schiefgeht. Niedliche kleine Mädchen tanzen und wirbeln in anmutigen Kleidern zu der verspielten Filmmusik von Hans Berg. Doch die Stimmung schlägt um, und die Handlung nimmt einen düsteren Verlauf mit Racheakten und hemmungslosen Taten, voller Wut, Schuld, Angst und grotesker Fantasien. In *It's the Mother* (2008) sehen wir eine nackt auf einem Bett ausgestreckte Frau, an der ihre bedürftigen kleinen Kinder klammern, zerren und um deren Aufmerksamkeit sie betteln. Dann kriechen sie nacheinander zurück in den Mutterleib, aus dem sie gekommen sind, und veranschaulichen dadurch die Opfer, die eine Mutter für ihre Kinder bringt.
Moving on to Greener Pastures (2008) zeigt wilde Kinder, die versuchen, eine Schlucht zu durchqueren, indem sie einen steilen Hügel hinabklettern. Doch jedes Mal, wenn eines von ihnen unten angekommen ist, wird sein Beinahe-Erfolg zunichte gemacht, da es von einer Meute gieriger Alligatoren verschluckt und zermalmt wird. In *Tiger Licking Girl's Butt* (2004), Djurbergs klassischem Remake eines Super-8-Films, den sie noch an der Kunstakademie drehte, trocknet sich ein nacktes Mädchen nach dem Bad ab, während hinter ihr unbemerkt ein Tiger lauert und sie hungrig beobachtet. Er streckt seine Zunge aus und leckt ihren Po. Zuerst reagiert sie angewidert, erliegt aber schließlich seiner Verführung und lässt sich wieder und wieder von ihm ablecken. Der Tiger schleckt, das Mädchen seufzt und nimmt ihn schließlich mit ins Bett. Szenarien wie diese demonstrieren Djurbergs lebhafte Vorstellungskraft und ihre Bereitschaft, alles öffentlich zu machen.
Putting Down the Prey (2008) zeigt ein Eskimo-Mädchen, das ein Walross harpuniert, sorgfältig dessen Bauch aufschneidet und ausnimmt, in ihn hineinschlüpft und die Haut um sich herum zunäht. Der Film ist ebenso bizarr und sonderbar, kühn und aufrichtig wie alle ihre Arbeiten. Djurberg setzt Szenarien ins Bild, über die wir kaum nachzudenken wagen und die wir erst recht nicht laut aussprechen würden. Doch sie nimmt dieses Risiko auf sich und lässt ihren Fantasien freien Lauf, wie tabuisiert oder verdreht sie auch sein mögen. Und der Stil: Die sorgfältig gestalteten Tonfiguren und handgefertigten Requisiten und Kostüme sind kostbar und verführerisch, farbenfroh, anmutig und zerbrechlich sowie meisterhaft animiert und orchestriert.

Nathalie Djurberg's stop motion animations (mostly made with clay and handmade props, but occasionally with simple charcoal) are like a child's sweetest fairy tale gone totally wrong. Sweet little girls prance and twirl in dainty dresses along to playful scores by Hans Berg. Yet the tone takes a sharp turn down a dark road full of vengeance, unabashed acting out, anger, guilt, fear, and grotesque fantasies. In *It's the Mother* (2008), we see a woman, naked, splayed out on a bed with all of her needy little children hanging on, tugging on her, begging her for attention. Then one by one they climb back into the womb where they came from, illustrating the sacrifices a mother makes for her children.
Moving on to Greener Pastures (2008) features wild children attempting to cross a ravine by climbing down a steep hill, yet each time one gets down the hill, his near triumph collapses as he is gobbled up and masticated by a horde of voracious alligators. In Djurberg's classic remake of her own art-school Super 8 film, *Tiger Licking Girl's Butt* (2004), a naked young girl towels off after her bath, while unbeknownst to her a tiger lurks behind her, watching hungrily. He laps out his tongue and licks her butt. The girl acts disgusted, but eventually succumbs to his charms and lets him lick her again and again. The tiger slurps and the girl oohs and she takes him into her bed. Scenarios like this demonstrate Djurberg's vivid imagination and willingness to put it all out there.
Putting Down the Prey (2008) depicts an Eskimo girl who harpoons a walrus, carefully cuts open its underbelly and guts it, then she slips inside and stitches the skin up and around her. It is so bizarre and weird and bold and honest like all of her work. Djurberg visualises scenarios which we would rarely allow ourselves to think about, let alone describe out loud. But she takes the risk and lets her fantasies play out, no matter how taboo or twisted they may be. And the style – carefully sculpted clay figures and hand-made props and costumes are precious and enticing, colorful and graceful and delicate, and expertly animated and scored.

Ali Subotnick

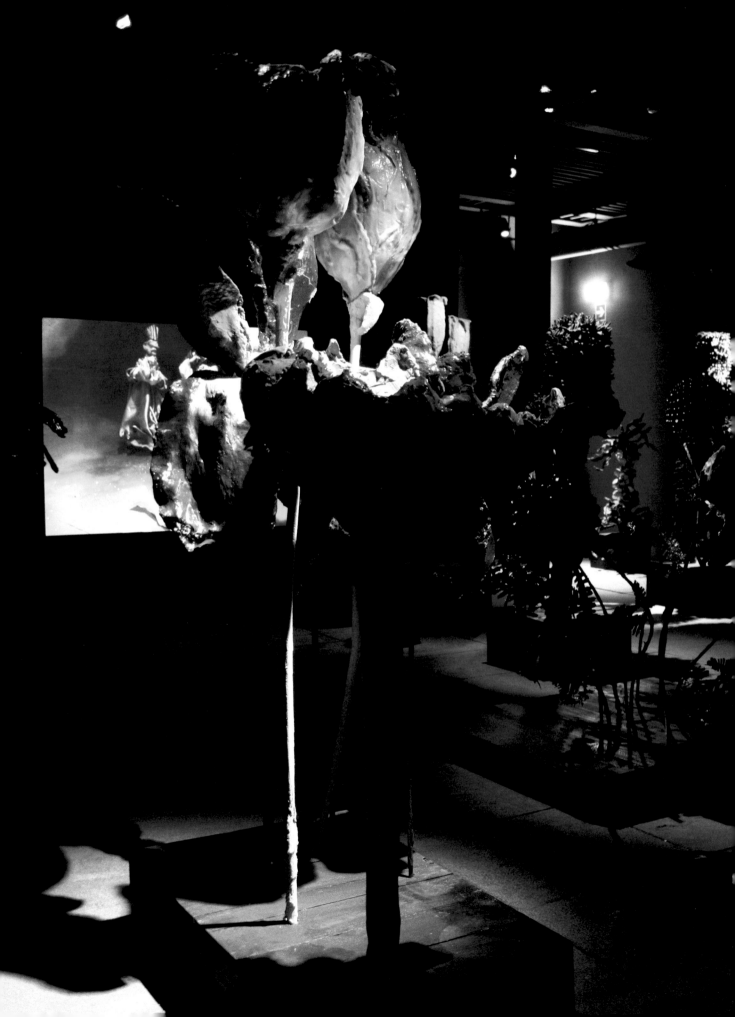

Tiger Licking Girl's Butt, 2004
Digital claymation video, colour,
music by Hans Berg
2:15 min

The Experiment (Greed), 2009
Digital claymation video, colour,
music by Hans Berg
10:45 min

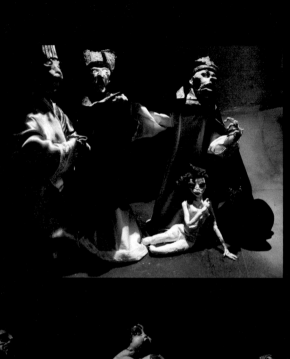
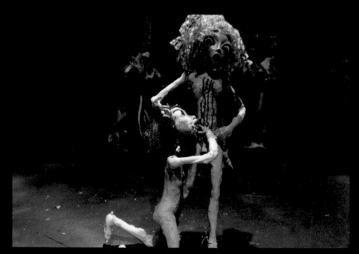
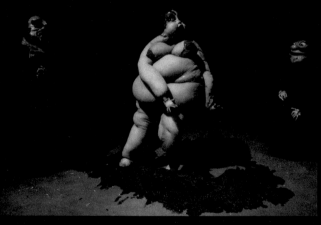
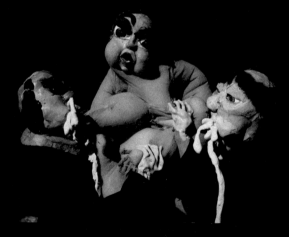

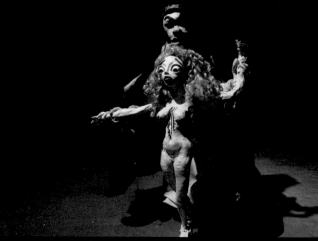

JASON DODGE

1969 geboren in Newton, PA, USA,
lebt und arbeitet in Berlin, Deutschland
**1969 born in Newton, PA, USA,
lives and works in Berlin, Germany**

www.luettgenmeijer.com
www.massimodecarlo.it
www.yvon-lambert.com

Wenn man die sparsamen, scheinbar banalen und doch elegant komponierten Anordnungen von Objekten betrachtet – etwa eine Sammlung von Glühbirnen, Kerzen und Streichhölzern, ein Paar Bratschensaiten oder eine einfache zusammengefaltete Decke, die mit einer weißen Schnur umwickelt ist –, würde man kaum glauben, dass die Arbeiten von Jason Dodge zumeist eine fantastische Erzählung beinhalten. Doch sie schließen nicht nur Geschichten mit ein, sondern beruhen auch auf dem Glauben des Betrachters daran und – was vielleicht noch wichtiger ist – auf dem Vertrauen in sein eigenes Vorstellungsvermögen. So handelt es sich bei der erwähnten Sammlung von Glühbirnen, Kerzen und anderem um eine Arbeit mit dem Titel *Darkness falls on Wołkowyja 74, 38-613 Polańczyk, Poland* (2005); sie besteht aus allen Arten von Leuchtmitteln, die sich in einem Haus an einem Waldrand in Polen befanden.

Die beiden Bratschensaiten in *The Viola of Béla Bartók* (2007) wurden von zwei Bratschen abgenommen, die nur ein einziges Mal benutzt wurden, um die namengebenden Bratschenduos von Bartók zu spielen. Die sorgsam zusammengelegte Decke ist eigentlich ein Wandteppich, der von der Algerierin Djidjiga Meffrer aus einem „nachtfarbenen" (wie der Künstler formuliert) Faden gewebt wurde, dessen Länge von der Erde bis über das Wetter reicht – daher der Werktitel *Above the Weather* (2007).

In allen Fällen verlangt die Geschichte vom Betrachter einen beinahe wissenschaftlichen Optimismus, um in die narrative Sphäre vorzudringen, die jedem seiner Werke innewohnt, und es dadurch von seiner anfänglichen Unergründlichkeit zu erlösen. Zudem wird die Herstellung einer Arbeit, ganz im Geist von Alighiero Boetti, oft an einen Mitarbeiter delegiert – der immer namentlich genannt wird und daher für die Wahrhaftigkeit des Werkes ausdrücklich Mitverantwortung trägt – und an einen fernen Ort verlegt. Dadurch wird die Sinnträchtigkeit des ganzen unwahrscheinlichen Szenarios gesteigert. Dodges romantische und dichte Verschmelzungen von Objekten, Erzählungen, Zeiten und verschiedenen Orten, die an andere Welten denken lassen, umgibt eine treffsichere und starke Poesie.

You might never guess by looking at his spare, seemingly banal, and yet elegantly composed conjunctions of objects – from a collection of bulbs, candles, and matches to a pair of viola strings or a simple, folded-up blanket with a white string around it – that the work of Jason Dodge almost always contains a fantastical narrative. Not only does it contain a narrative, it depends on it as well as on the viewer's faith in narrative, and perhaps even more importantly, the viewer's faith in his or her own imagination. For instance, the above-mentioned collection of bulbs, candles, etc. is a work entitled *Darkness falls on Wołkowyja 74, 38-613 Polańczyk, Poland* (2005), and consists of every form of illumination taken from a house on the edge of a forest in Poland.

The pair of viola strings in *The Viola of Béla Bartók* (2007) were taken off a pair of violas after they had been used only once to play the eponymous Bartók duos. The neatly folded blanket is actually a tapestry woven by a woman in Algeria named Djidjiga Meffrer from 'night-coloured' (artist's specification) string that equals the distance from the earth to above the weather – hence the title *Above the Weather* (2007).

In each case, the story requires that the viewer take an almost scientific leap of faith into the narrative ether that demurely lurks within each work, thus redeeming it from any initial inscrutability. What is more, in the spirit of Alighiero Boetti, the labour of each piece is often outsourced to a collaborator – who is always named and therefore explicitly complicit in its veracity – and displaced to a distant location, which gives the whole, implausible scenario even more evocative teeth. Redolent of elsewhere, Dodge's romantic and compact conflations of objects, narratives, times, and disparate places deal in a deft and powerful poetry.

Chris Sharp

*Your death, sub
marine*
2009
Installation view, Kunstverein Hannover

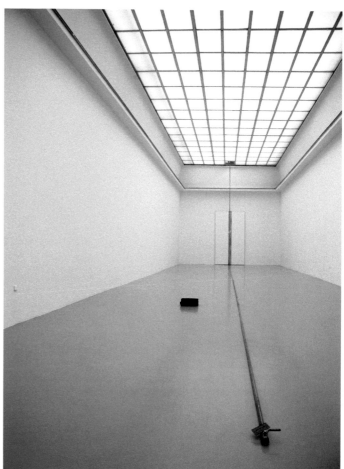
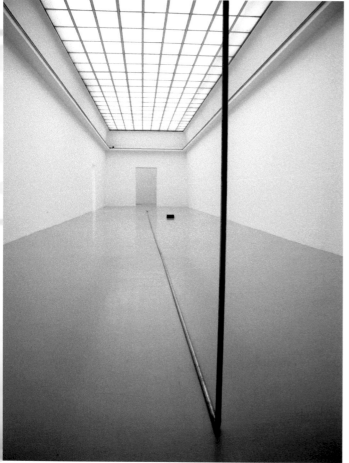

Exhibition view, 2008
Lüttgenmeijer, Berlin

*In Lübeck, Germany, Marlies Scholz wove a piece
of cloth. She was asked to choose yarn the color of
night and equaling the distance (12 km) from the
earth to above the weather
2008*

*Darkness falls on
Kallhamra, 646 96, Stjärnhov.
Everything that makes light, was taken from
a house at the edge of a forest in Sweden
2006–2010*

*In Algeria, Djidjiga Meffrer has woven a tapestry
from string equaling the distance from the earth to
above the weather; she was asked to choose string
the color of night
2007*

TRISHA DONNELLY

1974 geboren in San Francisco, CA, USA,
lebt und arbeitet in New York, NY, USA
1974 born in San Francisco, CA, USA,
lives and works in New York, NY, USA

2007 2nd Moscow Biennale of Contemporary Art – *Footnotes on Geopolitics, Market and Amnesia*
2006 4th berlin biennial for contemporary art – *Of Mice and Men*
2006 Whitney Biennial – *Day for Night, New York*
2003 50th International Art Exhibition / La Biennale di Venezia – *Dreams and Conflicts. The Dictatorship of the Viewer*

www.airdeparis.com
www.caseykaplangallery.com
www.presenhuber.com

Es erscheint aus mehreren Gründen merkwürdig, über die Arbeit von Trisha Donnelly in einem Buch über „Morgen" zu schreiben. Ich beginne mit einem von ihnen: In ihrer Kunst ist die Zeit ins Wanken gekommen. Sie ist niemals linear – manche würden sagen, es gibt darin keine Zeit, andere behaupten womöglich, dass es darin nichts als Zeit gibt. Doch dann gäbe es darin kein Morgen, oder nur ein Morgen – das ist schwer zu sagen. In der Zwischenzeit lässt sie die einfachen Unterscheidungen zwischen Medium und Produzent, zwischen Künstler und Publikum ins Leere laufen.

In ihrer New Yorker Ausstellung 2010 waren vier Monolithe zu sehen. Einer von ihnen hatte ein biomorphes Relief; die drei anderen wiesen gezackte, gezahnte oder gefiederte Formen auf. Die Arbeiten wurden aus Blöcken von Quarzit, Travertin, Granit und rosafarbenem portugiesischem Marmor von der Künstlerin mit der Hand quasi chirurgisch geschnitten. Die Schwarz-Weiß-Aufnahme einer Welle, kurz bevor sie bricht, erschien als eine verschlüsselte Botschaft, eine Andeutung langwieriger geologischer Prozesse, insbesondere der Erosion von Gestein durch Wasser.

Die Fotografie erinnerte an eine Arbeit aus dem Jahr 2003 in Donnellys Ausstellung im Institute of Contemporary Art in Philadelphia, die ebenfalls direkt an der Wand befestigt war und die einen großen Felsen zeigt, auf den sanft eine Welle zurollt. Der Begleittext zur Ausstellung führte an, dass das hervortretende Fragment an das Gesicht und den Torso einer Frau im Profil erinnerte, an einen auf der Wasseroberfläche treibenden Körper. Darunter hatte Donnelly ihre Idee in kursiver Schrift formuliert: „Dies ist ein Film, der nur ein Bild zeigt." Ihre Kunst handelt mit solchen (materiellen, formalen und konzeptuellen) Besonderheiten, wobei sie freie Interpretationen durchaus begrüßt. Dies hat manche Kritiker dazu geführt, Donnelly und ihre Produktion als rätselhaft und geheimnisvoll zu bezeichnen – eine bequeme Lesart, die schlicht die Forderung nach Lesbarkeit und den Wunsch nach Bedeutung maskiert. Doch es ist gerade die Fähigkeit ihres Werks, sich – vielleicht durch solche Spielräume der Zeit – über diese Forderungen hinwegzusetzen, die Donnelly zu einer der wichtigsten Künstlerinnen unserer Zeit macht, die weder gestern noch morgen ist.

It seems odd to write about Trisha Donnelly's work in a book about 'tomorrow', for several reasons. I will start with this one: time falters in her art. It is never linear – some would say there is no time; others might argue only time. But then there is no tomorrow, only tomorrow; it is hard to say. Meanwhile, she is collapsing easy distinctions between medium and producer, artist and audience.

Her exhibition in New York in 2010 featured four monoliths. One had a biomorphic relief; the three others featured jagged, toothed, or feathered forms. The works were extracted from blocks of quartzite, travertine, Black Portoro limestone, and Rose of Portugal marble, and were cut by the artist's hand, as though surgically. A black-and-white image of a wave about to break appeared as a coded missive, a suggestion of epic, geologic processes, particularly water's erosion of stone. The photograph brought to mind a 2003 work from Donnelly's exhibition at Philadelphia's Institute of Contemporary Art, also affixed directly to the wall, which depicts a large rock with a wave moving gently towards it. The exhibition guide suggested that the protruding fragment recalls the shape of a woman's face and her torso in profile, a body floating on the surface of the water. Below, Donnelly had added her idea in italics: 'This is a film that maintains one image.' Her art trades in such specificities (material, formal, and conceptual), even as it welcomes generous interpretations. This has led some critics to label Donnelly and her output as enigmatic and mysterious – a lazy reading that simply masks a request of legibility and a desire for meaning. But it is her work's ability to move beyond this insistence, perhaps through this slippage of time, which makes Donnelly one of the most significant artists today, which is neither yesterday nor tomorrow.

Lauren O'Neill-Butler

Diagram of Double-Gong, 2006
Pen and pencil on paper

Untitled, 2010
Quartzite
309 × 203 × 3 cm

Untitled, 2010
Travertine
156 × 81 × 18 cm

Untitled, 2009
DVD, colour, no sound
0:28 min

GEOFFREY FARMER

1967 geboren in Vancouver, Kanada, lebt und arbeitet in Vancouver
1967 born in Vancouver, Canada, lives and works in Vancouver

2008 16th Biennale of Sydney – *Revolutions – Forms That Turn*
2008 Brussels Biennial 1 – *Show me, don't tell me*

www.caseykaplangallery.com
www.catrionajeffries.com

Das Werk von Geoffrey Farmer ist unter anderem durch seinen zutiefst prozessualen Charakter geprägt – der Künstler gibt dem Prozess und Projekt auf programmatische Weise Vorrang vor dem Objekt und dem finalen Ergebnis. Anders formuliert, könnte man behaupten, dass das Wesen von Farmers künstlerischer Praxis in einer Destabilisierung sämtlicher Vorstellungen des Wesens liegt, das ein einzelnes, begrenztes Objekt umfassen könnte. Dieses Interesse am Prozess und am sprunghaften Charakter aufgeführter oder inszenierter Ereignisse bedeutet für gewöhnlich, dass ein Betrachter, der eine Ausstellung von Farmers Werk nur einmal sieht, lediglich einen flüchtigen Blick auf die erzählerische Entwicklung seiner Kunst erhascht; sehr oft kehrt der Künstler, sofern es die Umstände erlauben, an den Ort der Konzeption, Kreation und Ausführung zurück, um sein Werk sanft, aber bestimmt auf seinem Weg der ständigen Transformation zu leiten, sodass der teilnehmende Betrachter (um eine berühmte Äußerung von Heraklit zu umschreiben) nie zweimal dasselbe Environment betritt. So überrascht es nicht, dass die ästhetische Gesamtwirkung dieser labyrinthischen, stets veränderlichen Environments oft an Wucherungen, Streuungen, Versenkungen und Fragmentierungen denken lässt; sie offenbart eine tiefe Faszination durch Bricolage (Bri-Collage wäre der treffendere Begriff), Handwerk und die verblüffenden Artefakte der alltäglichen Objektwelt. Doch im Unterschied zu vielen Künstlern seiner Generation, die im Rahmen derselben allgemeinen Ästhetik arbeiten, sind Farmers Installationen stets streng choreografiert und folgen einem präzisen Drehbuch.

Ein narrativer Aspekt, der einige seiner bekannteren Galerieausstellungen kennzeichnete, war der des Ehrengeleits oder der Prozession: Ein festlich geschmückter Prunkwagen bildete das zentrale Element seiner Ausstellung in der Catriona Jeffries Gallery 2004; ein ähnliches Element flächendeckender Ornamentierung tauchte in seinem *Airliner Open Studio* (2006) wieder auf; und das Motiv des Marsches, diesmal in wirklich großem Maßstab, fand sich in der Ausstellung *The Surgeon and the Photographer* 2009 wieder, wo ein vielköpfiges Arrangement von 365 Figuren aus Papier und Stoff zu sehen war, das unter der sprichwörtlichen Flagge von Aby Warburgs „Mnemosyne-Atlas" marschierte – ein Aufstand von Form und Figuration, der von Warburgs originellem Sinn für antihierarchisches visuelles Denken erfüllt war.

One of the defining characteristics of Geoffrey Farmer's work is its profoundly processual character – the artist's programmatic prioritisation of process and project over object and end result. Putting it differently, we might say that the essence of Farmer's practice is located in the destabilisation of all ideas of essence as contained in a singular, finite object. This interest in process and in the mercurial nature of the performed or staged event usually means that a one-time visitor to an exhibition of Farmer's work catches no more than a fleeting glimpse of his art's narrative unfolding; very often, the artist will return, for as long as circumstances allow, to the site of conception, creation, and execution to gently but decidedly guide his work along a trajectory of constant transformation, so that the viewer-participant (to paraphrase a famous Heraclitean sound bite) never steps into the same environment twice. Not surprisingly, the overall aesthetic effect of these labyrinthine, ever-changing environments is often one of sprawl, scatter, immersion, and fragmentation, revealing a deep fascination with bricolage (bri-collage would be the more appropriate term), craft, and the bewildering artifice of the quotidian object-world. Yet in contrast to many artists of his generation who operate within the parameters of the same general aesthetic, Farmer's installations are always tightly choreographed and follow a very precise script.

One narrative aspect that has informed some of his more high-profile gallery exhibitions is that of the cortège or procession: the festively adorned parade float was the central element in an exhibition at Catriona Jeffries Gallery in 2004; a similar element of all-over ornamentation returned in his *Airliner Open Studio* (2006); and the motif of the march, this time on a truly massive scale, appeared again in his 2009 exhibition *The Surgeon and the Photographer,* which featured a multitudinous arrangement of 365 paper and cloth figures marching under the proverbial banner of Aby Warburg's 'Mnemosyne Atlas' – a riot of form and figuration animated by Warburg's original spirit of anti-hierarchical visual thought.

Dieter Roelstraete

Theatre of Cruelty, 2008
Props, found objects, fabric, computer-controlled LED lighting system, speakers, framed photographs
Dimensions variable

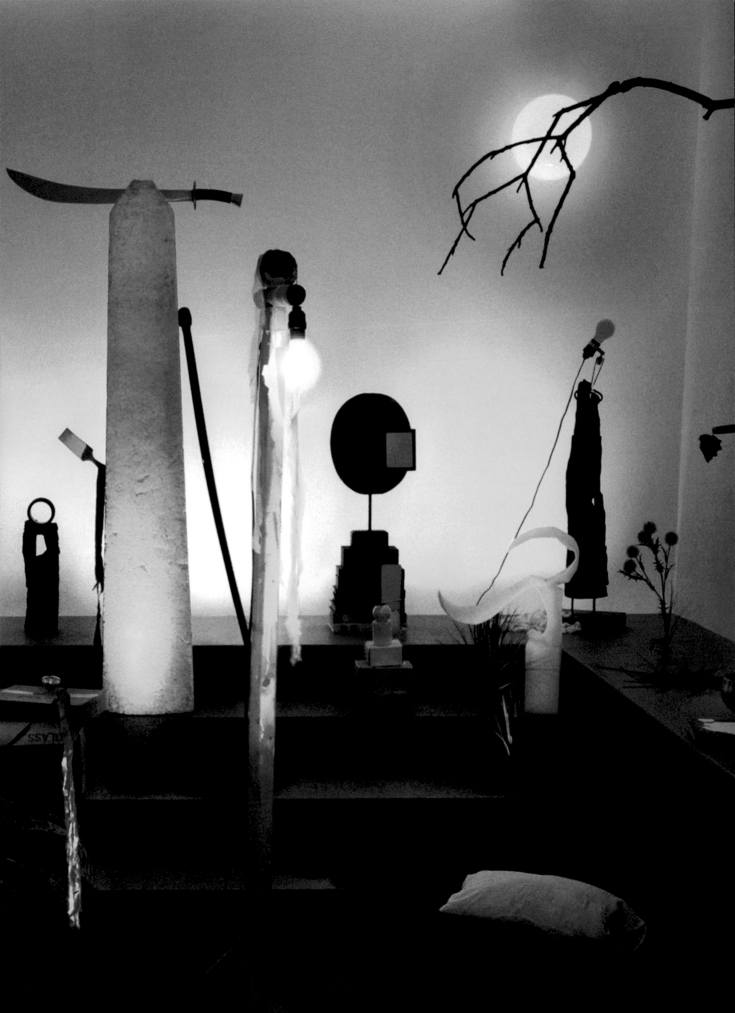

*The Surgeon and the
Photographer*, 2009
365 puppet figures, fabric, found
images, metal stands
45 × 13 × 13 cm (each figure)
Installation view, Catriona Jeffries,
Vancouver

The Last Two Million Years, 2007
Foamcore plinths, Perspex frames and
cut-outs from the history book *The
Last Two Million Years*
Dimensions variable

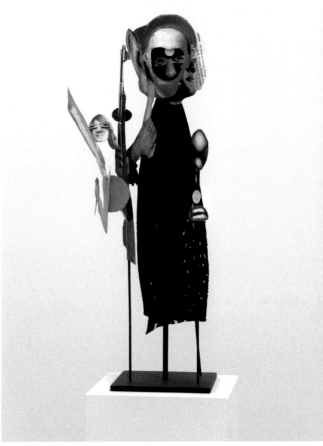

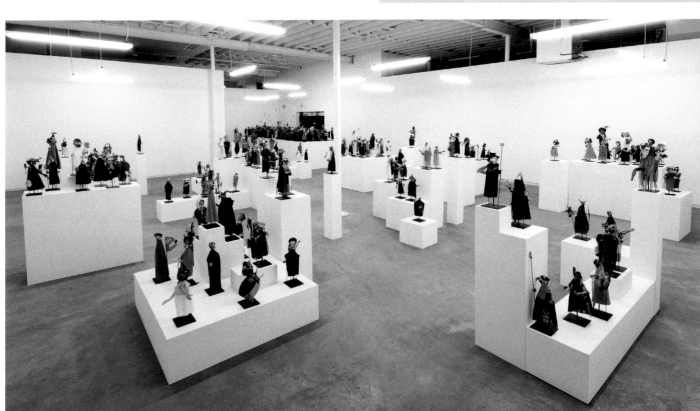

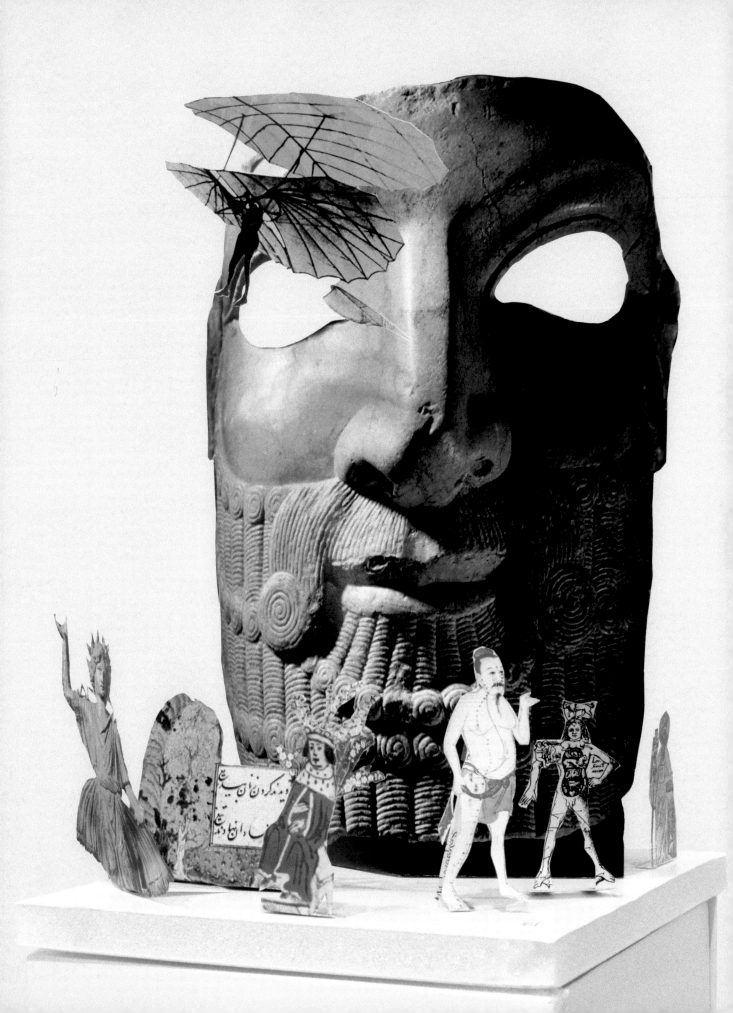

OMER FAST

1972 geboren in Jerusalem, Israel,
lebt und arbeitet in Berlin, Deutschland
**1972 born in Jerusalem, Israel,
lives and works in Berlin, Germany**

2008 Manifesta 7, European Biennial of
Contemporary Art, Trentino-Alto Adige
2008 Whitney Biennial, New York
2008 Liverpool Biennial of Contem-
porary Art

www.arratiabeer.com
www.gbagency.fr
www.postmastersart.com

„Wissen Sie, was Tableaux vivants sind?"
lässt Omer Fast in *Take a Deep Breath* (2008)
den Filmregisseur „Omer" fragen, der einen
Kurzfilm zur Entstehung eines Films über ein
Selbstmordattentat dreht. Tatsächlich sehen
wir einen Filmset und geschäftige Aktivitäten
in den Drehpausen, die sich ihrerseits als Teil
eines Films entpuppen – eine Inszenierung
der Inszenierung, im Prinzip endlos fortsetz-
bar. Fast bietet in vielen seiner Einzel- und
Mehrfachprojektionen mögliche Deutungen
an, er formuliert im und durch den Film eine
Poetik seines künstlerischen Vorgehens. So
äußert er in *The Casting* (2007), er sei daran
interessiert, wie Erfahrungen in Erinnerung
transformiert und vermittelt werden, wie sie
also zu Erzählungen und Filmen werden.
Fasts Filme beruhen meist auf Gesprächen
mit Zeugen einer realen Begebenheit, etwa
die Tötung eines Zivilisten bei einer Patrouille
im Irak und die verquere Liebesgeschichte
eines US-amerikanischen Soldaten in *The
Casting* (2009), die Geschichte eines afrika-
nischen Flüchtlings in *Nostalgia* (2009) oder
in *Spielberg's List* (2003) die Schilderungen
von Laiendarstellern, die als Statisten in
Schindlers Liste (1993) mitspielten.
Fast macht sich die Erkenntnis zunutze, dass
der Prozess der Erinnerung rekonstruktiv ver-
läuft und legt den Fokus auf das Moment der
Konstruktion. Seine Filminstallationen reflek-
tieren nicht nur, wie Reales medial transfor-
miert wird. Zugleich dekonstruieren sie immer
auch erzählerische und filmische Konven-
tionen: die aberwitzig schnelle Montage von
Nachrichten-Bits in *CNN Concatenated* (2002)
etwa, das Spiel mit Klischees in der Soap-
ähnlichen Struktur von *De Grote Boodschap*
(2007), stilistische Anleihen an Dokumentar-
film, Fernsehinterview und Spielfilm in der
Trilogie *Nostalgia* oder die Kamerafahrten in
Looking Pretty for God (After GW) (2008), die
einen nahtlosen Übergang von einem Szena-
rio zum nächsten – von dem Fotoshooting mit
Kindern zum Balsamierbetrieb eines Beerdi-
gungsinstituts – suggerieren: eine Verschrän-
kung, die sich zuspitzt und kollabiert, sobald
die Kinder die Ausführungen der Bestatter aus
dem Off mit ihren Lippen synchronisieren.
Das Wissen um die Mechanismen der media-
len Illusionsproduktion schließt die Faszinati-
on daran nicht aus – in dieser Erkenntnis liegt
auch eine politische Dimension, über die po-
litisch relevanten Inhalte seiner Filme hinaus.

'Do you know what tableaux vivants are?' In
Take a Deep Breath (2008), Omer Fast gives
this question to the film director 'Omer', who
is shooting a short film about the making of
a film about a suicide attack. We indeed see
a film set and bustling activity during the
shooting breaks, which turn out to be part
of yet another film – the mise-en-scène of
a mise-en-scène, a framing of frames that
might go on ad infinitum. Many of Fast's
single and multiple projections offer possi-
ble interpretations; he frames a poetics of
his artistic procedure on film and by filmic
means. In *The Casting* (2007), for instance,
he says he is interested in how experiences
are transformed into memories and then
conveyed to others, that is to say, how they
become narrations and films.
Most of Fast's films are based on conversa-
tions with witnesses to a real event, such
as the killing of a civilian during a patrol in
Iraq and a US American soldier's jumbled
love story in *The Casting* (2009); the story
of an African refugee in *Nostalgia* (2009);
or, in *Spielberg's List* (2003), the recollec-
tions of amateur actors who were extras on
Schindler's List (1993).
Availing himself of the insight that the pro-
cess of recollection is reconstructive in na-
ture, Fast places the focus on the aspect of
construction. His film installations not only
reflect on how the real is transformed in its
media representations. They simultaneous-
ly always also deconstruct conventions of
narrative and film: the insanely rapid mon-
tage of bits and pieces from news reports in
CNN Concatenated (2002), for example; the
play with clichés in the soap-operatic *De
Grote Boodschap* (2007); stylistic borrowings
from documentary film, television interview,
and feature film in the trilogy *Nostalgia;* or
the tracking shots in *Looking Pretty for God
(After GW)* (2008), which suggest a seamless
transition from one scenario to the next,
from a photo shoot with children to the em-
balming workshop at a funeral home: an in-
terweaving of two elements that comes to a
head and collapses once the children begin
to lip-synch the undertakers' remarks heard
in voice-over.
Knowing about the mechanisms by which
the media generate illusions does not pre-
clude being fascinated by them – there is a
political dimension to this insight, too, which
extends beyond the politically relevant sub-
ject matters in his films.

Astrid Wege

Take a Deep Breath, 2008
Two-channel video installation,
colour, sound
27:07 min

Nostalgia III, 2009
Super 16 film transferred to HDV,
colour, sound
31:48 min

The Casting, 2007
Four-channel video installation, colour, sound
14 min
Installation view,
Museum Moderner Kunst
Stiftung Ludwig, Vienna

CHRISTIAN FROSI

1973 geboren in Mailand, Italien, lebt
und arbeitet in Mailand
**1973 born in Milan, Italy, lives and
works in Milan**

www.christianfrosi.net

www.galerie-ruediger-schoettle.de
www.galleriazero.it

Christian Frosi hinterfragt den kunsthistorisch tradierten Begriff von Skulptur in einer Auseinandersetzung mit skulpturalen Objekten und Installationen. Readymades, die ihre ursprüngliche Funktion aufgeben, werden zum Anstoßen eines Prozesses eingesetzt. Beides vereint *New Title Jacob Christian Schäffer* (2007), ein Wäscheständer, der durch einen riesigen Heliumballon zum Schweben gebracht wird. Dank Zeit und Schwerkraft verbleibt nur eine schlaffe Hülle über dem zu Boden gesunkenen Haushaltsgerät. Diese unaufhaltsame, intendierte Verwandlung konstituiert dabei das Werk. Genauso bleibt es dem Material Schaum überlassen, den Ausstellungsraum in einem eventartigen Akt zu definieren, nachdem der Künstler eine Schaumkanone für *Foam* (2003–2008) aufstellt.

Frosi sieht sein Zutun oft nur als Anstoß zu einem von vielen möglichen Zuständen. Dieser Kontrollverlust birgt die Möglichkeit des Scheiterns, und so entsteht eine spürbar und sichtbar prekäre Balance zwischen stabil und instabil, fest und mobil, hart und weich. Spannungsvoll inszeniert Frosi übereinander, aneinander oder entgegengesetzt gelagerte Elemente, ohne sie narrativ zu verbinden, sondern um ihre Präsenz im Raum zu steigern. Dabei gelten ihm Kurt Schwitters und der „Merzbau" als wichtiges Vorbild seiner Kunst: Dieser in jahrelanger Arbeit konstruktivistisch verbaute Atelierraum in Hannover greift Prinzipien einer scheinbar unkontrollierten Entstehung und der künstlerischen Eroberung des Raumes vor.

Neben *Foam* verbildlicht dies auch *Duna* (2007). Die in Turin präsentierte Installation aus übereinandergelagerten und mit Sand überschütteten Styroporformen ähnelte eher einer Zikkurat als einer Düne. Und doch konnte sie symbolisch gelesen werden: Die ökologische Katastrophe der fortschreitenden Wüstenbildung bedroht auch unsere Breitengrade, in Italien ganz direkt die Weinberge und damit die kulturelle Identität. *Duna,* eine künstlich inszenierte natürliche Form, reflektiert das Absurde wie andere Arbeiten und Titel, zum Beispiel *Yippipie* (2008) oder *New Title 0000 Bicycle* (2006). Manch enigmatisches Kürzel scheint einem nur dem Künstler bekannten System anzugehören, andere klingen wie kindliche, primitive Laute oder sind deskriptiv wie *Foam* und verhindern eine auratische oder narrative Aufladung der Werke.

In a critical engagement with sculptural objects and installations, Christian Frosi examines the conception of sculpture handed down by art history. Readymades abdicate their original functions and serve to trigger a process. Both traits are united in *New Title Jacob Christian Schäffer* (2007), a laundry rack that is lifted afloat by a gigantic helium balloon. Thanks to the effects of time and gravity, nothing remains but a drooping fabric envelope hung over the domestic device, which has sunk to the ground. This inexorable and intended transformation is what constitutes the work. In similar fashion, the artist, having installed a foam cannon, leaves it to the material he has chosen in *Foam* (2003–2008) to define the exhibition space in an event-like act.

Frosi often sees his own contribution as no more than giving an arrangement a nudge that will lead to one of many possible states. This loss of control harbours the possibility of failure, engendering a palpably and visibly precarious balance between stable and unstable, between fixed and movable, between hard and soft. Frosi stages his elements mounted in tense superimpositions, juxtapositions, and antitheses without providing narrative links between them; the point is to heighten their presence in the space. He considers Kurt Schwitters and the 'Merzbau' to be the most important models his art follows: the latter, a studio in Hanover Schwitters worked for years to fill with a constructivist assemblage, anticipates principles of seemingly uncontrolled growth and of the artistic conquest of space.

Like *Foam, Duna* (2007) illustrates this process. The installation, presented in Turin, of stacked styrofoam moulds covered with sand resembled a ziggurat rather than a dune. And yet it allowed for a symbolic reading: the ecological catastrophe of desertification looms over our latitudes as well – in Italy, it directly threatens vineyards, and with them the country's cultural identity. *Duna,* the artificial staging of a natural phenomenon, reflects on the absurd, as do other works and titles such as *Yippipie* (2008) and *New Title 0000 Bicycle* (2006). Some enigmatic abbreviations seem to belong into a system known only to the artist; others suggest infantile or primitive sounds, while yet others, like *Foam,* are descriptive, preventing the beholder from charging the works with aura or narrative.

David Riedel

U 04 New Title, 2005
Wood, Jonathan Viner's shoes
120 × 20 × 20 cm

0000000000, 2007
Exhibition view, Fondazione
Sandretto Re Rebaudengo, Torino

Foam, 2003
Foam
Dimensions variable
Installation view,
ZERO..., Milan

CYPRIEN GAILLARD

1980 geboren in Paris, Frankreich, lebt
und arbeitet in Paris und Berlin,
Deutschland
**1980 born in Paris, France, lives and
works in Paris and Berlin, Germany**

2010 8th Gwangju Biennale –
10.000 Lives
2008 5th berlin biennial of contemporary
art – *When things cast no shadow*

www.bugadacargnel.com
www.laurabartlettgallery.co.uk
www.spruethmagers.com

Für Cyprien Gaillard ist die Moderne unsere Antike: ein Ruinenfeld, das Auskunft gibt über vergangene Vorlieben, Formfindungen, gesellschaftliche Ideen und deren Unzulänglichkeiten. Wenn Gaillard einen Landschaftsmaler mit farbenfrohen Ansichten von Sozialwohnungskomplexen beauftragt, Wohnhochhäuser in Kopien altmeisterlicher Stiche einfügt oder den brutalen Verfall der Vorstädte filmt, dann ist das ein Abgesang auf unsere Zivilisation und Begeisterung für den Wandel zugleich. Besonders seine Filme und Fotografien der Sprengung von Wohnhäusern, die einst einem sozialen Gedanken verpflichtet waren, machen diese Ambivalenz deutlich: Er hat eine nicht zu leugnende, fast kindliche Faszination für den großen Knall, dem eine Schönheit innewohnt, die jenseits der Kategorien „richtig" und „falsch" liegt.

Gaillard lebt seine eigene Lust an der Zerstörung nicht aus wie ein jugendlicher Pyromane, er kommt in Gestalt der Feuerwehr: Für eine Reihe von Videos suchte er sich besonders schöne Orte wie romantische Schlösser, filmt in deren verwunschenen Schlossgärten – und lässt dann in den Bäumen langsam alarmierenden weißen Qualm aufsteigen, der aus Feuerlöschern stammt. Unter anderem inszenierte er ein solches Spektakel auch in Robert Smithsons legendärem Land-Art-Projekt „Spiral Jetty" (1970). Die Wolken rufen katastrophische Erinnerungsbilder wach, am Ende legen sich die Löschflocken über die Szene wie die Asche über Pompeji.

Egal in welchem Medium, immer kreist Gaillard um die großen Themen von Ordnung und Chaos, von Überlebenswille und Vergeblichkeit; ob er nun rivalisierende Hooligan-Banden in osteuropäischen Vorstädten beim organisierten Massenkampf filmt, auf Polaroids die identischen Merkmale unterschiedlicher Orte auf der Welt festhält, oder einen Bogen zwischen Maya-Architektur, Sauf-Tourismus und Gang-Codes schlägt, wie in seinem Film *Cities of Gold and Mirrors* (2009). Gaillard muss sich keine Themen ausdenken, seine bis zum Bersten aufgeladenen Bilder findet der zärtliche Berserker in der Welt, die wir selbst gebaut haben, und an der er sich nahezu physisch abarbeitet.

In Cyprien Gaillard's eyes, modernity is our antiquity: a realm littered with ruins that tell us about the preferences, formal inventions, and social ideas of the past as well as their shortcomings. When Gaillard commissions a landscape painter to create colourful views of housing projects, inserts residential high-rises into copies after engravings by old masters, or films the brutal demise of the suburbs, he sings a farewell song to our civilisation while also welcoming its transformation with enthusiasm. This ambivalence is especially evident in his films and photographs of the demolition of residential buildings that had once been constructed in the pursuit of grand social ideas: he harbours an undeniable and almost childlike fascination for the big boom, and there is a beauty to these explosions that defies the categories of 'right' and 'wrong'.

Gaillard, rather than acting out his gusto for destruction in the manner of a teenage pyromaniac, comes in the guise of the fire brigade: for a series of videos, he sought out especially beautiful places such as romantic castles, shooting in their enchanted gardens – and then had alarming white smoke rise slowly amid the trees, although in reality it came from fire extinguishers. One place where he staged this sort of spectacle was Robert Smithson's legendary Land Art project 'Spiral Jetty' (1970). The clouds recall images of catastrophes; in the end, a flaky extinguishing agent settles on the scene like ashes over Pompeii.

No matter which medium he employs, Gaillard's work keeps circling around the big issues: order and chaos, the will to survive and futility – whether he films rival gangs of hooligans in Eastern European suburbs engaging in organised mass fighting, captures the identical features of different places around the world in polaroids, or connects Mayan architecture to booze tourism and gang codes, as in his film *Cities of Gold and Mirrors* (2009). Gaillard does not have to think up issues to examine: a gentle berserk, he finds his images, crammed to the point of bursting, in a world we ourselves have built, and which he works to depict with almost physical intensity.

Silke Hohmann

Desniansky Raion, 2007
DVD, colour, music by KOUDLAM
30 min

Belief in the Age of Disbelief
(Harlem), 2005
Etching
8 × 14.5 cm

Belief in the Age of Disbelief
(Les deux chemins au ruisseau), 2005
Etching
17 × 25 cm

Desniansky Raion, 2007
DVD, colour, music by KOUDLAM
30 min

RYAN GANDER

1976 geboren in Chester, Großbritannien, lebt und arbeitet in London, Großbritannien
1976 born in Chester, Great Britain, lives and works in London, Great Britain

2008 16th Biennale of Sydney – *Revolutions – Forms That Turn*
2007 9th Biennale de Lyon – *00s. The history of a decade that has not yet been named*
2006 The Tate Triennial – *New British Art,* London

www.annetgelink.nl
www.gbagency.fr
www.lissongallery.com
www.tanyabonakdargallery.com
www.taronasugallery.com

Die komplexe und freie konzeptuelle Praxis von Ryan Gander ist weniger durch strenge Regeln oder Grenzen als vor allem durch Erkundungen, Recherchen oder Fragen nach dem „Was wäre wenn" geprägt. Was wäre beispielsweise, wenn man Kinder aufforderte, die Elemente von Gerrit Rietvelds flach gepackten Möbeln aus Kistenlatten nach ihren eigenen Vorstellungen zusammenzubauen (*Rietveld Reconstruction,* 2006)? Was wäre, wenn man alle Figuren eines Schachspiels aus einem schwarz-weiß gestreiften Holz anfertigte, sodass keine Seite ausschließlich schwarz oder weiß wäre (*Bauhaus Revisited,* 2003)? Auch wenn diese Vorschläge klingen, als sei Gander ein erzmodernistischer Bildhauer oder Wiederverwerter: Tatsächlich ist er in kultureller Hinsicht eine diebische Elster; wie ein Universalgelehrter dekonstruiert er verbreitete Vorstellungen, um sie auf neuartige Weise wieder zusammenzusetzen. So filmt er beispielsweise in *Man on a Bridge (A Study of David Lange)* (2008) fünfzig Mal den gleichen Zehn-Sekunden-Ausschnitt nach; in *Is This Guilt in You Too (Cinema Verso)* (2006) lädt er die Betrachter ein, zu versuchen, sich einen Film auf der Rückseite einer fast durchsichtigen Kinoleinwand anzusehen.

Obwohl Gander kein bestimmtes Medium zu bevorzugen scheint, spielen Sprache und Erzählen in seinem Werk eine bedeutende Rolle – nicht zuletzt in seiner Serie von weitschweifigen, „frei assoziierenden" Vorträgen oder in seinem Versuch, ein sinnloses neues Wort, das Palindrom „mitim", in die englische Sprache einzuführen. Viele seiner Borges'schen Spiele und umständlichen Denkanstöße konfrontieren das Publikum mit der schwierigen Aufgabe, die Bedeutungsstränge selbst zu entwirren, auch wenn sich seine spielerischen Konzepte gelegentlich zu körperlichen, relationalen Herausforderungen entwickeln. Dies gilt besonders für *This Consequence* (2005), eine Arbeit, die die beunruhigende Präsenz eines Galeriebesitzers oder Aufsehers einschloss, der einen weißen Adidas-Trainingsanzug mit zwei unheimlichen roten Flecken trug, die auf den Stoff gestickt worden waren. Auch die Einbeziehung von und Zusammenarbeit mit anderen ist für Ganders flüchtige Kunst von zentraler Bedeutung – ob er nun mit einem befreundeten Künstler fiktionalisierte Zeitungsnachrufe austauscht oder auf einer Kunstmesse Fotos von Bildbetrachtern macht –, selbst wenn jede seiner solipsistischen Aktionen womöglich nur seinem eigenen, endlos unersättlichen Geist einen weiteren Spiegel vorhält.

Ryan Gander's complex and unfettered conceptual practice is stimulated by queries, investigations, or what-ifs, rather than strict rules or limits. For example, what if children were asked to reassemble the elements of Gerrit Rietveld's flat-packed 'crate furniture' to their own design (*Rietveld Reconstruction,* 2006)? What if all the pieces in a chess set were remade in zebra-striped wood, so that neither side was entirely black or white (*Bauhaus Revisited,* 2003)? While these proposals make Gander sound like an arch-modernist sculptor or recycler, he is in fact a cultural magpie in the widest sense, polymathically taking popular notions apart only to rebuild them in new ways – perhaps by refilming the same ten-second clip 50 times over, as in *Man on a Bridge (A Study of David Lange)* (2008), say, or by inviting viewers to try and appreciate another film, *Is This Guilt in You Too (Cinema Verso)* (2006), from behind a near-opaque cinema screen.

Although Gander seems to prefer no medium over any other, language and storytelling play an overarching role in his work, not least in his series of rambling, 'Loose Association' lectures or in his attempt to slip a nonsensical, palindromic new word, 'mitim', into the English language. Much of this Borgesian gameplaying and circuitous thought provocation presents the audience with the tricky task of unravelling the strands of meaning themselves, although occasionally his ludic concepts drift into more bodily, relational challenges, especially in *This Consequence* (2005), which involved the unsettling presence of a gallery owner or invigilator dressed in an all-white Adidas tracksuit with two additional sinister red stains embroidered into the fabric. Invitation and collaboration are also at the heart of Gander's fugitive art – whether he is exchanging fictionalised newspaper obituaries with an artist-friend or taking pictures of people looking at pictures at an art fair – although arguably every solipsistic action he takes merely holds up yet another mirror to his ceaselessly voracious mind.

Ossian Ward

Man on a Bridge (A Study of David Lange), 2008
16mm film transferred to HDV, colour, sound
16:27 min

*Only really applicable to those that
can visualise it upside down, back
to front and inside out,* 2009
Smoke machine, sensors
Dimensions variable

Rietveld Reconstruction: Diego, 2007
Two Rietveld cargo chairs and a Riet-
veld cargo table reassembled with the
assistance of Diego, aged 7
Dimensions variable

MARIO GARCÍA TORRES

1975 geboren in Monclova, Mexiko, lebt und arbeitet in Mexiko-Stadt, Mexiko
1975 born in Monclova, Mexico, lives and works in Mexico City, Mexico

2010 29th Bienal de São Paulo – *Há sempre um copo de mar para o homem navegar / There is always a cup of sea to sail in*
2007 52nd International Art Exhibition / La Biennale di Venezia – *Think with the Senses – Feel with the Mind*
2007 2nd Moscow Biennale of Contemporary Art – *Footnotes on Geopolitics, Market and Amnesia*

www.enconstruccion.org

www.janmot.com
www.proyectosmonclova.com
www.takaishiigallery.com
www.whitecube.com

Für Mario García Torres ist die Geschichte der Kunst, und insbesondere des Konzeptualismus, alles andere als abgeschlossen. Wegen der Fülle und des immateriellen Charakters der Kunst jener Ära sind ihre historischen Abrisse zwangsläufig voller blinder Flecken, unvollständiger Darstellungen und Gerüchte, die sich nicht einfach durch die Existenz traditioneller Kunstobjekte beweisen oder widerlegen lassen. García Torres ist dafür bekannt, beharrlich in dieser Grauzone zu schürfen, ihre Geschäfte auf Treu und Glauben zu prüfen, ihr noch nicht erschlossenes Potenzial auszuschöpfen und einige ihrer Strategien individuell anzupassen, um die Glaubwürdigkeit der Geschichte als solcher zu untersuchen und Probleme von Autorität und auch Autorschaft zu hinterfragen. In einer charakteristischen Arbeit, *What Happens in Halifax Stays in Halifax (in 36 Slides)* (2004–2006), kommen fast alle dieser Anliegen ins Spiel. Hierfür erforschte García Torres ein wenig bekanntes Instruction Piece von Robert Barry, in dem der ältere Konzeptualist eine Studentenklasse von David Askevold in Nova Scotia aufforderte, ein Geheimnis zu erfinden; sollte das Geheimnis jemals außerhalb der Gruppe – oder auch nur dem Künstler selbst – bekannt werden, würde das Kunstwerk aufhören zu existieren. García Torres versuchte herauszubekommen, ob das Kunstwerk nach 35 Jahren noch existierte; er machte einige der Studenten ausfindig, interviewte sie und präsentierte seine Erkenntnisse in einer Diaprojektion. Für sein Frieze-Projekt anlässlich der Verleihung des Cartier Awards verfasste der Künstler zusammen mit Aaron Schuster *I Am Not a Flopper Or ...* (2007), den Vortrag eines gewissen Alan Smithee. Dieser erwies sich als eine fiktionale Hülse, als nützlicher Sündenbock, dem die Produktion schlechter Filme zugeschrieben wird und dessen wandelbare Konturen als identifizierbare Künstlerfigur praktisch nicht greifbar oder definierbar sind. So könnte man Smithee nicht nur als Allegorie für die Anliegen von García Torres' künstlerischer Praxis im Besonderen, sondern, bis zu einem gewissen Punkt, auch für die Kunst im Allgemeinen betrachten.

For Mario García Torres, the history of art, and Conceptualism in particular, is far from being a closed book. Given the rich, immaterial nature of the era's art, any history of it is inevitably full of blind spots, incomplete accounts, and hearsay that cannot easily be verified or contested by the existence of traditional art objects. García Torres is known to assiduously mine this gray area, exploring its purchase on veracity, exploiting its untaped potential, while personalising certain of its strategies to examine the reliability of narrative itself and question issues of authority and, eventually, authorship. One of the artist's more emblematic works, *What Happens in Halifax Stays in Halifax (in 36 Slides)* (2004–2006), puts almost all of these preoccupations into play. For this piece, García Torres investigated a little-known instruction piece by Robert Barry in which the elder conceptualist asked a class of David Askevold's students in Nova Scotia to create a secret, specifying that should the secret ever be divulged outside of the group, even to the artist himself, the artwork would cease to exist. Seeking to determine whether or not the work still existed 35 years later, García Torres tracked down a number of the students and interviewed them, presenting his findings in a slide projection. For his 2007 Cartier Award project for the Frieze, the artist co-authored with Aaron Schuster *I Am Not a Flopper Or ...* (2007), a lecture by a certain Alan Smithee, who turns out to be a fictional receptacle, a serviceable scapegoat to whom the creation of bad movies is attributed and whose protean contours as an identifiable artistic entity are virtually impossible to grasp and define. Smithee could thus be seen as an allegory not only of the stakes of García Torres' practice in particular, but, to a certain extent, of art in general.

Chris Sharp

I promise to do my best as an artist, at least for the following 31 years, 2007
from the series
I Promise ..., 2004 ongoing
Ink on hotel stationary
Dimensions variable

the times hotel

I promise to do my best
as an artist, at least for the
following 31 years.

Marie Curie Torres
June 23rd, 07

Herengracht 137 – NL-1015 BG Amsterdam – T. +31 20-330 6030 – F. +31 20-320 5273 – www.thetimeshotel.com
Bank: ING rek.nr.: 6761.30.704 – NL 57 INGB 0676130704 – Swift address: INGBNL2A
K.v.K. Amsterdam nr.: 34222973 – B.T.W. nr.: NL 8147.21.886.B01
"Op alle door ons aangegane overeenkomsten zijn van toepassing de Uniforme Voorwaarden Horeca (UVH). Deze liggen bij ons ter inzage en worden op verzoek onverwijld kosteloos toegezonden.
De UVH zijn bindend voor iedereen die van onze diensten gebruik maakt."

What Happens in Halifax Stays in Halifax
(in 36 Slides), 2004–2006
Slide projection, fifty b/w 35mm slides
9 min

While there, a class portrait that had been shot in 1969 was retaken. It was clear that some people were missing.

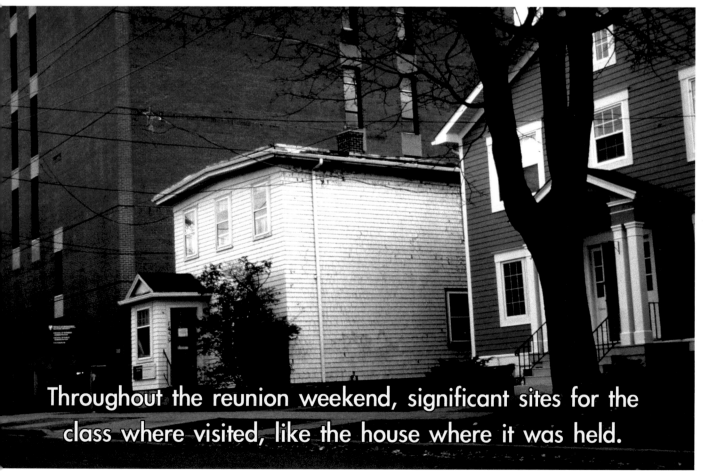

Throughout the reunion weekend, significant sites for the class where visited, like the house where it was held.

MANUEL GRAF

1978 geboren in Brühl, Deutschland,
lebt und arbeitet in Istanbul, Türkei,
Paris, Frankreich, und Düsseldorf,
Deutschland
1978 born in Brühl, Germany, lives and
works in Istanbul, Turkey, Paris, France,
and Düsseldorf, Germany

www.johannkoenig.de
www.van-horn.net

Manuel Graf bündelt in seinen computeranimierten Videos philosophische Geschichten über die Zeit als nichtlineares Kontinuum, innerhalb dessen Entwicklungsstufen und Innovationen vor- und zurückgespult werden können. Komplexität kaschiert er dabei mit naiven Illustrationen (Schmetterling und Blumen in *Woher kommt die Kunst? oder: Die Blüte des Menschen,* 2006), technische Perfektion mit analogen Formaten wie dem Vortrag seines ehemaligen Lehrers in *Über die aus der Zukunft fließende Zeit* (2006). Dieser erläutert die Theorie des Paläontologen O. H. Schindewolf, die anhand von Schädelmessungen vom Urmenschen bis zum Homo Sapiens und vom Kind zum Erwachsenen beweist, dass biogenetische Grundregel und Evolutionstheorie sich manchmal ins Gegenteil verkehren. Die Zeit fließt in zwei Richtungen, sodass Älter- und Jüngerwerden möglich sind. In *Buchtipp 2* (2010) gibt es wieder eine ungewohnt missionarische, wenn auch weniger frontale Wissensvermittlung. Auf einem Monitor diskutieren Paare Rudolf Steiners „Kernpunkte der sozialen Frage" von 1920, eine Schrift über die notwendige Entwicklung des Geistigen in der Gesellschaft, die ebenfalls die Bedeutung des Darwinismus relativiert und scharfe Kritik am Primat der Wirtschaft übt. Tisch, Sitze und Keramik-Teeservice, ebenso wie die schicken Schnürsandalen mit Keilabsatz, sind von Graf selbst gemacht. Er präsentiert Weltverbesserungsvorschläge in Theorie und künstlerischer Praxis. Seine Videos und Objekte sind wie animistische Werkzeuge auf dem Weg zu einem anderen, ganzheitlichen Denken und Handeln.

In seinen frühen, anspielungsreichen Videos setzte der Künstler antike, moderne und postmoderne Architektur als Bedeutungsträger für gesellschaftliche Zustände ein: nachdem die Moderne explodiert (*Shulmantonioni,* eine viel beachtete Akademiearbeit von 2004) und die Module der Architektengruppe Archigram verfaulen, fallen die Entwürfe der Architekten Robert Venturi und Léon Krier zukunftsorientiert hinter sie zurück. Mithilfe von Musik, Film- und Popzitaten setzt Graf Architektur sowohl als real gewordene Utopien ein als auch umgekehrt als Raum, in dem sich die in ihr angelegten Ideen erst entwickeln. Diesen Raum schafft er als Künstler nun selbst, er legt ihn wie alle seine Arbeiten als Modell an, aber mit einer Radikalität, die nicht ohne Folgen für die Realität bleibt.

In his computer-animated videos, Manuel Graf presents condensed philosophical stories about time as a nonlinear continuum within which stages of development and innovations can be fast-forwarded and rewound. He camouflages complexity with naïve illustrations (the butterfly and flowers in *Woher kommt die Kunst? oder: Die Blüte des Menschen,* 2006) and technical perfection with analogue formats, such as his former teacher's lecture in *Über die aus der Zukunft fließende Zeit* (2006). The teacher is explaining a theory proposed by the palaeontologist O. H. Schindewolf, who, drawing on measurements of human skulls from prehistoric man to homo sapiens and from children to adults, proves that the fundamental biogenetic rule and the theory of evolution sometimes turn into their opposites. Time flows in two directions, and so becoming older or younger is possible. *Buchtipp 2* (2010) again offers proffers missionary, if less frontal, instruction. On a monitor we see couples discussing Rudolf Steiner's 'Towards Social Renewal' (1920), a book about the necessary development of the spiritual element in society that likewise relativises the importance of Darwinism and sharply criticises the primacy of economic forces. Graf himself has made the table, seats, and ceramic tea service, as well as the chic lace-up wedge sandals. He presents proposals on how to improve the world in theory and artistic praxis. His videos and objects are like animist tools on the way toward a different, holistic way of thinking and acting.

In his highly allusive early videos, the artist used ancient, modern, and postmodern architecture as vehicles to signify social states: after modernity has exploded (*Shulmantonioni,* a work he created in 2004, while still in art school, that drew a lot of attention), after the modules designed by the architectural group Archigram have putrefied, the designs proposed by architects such as Robert Venturi and Léon Krier move toward the future by relapsing behind these earlier schemes. Using quotations from music, film, and pop culture, Graf deploys architecture both as utopia that has become reality and, inversely, as a space in which the ideas it contains in nuce first unfold. Now he, as an artist, creates this space himself, conceiving it, like all his works, as a model – but one whose radicalness does not remain without consequence for reality.

Rita Kersting

Shulmantonioni, 2004
Video transferred to DVD
3 min

Buchtipp 2, 2010
Video (14:15 min), furniture, TV monitor,
lamps, ceramic, five pairs of shoes,
Polaroid photographs
Dimensions variable

AMY GRANAT

1976 geboren in Saint Louis, MO, USA,
lebt und arbeitet in New York, NY, USA
**1976 born in Saint Louis, MO, USA,
lives and works in New York, NY, USA**

2008 Whitney Biennial, New York

www.cinemazero.com

www.angstromgallery.com
www.galeriekamm.de
www.presenhuber.com

Für Amy Granat ist Film überall und nirgends. Ihr facettenreiches Werk ist dem Erbe der Experimentalfilmer verpflichtet und schafft zugleich neue Beziehungen und Dialoge zwischen Malern, Fotografen, Schriftstellern und Musikern. In Granats Werk ist das Ende immer ein Anfang und das Wegnehmen eine Art Hinzufügung. Unter Verzicht auf eine lineare oder erzählerische Struktur des Films fühlt sie sich von zirkulären Formen und Systemen angezogen. Ihr Interesse an Kreisen zieht sich durch ihr gesamtes Œuvre und verbindet frühe Werke wie *Hole-Punch* (2005) – kurze Loops durchlöcherter Filmstreifen – mit ihrer jüngsten Arbeit, *The Sheltering Sky* (2010) – eine abendfüllende Meditation über die natürlichen Kreisläufe von Sonne, Leben und Tod, die auf dem gleichnamigen Roman von Paul Bowles beruht.

Einige von Granats Filmen, darunter auch *Hole-Punch,* sind ohne Kamera entstanden. Sie verwendet dafür unbenutztes 16-mm-Filmmaterial und beschädigt es, indem sie Löcher hineinstanzt, es mit Rasierklingen zerkratzt oder mit Chemikalien verätzt. Ihre destruktiven Handlungen werden jedoch rasch zu Momenten der Wiedergeburt; sobald der Filmstreifen durch einen Projektor läuft, fällt das Licht durch seine Löcher und Schnitte, sodass abstrakte Filme aus tanzenden Kreisen und Linien entstehen. Durch den gleichzeitigen Einsatz mehrerer Projektoren schafft sie Environments aus akkumuliertem Licht und Klang, in die die Betrachter eintauchen. Auch transformiert Granat ihre Filmstreifen in Fotogramme und hält abstrakte Formen im Raum fest, indem sie in der Dunkelkammer Standbilder herstellt – ein Verfahren, das sie gewissermaßen als ein flüssiges, improvisiertes Zeichnen betrachtet.

Landscape (2009) ist eine stille Hommage an eine Stätte mit Grabhügeln der amerikanischen Ureinwohner, während *2+1+1+2 (for Niki)* (2008) – wie ein Steven Parrino oder ein Georgia O'Keeffe – einem Totenschädel neues Leben einhaucht. Im Film wie im Leben beginnt und endet alles mit dem Licht. Tatsächlich ist die Wüste – ein Ort, an dem Zeit, Raum und Sonne eine Endlosschleife zu bilden scheinen – die Protagonistin in zwei ihrer anspruchsvollsten Filme, *The Sheltering Sky,* der in Kalifornien gedreht wurde, und *T.S.O.Y.W.* (2003–2008, mit Drew Heitzler), eine Variante von Goethes tragischer „Werther"-Geschichte, die während einer Reise zu den Meilensteinen der Land-Art entstand. Der Film zeigt Granats sicherlich bevorzugtes Beispiel der Earthworks, Nancy Holts großartige Betonringe.

For Amy Granat, film is everywhere and nowhere. While indebted to the legacies of experimental filmmakers, her multi-faceted work opens up new relationships and conversations between painters, photographers, writers, and musicians. In Granat's work, the end is always a beginning, and subtraction a type of addition. Renouncing the linear or narrative structure of film, she is drawn to circular forms and systems. Spanning her entire oeuvre, her interest in circles connects early works such as *Hole-Punch* (2005) – short loops of hole-punched film strips – to her most recent piece, *The Sheltering Sky* (2010), a feature-length meditation on the natural cycles of life, death, and the sun, based on the eponymous novel by Paul Bowles.

Several of Granat's films, including *Hole-Punch,* are made without using a camera. Taking strips of virgin 16mm film stock, the artist damages the material by punching holes through it, scratching it with razor blades, or burning it with chemicals. Her acts of destruction, however, soon become moments of re-birth, and when run through a projector, the film's holes and cuts make way for light to pass through, creating abstract movies of dancing circles and lines. Using several projectors at once, she builds immersive environments of accumulated light and sound. Granat also turns her film strips into photograms, freezing abstract shapes in space by making stills in the darkroom, a process she sees as a type of fluid and improvised sketching.

Landscape (2009) is a quiet homage to the site of ancient Native American burial mounds, while *2+1+1+2 (for Niki)* (2008) breathes new life into a skull, like a Steven Parrino or a Georgia O'Keeffe. In film, as in life, it all begins and ends with light. In fact, the desert – a place where time, space, and the sun seem forever on loop – is the main character in her two most ambitious films, *The Sheltering Sky,* shot in California, and *T.S.O.Y.W.* (2003–2008, with Drew Heitzler), a modified version of Goethe's tragic 'Werther' story, filmed while on a road-trip to the landmarks of Land Art. The film features what is surely Granat's favorite earthworks, Nancy Holt's great concrete circles.

Anthony Huberman

T.S.O.Y.W., 2007
Two-channel projection, 16mm film
transferred to DVD, colour, sound
3:20 h

Landscape Film, 2009
16mm film transferred to DVD, rear projection
screen
8:45 min

Exhibition view, 2009
Galerie Eva Presenhuber, Zurich

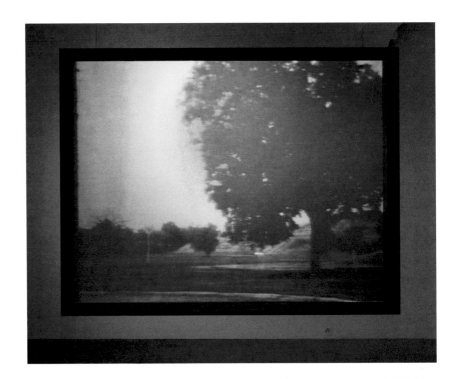

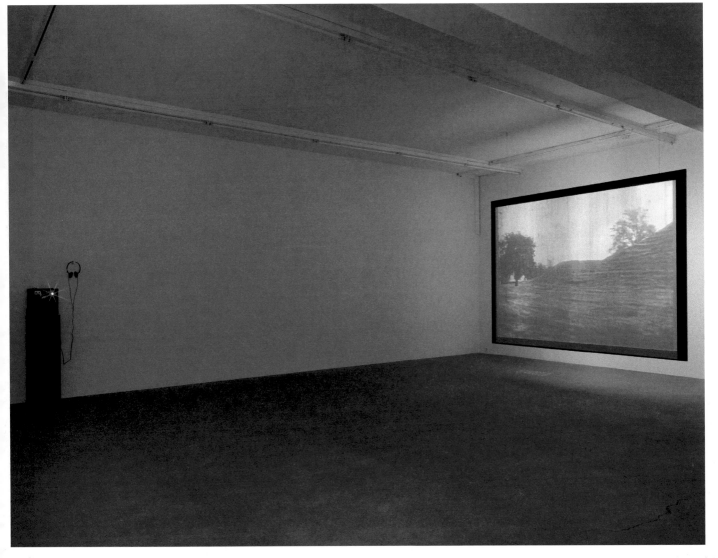

WADE GUYTON

1972 geboren in Hammond, IN, USA,
lebt und arbeitet in New York, NY, USA
**1972 born in Hammond, IN, USA,
lives and works in New York, NY, USA**

2009 53rd International Art Exhibition /
La Biennale di Venezia – *Fare Mondi /
Making Worlds*
2007 9th Biennale de Lyon – *00s.
The history of a decade that has not
yet been named*
2004 Whitney Biennial, New York

www.crousel.com
www.francescapia.com
www.galerie-capitain.com
www.giomarconi.com
www.petzel.com

Wade Guyton kann man nicht als reinen Maler bezeichnen: Bei seinen Bildern handelt es sich um Kompositionen, die keineswegs auf die Traditionen klassischer Malerei zurückgreifen, in denen die Leinwand zum Aktionsort für Auge und Hand wird, um Kreativität und Individualität des künstlerischen Subjekts auszudrücken. Vielmehr basieren Guytons Arbeiten auf Entscheidungen, die aus der Wahl ihrer technischen Werkzeuge und deren Handhabung resultieren. Das Auftragen der Farben delegiert er etwa vielfach an einen modernen Tintenstrahldrucker. Allein die Beziehung von Figur und Grund ist noch der ausschließlichen Hoheit des Produzenten geschuldet.

Dabei ist Guytons Repertoire von Figuren, Zeichen und Mustern großenteils von einfacher, semi-abstrakter Natur: horizontale Streifen, Rasterstrukturen, die Form eines U oder X sowie rechteckige Flächen, die entweder monolithisch die Bilder dominieren oder im ornamentalen Rapport in Serie auftreten. Diese Figuren, die mechanisch auf den Träger, die in den Drucker eingespannte Leinwand, übertragen werden, entstammen jedoch nicht einer gestischen Setzung des Künstlers, sondern einer mathematischen Programmierung. Der Wille oder die Idee des Schöpfers werden in Algorithmen übersetzt, die ein handelsüblicher Drucker „verstehen" und ausführen kann. Somit ist Guytons Malerei konzeptionell; er gibt Handschrift und Gesten zugunsten der maschinellen Ermächtigung auf, um das Problem der Blendung durch handwerkliche Brillanz sowohl systematisch auszuschalten als auch verstandesmäßig zu reflektieren.

Im konzeptionellen Dispositiv dieser Bildschöpfung ist die Ausreizung der Grenzen der verwendeten Apparate kalkuliertes wie potentes Gestaltungsmittel. Die Inkompatibilität von Leinenstoffen und Tintenstrahldrucker eröffnet Raum für zufällige Prozesse, die sich im Ergebnis deutlich niederschlagen. Die fehlerhafte Verteilung der Tinte, Schlieren, das unkontrollierte Auslaufen der Farbpatronen oder das Verstopfen der Druckköpfe verhelfen der Produktion, die eigentlich auf sachliche Wiederholung programmiert ist, dann doch zu einer originären und unverwechselbaren, jeweils singulären Komposition.

We cannot call Wade Guyton a painter pure and simple: his pictures are compositions that in no way draw on the traditions of classical painting, where the canvas becomes a stage for actions of the eye and the hand that serve to express the artistic subject's creativity and individuality. Guyton's works are instead based on decisions that depend on the choice of technical devices and on how these devices are handled. For instance, he often delegates the application of the colours to a modern inkjet printer. Only the relation between figure and ground remains the producer's sovereign decision.

Guyton's repertoire of figures, signs, and patterns is largely plain and semi-abstract in character: it encompasses horizontal stripes, grid structures, U- and X-shaped figures, and rectangular areas that either dominate a picture as monoliths or appear in ornamental series. Yet these figures, which are mechanically applied to the support medium, a canvas fed into the printer, derive not from a gestural pictorial act on the part of the artist but from mathematical programming. The creator's intention or his idea is translated into algorithms a commercially available printer can 'understand' and execute. Guyton's paintings, then, are conceptual; he forgoes a signature style and gestures in favour of mechanical empowerment in order to systematically eliminate – but also initiate a rational reflection on – the blinding power of the artist's technical brilliance.

In the conceptual apparatus of this visual creation, testing the limits of the machinery the artist employs is a calculated and potent artistic instrument. The incompatibility of linen cloth and inkjet printer opens the door to random processes that recognisably shape the results. Flaws in the distribution of ink, smears, uncontrollable spills from the ink cartridges, or clogged print-heads ultimately restore originality and uniqueness to a production programmed to be methodically repetitive, creating a composition that is singular in each instance.

Matthias Mühling

Exhibition view, 2009
Gió Marconi, Milan

Painting: Now and Forever, Part II, 2008
Exhibition view,
Matthew Marks Gallery, New York

Untitled, 2008
Epson UltraChrome inkjet on linen
213.5 × 175.5 cm

RACHEL HARRISON

1966 geboren in New York, NY, USA,
lebt und arbeitet in New York
**1966 born in New York, NY, USA,
lives and works in New York**

2009 53rd International Art Exhibition /
La Biennale di Venezia – *Fare Mondi /
Making Worlds*
2009 The Tate Triennial – *Altermodern*,
London
2008 Whitney Biennial, New York
2006 4th berlin biennial for contem-
porary art – *Of Mice and Men*

www.galerie-nagel.de
www.greenenaftaligallery.com
www.meyerkainer.com

I'm with Stupid, 2007
Wood, polystyrene, cement, Parex,
acrylic, child mannequin, papier-mâché
skull, green wig, festive hat, SpongeBob
SquarePants sneakers, Pokémon T-shirt,
wheels, canned fruits and vegetables,
artificial carrot, artificial feathers,
artificial grass, Batman mask, cat mask,
necktie, scarf, plastic beads
165 × 79 × 61 cm

Rachel Harrison arbeitet wie ein Fahrzeug der Müllabfuhr: Sie hält an jedem Haus und sammelt die Wertstoffe und Abfälle des täglichen Lebens ein. Doch anstatt alles zu verschlingen und daraus eine kompakte Masse für die Deponie zusammenzupressen, greift Harrison sich die US-amerikanischen Ikonen, Helden, Verlierer und Hinterhof-Schätze. Sie schustert Skulpturen, Fotografien und Installationen mit humorvollen politischen und gesellschaftlichen Kommentaren zusammen. Ihre grellen, klebrigen, bonbonfarbenen Formen platzen aus allen Nähten, sind aufeinandergestapelt und schaffen eigenwillige Plattformen für Bilder – oftmals ein Video oder ein Foto einer beliebten Ikone, einer anonymen Person oder eines unspezifischen Ortes – und/oder Objekte: ausrangierte Spielzeuge und beliebiger Nippes, wie eine hellgrüne Perücke, Spielzeug-Actionfiguren und Flaggen.

Die figurative Assemblage *Pink Stool* (2005) besteht aus einem intensiven pinkfarbenen Klecks mit zwei beinähnlichen Stümpfen, der auf der Kante eines runden, mit Goldflitter übersäten Holzschemels hockt. Von der Rückseite sehen wir eine dunkel gelockte Perücke, die mit einem gold und pink gestreiften Schal bedeckt ist. Harrisons sonderbare Anordnungen nicht zusammenpassender Materialien verschmelzen Kitsch und Formalismus mit einem beinahe zynischen finsteren Humor. Sie lässt uns neu über Ikonen nachdenken, die wir zu kennen glauben oder schon vergessen haben oder die uns noch nie durch den Kopf gegangen sind. Wir erkennen neue Verbindungen und absurde Beziehungen zwischen scheinbar bedeutungslosen Dingen und übersehenen Menschen und Orten; Harrison bietet uns mit ihrer Weiterverarbeitung der Überbleibsel Amerikas neue Geschichten und Rätsel, die wir ergänzen müssen. Sie ist ironisch und scharfsinnig und gibt Tipps und Hinweise, drängt uns aber nie die ganze Geschichte oder Idee auf; sie respektiert ihr Publikum und gibt ihm eine Chance, aus ihren spielerischen Angeboten eigene Verbindungen und Schlüsse zu ziehen.

In ihrem Spiel mit der Geschichte der Skulptur, Fotografie und Collage würfelt sie diese Medien durcheinander, zitiert die Vorgänger und findet dadurch einen neuen Weg, einen neuen Bezugsrahmen für Bilder. Sie hat keine Angst, geschmacklos oder grob oder smarter als ihr Publikum zu sein, aber es wird bei ihr immer etwas zum Lachen geben, selbst wenn es ein nervöses Lachen ist.

Rachel Harrison works like a garbage truck, stopping at house after house to pick up the recycling and detritus of everyday life. But instead of gobbling it all up and compacting it into a mass for the dump, Harrison picks out the US American icons, heroes, losers and backyard treasures. She cobbles together sculpture, photography and installation with humorous political and social commentary. Her gaudy, gooey, candy-coloured forms burst from the seams and sit atop each other awkwardly, providing a platform for pictures – often a video or a photograph of a popular icon, an anonymous person, or a generic location – and/or objects – discarded toys and random tchotchkes, such as a bright green wig, toy action figures, and flags.

The figurative assemblage *Pink Stool* (2005) consists of a Pepto-Bismol coloured blob with two leg-like stumps; it sits on the edge of a round wooden stool dusted with gold glitter. From the back we see a dark wavy wig covered by a striped pink and gold scarf. Harrison's curious assembly of incongruent materials merges kitsch and formalism with an almost cynical dark humour. She makes us rethink those icons that we think we know or forgot about or never even thought about. We see new connections and absurd relationships among seemingly insignificant things and unnoticed people and places, and through her redigestion of America's leftovers, she gives us new stories and puzzles to complete. She's wry and sharp and offers clues and tips but never shoves the entire story or idea in our face, respecting her audience and offering them a chance to draw their own connections and conclusions from her playful offerings.

Toying with the history of sculpture, photography and collage, she jumbles all these media together, quoting the precedents while forging a new path, a new form for framing images. She is not afraid to be vulgar or crass or smarter than you, but she will always give you something to laugh about, even if it is nervous laughter.

Ali Subotnick

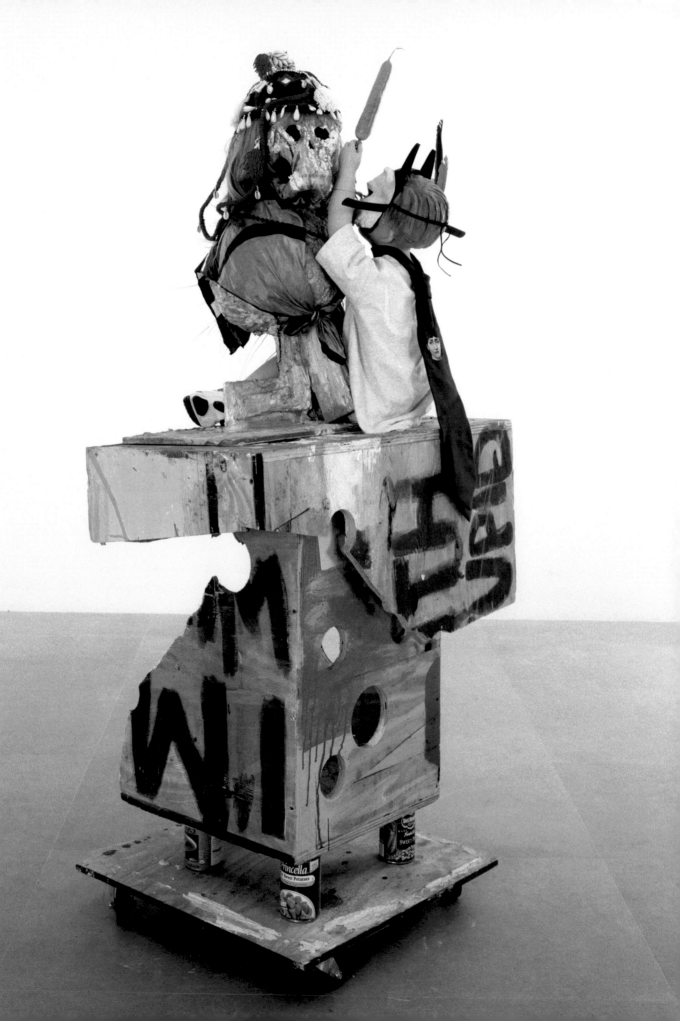

Chicken, 2008
Wood pedestal, acrylic, digital pigment print,
rubber toy chicken, sawdust
112 × 51 × 178 cm

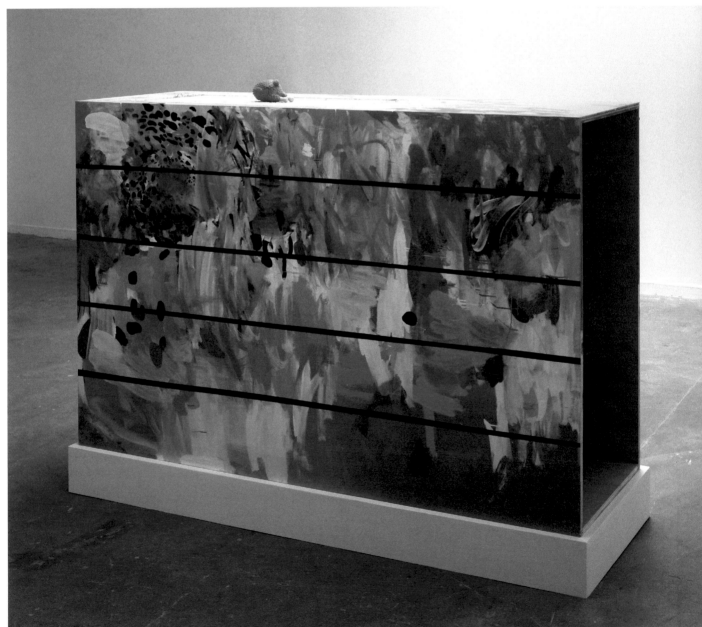

Haycation, 2009–2010
Exhibition views,
Portikus, Frankfurt/Main

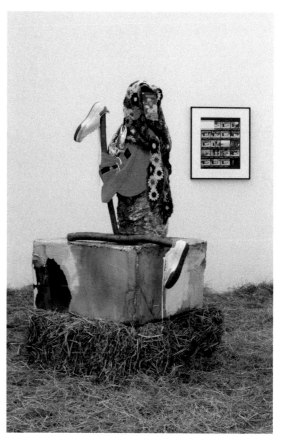

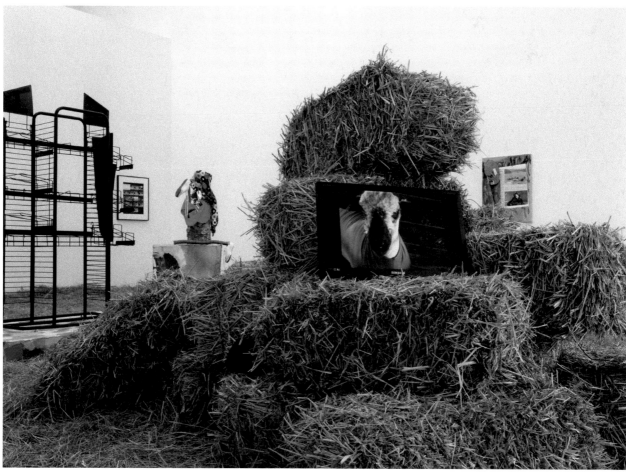

SHARON HAYES

1970 geboren in Baltimore, MD, USA,
lebt und arbeitet in New York, NY, USA
1970 born in Baltimore, MD, USA,
lives and works in New York, NY, USA

2010 Whitney Biennial – *2010*, New York
2009 11th International Istanbul
Biennial – *What Keeps Mankind Alive?*
2007 documenta 12, Kassel

www.shaze.info

www.tanyaleighton.com

Im letzten Jahrzehnt erhielt Sharon Hayes breite Anerkennung für ihre politisch aufgeladenen Arbeiten, in denen sie oftmals selbst historische Texte nachspricht und zu neuem Leben erweckt – von Statements, die Patty Hearst und die Symbionese Liberation Army verfassten, bis zu Ronald Reagans 36 „Reden an die Nation". Für ihre Performance-Serie *In the Near Future* (2005–2009) stand die Künstlerin mit einem Schild mit der Aufschrift I AM A MAN (Ich bin ein Mann) vor der St. Patrick's Cathedral und an anderen Orten in New York (sowie in fünf weiteren Städten: London, Wien, Warschau, Paris, Brüssel). In Zusammenarbeit mit der New Yorker Non-Profit-Organisation Creative Time mobilisierte Hayes Freiwillige aus einer örtlichen Gruppe von Lesben und Schwulen und ließ diese für ihre Arbeit *Revolutionary Love: I Am Your Worst Fear, I am Your Best Fantasy* vor der Democratic National Convention in Denver 2008 Liebesbriefe vorlesen. In all diesen Arbeiten untersuchte und erweiterte Hayes die gesellschaftliche Rolle von Künstlern, verwischte die Grenzen zwischen Kunst und Aktivismus und hob zugleich das Spannungsverhältnis zwischen kollektivem Protest und persönlichem Handeln hervor. Ihre Interventionen finden häufig im öffentlichen Raum statt und richten sich ebenso an Passanten oder an Leute in der Mittagspause wie an ein Kunstpublikum.

Neben den Anregungen, die ihre Arbeiten der Graswurzelbewegung und der Geschichte der Performance verdanken, greift Hayes auch auf wissenschaftliche Quellen – vor allem auf Kulturanthropologie und Philosophie – zurück und verweist auf die Schriften bahnbrechender Denker wie Michel Foucault und Judith Butler. Ihre aktuellen Arbeiten, darunter eine Vier-Kanal-Videoinstallation für die Whitney Biennial 2010 mit dem Titel *Parole* (2010), vereinen die Sprachen des politischen und des romantischen Begehrens, die durch frühe lesbische Aktivistinnen wie Anna Rüling und das spätere Gay Liberation Movement geprägt wurden; sie beschäftigen sich mit den Korrespondenzen zwischen der Gleichberechtigung der Geschlechter, Redefreiheit und Liebe, wie auch mit den Resonanzen und Missklängen zwischen historischen Formen des Protests und der aktuellen Redefreiheit in der Öffentlichkeit.

Over the last decade, Sharon Hayes has garnered acclaim for her politically charged works that often feature the artist respeaking and reviving historical texts – from statements written by Patty Hearst and the Symbionese Liberation Army to Ronald Reagan's thirty-six 'Address to the Nation' speeches. For her performances *In the Near Future* (2005–2009), the artist has stood in front of St. Patrick's Cathedral, among other places in New York (and five other cities: London, Vienna, Warsaw, Paris, Brussels), with a sign that declares I AM A MAN. In collaboration with the New York non-profit Creative Time, Hayes organised volunteers from a local queer community to read love letters outside the 2008 Democratic National Convention in Denver for *Revolutionary Love: I Am Your Worst Fear, I am Your Best Fantasy*. In each of these performances, Hayes has explored and expanded the social role of the artist, blurring boundaries between art and activism while highlighting tensions between collective protest and personal action. Her interventions often unfold in public space and are designed to address passersby, people on their lunch breaks, as well as the art community.

In addition to finding inspiration in grassroots politics and the history of performance art, Hayes's works also draw upon scholarly sources – predominately cultural anthropology and philosophy – and recall the writings of groundbreaking luminaries such as Michel Foucault and Judith Butler. Her recent works, including the four-channel video installation she made for the 2010 Whitney Biennial, titled *Parole* (2010), conflate the languages of political and romantic desire, as forged by early lesbian activists like Anna Rüling and the later Gay Liberation Movement, while focusing on correspondences between gender equality, free speech, and love, as well as the resonances and discordances between past forms of protest and free speech in the public sphere today.

Lauren O'Neill-Butler

In the Near Future, New York (detail),
2005
Multiple-slide-projection installation,
9 actions, 9 projections, 223 original
slides (729 in total)
Dimensions variable

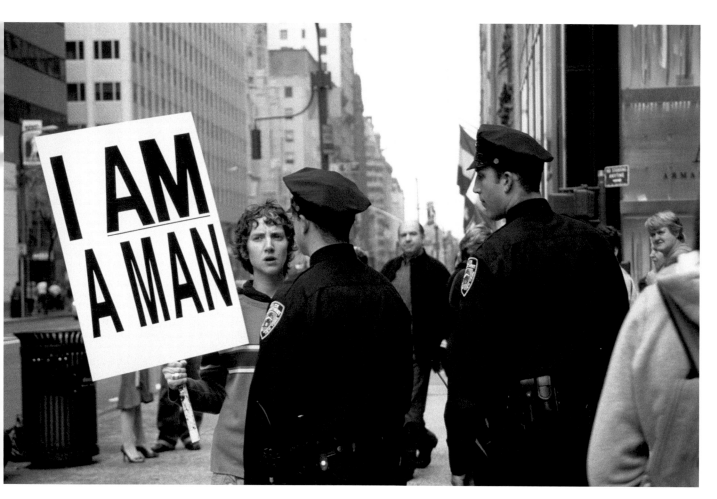

YARD (Sign), 1961/2009
Installation of 152 lawn signs
Dimensions variable
Installation view, New York Marble
Cemetery, as part of Hauser & Wirth's
Allan Kaprow: Yard show

*Revolutionary Love: I am Your
Worst Fear, I am Your Best Fantasy*
(detail), 2008
Documentation of performance,
Democratic National Convention,
Denver

*Revolutionary Love: I am Your
Worst Fear, I am Your Best Fantasy*
(detail), 2008
Documentation of performance,
Republican National Convention,
St. Paul

DIANGO HERNÁNDEZ

1970 geboren in Sancti Spíritus, Kuba,
lebt und arbeitet in Düsseldorf,
Deutschland
**1970 born in Sancti Spíritus, Cuba,
lives and works in Düsseldorf, Germany**

2010 Liverpool Biennial of Contemporary
Art
2006 15th Biennale of Sydney – *Zones
of Contact*
2006 27th Bienal de São Paulo – *Como
viver junto / How to Live Together*
2005 International Art Exhibition /
La Biennale di Venezia – *The Experience
of Art; Always a Little Further*

www.diango.net

www.alexanderandbonin.com
www.bthumm.de
www.federicoluger.com
www.galerie-wiesehoefer.de
www.paolomariadeanesi.it
www.pepecobo.com
www.stellalohausgallery.com

Seit Beginn seiner künstlerischen Karriere
hat sich Diango Hernández mit der jüngsten
Vergangenheit seiner kubanischen Heimat
auseinandergesetzt. Immer wieder themati-
siert er in seinen Installationen, Videos und
Zeichnungen die Situation in Kuba nach den
enormen politischen und ökonomischen Um-
wälzungen, die der Zerfall der Sowjetunion
mit sich brachte. Emblematisch verwirklicht
sich diese historische Bezugnahme in *Years*
(2008). Es besteht aus den fortlaufenden
Jahreszahlen von 1959 bis 2008, die auf die
Zeit verweisen, in der Fidel Castro die Kari-
bikinsel regierte: Eine spezifische Periode
kubanischer Geschichte wird zur gestalteten
Skulptur. Im Ausstellungsraum fungiert das
Objekt aus Stahl, der mit Flugrost überzogen
ist, als Raumteiler, der umgangen, aber nicht
durchschritten werden kann. Der Besucher
befindet sich also wahlweise vor oder hinter
dem filigranen Eisernen Vorhang, der deutlich
als vergänglich, jedoch immer noch faktisch
präsent von seiner isolierenden wie teilenden
Existenz erzählt.
2009 hat Hernández mit *Losing You Tonight*
einen Parcours aus Installationen durch
die Räume des Museum für Gegenwarts-
kunst Siegen entworfen. In der Ausstellung
beschäftigt er sich mit seiner Jugend und
Schulzeit im kommunistischen Kuba; er er-
innert an den unwiederbringlichen Verlust
eines Freundes. Kurz vor dem Abitur kam es
in dem von Hernández besuchten Internat zu
einer gewaltsamen Auseinandersetzung zwi-
schen Schülern, wobei einer der Beteiligten
seinen Verletzungen erlag. Einige Wochen
später fand Hernández einen Text zwischen
Matratze und Bettgestell des verstorbenen
Mitschülers, in dem dieser seine ersten äs-
thetischen Erfahrungen in einem Museum
festgehalten hatte. *Losing You Tonight* bringt
das Initialerlebnis des Verlustes zurück an
den Ort seines Entstehens. Das autobio-
grafische Moment wird dabei für den Erfah-
rungshorizont des Besuchers geöffnet und
so in eine komplexe Narration verwandelt,
die – aufklärerisch agierend und zugleich
mit eminenter Leichtigkeit das Rätselhafte
und Mysteriöse berührend – in Form eines
Requiems Mythos und politische Erfahrung
zusammenführt.

Since the inception of his career as an art-
ist, Diango Hernández has critically exam-
ined the most recent past of his native Cuba.
In his installations, videos, and drawings, he
has repeatedly addressed the situation in
Cuba after the enormous political and eco-
nomic upheaval brought on by the disinte-
gration of the Soviet Union. An emblematic
realisation of this historical reference can
be found in *Years* (2008), which consists of
a series of numbers, arranged in steady
succession, from 1959 to 2008 – the years
during which Fidel Castro governed the Ca-
ribbean island nation – turning a specific pe-
riod in Cuban history into sculptural form. In
the exhibition space, the steel object, coat-
ed with rust bloom, acts as a room divid-
er the visitor can walk around but not pass
through, giving him the choice to position
himself in front of or behind this fragile Iron
Curtain: an object that, despite its recogni-
sable transience, remains effective in the
present, telling the story of its isolating as
well as dividing existence.
In 2009, Hernández designed *Losing You To-
night,* a series of installations leading the
visitor through the rooms of the Museum of
Contemporary Art Siegen (Germany). The ex-
hibition examines his youth and school years
in communist Cuba; the artist remembers
the irrecoverable loss of a friend. Shortly
before they were to graduate, there was a
violent altercation between students at the
boarding school Hernández attended; one
of the students involved died of his injuries.
A few weeks later, Hernández found a note
between his dead fellow student's mattress
and the bed frame in which the latter had re-
corded his first aesthetic experiences on the
occasion of a visit to a museum. *Losing You
Tonight* brings the initial shock of loss back
to the place of its origin, opening the auto-
biographical moment toward the visitor's
experiential horizon and transforming it into
a complex narrative that – with a demystify-
ing gesture and yet activating, with striking
lightness, the registers of the enigmatic and
mysterious – fuses myth and political expe-
rience in the form of a requiem.

Matthias Mühling

*Il Museo Delle Ombre / The Museum
of Shadows,* 2009
Twenty wooden lampshades with
spotlight, porcelain figurine pieces,
bulbs, glass shelves, metal holders,
speakers, porcelain sculpture,
acrylic box
Dimensions variable
Installation view, Museum für
Gegenwartskunst Siegen

Untitled, from the series *Amateur*,
1996–2003
Watercolour, ink, iodine on paper
30 × 39 cm

We are Unfinished Drawings, 2006
Charcoal, graphite, water on paper,
pedestal (MDF)
800 × 1500 × 350 cm
Installation view,
27th Bienal de São Paulo

*Drawing (Mother that's Why
Nobody Can Find Us)*, 2006
Chairs, acrylic and charcoal
on projection screen
245 × 130 × 138 cm

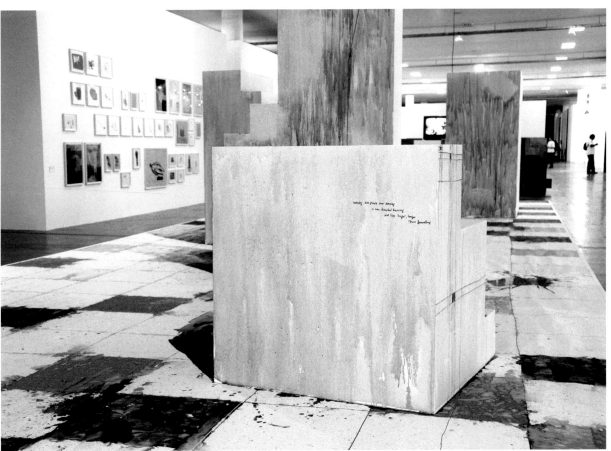

RUNA ISLAM

1970 geboren in Dhaka, Bangladesch,
lebt und arbeitet in London, Groß-
britannien
**1970 born in Dhaka, Bangladesh, lives
and works in London, Great Britain**

2010 29th Bienal de São Paulo – *Há
sempre um copo de mar para o homem
navegar / There is always a cup of sea
to sail in*
2008 Manifesta 7, European Biennial of
Contemporary Art, Trentino-Alto Adige
2005 51st International Art Exhibition /
La Biennale di Venezia – *The Experience
of Art; Always a Little Further*
2003 8th International Istanbul
Biennial – *Poetic Justice*

www.shugoarts.com
www.whitecube.com

Die Filme von Runa Islam verbinden Tradi-
tionen des Kinos, des Dokumentarfilms, der
Poesie und des Strukturalismus miteinander;
sie kombinieren und verwirren Wahrheit und
Fiktion, die Islam nicht als etwas sich gegen-
seitig ausschließendes behandelt, sondern
als ein Paar, das zwangsläufig und paradoxer-
weise die Realität des filmischen Bildes teilt.
Islam begann 1994, Filme mit einer Super-8-
Kamera zu drehen, und experimentiert seit-
dem mit ganz unterschiedlichen Techniken,
darunter 16-mm- und 35-mm-Film sowie, im
Fall von *C I N E M A T O G R A P H Y* (2007) und
Empty the Pond to Get the Fish (2008), com-
putergesteuerten Kameras. Trotz ihres Inte-
resses an der Technik hinter der Produktion
von bewegten Bildern und an der Geschichte
des Kinos sucht sie nach der lebendigen, be-
seelten Seite des mechanischen Auges und
unterhält eine enge Beziehung zur Schönheit
und Magie der Illusion.
Ihre Arbeiten sind nicht nur von Jean-Luc
Godards Brecht'scher Technik und von Robert
Bressons kurzen Fragmenten inspiriert, son-
dern auch von einem Proust'schen Drang,
Bilder wiederzufinden, die ihre Betrachter
womöglich verloren haben. So verleiht ihr
Einsatz von Zeitlupe, Nahaufnahmen und
Ton ihren selbstreflexiven Strukturen einen
symphonischen Aufbau; er gibt ihrem Forma-
lismus einen gewissen Zauber und lässt ver-
traute Dinge, Orte und Gebäude fremdartig
und lebendig wirken. Ihre sorgfältig kadrier-
ten Kamerafahrten sind mit der Vorstellung
von einer filmischen Landschaft und einer er-
zählerischen Sequenz komponiert, doch sie
zeichnen auch Linien in den Raum. Der Film
kann für Islam die Strenge einer empirischen
Untersuchung mit dem offenen Charakter ei-
nes bruchstückhaften Gedankens verbinden.
Islams Filme zeigen häufig Menschen oder
Orte, die (beinahe) stillstehen. Diese Arbeiten
ohne Dialoge konzentrieren sich auf einzelne
isolierte Gesten oder Bewegungen, wie etwa
das Zerbrechen von Porzellangeschirr in *Be
the First to See What You See as You See It*
(2004), das Vor-und-Zurück einer Seilbahn
in *Time Lines* (2005) oder die Untätigkeit der
Rikschafahrer in *First Day of Spring* (2005). In
jedem Fall verstehen die Betrachter, dass die
Kamera auflebt, wenn die Menschen ruhen.

Combining cinematic, documentary, poet-
ic, and structuralist traditions, Runa Islam's
films merge and confuse truth and fiction,
which she treats not as mutually exclusive
but as a pair that necessarily and paradox-
ically share the reality of the filmed image.
Islam began making films in 1994 using a Su-
per 8 camera, and continues to experiment
with a wide variety of techniques, including
16mm and 35mm film, as well as computer-
assisted motion control technology, in the
case of *C I N E M A T O G R A P H Y* (2007) and
Empty the Pond to Get the Fish (2008). While
she is drawn to the systems that lie behind
the fabrication of moving images and to cine-
matic history, Islam is eager to find the heart
and soul of the mechanical eye and main-
tains a close connection to the beauty and
magic of illusion. Her works are inspired not
only by the Brechtian methods of Jean-Luc
Godard and the short fragments of Robert
Bresson, but also by a Proustian urge to re-
trieve images her viewers may have lost.
Her use of slow motion, close-ups, and
sound, for example, adds a symphonic tex-
ture to her self-reflexive structures, giving
her formalism an air of enchantment and
making familiar objects, places, and build-
ings seem alien and alive. Her carefully
framed tracking shots are composed with a
filmic landscape and narrative sequence in
mind, but they also draw lines in space. Film,
for Islam, can reconcile the rigour of an em-
pirical study with the open-ended nature of
a fragile thought.
Many of Islam's films feature people or plac-
es standing still or almost still. Void of di-
alogue, these works focus on single and
isolated gestures or movements, such as
breaking porcelain dinnerware in *Be the First
to See What You See as You See It* (2004), the
back-and-forth of a cable car in *Time Lines*
(2005), or the idling of rickshaw drivers in
First Day of Spring (2005). In each case, view-
ers understand that when people rest, the
camera comes alive.

Anthony Huberman

Empty the Pond to Get the Fish, 2008
35mm film, colour, sound
12:08 min
Installation view, White Cube Hoxton
Square, London

CINEMATOGRAPHY
(production still), 2007
16mm film, colour, sound
6:39 min

Assault, 2008
16mm film, colour, sound
5:31 min

LUIS JACOB

1971 geboren in Lima, Peru,
lebt und arbeitet in Toronto, Kanada
**1971 born in Lima, Peru,
lives and works in Toronto, Canada**

2007 documenta 12, Kassel

www.birchlibralato.com

Das Werk von Luis Jacob entwickelt sich in diversen auseinanderlaufenden (und gelegentlich zusammentreffenden) Bahnen. Jacobs ursprüngliche Ausbildung als Philosoph prägt sicherlich sein Interesse an alternativen Erkenntnistheorien und am Aufbrechen etablierter Hierarchien des Denkens und der visuellen Intelligenz; hierin spiegelt sich auch seine Auseinandersetzung mit der politischen Theorie und Praxis des Anarchismus wider. Seine kaleidoskopischen *Albums,* die Collage-Arbeiten, die wahrscheinlich am stärksten zu seiner heutigen Bekanntheit beigetragen haben, belegen diese Recherchethemen eindeutig: Ihre Größe variiert von zwölf bis über hundert „Seiten", wobei jede einzelne aus sorgfältig austarierten Bildgruppen besteht; jedes Album ähnelt sowohl einer „anderen" (Kunst-)Geschichte wie auch einem eleganten Strom der Visualisierung und Verkörperung von Gedanken – besonders der Vergleich mit Aby Warburgs „Mnemosyne-Atlas" ist verführerisch. Jacob war eine treibende Kraft beim jüngsten Revival des (vorwiegend künstlerischen) Interesses am Werk des abtrünnigen Kunsthistorikers Warburg, dessen Leben der Vorstellung, dass „der Wahnsinn Methode" haben kann, neue Bedeutung verliehen hat. Eine Leidenschaft für abweichende kunsthistorische Lehrmeinungen prägt auch Arbeiten wie *Towards a Theory of Impressionist and Expressionist Spectatorship* (2002) und *A Dance for Those of Us Whose Hearts Have Turned to Ice* (2007).
Die Kehrseite dieser vornehmlich investigativen, intellektuellen Ausrichtung (nicht zu vergessen, dass Jacob auch als Autor, Dozent und Kurator tätig ist) zeigt sich im Interesse des Künstlers am Aufbau von „communities", sowohl als „reale", in der Gegenwart auszuübende Praxis wie auch erneut als Gegenstand einer historischen Recherche. Vielleicht rührt daher der Hauch von Nostalgie, der Jacobs Rückblicke auf die Geschichte der Utopien des Alltags gelegentlich durchzieht – ein Gefühl, das leicht aufkommt, wenn man in ein Environment wie *Habitat* (2005) eintaucht. Der Titel bezieht sich auf den berühmten Mehrfamilien-Wohnblock, den Mosche Safdie 1967 für die Weltausstellung in Montreal entwarf – die Veranstaltung, bei der auch eine von R. Buckminster Fullers sagenhaften geodätischen Kuppeln präsentiert wurde: eine weitere architektonische Chiffre für utopisches Denken, das schon häufiger in Jacobs Werk anzutreffen war, wie etwa in *Flashlight* (2005), einer Installation im öffentlichen Raum, und in *Wildflowers of Manitoba* (mit Noam Gonick, 2007).

The work of Luis Jacob proceeds along a number of diverging (and occasionally converging) paths. Jacob's original training in the field of philosophy can certainly be seen to inform his interest in alternative epistemologies and the dislocation of established hierarchies of thought and visual intelligence, reflecting his study of the political theory and practice of anarchism. His kaleidoscopic *Albums,* the collage works for which he is perhaps best known today, most directly articulate these research interests: ranging in size from twelve to over a hundred 'pages', with each page made up of a finely balanced cluster of images, each album resembles both an 'other' (art) history as well as an elegant stream of visualised, embodied thought – the comparison with Aby Warburg's 'Mnemosyne Atlas' is a particularly tempting one, and Jacob has been an influential force in the recent revival of (predominantly artistic) interest in the work of renegade art historian Warburg, whose life gives new meaning to the idea that there can be a 'method to madness'. A passion for art-historical heterodoxy also informs works such as *Towards a Theory of Impressionist and Expressionist Spectatorship* (2002) and *A Dance for Those of Us Whose Hearts Have Turned to Ice* (2007).
The flipside of this essentially investigative, cerebral thrust (it should be noted that Jacob is also active as a writer, teacher, and curator) emerges in the artist's interest in community-building, both as a 'real' practice to be enacted in the present and as the object, once again, of historical research – hence perhaps the distinct whiff of nostalgia that permeates some of Jacob's retrospective glances at the history of everyday utopia, a sentiment easily evoked by roaming through an immersive environment such as *Habitat* (2005). The title of this work refers to the celebrated multifamily housing unit designed by Moshe Safdie for the World Expo in Montreal in 1967 – the same event that also witnessed the premiere of one of R. Buckminster Fuller's fabled geodesic domes, another architectural cipher of utopian thought that has made a number of appearances in Jacob's practice, thus in the public art installation *Flashlight* (2005) and in *Wildflowers of Manitoba* (with Noam Gonick, 2007).

Dieter Roelstraete

Without Persons, 1999–2008
Blu-ray video, colour, sound
22:45 min
Installation view,
Maple Leaf Gardens, Toronto

The Thing (collaboration
with Chris Curreri), 2008
Colour photograph
29 × 36 cm

The Thing, 2008
Exhibition view,
Septemba, Berlin

*A Dance for Those of Us Whose Hearts
Have Turned to Ice, Based on the
Choreography of Françoise Sullivan and
the Sculpture of Barbara Hepworth
(With Sign-Language Supplement)*, 2007
DVD (8:35 min), colour, no sound,
mixed media
426 × 365 × 240 cm
Installation view, documenta 12, Kassel

Album III, 2004
Image montage in plastic laminate,
159 panels
46 × 30.5 cm (each panel)
Installation view, documenta 12, Kassel

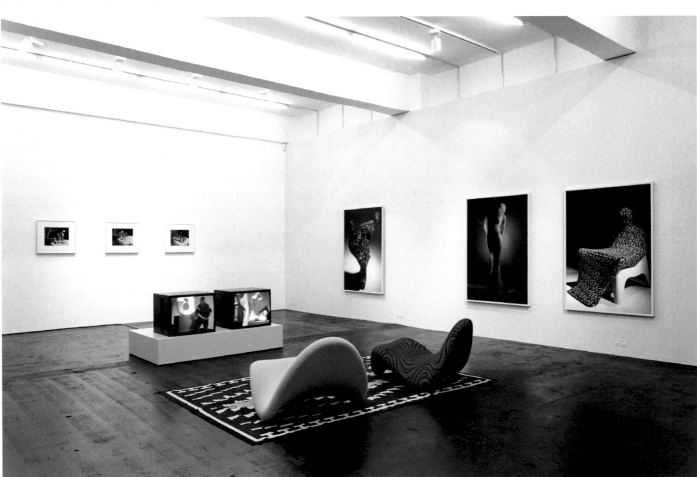

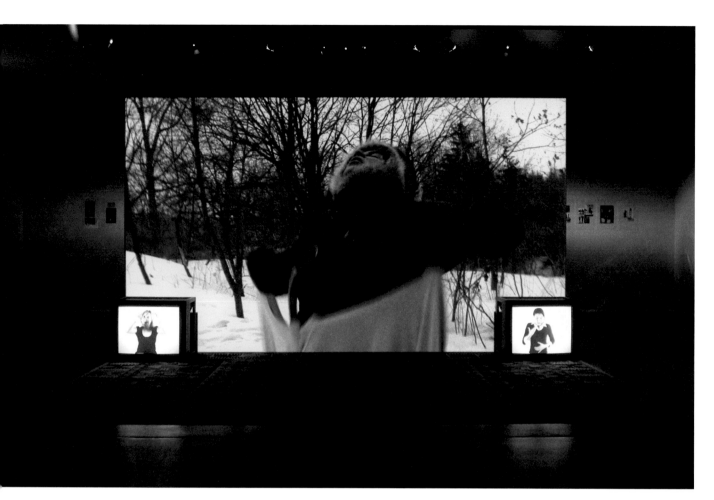

JESPER JUST

1974 geboren in Kopenhagen, Dänemark,
lebt und arbeitet in New York, NY, USA
**1974 born in Copenhagen, Denmark,
lives and works in New York, NY, USA**

2008 Liverpool Biennial of Contemporary Art
2006 Busan Biennale – *Everywhere*

www.jesperjust.com

www.christinawilson.net
www.perrotin.com
www.perryrubenstein.com

Vielleicht war es kein Zufall, dass die Psychoanalyse und die bewegten Bilder des Kinos ungefähr zur gleichen Zeit aufkamen: Der verweilende Blick der Kamera von Jesper Just scheint nicht nur die Gesichter seiner Darsteller, sondern auch ihre verborgenen Gefühle und tiefsten Wünsche mit nahezu forensischer Gründlichkeit zu erforschen. Seine langsamen, wortlosen Stücke ähneln durch ihre kurze Laufzeit (für gewöhnlich unter zehn Minuten) kleinen Psychodramen, die aus Hollywood-Spielfilmen mit ihren kostspieligen Produktionswerten und ihrer opulenten 16-mm-Ästhetik herausgeschnitten wurden. Justs raffinierte Szenen sind voller einsamer Menschen, die sich in Landschaften verloren haben oder in gestörten Beziehungen gefangen sind, die oft in einem opernhaften Crescendo oder in einem elegischen offenen Ende gipfeln. Die zärtliche, aber zweideutige Begegnung zwischen Vater und Sohn in *The Sweetest Embrace of All* (2004) (die sich auch zwischen Liebhabern abspielen könnte) endet in einer wilden Prügelei, während die eifersüchtige Dreiecksbeziehung in *Something to Love* (2005) durch eine finale Umkehrung männlicher und weiblicher Rollen durcheinandergerät.

Die Protagonisten in Justs kurzen Stücken nehmen verschiedene Geschlechterrollen ein, die das ganze Spektrum von hetero-, homo- und transsexuellen Möglichkeiten umfassen. Ein aktuelles Beispiel ist *Romantic Delusions* (2008); es zeigt Udo Kier als verwirrten (vielleicht hermaphroditischen) Flaneur in Frauenkleidern, der traurig durch Bukarest streift, während sich die Gegensätze zwischen Ost und West, Mann und Frau auf schizophrenen Split Screens zeigen. Justs breites Spektrum filmischer Einflüsse, die von der aufgeladenen Atmosphäre einer Chantal Akerman oder eines David Lynch bis zu der Action und Spannung Michael Manns und des klassischen Film noir reichen, vermeidet die Klischees von Queer Theory oder High Camp. Obwohl sie ohne gesprochene Erzählung auskommen, orchestriert Just seine zwischenmenschliche Kommunikation meisterhaft durch Blickkontakte oder den klugen Einsatz seines bevorzugten Mediums Musik: sei es durch harmonisch platzierte Stücke wie den Männerchor in *No Man is an Island II* (2004) oder durch die herzergreifende Ballade, die die geschlechtsumgewandelte Künstlerin Baby Dee in dem surrealen *A Question of Silence* (2008) vorträgt.

Perhaps it was no coincidence that psychoanalysis and the moving images of cinema emerged at roughly the same time: Jesper Just's lingering camera lens certainly seems to capture an almost forensic examination of not just his characters' faces, but their hidden emotions and deepest desires too. His slow-moving, wordless playlets, with their short running times (usually under ten minutes), resemble mini-psychodramas excised from feature-length Hollywood movies, complete with concomitant high-budget production values and rich 16mm aesthetics. Just's slick scenes are populated by lonely people lost in landscapes or trapped in dysfunctional relationships, often climaxing in operatic crescendos or elegiac, open endings. The tender but ambiguous father-son encounter of *The Sweetest Embrace of All* (2004) (which could also be between lovers) ends in violent thrashing, while the jealous love triangle of *Something to Love* (2005) is confused by a final twist in male-female relationship roles.

The protagonists in Just's vignettes inhabit various gender guises, covering the full gamut of hetero-, homo- and transsexual possibilities, a recent example being *Romantic Delusions* (2008), featuring Udo Kier as a bewildered cross-dressing (possibly hermaphrodite) 'flâneur' who drifts sadly through Bucharest as the dichotomies of East/West and man/woman play out over schizophrenic split-screens. Clichés of queer theory or high camp are avoided by Just's wide-ranging mixture of celluloid influences, combining the loaded atmospheres of Chantal Akerman or David Lynch with the action and suspense of Michael Mann and classic Film noir. Although forgoing any spoken narrative, Just orchestrates his human communications expertly, either via eye contact or through the judicious use of his preferred medium of music: whether in harmonic set pieces, such as the all-male chorus of *No Man is an Island II* (2004), or in the heart-rending ballad performed by transgendered singer Baby Dee in the surreal *A Question of Silence* (2008).

Ossian Ward

Sirens of Chrome, 2010
Video transferred to Blu-ray Disc,
colour, sound
12 min

Romantic Delusions, 2008
8mm film transferred to DVD, colour, sound
10:25 min

A Vicious Undertow, 2007
Super 16mm, b/w, sound
10 min

ANNETTE KELM

1975 geboren in Stuttgart, Deutschland,
lebt und arbeitet in Berlin, Deutschland
**1975 born in Stuttgart, Germany,
lives and works in Berlin, Germany**

2008 Brussels Biennial 1 – *Show me,
don't tell me*
2007 9th Biennale de Lyon – *00s.
The history of a decade that has not
yet been named*

www.andrewkreps.com
www.giomarconi.com
www.heraldst.com
www.johannkoenig.de
www.marcfoxx.com

Die Fotografie von Annette Kelm ist von einer eigentümlich enigmatischen Sachlichkeit geprägt. Tatsächlich geht es Kelm nicht um Verrätselung, sondern um verdichtete Bildhaftigkeit. Ihre charakteristische Art, etwas im Ungreifbaren zu belassen, ist stets präzise durchformuliert. In ihren Bildern verbinden sich nüchterne Objektivität, malerisch kalkulierter Bildaufbau und subtile Anspielungen, die nie glatt aufzulösen sind. Etwa in *Archaeology and Photography* (2008): Die Kombination zweier antiquarischer Bücher zur Fototheorie – einem davon verdankt das Bild den Titel – mit zwei krummen weißen Zucchini vor einem Hintergrund aus kleingemustert grünem Blümchenstoff ist eine ebenso komische wie raffinierte Komposition. Das Muster flacht den Bildraum extrem ab und löst das literarische Gemüsestillleben fast ins Ornamentale auf. Die Verwendung von Stoffen als Hintergrund ist ein typisches Stilmittel Kelms, das die gängige Praxis von Studiofotografie paraphrasiert. Sie deutet dieses Verfahren um, indem sie die Objekte in den Oberflächen regelrecht aufgehen lässt – und so in ihrer Bildwerdung vorführt.
In den *Big Prints* (2007) hat Kelm dies noch gesteigert. Die Aufnahmen großgemusterter Stoffentwürfe von Dorothy Draper zeigen ihr Sujet direkt und frontal. Dabei wird das eigentliche Objekt, das Stück Stoff also, hinter der Dominanz der Muster beinahe unsichtbar – ein semantisches Vexierspiel, in dem Sujet und Abbild quasi die Plätze tauschen. Auch im dreiteiligen *Stars Look Back* (2006) präsentiert Kelm das Objekt, die hawaiianische Bambus-Version eines klassischen Bauhaus-Tischchens, in Verschränkung mit der Linientextur des Hintergrundstoffs, die sich zudem mit dem Schattenwurf des Möbels kreuzt. Die irritierende Unschärfe der Bilder, ihr unklares Schwarz-Weiß und fehlerhafte Lichtreflexe legen weitere Spuren: Kelm hat Schwarz-Weiß-Polaroids, wie man sie in der Studiofotografie zur Kontrolle der Ausleuchtung macht, in Farbe abfotografiert, die Lichtflecken sind Fehler auf der Vorlage. Sie zeigt also das Foto eines Fotos, holt eine zweite Ebene ins Bild, mit der sich, ähnlich wie bei den *Big Prints,* das „objektiv" gezeigte Ding unlöslich verbindet – und demonstriert dadurch die mediale Illusion des Fotografischen gleich mit.

The dominant mood in Annette Kelm's photographs is an oddly enigmatic objectivity. And indeed, Kelm's aim is not mystification but condensed visualisation. Her characteristic way of preserving a measure of intangibility is always sustained by rigorous visual implementation. Her pictures fuse sober objectivity and a pictorial layout calculated with a painter's precision with subtle allusions that are never quite resolved. Thus in *Archaeology and Photography* (2008): the combination of two antiquarian books on the theory of photography – the work owes its title to one of them – with two crooked white zucchini before a backdrop of green fabric bearing an intricate floral pattern makes for a composition that is as funny as it is sophisticated. The patterning renders the pictorial space extremely shallow and almost dissolves the literary still life with vegetables into an ornament. The use of fabrics for backgrounds is a characteristic trope in Kelm, a paraphrase on a widespread practice in studio photography. She reinterprets this practice by making her objects positively dissolve into the surfaces – demonstrating that and how they become images.
In the *Big Prints* (2007), Kelm has taken this principle one step further. The shots of fabric printed with large patterns designed by Dorothy Draper show their subject directly, in a frontal view. The real subject of the picture, the piece of fabric, becomes almost invisible behind the dominance of the patterns – a semantic visual ambiguity in which subject and likeness, as it were, change places. In the three-part work *Stars Look Back* (2006), too, Kelm presents the object, the Hawaiian bamboo version of a classic Bauhaus side table, interlaced with the linear texture of a background drapery that is also crossed by the shadow the piece of furniture casts. The irritating blurriness of the pictures, their muddy black-and-white, and defective flares are further hints: Kelm took colour photographs of black-and-white polaroids of the sort used in studio photography to check the lighting; the bright spots are defects on these originals. What she shows, then, is the photograph of a photograph, bringing a second level into the picture that, not unlike in the *Big Prints,* attaches indissolubly to the object of 'objective' depiction – demonstrating, within photographic likeness, that it is an illusion engendered by its medium.

Jens Asthoff

*Erstes Musterhaus, Hellerau,
Heideweg, Deutsche Werkstätten
Hellerau, Architekt Adelbert
Niemeyer, 1920, 2008*
C-print
75.5 × 58 cm

Archaeology and Photography, 2008
C-print mounted on aluminium dibond
70.6 × 86.6 cm

*Big Print #1 (Lahala Tweed –
cotton chevron, fall 1949, design
Dorothy Draper, courtesy
Schumacher & Co), 2007*
C-print
130.5 × 100.5 cm

*Big Print #6 (Jungle Leaves –
cotton twill, 1947, design
Dorothy Draper, courtesy
Schumacher & Co), 2007*
C-print
131.5 × 100.5 cm

*Big Print #2 (Maui Fern –
cotton 'mainsail cloth', fall 1949,
design Dorothy Draper, courtesy
Schumacher & Co), 2007*
C-print
131.5 × 100.5 cm

GABRIEL KURI

1970 geboren in Mexiko-Stadt, Mexiko,
lebt und arbeitet in Mexiko-Stadt und
Brüssel, Belgien
1970 born in Mexico City, Mexico,
lives and works in Mexico City and
Brussels, Belgium

2008 5th berlin biennial for contemporary art – *When things cast no shadow*
2003 50th International Art Exhibition /
La Biennale di Venezia – *Dreams and
Conflicts. The Dictatorship of the Viewer*

www.estherschipper.com
www.franconoero.com
www.kurimanzutto.com
www.sadiecoles.com

Das (überwiegend skulpturale) Werk von Gabriel Kuri verrät eine hohe Sensibilität für das ästhetische Potenzial des Alltagslebens – genauer gesagt, für die materiellen Dinge, die es anfüllen und prägen – und offenbart eine ungewöhnliche Einsicht in das Wesen der Ökonomie, die dieses Leben bedingt. Konzeptuell kreist ein großer Teil von Kuris Werk um verschiedene Anliegen, die für gewöhnlich nicht als vorrangige Gebiete künstlerischer Kompetenz gelten, darunter vor allem die Trias von Handel, (illegalen) Geschäften und Transaktionen. Dieser ziemlich unorthodoxe Komplex von Interessen manifestiert sich in einer Reihe von Arbeiten, die aus gewöhnlichen Materialien bestehen oder sie verwenden, darunter Einkaufstüten, Wartenummern, Wirtschaftsseiten von Tageszeitungen und Kassenbons – einige seiner bekanntesten Arbeiten sind großformatige Tapisserien aus Wertkarten oder banalen Werbeprospekten, die uns unweigerlich an die Begeisterung der Pop-Art für einen freundlichen Konsumkapitalismus erinnern. Auf einer weniger augenfällig formalen oder materiellen Ebene prägt die Magie der Ökonomie offenkundig auch Kuris Untersuchungen zum skulpturalen Potenzial von Tropen, Instrumenten und Modellen wie Wachstumskurven, Tortendiagrammen und anderen statistischen Formen und Hilfsmitteln, die dem Zählen, Kartieren und Quantifizieren dienen. Letztlich sind es jedoch oft die physikalischen Eigenschaften eines bestimmten Materials, ob „natürlich" oder nicht, die das finale Erscheinungsbild (und damit auch die definitive Bedeutung) eines Werks diktieren – daher beharrt der Künstler auf der „skulpturalen" Qualität seiner Arbeit. Dies ist vielleicht auch der Grund dafür, dass immer wieder allegorische (und manchmal auch reale) Figuren von Entropie und Zufall in seinem Werk auftauchen, beispielsweise durch die Nutzbarmachung halbnatürlicher Prozesse – sei es mittels der Einbeziehung von Kühlschränken, Ventilatoren und Kassenautomaten, die die Arbeit buchstäblich mit Leben erfüllen, oder in Form von organischen und damit vergänglichen Elementen („Zutaten") wie Früchten und Rasenstücken.

The (primarily sculptural) work of Gabriel Kuri reveals a finely attuned sensitivity to the aesthetic potential of everyday life – more specifically, of the material objects that both populate and give shape to it – as well as a rare intelligence in grasping the economic nature that conditions this life. Conceptually, much of Kuri's work revolves around a number of concerns not usually regarded as the primary fields of artistic expertise, most prominently among them the triad of trade, traffic, and transaction. This rather unorthodox complex of interests is manifest in a range of works made up of, or using, odd materials such as shopping bags, waiting stubs, financial pages from newspapers, and receipts – some of his best-known works are large-scale tapestries based on tickets or on banal advertising leaflets, inevitably reminding us of Pop Art's enchantment with a benign commodity capitalism. On a less ostentatiously formal or material level, the magic of economism also appears to inform Kuri's explorations of the sculptural potential of tropes, tools, and models such as the growth curve, the pie chart, and other statistical forms and devices of counting, mapping, and quantifying. In the end, however, it is often the physical properties of a given material, whether 'natural' or not, that dictate the final appearance (and, correspondingly, ultimate meaning) of the work – hence the artist's insistence on the 'sculptural' quality of his practice. This is perhaps also why allegorical (and, occasionally, real) figures of entropy and chance regularly appear in his work, in the form of a harnessing of semi-natural processes for instance – by way of the inclusion of fridges, fans and automated cashiers that literally animate the work – or in the form of organic, which is to say, perishable elements ('ingredients') such as fruit and patches of grass.

Dieter Roelstraete

*Sin título / Untitled
(Cohete despegando),* 2007
Consumption tickets, postcard,
and screenprint on paper
44 × 30 cm

Items in Care of Items, 2008
Painted steel, numbered magnetic
discs, assorted items
Dimensions variable
Installation view,
Neue Nationalgalerie, Berlin

That Runs Through, 2009
Bag of charcoal, stone, stack of
'Financial Times', archival box,
newspaper, kitty litter, bag of kitty
litter, wastebasket, mophead,
backdrop paper
355 × 223 × 137 cm

Complimentary Cornice, 2008
Marble slabs, complimentary toiletries
132 × 190.5 × 3 cm

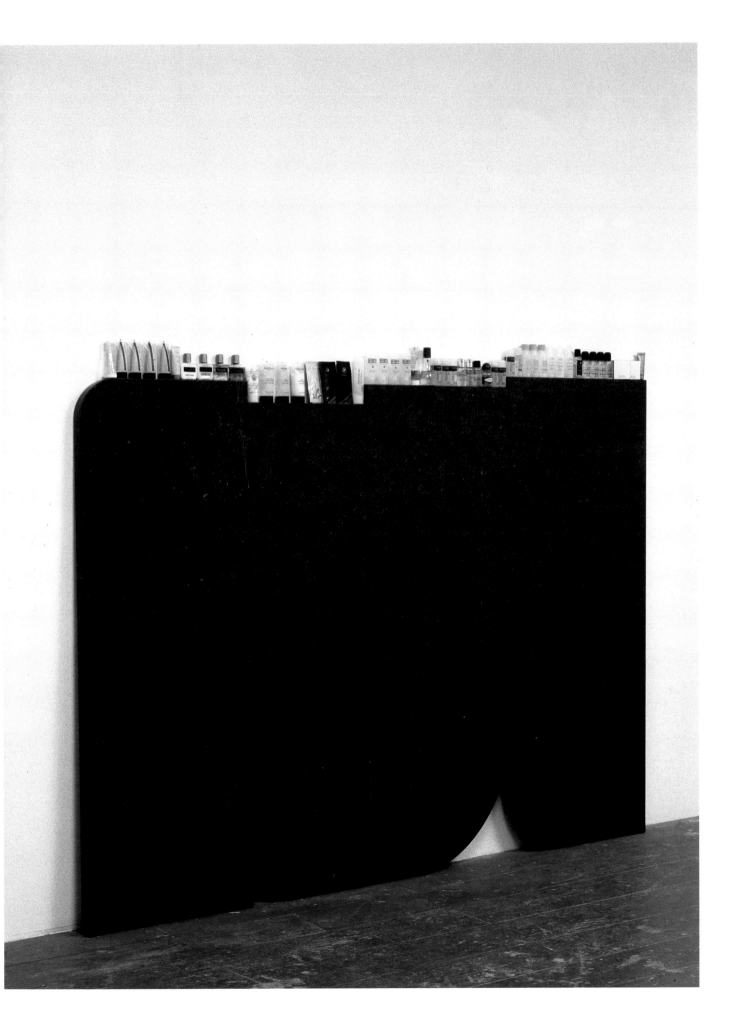

ROBERT KUŚMIROWSKI

1973 geboren in Łódź, Polen,
lebt und arbeitet in Lublin, Polen
**1973 born in Łódź, Poland,
lives and works in Lublin, Poland**

2006 4th berlin biennial for contemporary art – *Of Mice and Men*

www.fgf.com.pl
www.johnengalerie.com

Die Arbeiten von Robert Kuśmirowski riechen nach Geschichte und weisen eine dicke Patina auf – Sammlungen vergilbender Dokumente, sepiabraune Fotografien und Briefmarken, ein Fahrrad im Stil der 1920er Jahre oder ein Winkel eines verfallenden Friedhofs, der unvorhergesehen in einer Galerie auftaucht. Bei genauerer Betrachtung dieser vermeintlichen Relikte der Vergangenheit zeigt sich jedoch, dass es sich um kunstvolle Simulationen handelt. Alles, von der maschinengeschriebenen Beschriftung, den offiziellen Siegeln und dem von der Zeit beschädigten Papier bis zu den angeschlagenen Grabsteinen, dem wuchernden Unkraut und dem rostigen Eisentor, wurde akribisch per Hand gefertigt und mit perfektionistischer Liebe zum Detail bearbeitet. Die politisch und historisch aufgeladene Aktivität, zweidimensionale Dokumente zu fälschen, wird mit verwirrenden Ergebnissen in die dritte Dimension erweitert: Zwischen dem eigentlichen Ding und seiner Nachbildung, die nicht authentisch, aber auf unheimliche Weise überzeugend ist, entsteht eine beunruhigende Austauschbarkeit. Während die Vergangenheit in zeitlicher Hinsicht abgekoppelt wird, werden grundlegende Fragen über das Wesen der Wirklichkeit und unsere Wahrnehmung dieser Wirklichkeit aufgeworfen.

Kuśmirowski hat davon gesprochen, dass er „eine Aura von Grund auf aufbauen" wolle. Die Grenzen dieser Idee lotete er in *Wagon* (2006) aus, ein Eisenbahnwaggon von der Art, die für die Deportation von Gefangenen nach Auschwitz verwendet wurde und dessen Aura beinahe ebenso gewichtig ist, wie das Objekt selbst wirkt. Dass auch dieses eine pure Fälschung ist, erscheint beinahe so unbegreiflich wie die historischen Ereignisse, auf die es sich bezieht. Wirklichkeit und Vorstellung, Zeit und Geschichte, subjektive und kollektive Erinnerung werden in Kuśmirowskis hybriden Objekten dehnbar und unvorhersagbar. Der Ausstellungsraum wird zu einer Bühne, und die Arbeiten scheinen auf die performative Anstrengung hinzudeuten, die zu ihrer Herstellung erforderlich war. Dies wurde besonders deutlich bei der Arbeit *Bunker* (2009), für die Kuśmirowski einen Raum der Barbican Art Gallery in den maßstabsgetreuen Nachbau eines Bunkers aus dem Zweiten Weltkrieg transformierte und dem Publikum ermöglichte, den Umbauprozess mitzuerleben. Doch selbst das ausdrückliche Wissen um das befristete Konstrukt verhinderte nicht, dass die Atmosphäre erschreckend real erschien.

Robert Kuśmirowski's works reek of history and are thick with patina – collections of yellowing documents, sepia photographs and postage stamps, a 1920s-style bicycle, or a corner of a dilapidated cemetery that appears unexpectedly in a gallery. Closer inspection of these apparent relics from the past, however, reveals them to be elaborate simulations. Everything, from the typewritten lettering, official seals and time-damaged paper to the chipped gravestones, bedraggled weeds and rusting iron gate, has been meticulously created by hand and finished with a perfectionist's attention to detail. The politically and historically loaded activity of forging two-dimensional documents is extended to the three-dimensional realm with disconcerting results, as an unsettling interchangeability emerges between the thing itself and its replica, drained of authenticity but uncannily convincing. While the past is unmoored in temporal terms, fundamental questions are raised about the nature of reality and our perception of it.

Kuśmirowski has spoken of wanting to 'build aura from scratch', a notion he takes to the limits in *Wagon* (2006), a railway car of the sort used to transport detainees to Auschwitz, whose aura is almost as weighty as the object itself appears to be. That this too is pure fabrication seems almost as impossible to comprehend as the historical events to which it refers. Reality and imagination, time and history, subjective and collective memory become elastic and unpredictable in Kuśmirowski's hybrid objects. The exhibition space takes on a stage-like character and the works seem to point towards the performative effort involved in their creation. This was emphasised in *Bunker* (2009), where Kuśmirowski transformed one of the Barbican's galleries into a life-size replica of a World War II bunker, allowing the audience to witness the transformative process. Even this explicit knowledge that the atmosphere was a mere temporary construction did not prevent it from appearing chillingly real.

Kirsty Bell

Bunker, 2009
Exhibition view, Barbican Art Gallery,
London

DOM, 2004
Exhibition view,
Johnen Galerie, Berlin

Wagon, 2006
Exhibition view,
4th berlin biennial for
contemporary art, Former
Jewish School for Girls

Unacabine, 2008
Exhibition view,
New Museum, New York

TIM LEE

1975 geboren in Seoul, Südkorea,
lebt und arbeitet in Berlin, Deutschland
**1975 born in Seoul, South Korea,
lives and works in Berlin, Germany**

2008 16th Biennale of Sydney –
Revolutions – Forms That Turn
2005 Sharjah Biennial 7 – *Belonging*

www.teel.ca

www.galerie-ruediger-schoettle.de
www.johnengalerie.com
www.lissongallery.com

Das Werk von Tim Lee ist im Umfeld sich überlagernder Traditionen angesiedelt, teils historischer, teils aber auch sehr junger, darunter das Selbstporträt und Reenactment. Lee erscheint regelmäßig selbst in seinem Werk (großformatige Fotografien, Dia-Installationen, Video), in erster Linie als Hommage an seine Zeitgenossen und an Vorgänger im erweiterten Feld der Kulturproduktion, das charakterisiert ist von der Auflösung einstmals streng bewachter Grenzen zwischen „high" und „low", Hochkunst und Populärkultur. Die Gegenstände dieser Hommagen reichen von fast schon Vergessenen wie dem kanadischen Hockey-Wunder Bobby Orr oder dem Baseballspieler Ted Williams bis zu kanonischen Figuren wie George und Ira Gershwin oder Bruce Nauman und Ikonen wie Glenn Gould, Iggy Pop oder Neil Young. Neben einem ausgeprägten Interesse an kanadischer Kultur und an den gelegentlichen Verschmelzungen der Popmusik mit der Kunst des 20. Jahrhunderts (Dan Grahams „Interpretation" der Beastie Boys oder Public Enemy, angereichert mit Alexander Rodtschenko) ist ein dominierender Faktor dieser „Porträts" oftmals die Geschichte der Komödie, von den Marx Brothers und Buster Keaton bis zu Jerry Lewis, Steve Martin und Peter Sellers – ein rutschiges Gelände, von dem sich viele Künstler lieber fernhalten.

Referenzen, Remakes, Remixe, Varianten: Das klingt vielleicht nach der erprobten postmodernen Sichtweise der Kultur als Gewimmel frei flottierender, losgelöster Signifikanten. Doch es liegt auch etwas unverfroren „Modernes" (und daher „Retrospektives") in dem dezidierten Interesse des Künstlers an den Mechanismen des Sehens, an Optik und festgelegten Blicktraditionen – und an der Rolle, die der Apparat bei der Produktion von Identitäten und Identifikationen spielt. Schließlich besteht ein Grundprinzip des Modernismus in der Kunst in seiner Verpflichtung, ihre Ausdrucksmittel und ihren Charakter als Medium ständig zu hinterfragen. In dieser Hinsicht ist Lees Werk sichtlich geprägt von der Ausbildung des Künstlers im ausgesprochen diskursiven Kontext der Kunstwelt von Vancouver: eine Kultur sehr verführerischer und oftmals atemberaubend schöner Bilder, die nur zu gut um die ökonomischen (*und* ideologischen) Bedingungen ihrer eigenen Produktion weiß.

The work of Tim Lee operates within the perimeter of a number of intersecting traditions, some ancient, some very new, such as that of self-portraiture and re-enactment. Lee regularly appears in his own work (large-scale photography, slide installations, video), but does so primarily to pay homage to his peers and predecessors in a generalised field of cultural production marked by the dissolution of the once anxiously guarded barriers between 'high' and 'low' (or 'pop') culture. The subjects of such homage range in stature from the mostly forgotten, such as Canadian hockey prodigy Bobby Orr or baseball player Ted Williams, to the canonical, such as George and Ira Gershwin or Bruce Nauman, and the iconic, such as Glenn Gould, Iggy Pop, or Neil Young. Besides a marked interest in Canadiana on the one hand and pop music's occasional conflations with 20th-century art (The Beastie Boys as 'read' through Dan Graham, Public Enemy enhanced by Alexander Rodchenko) on the other, a dominant factor in these 'portraits' often appears to be the history of comedy, from the Marx Brothers and Buster Keaton to Jerry Lewis, Steve Martin, and Peter Sellers – slippery terrain that many artists prefer to stay away from.

References, remakes, remixes, variations: this may sound like the tried and tested terrain of the postmodern world-view of culture as a teeming mass of floating, anchor-less signifiers. But there is also something unabashedly 'modern' (and hence 'retrospective') about the artist's keen interest in the mechanics of vision, in optics and scopic regimes – and in the role of the apparatus in the production of identities and identifications: one defining tenet of modernism in the arts, after all, is its commitment to a continuous interrogation of the means of its own articulation, its mediation. In this respect, Lee's work sports the visible marks of the artist's formation in the highly discursive context of the Vancouver art world: a culture of very seductive, often stunningly beautiful imagery that is only too well aware of the economic (*and* ideological) conditions of its own production.

Dieter Roelstraete

Untitled (Neil Young, 1968), 2006
Two C-prints
152 × 122 cm (each)

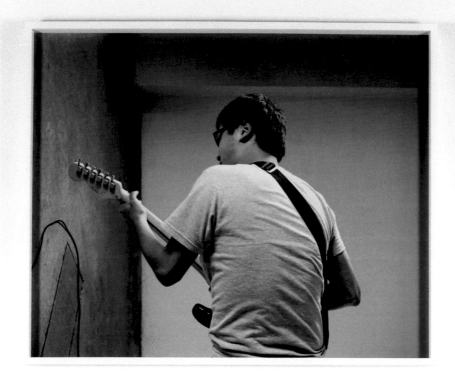
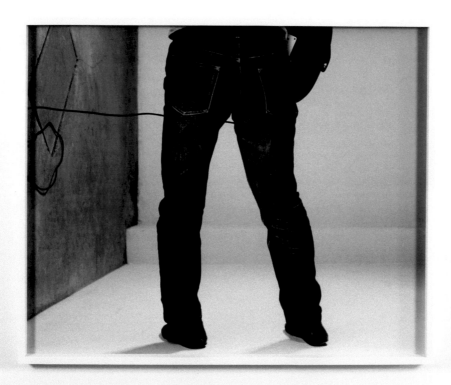

Untitled, 1988, 2006
Two-sided silvered mirror
with aluminium frame
232 × 171 cm

The Goldberg Variations, Aria,
BWV 988, 1741, Johann Sebastian Bach
(Glenn Gould, 1981), 2007
Two-channel video installation,
b/w, sound
2:58 min

Untitled (Studio Roll, 1970), 2009
Single-channel video projection
on transparent screen, b/w, sound
146 × 122 cm
0:59 min

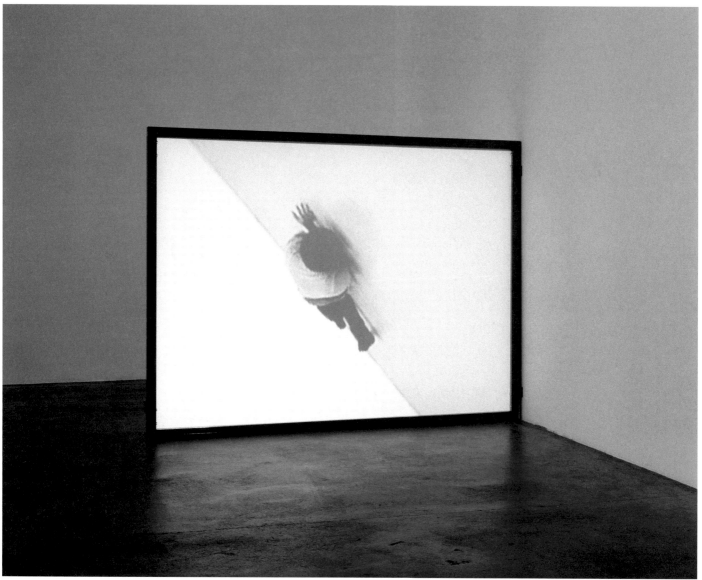

MANUELA LEINHOSS

1973 geboren in Meerane, Deutschland,
lebt und arbeitet in Berlin, Deutschland
**1973 born in Meerane, Germany,
lives and works in Berlin, Germany**

www.mickyschubert.de
www.raebervonstenglin.com

Die skulpturalen Objekte von Manuela Leinhoß bestehen aus Gips, Holz, Eisen oder Karton, Materialien also, die für ein eher klassisches Verständnis von Skulptur stehen. Draht, Stoff, Spachtelmasse, Papier und kleine Fundstücke schaffen eine poetisch-elegante Formensprache, die jedoch sichtbare Spuren des Arbeitsprozesses zulässt. Formal gesehen, sind Leinhoß' Werke möbelartige Skulpturen, Gebilde, die Kulissen ähneln, und surrealistische Architekturmodelle: *The Softer You Play it, the Stronger it Gets* (2007) ist ein stelenartiges Schrankobjekt, das mit Vitrinenelementen, Ablageflächen und einem Rollo versehen ist, Elemente, die Privates und Öffentliches anzeigen. Die Idee von Schubfächern, Kästen oder Vitrinen ohne eine wirkliche Funktion nimmt auch *The Box is Only Temporary* (2008) auf, dessen Titel sich auf eine Zeile aus einem Gedicht von Sylvia Plath bezieht. Daneben entstehen Wandarbeiten und autonome Objekte wie *Ajar* (2008), die vom Betrachter umschritten werden sollen. Ihre Präsentation eröffnet einen Dialog mit dem umgebenden Raum, anderen Werken und auch dem Betrachter. Denn bei aller formalen Strenge laden einige Arbeiten durch Öffnungen oder Griffe zur Annäherung ein.

Gleichzeitig betreibt Leinhoß durch Bezüge zur Kunst- und Literaturgeschichte eine Auseinandersetzung mit der Moderne, deren ästhetischem Vokabular und Materialität. Bei aller formalen Reduktion machen die Titel inhaltliche Assoziationsangebote, die jedoch niemals eindeutig dechiffrierbar sind. Einige Wandarbeiten, zum Beispiel *Anonym* oder *Cri* (beide 2007), erinnern an die Minimal Art, obwohl sie deren industrielle Ästhetik bewusst vermeiden oder sich zu rätselhaft möbelartigen Objekten wie *A Formal Feeling Comes* (2007) entwickeln. *Kopf* (2007) dagegen erinnert unverkennbar an Constantin Brancusi. Das fragile Werk *Fin de siècle* (2007) verrät schon im Titel Leinhoß' Inspiration durch diese Epoche, in der Künstler und die Ideen von Dekadenz und *L'art pour l'art* gefeiert wurden. Leinhoß, die mit Künstlerinnen wie Michaela Eichwald und Thea Djordjadze zusammengearbeitet hat, entwickelt ihr Werk aus diesen künstlerischen Referenzen. Dies wird im Künstlerbuch *A Formal Feeling Comes* deutlich, in dem sie eigene Arbeiten in Bezug zu Werken anderer Künstler, zu einem Roman aus der Fischer-Reihe „Neue Frau" oder zu Rainer Maria Rilkes „Malte Laurids Brigge" setzt und somit selbst ein erstes Resümee ihrer künstlerischen Arbeit zieht.

Manuela Leinhoß's sculptural objects consist of plaster, wood, iron, or cardboard – materials, that is to say, that stand for a fairly classical conception of sculpture. Wires, fabrics, putty, and little found objects form a poetical and elegant visual language that nonetheless tolerates visible traces of the creative process. In formal terms, Leinhoß's oeuvre includes objects such as furniture-like sculptures, structures resembling stage sets, and Surrealist architectural models: *The Softer You Play it, the Stronger it Gets* (2007), a wardrobe-object suggestive of a stele, features glass showcase elements, sideboards, and a roller blind, elements that indicate the presence of private as well as public matters. The idea of drawers, boxes, or display cases without real function returns in *The Box is Only Temporary* (2008) – the title refers to a line in a poem by Sylvia Plath. Leinhoß also creates wall works and autonomous objects such as *Ajar* (2008), which the beholder is invited to walk around. Their presentation opens a dialogue with the surrounding space and other works as well as the beholder; for despite their formal rigour, some works invite the viewer to approach them by presenting openings or handles.

At the same time, Leinhoß uses references to the history of art and literature in pursuit of a critical engagement with modernism, its aesthetic vocabulary and its material features. Despite the formal reduction of her works, the titles offer possible associations on the level of content, although they can never be decoded to produce an unambiguous reading. Some wall works, such as *Anonym* or *Cri* (both 2007), recall Minimal Art even as they deliberately avoid its industrial aesthetic, sometimes developing into enigmatically furniture-like objects such as *A Formal Feeling Comes* (2007). *Kopf* (2007), by contrast, is unmistakably reminiscent of Constantin Brancusi. The fragile work *Fin de siècle* (2007) betrays in its very title the inspiration Leinhoß draws from this era, which celebrated its artists and the ideas of decadence and *l'art pour l'art.* Leinhoß, who has collaborated with artists such as Michaela Eichwald and Thea Djordjadze, develops her work out of these artistic references, as is evident in the artist's book *A Formal Feeling Comes*, where she relates her own works to those of other artists, to a novel from Fischer Verlag's 'New Woman' series, or to Rainer Maria Rilke's 'Malte Laurids Brigge', taking stock of her oeuvre to date.

David Riedel

A Formal Feeling Comes, 2007
Plaster, wood, wire, lacquer
123.5 × 40 × 63.5 cm

Capable, 2010
Plaster, wood, terracotta,
cable, dispersion paint, lacquer
Dimensions variable

Vertiefen, 2010
Wood, papier-mâché,
dispersion paint
150 × 136 × 13cm

Ohne Titel, 2007
Plaster, wood, lacquer
30 × 31 × 7 cm

Entering into, 2010
Plaster, wood, papier-mâché,
dispersion paint, lacquer
105.5 × 77.5 × 23cm

Become, 2008
Plaster, wood, terracotta, casein paint,
lacquer, modelling clay, papier-mâché
40 × 52 × 34 cm

DANIEL LERGON

1978 geboren in Bonn, Deutschland,
lebt und arbeitet in Berlin, Deutschland
**1978 born in Bonn, Germany,
lives and works in Berlin, Germany**

www.alminerech.com
www.andersen-s.dk
www.christianlethert.com
www.galerieandreashuber.at

Das Werk von Daniel Lergon steht exemplarisch für eine junge Generation von Künstlern, die sich mit dem oft totgesagten Medium Malerei auseinandersetzt. Seine monumentalen Bilder erscheinen ebenso vertraut wie rätselhaft, sie erweisen sowohl der Farbfeldmalerei als auch der informellen Abstraktion ihre Reverenz und wirken im gleichen Moment eigenständig und im besten Sinne zeitgenössisch. Denn obwohl ihr Formenvokabular durchgehend abstrakt ist, lässt Lergon Assoziationen an im 21. Jahrhundert präsente Bildwelten zu: kosmische Phänomene wie z. B. Spiralnebel oder Pulsare. Dabei geht es ihm nicht um die Bebilderung von astronomischen oder physikalischen Phänomenen, sondern um künstlerische Formgebung: Vielleicht auch deshalb bleiben seine Bilder unbetitelt.

Ausgeführt sind sie gleichermaßen opulent wie minimalistisch. Die gestisch aufgetragenen, an ihren Rändern ausfransenden Farbfelder und Farbbahnen scheinen vor monochromen Hintergründen zu schweben oder aus diesen hervorzubrechen. Diese ambivalente Spannung von Form und Farbe, die von subtil abgestuften Schattierungen zu intensiven Kontrasten reicht, wird durch die Materialität der Bilder unterstützt: Bisweilen lassen fluoreszierende Leinwände und Farben oder transparente Lacke matte oder das Licht prismatisch reflektierende Flächen entstehen. Souverän inszeniert Lergon auf diesen Bildern das Licht, dessen Regie er sodann auf den Betrachter überträgt. Retroreflektive Leinwände lassen um seine Schatten ein aureolenhaftes Leuchten entstehen, das durch den sogenannten Heiligenschein-Effekt ausgelöst wird. Durch die Interaktion des Betrachters, die Bewegung seines Schattens, entsteht ein auratisch aufgeladener „Eigenraum" (Gregory Carlock) vor diesen Bildern.

Optische Phänomene und deren Rezeption bilden einen Subtext, aus dem Lergon ein hohes Maß an Schönheit und Poesie entwickelt. Dieses Konzept führt er in den programmatisch wirkenden Titeln seiner Ausstellungen fort: So thematisierte er zum Beispiel in *Oktave* (2006) das Spektrum der Farben oder in *nimbi* (2008) das Wechselspiel von Licht und Oberfläche. Damit führt Lergon die kunsthistorische Beschäftigung mit Licht, hier nun als physikalische und künstlerische Sensation, fort und nutzt es als eine Erweiterung der Malerei.

Daniel Lergon is an exemplary representative of a generation of young artists who engage with a medium that has been declared dead many times: painting. His monumental pictures strike the beholder as both familiar and enigmatic; paying homage to Colour Field painting as well as the abstraction of the Informel, they nonetheless have their own distinctive style and are contemporary in the best sense of the word. For although the formal vocabulary is abstract throughout, Lergon allows the beholder to associate imagery recognisable to 21st-century eyes: cosmic phenomena, spiral galaxies, or pulsars. The aim, however, is not to illustrate astronomic or physical phenomena but to create artistic form: another reason, perhaps, why his pictures remain untitled.

The execution is opulent and minimalistic at once. The fields and stripes of colourful paint, applied with gestural brushstrokes and fraying along the edges, seem to float in front of, or to burst from, monochrome backdrops. This ambivalent tension between form and colour, ranging from subtly graded tints to intense contrasts, is sustained by the material facture of the paintings: occasionally he uses fluorescent canvases and paints; transparent lacquers engender matte surfaces, while others reflect light in prismatic refraction. With perfect poise, Lergon stages light itself in these pictures, leaving the director's chair to the beholder. Retroflective canvases generate an aureola-like luminescence around shaded areas, caused by what is called the nimbus effect. The interaction with the beholder, the movement of his shadow, produces an auratically charged 'Eigenraum' (Gregory Carlock) in front of these pictures.

Optical phenomena and the ways they have been perceived constitute a subtext out of which Lergon develops a great deal of beauty and poetry. This concept extends into the titles of his exhibitions, which suggest programmatic ideas: in *Oktave* (2006), for example, he examined the colour spectrum; in *nimbi* (2008), the interplay between light and surface. Lergon thus continues the art-historical study of light, here in the form of a physical and artistic sensation, using it as a powerful extension of painting.

David Riedel

Untitled, 2008
Lacquer on retroreflective fabric
300 × 300 cm

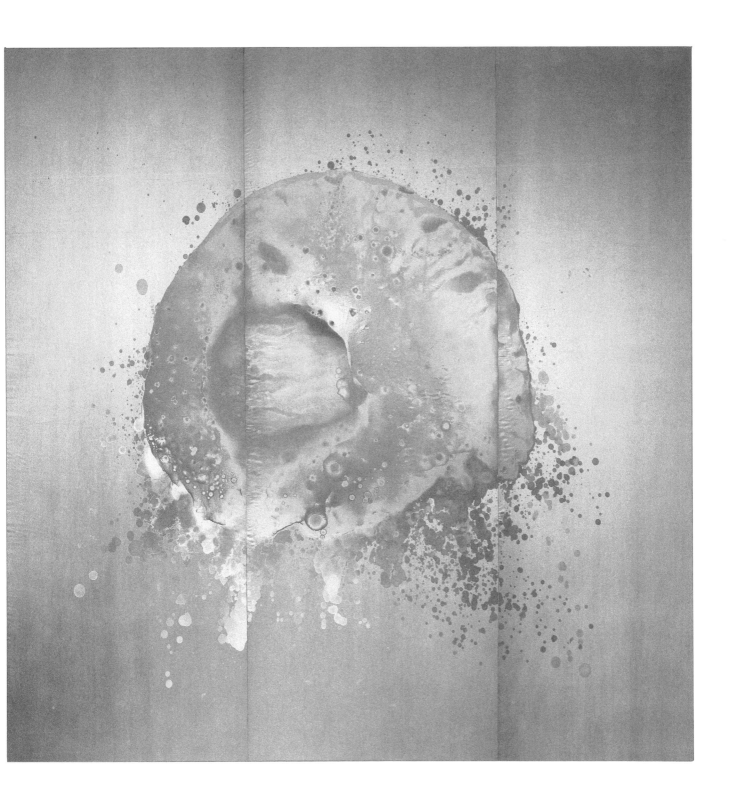

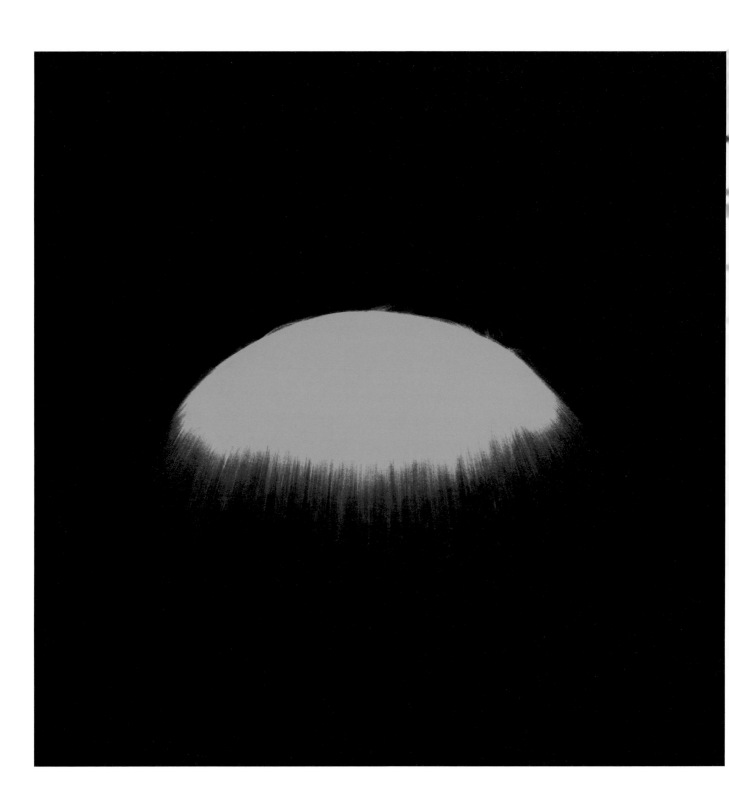

Untitled, 2008
Acrylic paint on fabric
200 × 200 cm

Untitled, 2007
Lacquer on fabric
250 × 250 cm

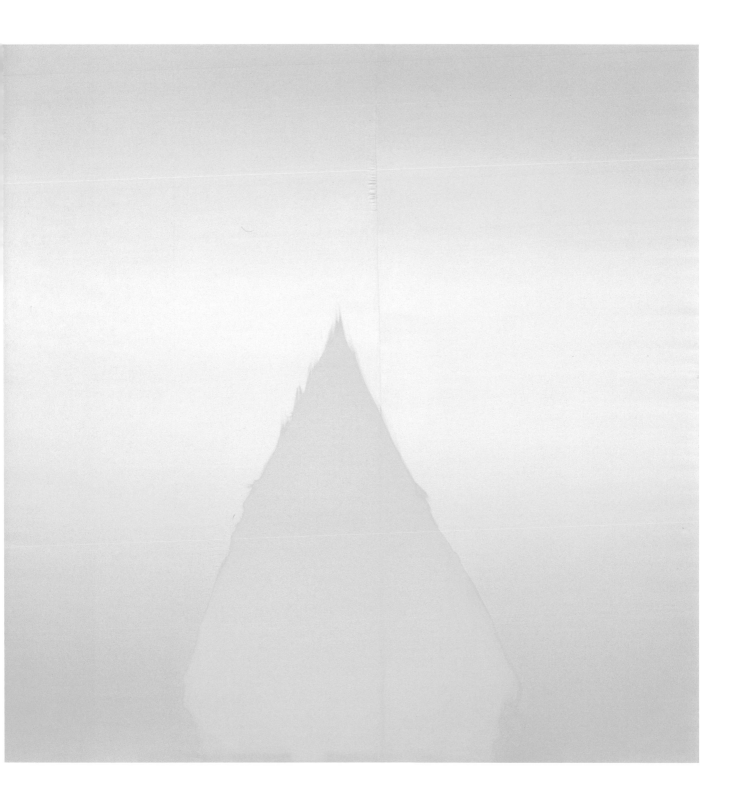

DAVID LIESKE

1979 geboren in Hamburg, Deutschland, lebt und arbeitet in Tel Aviv, Israel, und Berlin, Deutschland
1979 born in Hamburg, Germany, lives and works in Tel Aviv, Israel, and Berlin, Germany

www.alexzachary.com
www.corvi-mora.com

Die Installationen, Objekte und Fotografien von David Lieske entstehen in der Auseinandersetzung mit der Avantgarde der 1960er Jahre. Minimal Art und Konzeptkunst bilden das geistige und formale Fundament seiner Werke. Formale Beziehungen zur Konzeptkunst spiegeln sich in der Wahl von Readymades, Dokumenten, Schwarz-Weiß-Fotografien und Neonschriftröhren und im Einsatz komplexer Werktitel. In der Ausstellung *Atlantis* (2006) beschäftigt sich Lieske mit Platons Fiktion eines idealen Staates: Bauzeichnungen für gewollt ruinöse Mauern, gerahmte Frontispize und Umschlagblätter literarischer Abhandlungen zum Thema sowie ein Stapel Mauersteine ermöglichen eine facettenreiche Reflexion über Atlantis und zugleich über das Erschaffen und Zerstören als geistesgeschichtliche Idee.

Daneben erweitert Lieske die Konzeptkunst um eine ihr unbekannte emotionale und persönliche Tiefe: Für die „Texte zur Kunst"-Edition *Navigating the Atmosphere* (2007) beauftragte er einen Kalligraphen, eine Karte mit einem Hinweis auf die Liebe des Künstlers zum Empfänger zu versehen. Andere Werke beziehen sich auf H.P. Lovecraft oder Pier Paolo Pasolini. Dieser ironisierte den Namen seines friaulischen Heimatortes Casarsa zu *Case arse* (verbrannte Häuser). Lieske setzt ein Reithindernis ins Zentrum seiner Installation: Zusätzliche Barrierestangen machen aus dem nutzbaren Objekt jedoch eine das Readymade ad absurdum führende minimalistische Skulptur; die Kombination mit Fotografien der friaulischen Landschaft aus einer Pasolini-Monografie eröffnet einen Dialog zwischen zwei Symbolen ländlicher Lebensweise.

In einer Ausstellung 2009 beruft sich Lieske auf den bis 2004 verschollen geglaubten *Afrikanischen Stuhl* von Marcel Breuer und Gunta Stölzl. Mittels bunt gemusterter Stoffe schafft er ein afrikanisch anmutendes Interieur, in dem das Motiv des Reithindernisses erneut auftaucht. Das konzeptuelle Interesse an der Barriere, am Überwinden einer Vielzahl von inhaltlichen Bezügen, ist symptomatisch für Lieskes Kunst. Denn bei aller Wichtigkeit einer ästhetischen und formalistisch interessierten Ausführung verlangt seine Kunst vom Betrachter eine intellektuelle Auseinandersetzung, die durch bewusst eingesetzte Selbstreferenzialität und gezielte Verschlüsselung eigentlich alltäglicher Motive erschwert wird.

David Lieske's installations, objects, and photographs are the products of his critical engagement with 1960s avant-garde art. Minimal and Conceptual Art form the intellectual and formal foundations on which his works rest. The formal kinship with Conceptual Art is reflected in his choice of techniques such as readymades, documents, black-and-white photographs, and fluorescent-light lettering, as well as the use of complicated titles. In his exhibition *Atlantis* (2006), Lieske examines Plato's fiction of an ideal state: architectural plans for deliberately ruinous walls, framed frontispieces and book covers from literary treatises on the subject, and a stack of bricks enable a multifaceted reflection about Atlantis and at once also about the idea of creation and destruction in intellectual history.

In other works, Lieske adds heretofore unknown emotional and personal depth to Conceptual Art: for the edition *Navigating the Atmosphere* (2007) he conceived for 'Texte zur Kunst', he commissioned a calligrapher to send a card inscribed with a note about the artist's love for the recipient. Other works refer to H.P. Lovecraft or Pier Paolo Pasolini. The latter ironically distorted the name of his Friulian hometown Casarse into *Case arse* (burnt-down houses). Lieske puts a horse-riding obstacle at the centre of his installation: additional barrier bars, however, turn the usable object into a minimalist sculpture that reduces the readymade ad absurdum; the combination with photographs of the Friulian landscape taken from a monograph about Pasolini opens up a dialogue between two symbols of rural life.

In an exhibition shown in 2009, Lieske invokes Marcel Breuer and Gunta Stölz's *African Chair,* which was believed to have been lost until 2004. Using colourful patterned fabrics, he creates an interior setting suggestive of Africa, in which the motif of the riding obstacle reappears. The conceptual interest in the barrier, in overcoming a multiplicity of references on the level of content, is symptomatic of Lieske's art. For important though an execution whose main interest is in aesthetic and formal aspects may be, his art demands that the beholder engage it on an intellectual level, a process complicated by the deliberate deployment of self-reference and the purposive encryption of motifs that are otherwise perfectly mundane.

David Riedel

Atlantis, 2006
Exhibition view, Galerie Daniel Buchholz, Cologne

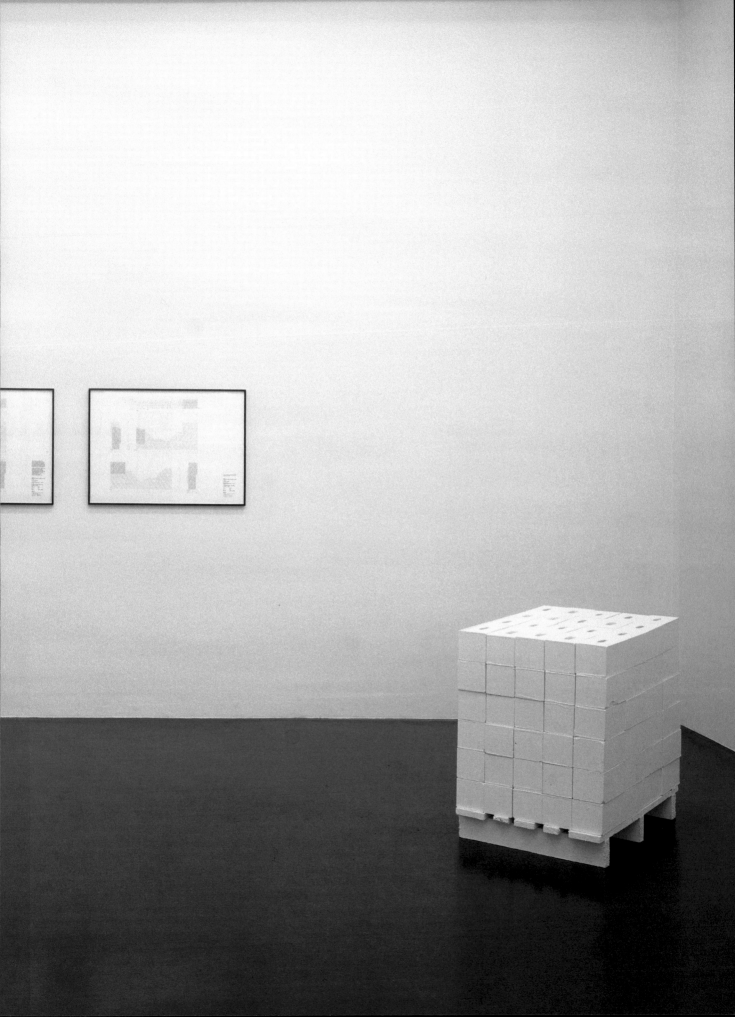

Der afrikanische Stuhl von Marcel Breuer und
Gunta Stölzl aus der Anfangszeit des Bauhauses
80 Jahre verschollen geglaubt nun aufgefunden
und erstmals praesentiert, 2009
Exhibition view, Corvi-Mora, London

Form I (The Value of Things), 2008
Bronze
10 × 300 × 10 cm

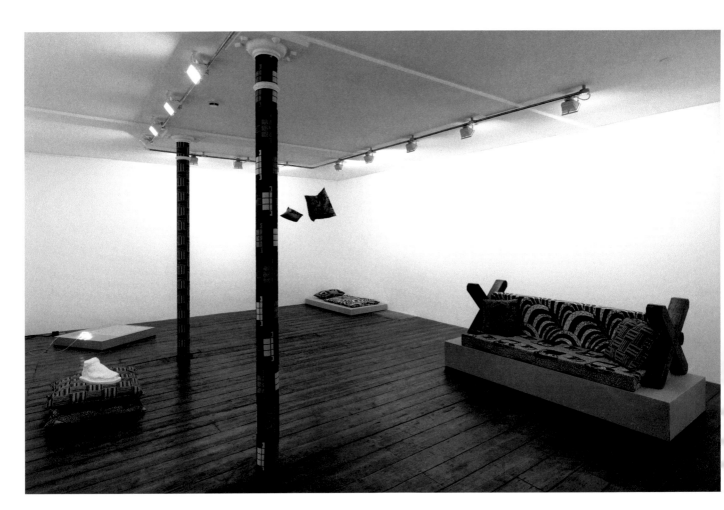

Case Arse, 2004
Cavaletti poles, posts, plastic caps, metal rests
Dimensions variable
Installation view, Kunstverein Hamburg

Case Arse, 2004
Exhibition view, Rheinschau, Cologne

DAVID MALJKOVIĆ

1973 geboren in Rijeka, Jugoslawien,
lebt und arbeitet in Zagreb, Kroatien
**1973 born in Rijeka, Yugoslavia,
lives and works in Zagreb, Croatia**

2010 29th Bienal de São Paulo – *Há
sempre um copo de mar para o homem
navegar / There is always a cup of sea
to sail in*
2009 11th International Istanbul
Biennial – *What Keeps Mankind Alive?*
2008 5th berlin biennial for contemp-
orary art – *When things cast no shadow*
2007 52nd International Art Exhibition /
La Biennale di Venezia, Croatian Pavilion

www.annetgelink.nl
www.georgkargl.com
www.metropicturesgallery.com
www.spruethmagers.com

In seinen Filmen, Zeichnungen, Collagen und Installationen findet David Maljković vielschichtige Bilder für das anachronistische Nachleben der Moderne in der Jetztzeit des ehemaligen Jugoslawiens, die über diesen spezifischen Kontext indes weit hinauszuweisen vermögen: Ausgehend von persönlichen Erinnerungen, aber auch von historischem Material, evoziert der kroatische Künstler die utopischen Aspirationen, die sich auch unter realsozialistischen Vorzeichen einstmals mit abstrakten, vermeintlich universal gültigen Formensprachen verbanden, um ihr zeitgenössisches Potenzial fern jeder nostalgischen Anwandlung zu aktivieren.

Geschichte wird von Maljković nicht nur jenseits des westlichen Kanons und der offiziellen Erinnerungskultur der neuen Nationalstaaten Osteuropas rekonstruiert, sondern angesichts postsozialistischer Tendenzen zur kollektiven Amnesie ästhetisch reanimiert. So führt eine Serie von Collagen unter dem Titel *Lost Memories from these Days* (2006–2008) auf das in den 1960er Jahren errichtete Weltausstellungsgelände in Zagreb. Maljković konfrontiert Aufnahmen des heute heruntergekommenen Areals mit Ansichten aus dessen kurzer Blütezeit; in diesen palimpsestartigen Arrangements entsteht so das Bild einer heute fast vergessenen ehemaligen Zukunft.

In Maljkovićs *Retired Form* (2008) fängt die Kreisfahrt der Kamera hingegen Rentner ein, die sich um eine den Opfern des Zweiten Weltkriegs gewidmete abstrakte Plastik des jugoslawischen Bildhauers Vojin Bakić in einem Zagreber Park versammelt haben. Während des Balkankrieges fielen Bakićs modernistische Werke zunehmend dem Vergessen anheim. In dem 16-mm-Film in Schwarz-Weiß spiegelt sich die Sonne in dem metallisch glänzenden Monument, das nunmehr nur sich selbst zu kommemorieren scheint; die geometrische Form blendet ihre Betrachter und wirkt, der Titel deutet es an, wie aus einem lang währenden Ruhestand geweckt.

Die Kunst von Maljković sucht nicht den ödipalen Konflikt mit avantgardistischen Übervätern. Vielmehr stellt sie in oftmals entrückt wirkenden, statischen Bildern die Frage nach der aktuellen Relevanz des Erbes einer Moderne, die längst schon kein Bollwerk mehr ist, das es zu stürmen gälte, sondern eine Ruinenlandschaft mit aus heutiger Perspektive neuerlich zu realisierenden ästhetischen Qualitäten und zukünftigen Versprechen.

In his films, drawings, collages, and installations, David Maljković finds complex images for the anachronistic afterlife modernism leads in the present day of the former Yugoslavia – yet the images gesture far beyond this specific context: based on personal recollections, but also on historic materials, the Croatian artist evokes the utopian aspirations once associated, under the aegis of Real Socialism no less than in the West, with abstract and allegedly universal formal vocabularies, activating their contemporary potential without the slightest tinge of nostalgia.

Maljković not only reconstructs history beyond the western canon and the official culture of remembrance in the new nationstates of Eastern Europe; he also brings this history to new aesthetic life in the face of post-socialist tendencies toward collective amnesia. A series of collages entitled *Lost Memories from these Days* (2006–2008), for instance, takes us to the World Expo area built in Zagreb during the nineteen-sixties. Maljković confronts pictures of the compound in its current dilapidated state with views from its brief heyday; what emerges from the resulting palimpsest-like arrangements is the image of an all-but-forgotten former future.

In Maljković's *Retired Form* (2008), by contrast, the camera, moving in a circle, captures retirees who have assembled in a Zagreb park around an abstract sculpture created by the Yugoslav sculptor Vojin Bakić, a monument to the victims of World War II. During the Yugoslav Wars, Bakić's modernist works increasingly fell into oblivion. In Maljković's black-and-white 16mm film, the glittering metal monument, reflecting the sun, no longer seems to commemorate anything but itself; its geometric shape blinds the beholders and, as the title suggests, looks as though it had been brought back from many years of retirement.

Maljković's art does not seek out an Oedipal conflict with the founding fathers of the avant-garde. In images that are often static and seemingly lost in reverie, it instead raises the question of the contemporary relevance of a modernist inheritance that has long ceased to be a bastion worthy of being stormed – it has become a landscape littered with the ruins of aesthetic qualities and future promises that deserve an attempt at realising them afresh in a contemporary perspective.

André Rottmann

Lost Review, 2008
Collage
32.5 × 23.5 cm

Fabrication:

Tours / foreuses / fraiseuses / marteaux pneumatiques / etaux limeurs / meuleuses / machines à fileter / équipement pour machines outils / pompes dentées / engrenages / accouplements élastiques

DEMANDEZ DES OFFRES DÉTAILLÉES

FABRIQUE DE MACHINES OUTILS

· PRVOMAJSKA ·

ZAGREB · ŽITNJAK, B. P. 102, TÉLÉPHONE: 41-755, TÉLÉGRAMME: PRVOMAJSKA ZAGREB

Lost Memories from these Days, 2007
Collage
30 × 22.5 cm

Lost Memories from these Days, 2007
Collage
30 × 22.5 cm

Lost Memories from these Days, 2008
Collage
30 × 42 cm

Scene for New Heritage 2, 2006
DVD, colour, sound
6:06 min

VICTOR MAN

1974 geboren in Cluj-Napoca, Rumänien,
lebt und arbeitet in Cluj
**1974 born in Cluj-Napoca, Romania,
lives and works in Cluj**

2008 Busan Biennale – *Expenditure*
2007 52nd International Art Exhibition /
La Biennale di Venezia – *Think with the
Senses – Feel with the Mind*

www.gladstonegallery.com
www.johnengalerie.com
www.plan-b.ro

In Welt und Werk von Victor Man sind die Lichter gelöscht worden. Seine Bilder scheinen mit einem dünnen schwarzen Baumwollstoff bedeckt zu sein, mit einer hauchdünnen Schicht Grisaillemalerei, die wie jene Theatervorhänge funktioniert, die für das Publikum zunächst opak aussehen und erst dann transparent werden, wenn die Bühne allmählich beleuchtet wird. Aus einem Bild in dunklen Grau- und Olivtönen tritt zögerlich wie eine Morgendämmerung ein Klassiker der alten Kunst, die Grablegung Christi (*The Deposition*) hervor; eine Figur in Lederkleidung verschwindet in *Untitled (Shaman II)* im Schatten (beide 2008); währenddessen gibt in einem anderen unbetitelten Bild ein Paar glitzernder roter Schuhe, die der Dorothy aus dem „Zauberer von Oz" würdig wären, einen Hinweis darauf, woher der Künstler seine stark verkürzten und verborgenen Anspielungen bezieht.

Auch Mans skulpturale Objekte erschließen sich nur langsam, ob es sich dabei um nicht monumentale Betonblöcke oder um komplexere Verbindungen von Stahlarmaturen mit angeeigneten Readymades und ausgestopften Tieren handelt. Das tiefe Gefühl von Isolation und Unruhe, das die einzelnen Arbeiten hervorrufen, schwindet auch dann nicht ganz, wenn die Konstruktionen und Bilder zu Konstellationen arrangiert werden, in denen sich jedes einzelne Element aus den Verständnislücken und anspielungsreichen Aussparungen der anderen zu speisen scheint. Vielleicht steigern Mans transsilvanisches Erbe und sein Leben im postkommunistischen Rumänien die Wirkung seines starken Gebräus aus Mythen und Erinnerungen. Ebenso wichtig sind ihm jedoch seine Untersuchungen zur kunsthistorischen Esoterik, wie etwa in seiner Ausstellung *If Mind Were All There Was* in der Hayward Gallery 2009; darin ging er der Frage nach, warum im 17. Jahrhundert in ein Fresko von Piero della Francesca der Name „Giuseppe Sacchi" eingeritzt worden sein könnte, was eine Kettenreaktion von Fantasien und Vermutungen über diesen Künstler auslöste. Die eingangs erwähnte mittelalterliche Finsternis ist jedoch nicht gnadenlos und unerbittlich, sondern wird von lichten Momenten – Andeutungen von Figuren oder halberinnerten Fotos – und sogar von einer gelegentlichen Erlösung unterbrochen, wie in der Neon-und-Text-Arbeit von 2008, die durch den einfachen Gebrauch eines Kommas optimistisch auf ein Fortleben hindeutet: *Untitled (We Die,)*.

The lights have been turned off in Victor Man's world and work. His paintings seem to be covered by a black scrim: a layer of gauzy grisaille paint that acts in the same way as those drop curtains commonly used in theatres, which at first appear opaque to the audience, but then turn transparent when the lights from the stage slowly come up. A version of that Old Masterly standard, The Deposition of Christ, emerges haltingly like a dawn from a 2008 canvas of dark greys and olive tones (*The Deposition*); a leather-clad figure disappears into shadow in *Untitled (Shaman II)* (both 2008); while a pair of glittering red shoes worthy of Dorothy in the 'Wizard of Oz' (in another untitled painting) hints at where the artist might have found his heavily cropped and concealed reference points.

Man's sculpted objects reveal themselves slowly, too, whether they are unmonumental concrete blocks or more complex amalgamations of steel armature with appropriated readymades and taxidermied animals. The profound sense of disconnect and disquiet provoked by these works in isolation is only partially dispelled when the constructions and paintings are installed together into constellations, in which each disparate element seems to feed off the lacunae and suggestive gaps of the other. Perhaps Man's Transylvanian heritage and continued existence in a post-communist Romania add weight to his potent witches' brew of myth and memory, but just as important to him are his enquiries into art-historical esoterica, as in the 2009 exhibition *If Mind Were All There Was* in the Hayward Gallery, which explored why a fresco by Piero della Francesca might have been graffitied over in the 17th century with the name 'Giuseppe Sacchi', setting off a chain-reaction of connections and claims for the artist. The aforementioned gothic darkness is not remorselessly relentless, however, punctuated as it is by moments of clarity – allusive figures or half-remembered photos – and even the occasional redemption, as in the neon and text piece of 2008 that hints at an optimistic afterlife through the simple use of a comma: *Untitled (We Die,)*.

Ossian Ward

Ubiquitous You, 2008
Oil on linen mounted on wood with pelt
74 × 41 cm

Archival Luster, 2008
Oil on linen on wood, beads, screen,
photocopy, plastic sleeve
84.5 × 42 cm

*Untitled (After St. Anthony the Hermit Tortured
by the Devils, 1423, Sassetta),* 2008
Oil on linen mounted on wood
24 × 39 cm

Untitled (We Die,), 2008
Neon, vinyl
25 × 55 × 4 cm
Installation view, GAMeC –
Galleria d'Arte Moderna
e Contemporanea di Bergamo

*Untitled (Minded Subsequent
Practices)*, 2007
Mixed media
Dimensions variable

JÁN MANČUŠKA

1972 geboren in Bratislava, Tschecho-
slowakei, lebt und arbeitet in Prag,
Tschechische Republik, und Berlin,
Deutschland
**1972 born in Bratislava, Czechoslovakia,
lives and works in Prague, Czech
Republic, and Berlin, Germany**

2006 4th berlin biennial for contem-
porary art – *Of Mice and Men*
2005 51st International Art Exhibition /
La Biennale di Venezia, Czech and Slovak
Pavilion
2002 Manifesta 4, European Biennial of
Contemporary Art, Frankfurt / Main

www.janmancuska.com

www.andrewkreps.com
www.georgkargl.com
www.meyer-riegger.de

Ján Mančuška beschäftigt sich mit Fragen
von Zeit, Erinnerung, Selbstreflexivität, Er-
zählstrukturen und den Konventionen des Ki-
nos, die diese verbreiten. Er fand um die Mitte
der 2000er Jahre zunächst mit textbasierten
Installationen internationale Anerkennung.
Dabei verwendete er wahre, oftmals emotio-
nal aufgeladene Geschichten, die ihm Freun-
de und Familienmitglieder berichtet hatten
und die er in eine räumliche Form brachte,
um relativistische, multiple Perspektiven und
nichtlineare Methoden des Erzählens wider-
zuspiegeln. Diese untersuchte er in Arbeiten
wie *True Story* (2005), einem Vorfall mit ras-
sistischem Hintergrund zwischen einer Frau,
ihrem Freund und einem Schwarzen, von dem
sie annahm, dass er sie attackieren würde.
Der Künstler hängte Wörter aus Aluminium-
streifen in Brusthöhe als lockeres, asymme-
trisches Netz so in einen Raum, dass sich die
Streifen an den Punkten kreuzten, wo sich die
verschiedenen Perspektiven überschnitten.
Die Betrachter waren eingeladen, die brüchi-
ge Erzählung räumlich zu erfahren.
In den vergangenen Jahren wandte sich der
Künstler immer ausdrücklicher dem Film
und dem Theater zu, um ähnliche Fragestel-
lungen und Erzählkonventionen auszuloten.
Reverse Play (2008/2010) zum Beispiel ist
ein existenzielles Drama über eine verpasste
Gelegenheit; es wird von Tänzern rückwärts
aufgeführt, während eine Stimme aus dem
Off den Inhalt des Dramas linear wiedergibt,
sodass im Verlauf des Stücks Vergangenheit
und Gegenwart zeitweise aufeinandertreffen
und sich unweigerlich wieder trennen. Das
zweiteilige Video *Reflection* (2009) besteht
aus filmischen Übergängen und ungereimten
Erinnerungen von Beckett'scher Schlagfer-
tigkeit, die mit Godard'scher Selbstreflexi-
vität präsentiert werden (auf die Sätze folgt
ein „sagte er" oder „sagte sie"). Darin denken
zwei Paare über Ereignisse nach, die entwe-
der nie stattfinden oder deren lächerliche
Bruchstückhaftigkeit sich niemals vervoll-
ständigen lässt. Doch trotz seiner analyti-
schen Betrachtungen über die Strukturen von
Geschichten und darüber, wie diese Struk-
turen die Geschichten selbst beeinflussen,
besitzt Mančuškas Werk ein seltenes und un-
widerstehliches Pathos.

Preoccupied with questions of time, memo-
ry, self-reflexivity, narrative structures, and
the cinematic conventions that propagate
them, Ján Mančuška originally came to in-
ternational recognition in the mid-noughties
with his text-based installations. For these
works, the artist took true stories, often of
an emotionally charged nature, as relayed by
friends and family and spatially formalised
them to reflect relativistic, multiple per-
spectives and non-linear storytelling meth-
odologies. This was explored in works such
as *True Story* (2005), a racially fraught epi-
sode between a woman, her boyfriend, and
a black man she thought was going to attack
her, where the artist hung words in alumini-
um strips at chest-height in a space – so that
the strips crisscrossed one another (picture
a loose, asymmetrical web) at those points
where the varying perspectives intersected,
thus inviting the viewer to spatially negotiate
the refracted narrative.
The past few years have seen the artist
turning more and more explicitly to film and
theatre to engage similar issues and narra-
tive conventions. *Reverse Play* (2008/2010),
for example, is an existential drama about
a lost opportunity, enacted by dancers in
reverse while a voiceover linearly narrates
the contents of the drama, the past and the
present periodically colliding and irrevers-
ibly sundering as the play proceeds. The
two-part video *Reflection* (2009) consists
of a Beckettian repartee of cinematic tran-
sitions and mnemonic irresolution, relayed
with Godardian self-reflexivity (phrases
are followed by 'he said' or 'she said'), in
which two different couples meditate on
events that either never happen or in which
memory's laughable lapses are never re-
solved. And yet for all his analytical medita-
tion upon the structures of stories and how
those structures shape the stories them-
selves, Mančuška's work possesses a rare
and compelling pathos.

Chris Sharp

*The Other (I asked my wife to blacken all
parts of my body I cannot see),* 2007
35mm film strips, light boxes,
aluminium bar
Dimensions variable

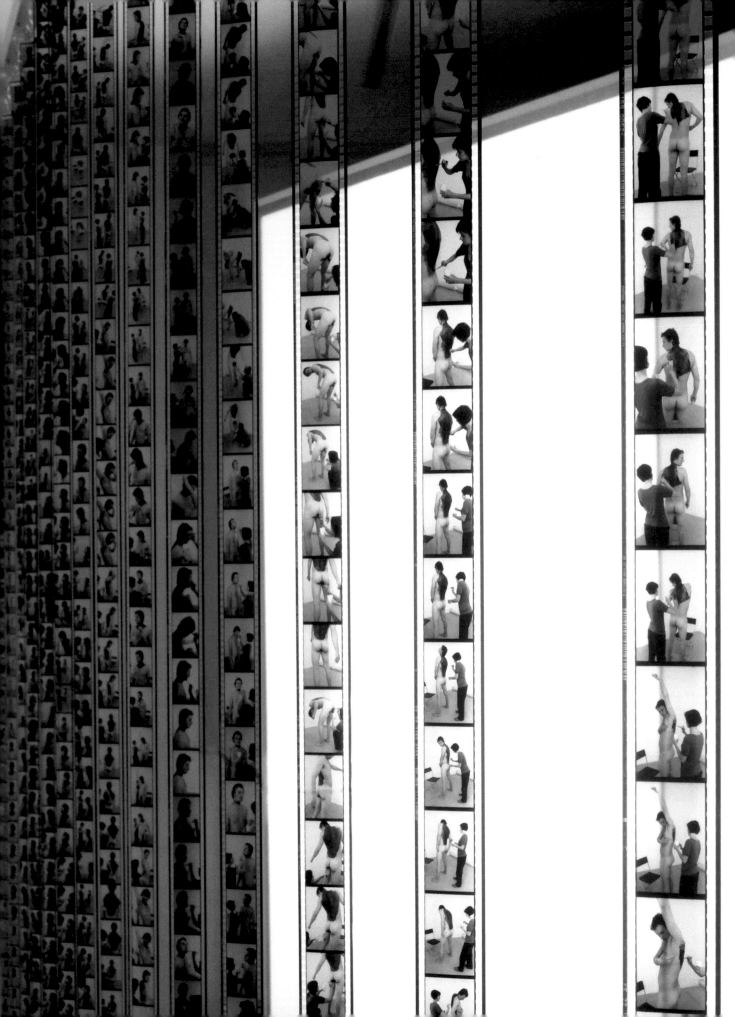

Reverse Play, 2008/2010
Live performance for five actors
and speaker in black box,
theatre space
40 min

20 Minutes After, 2006
Light projection, aluminium letters
on wires, hand writing on wall
Dimensions variable
Installation view, 4th berlin
biennial for contemporary art,
KW Institute for Contemporary Art

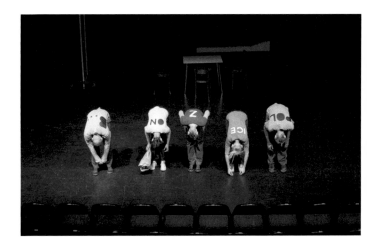

Somebody CALLED. She was home alone. She got ready to get DRESSED and go out. But now she HURRIED to THE next room where the phone was ringing. She PICKED UP the receiver. It was her sister calling that her father was in a hospital. He'd been unconscious all day before they found him. He'd suffered a brain stroke. SHE wasn't so surprised. She had seen it coming. She felt simply the kind of feeling brought on when something horrible happens. SOMEBODY could feel liberated by that. She thought for a while. THEN she got dressed and WENT outside. SHE went to the nearest SHOP. when it was her turn, she spoke to the salesman. It seemed as if she did not understand her. SHE repeated her request and eventually found what she wanted TO BUY. once again she was back outside on THE street. Then it came to her. She realized that she'd spoken Russian TO the saleswoman. She hadn't spoken Russian for at least thirty years back when she'd learned Russian at school. AND it would take a lot of work before she'd be able to put together a coherent sentence. Twenty minutes had elapsed since the PHONE rang. Before returning home she stood OUT on the street for a while. She was cold.

SOMEBODY CALLED SHE PICKED UP THEN WENT SHE HURRIED THE
THE PHONE AND OUT TO SHOP TO BUY

KRIS MARTIN

1972 geboren in Kortrijk, Belgien, lebt und arbeitet in Gent, Belgien
1972 born in Kortrijk, Belgium, lives and works in Ghent, Belgium

2010 Liverpool Biennial of Contemporary Art
2006 4th berlin biennial for contemporary art – *Of Mice and Men*

www.alminerech.com
www.johannkoenig.de
www.marcfoxx.com
www.sieshoeke.de
www.whitecube.de

Über dem Werk des konzeptuellen Künstlers Kris Martin liegt oft ein Gefühl von Endlichkeit. Eine fortlaufende Serie von Schlusspunkten, *Endpoints* (seit 2004), zeigt die letzten Punkte aus Erzählungen von Edgar Allan Poe, H. G. Wells, Thomas Mann und anderen Autoren; bei *100 Years* (2004) hingegen handelt es sich um eine Metallkugel, die 2104, exakt ein Jahrhundert nach ihrer Herstellung, explodieren wird (wie eine Inschrift auf ihrer Oberfläche versichert). Tatsächlich ist Zeit essenziell für Martin, dessen nahezu unablässige Beschäftigung mit Sterblichkeit und den flüchtigen Eigenschaften der Kunst seine bisherige Laufbahn bestimmt hat; sie führte ihn dazu, die Zahl seiner bislang erlebten Tage (*My Days are Counted,* 2005), die Vergeblichkeit der Zeitmessung (die sich ständig drehende, aber leer bleibende Flughafen-Anzeigetafel *Mandi III,* 2003) und die natürliche Entropie und Überalterung aller Dinge zu betrachten. Neben seinen spektakulären Installationen, bei denen beispielsweise ein ganzer Raum mit einem Heißluftballon oder mit riesigen Felsen gefüllt wurde (durch die Hinzufügung kleiner Kreuze auf ihren Gipfeln in Gebirge transformiert), hat Martin mit interaktiven Soundarbeiten und respektlosen Interventionen auch den Bereich der Performance betreten. So störte er bekanntlich das kommerzielle Getümmel einer Kunstmesse mit einer plötzlichen Lautsprecheransage einer grundlosen Schweigeminute: „For nobody. For nothing. Just one minute for yourself" (*Mandi XVI,* 2007). Martins ähnlich unbefangene Einstellung gegenüber älteren kulturellen Hervorbringungen zeigt sich auch in seinen handschriftlichen Herkulesarbeiten – darunter eine sich selbst auslöschende Abschrift von Franz Kafkas „Die Verwandlung" auf einer einzigen DIN-A4-Seite und eine 1.494-seitige Version von Dostojewskis Roman „Der Idiot", in der sein eigener Name den des Antihelden ersetzt – ebenso wie in seiner wiederholten Zerstörung und Restaurierung einer großen blauweißen chinesischen Porzellanvase (*Vase,* 2005). Die Vorstellung, dass Kunst nur für eine bestimmte Zeit gut ist – bis sie entweder verfällt, unmodern oder wirkungslos wird – teilt Martin unbedingt.

A sense of the finite hangs over much of the work of the conceptual artist Kris Martin. An ongoing series of *Endpoints* (since 2004) features the final full stops cut from stories by, e.g., Edgar Allan Poe, H. G. Wells or Thomas Mann, while *100 Years* (2004) is a metallic sphere that is set to explode in 2104, exactly a century after its manufacture (as an inscription on its surface assures). Time is indeed of the essence for Martin, whose almost constant interrogation of mortality and art's transient qualities has characterised his career so far and led him to consider his own number of days spent alive (*My Days are Counted,* 2005), the futility of timekeeping (the ever-flipping but blank departures board *Mandi III,* 2003), and the natural entropy and obsolescence of all things.
In addition to spectacular installations in which whole galleries have been filled with a hot-air balloon or enormous rocks (transformed into mountains by the addition of tiny crosses on their peaks), Martin has crossed into the performative arena in interactive sound pieces and insolent interventions – he famously disturbed the commercial hurly-burly of an art fair with a sudden tannoy announcement of a minute's silence, for no given reason: 'For nobody. For nothing. Just one minute for yourself' (*Mandi XVI,* 2007). Martin's similarly unintimidated stance towards previous cultures is affirmed by his Herculean efforts of handwriting – including a self-obliterating transcription of Franz Kafka's 'Metamorphosis' on a single A4 sheet and a 1,494-page version of Dostoyevsky's novel 'The Idiot', with his own name in place of the anti-hero's – as well as in his repeated smashing and restoration of a tall Chinese blue-and-white porcelain vase (*Vase,* 2005). The notion that art is only good for a certain period of time – before it either expires or becomes unfashionable or no longer potent – is one Martin strictly adheres to himself.

Ossian Ward

100 Years, 2004
Mixed media
Ø 20 cm

Still Alive, 2005
Bronze, silver-plated
Measures one-to-one to the artist's
skull, 18 × 13 × 10 cm

Vase, 2005
Chinese porcelain, glue
Height: 225 cm

Mandi III, 2003
Information flapboard, black metal
160 × 454 × 20 cm
Installation view, 4th berlin biennial
for contemporary art, St.-Johannes-
Evangelist-Kirche

ANNA MOLSKA

1983 geboren in Prudnik, Polen, lebt und
arbeitet in Warschau, Polen
**1983 born in Prudnik, Poland, lives and
works in Warsaw, Poland**

2008 5th berlin biennial for contem-
porary art – *When things cast no shadow*

www.broadway1602.com
www.fgf.com.pl

Jesus Loves Me, 2005
Video, b/w, sound
2:45 min

Das Video *W=F*s (work)* (2008) von Anna Molska gleicht einer Mischung aus Dokumentation und Beckett-Inszenierung. Eine Gruppe polnischer Arbeiter montiert auf einem schlammigen Feld eine gigantische Stahlkonstruktion und posiert nach getaner Arbeit für die Kamera. Der Anblick ähnelt Alexander Rodtschenkos 1936 entstandenen Aufnahmen „menschlicher Pyramiden", auf denen gestählte Sportler lebende Skulpturen bildeten – als Sinnbild der modernen Faszination für Kraft, Harmonie und Geometrie. Molskas Version ist hingegen betont unheroisch, die Arbeiter lächeln unsicher und wirken verloren. Auf der berlin biennale 2008 wurde das Werk gemeinsam mit *P=W:t (power)* (2007–2008) gezeigt: Aus dem Off prasseln Hunderte von weiß gestrichenen Bällen in eine mit roten Linien markierte Squashhalle. Im Zusammenspiel mit den Formen von Linie, Quadrat, Kugel erscheinen die unkontrolliert umherschießenden Bälle wie die performative Antwort auf die geometrische Strenge des russischen Konstruktivismus.

Wenn Molska in Arbeiten wie *Tanagram* (2006–2007) den Einfluss sowjetischer Propaganda und des Suprematismus auf die polnische Avantgarde reflektiert, untersucht sie immer auch Kraft- und Machtverhältnisse von Kunst- und Kulturproduktion. Die riesigen schwarzen Blöcke, die die beiden jugendlichen Gladiatoren zu einer Soundcollage aus Rote-Armee-Chören und Folkloreklängen im Studio herumschieben, lassen an Segmente eines gigantischen, dreidimensionalen Puzzles denken, das an das „Schwarze Quadrat" Kasimir Malewitschs erinnert. Es handelt sich im wahrsten Sinne um Machtblöcke, aus denen neue Formen gelegt werden. Wenn Molska in *The Weavers* (2009) mit schlesischen Bergleuten vor dem Hintergrund einer maroden Industrieanlage Passagen aus Gerhart Hauptmanns „Die Weber" neu einstudiert, wird der Kontrast zwischen dem im Stück aufgeführten revolutionären Weberaufstand von 1844 und der realen Resignation unter den Kumpeln deutlich. Die Video- und Performancearbeiten von Molska wirken auf den ersten Blick wie Endspiele der Moderne. Im Zeitalter gescheiterter Utopien und Ideologien werden die Dinge nacherzählt, nachgespielt, nachgebaut. Der ursprüngliche Kanon scheint auf der Strecke geblieben zu sein. Dennoch sind sie alles andere als absurd. Die tradierten Kunstformen, die Molska in immer wieder neuen Konstellationen kombiniert, bilden die Bausteine für eine Bühne, auf der gleichermaßen die Paradigmen der Moderne wie auch unserer heutigen Gesellschaft verhandelt werden.

Anna Molska's video *W=F*s (work)* (2008) resembles a mixture between a documentary and a Beckett production. A team of Polish workers assembles a gigantic steel structure in a muddy field; having completed their work, the workers pose for the camera. The scene is reminiscent of the 'human pyramids' Alexander Rodchenko captured in photographs made in 1936, in which athletes arranged their worked-out bodies in living sculptures – emblems of the modern fascination with strength, harmony, and geometry. Molska's version, by contrast, is emphatically unheroic, the workers smile awkwardly and seem lost. At the berlin biennial in 2008, the work was shown together with *P=W:t (power)* (2007–2008): hundreds of balls painted white drop from off-screen into a squash court marked with red lines. In the interplay between the shapes – lines, squares, spheres – the balls, ricocheting uncontrollably, seem like a perfect answer to the geometric rigour of Russian Constructivism.

When Molska reflects on the influence Soviet propaganda and Suprematism exerted over the Polish avant-garde, thus in *Tanagram* (2006–2007), she always also conducts an examination of the power dynamic and the balance of forces shaping artistic and cultural production. The huge black blocks the two youthful gladiators push around the studio, accompanied by a sound collage mixing Red Army choruses and folkloristic tunes, suggest pieces in a gigantic three-dimensional puzzle reminiscent of Kazimir Malevich's 'Black Square'. These are, quite literally, blocs of power being arranged into new shapes. In *The Weavers* (2009), Molska rehearses passages from Gerhart Hauptmann's play 'The Weavers' with Silesian miners – a dilapidated industrial compound looms in the background – to create a striking illustration of the contrast between the 1844 revolutionary uprising of the weavers and the real resignation among the workers.

At first glance, Molska's videos and performances look like modernity's endgames. In an age defined by the failure of utopias and ideologies, they retell, re-enact, reconstruct. The original canon seems to have fallen by the wayside. Yet these works are anything but absurd. The traditional forms Molska recombines in forever new constellations form the building blocks for a stage on which she negotiates both the paradigms of modernity and those of our contemporary society.

Oliver Koerner von Gustorf

Tanagram, 2006–2007
Video, b/w, sound
5:10 min

*W=F*s (work)*, 2008
DVD, colour, sound
9 min

P=W:t (power), 2007–2008
DVD, colour, sound
9 min

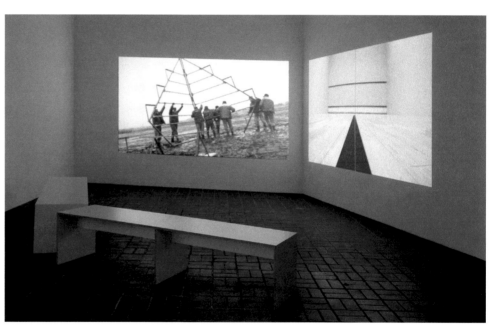

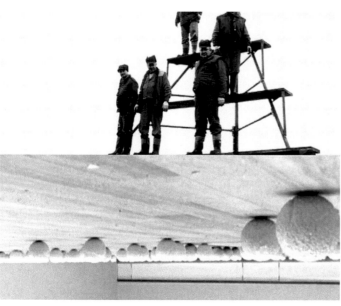

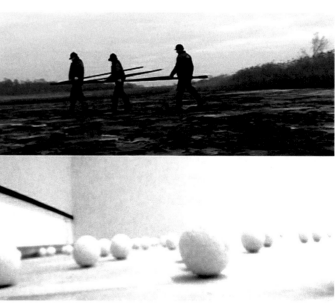

MATTHEW MONAHAN

1972 geboren in Eureka, CA, USA, lebt
und arbeitet in Los Angeles, CA, USA
**1972 born in Eureka, CA, USA, lives and
works in Los Angeles, CA, USA**

2008 7th Gwangju Biennale – *Annual
Report: A Year in Exhibitions*
2006 4th berlin biennial for contem-
porary art – *Of Mice and Men*
2006 Whitney Biennial – *Day for Night*,
New York

www.mmmonahan.com

www.antonkerngallery.com
www.fonswelters.nl
www.modernart.net

In seinen Skulpturen, Installationen und
Zeichnungen präsentiert Matthew Monahan
eine Reihe von Artefakten, die von einem fer-
nen Planeten irgendwo zwischen dem alten
Griechenland und einem futuristischen Mars
zu stammen scheinen. In seinen Assem-
blage-Skulpturen, die von Glasscheiben und
Klemmen zusammengehalten oder auf selbst
gebauten Sockeln aus farbigen Trockenbau-
platten gezeigt werden, bringt er höchst un-
terschiedliche Gegenstände zusammen. Er
recycelt sein eigenes Werk, meißelt Objekte
aus grünem Gartenbauschaum, zerknüllt sei-
ne eigenen Zeichnungen von Gesichtern und
Masken und kombiniert sie mit gefundenen
Gegenständen, die er im Lauf der Zeit auf Rei-
sen in Asien und Europa ebenso wie in seinem
Alltag gesammelt hat. In Ausstellungen ar-
rangiert er diese Arbeiten sorgfältig in ausge-
klügelten labyrinthischen Installationen, die
ein verdrehtes Kuriositätenkabinett bilden.
Seine Welt ist voller Dämonen, Engel, Gott-
heiten und anderer Mischwesen aus Mensch
und Tier. Ähnlich wie bei antiken griechi-
schen und römischen Statuen fehlen ihnen
Gliedmaßen oder Nasen, sie sind zwischen
Glasscheiben gefangen oder werden von
anderen Strukturen getragen, die an Kisten
oder funktionale Gegenstände wie Regale
und Beistelltische erinnern. Monahan stellt
niemals gewöhnliche Gesichter oder Körper
dar; seine ausdrucksstarken Figuren, die er
als „Psychographs" bezeichnet, sind oft un-
definierbar oder beschädigt. Seine frühen
Zeichnungen waren stark von chinesischen
Rollbildern beeinflusst, und die Zeichnung
hat für ihn immer noch eine hohe Bedeutung.
Mit einer Gabel macht er aus Kohle auf Reis-
papier symmetrische figurative Zeichnungen
und schafft so Gestalten, die gleichzeitig aus
der Vergangenheit und der Zukunft kommen.
Vor Kurzem begann er, seine großformatigen
skulpturalen Assemblagen in Bronze zu gie-
ßen und sein Werk dadurch zu seinen bildhau-
erischen Ursprüngen zurückzuführen. Auch
fertigt er durch Wachsabformungen Unikate
von kleineren Elementen seiner Assembla-
gen an und wirft dadurch Fragen von Abguss
und Kopie auf. Monahan ist ein unerschro-
ckener Forscher, der unablässig Menschen
und Dinge sammelt, zusammenbringt, neu
arrangiert, anfertigt und demontiert; auf die-
se Weise schreibt er die Geschichte zu einer
Erzählung über eine verschwundene Welt um,
die möglicherweise gar nicht existiert, aber in
jedem Fall einen Besuch zu lohnen scheint.

In his sculptures, installations, and draw-
ings, Matthew Monahan presents an array
of artifacts that seem to have descended
from a distant planet somewhere between
ancient Greece and a futuristic Mars. In his
assemblage sculptures, which are held to-
gether by pieces of glass and clamps or dis-
played on homemade pedestals of coloured
drywall, he brings together an array of dis-
parate objects. He recycles his own work,
carves objects out of green gardening foam,
crushes up his own drawings of faces and
masks, and combines them with found ob-
jects collected over time from his travels in
Asia and Europe as well as daily life. For ex-
hibitions, he carefully arranges these works
in elaborate labyrinthine installations that
create a twisted cabinet of curiosities.
His world is full of demons, angels, deities
and other animal-human creatures. They are
missing limbs, or noses, much like ancient
Roman or Greek statuary, and are caged in
glass or held up by other structures to re-
semble boxes or even functional objects
like shelving and coffee tables. Monahan
never depicts conventional faces or bod-
ies; his intensely expressive figures, which
he calls 'Psychographs' are often indistinct
or flawed. His early drawings were heavi-
ly influenced by Chinese scrolls and he still
maintains a strong emphasis on drawing. He
makes symmetrical figure drawings with a
fork using carbon on rice paper – creating
figures that simultaneously come from the
past and the future. He recently began cast-
ing his large-scale sculptural assemblages
in bronze, taking the work full circle to its
statuary roots. He is also making unique wax
casts of smaller parts of his assemblage
works, challenging notions of casting and
replication. Monahan is an intrepid explor-
er, constantly collecting, assembling, rear-
ranging, crafting and disassembling people
and things, reordering history into a narra-
tive of a lost world that may or may not exist,
but seems like a wild place to visit.

Ali Subotnick

Rangoon Detour, 2008
Glass, foam, wax, pigment, wood,
straps, ratchets
243 × 71 × 63 cm

Untitled, 2009
Polyurethane foam, wax, epoxy
resin, glitter, paint, drawing on
paper, glass, ratchet straps
200 × 35 × 35 cm

North Star Supplicant, 2007
Foam, wax, pigment, gold leaf,
drywall
201 × 244 × 159 cm

Ponce de León, 2009
Polyurethane foam, wax,
metal leaf, epoxy resin, litho ink
monoprint on paper, wood, brass,
paint, glass, ratchet straps
208 × 95 × 46 cm

ROMAN ONDÁK

1966 geboren in Žilina, Tschechoslo-
wakei, lebt und arbeitet in Bratislava,
Slowakische Republik
**1966 born in Žilina, Czechoslovakia,
lives and works in Bratislava, Slovak
Republic**

2010 6th Berlin Biennale for Contem-
porary Art – *what is waiting out there*
2009 53rd International Art Exhibition /
La Biennale di Venezia, Czech and Slovak
Pavilion
2006 27th Bienal de São Paulo – *Como
viver junto / How to Live Together*
2003 50th International Art Exhibition /
La Biennale di Venezia – *Dreams and
Conflicts. The Dictatorship of the Viewer*

www.gbagency.fr
www.johnengalerie.com
www.martinjanda.at

Roman Ondák verhandelt mit seinen anti-
monumentalen, oftmals performativen und
ortsbezogenen Arbeiten die Beziehung zwi-
schen dem institutionellen Feld der zeitge-
nössischen Kunst und den prosaischen Er-
eignissen des modernen Alltagslebens – und
das vor dem Hintergrund der Geschichte post-
minimalistischer und konzeptueller Kunst
jenseits der geopolitischen Blockbildung der
Nachkriegszeit. Mit zumeist lapidaren Hand-
lungsanweisungen, vermittels architektoni-
scher Modelle und mithilfe diskreter räumli-
cher Eingriffe entfremdet Ondák alltägliche
Situationen sowie Konventionen der Aus-
stellung von Gegenwartskunst. Er öffnet sie
für eine reflexive ästhetische Erfahrung, die
die Unterscheidung zwischen künstlerischer
Produktion und vermeintlich äußerlichen
Strukturen und Ereignissen herauszufordern
vermag.
Ondáks Werke sind oftmals so subtil, dass
sie kaum wahrzunehmen sind. Für *Resis-
tance* (2006), eine Performance im Museum
Moderner Kunst Stiftung Ludwig in Wien,
besuchte eine kleine Personengruppe eine
Eröffnung mit offenen Schnürsenkeln. Das
kollektive Moment der Irritation entzog sich
einer Identifizierung als Happening. Die Per-
formance *Good Feelings in Good Times* (2003)
realisierte Ondák an verschiedenen Orten,
etwa auf der Frieze Art Fair. Ondák inszenier-
te Warteschlangen, die der zunehmenden Po-
pularität der Gegenwartskunst entsprechend
eine Erwartung schürten, die nicht eingelöst
wurde und eben darin mit der Logik der Event-
kultur brach.
Für die Arbeit *It Will All Turn Out Right in the
End* (2005–2006) ließ Ondák die Turbinenhal-
le der Tate Modern – oft überdimensionierter
Schauplatz spektakulärer Kunstprojekte – in
verkleinertem Maßstab duplizieren und stellt
seither diese detailgetreue Replik als für nur
wenige Besucher gleichzeitig begehbaren
Raum in verschiedenen Museumskontexten
aus. So verkehrt Ondák nicht nur das Größen-
verhältnis zwischen Betrachter und institu-
tionellem Container, sondern stellt mit seiner
aneignenden Geste zudem die Frage nach der
Bedeutung des einzelnen Werks in massen-
kompatiblen Museen, die eine zunehmend
enge Verbindung zur Unterhaltungsindustrie
suchen. In konsequenter Fortsetzung hob
Ondák auf der Biennale in Venedig 2009 die
Grenze zwischen der Architektur und den
Giardini temporär auf: Unter dem Titel *Loop*
ließ er die venezianische Vegetation als pit-
toreskes Beiwerk der Ausstellung auch deren
Innenraum besetzen.

Roman Ondák's anti-monumental and often
performative and site-specific works exam-
ine the relationship between the institution-
al field of contemporary art and the prosaic
events of modern everyday life – against the
backdrop of the history of post-Minimalist
and Conceptual Art beyond the geopolitical
blocs of the post-war era. By issuing usu-
ally lapidary instructions, presenting archi-
tectonic models, and performing discreet
spatial interventions, Ondák defamiliaris-
es everyday situations and the conventions
that govern exhibitions of contemporary art,
opening them up to a reflective aesthetic ex-
perience that can challenge the distinction
between artistic production and ostensibly
external structures and events.
Many of Ondák's works are so subtle as to
be almost imperceptible. For *Resistance*
(2006), a performance staged at the Muse-
um Moderner Kunst Stiftung Ludwig, Vienna,
a small group of people attended an opening
with their shoelaces untied. The collective
moment of irritation defied identification as
a happening. The performance *Good Feel-
ings in Good Times* (2003) was realised at
various sites, including the Frieze Art Fair.
Given the growing popularity of contempo-
rary art, Ondák's staged queues of people
stirred up expectations – but these expec-
tations came to nothing, collapsing the logic
of an event culture.
For *It Will All Turn Out Right in the End* (2005–
2006), Ondák had Tate Modern's Turbine Hall –
frequently the oversized scene of spectacular
art projects – duplicated in miniature; he has
since exhibited the highly detailed replica, a
room only a few visitors can enter at a time,
in various museum contexts. Ondák thus not
only upends the proportions between the
beholder and the institutional container;
his gesture of appropriation also raises the
question of the significance of the individu-
al work in museums designed for mass audi-
ences that have fostered increasingly close
ties with the entertainment industry. Making
the logical next step, Ondák's contribution
to the 2009 Biennale di Venezia temporarily
suspended the boundary between the archi-
tecture and the Giardini: in a work entitled
Loop, he allowed the Venetian flora, usually
a picturesque decoration around the exhibi-
tion, to occupy the interior space of art.

André Rottmann

Loop, 2009
Exhibition view, 53rd International Art
Exhibition / La Biennale di Venezia,
Czech and Slovak Pavilion

Resistance, 2006
A small group of people was asked
to come to a public event, where
they mingled in the crowd with their
untied shoelaces.
Performance, Museum Moderner
Kunst Stiftung Ludwig, Vienna

Good Feelings in Good Times, 2003
Artificially created queue
Performance, Kölnischer Kunstverein,
Cologne

Measuring the Universe, 2007
For the whole duration of the exhibition
museum attendants offer to the exhibi-
tion visitors marking their height on the
gallery walls along with their first name
and the date on which the measurement
was taken.
Performance, Pinakothek der
Moderne, Munich

It Will All Turn Out Right in the End,
2005–2006
Scaled down model of the Tate Modern's
Turbine Hall
Installation view, CAC Brétigny

ADRIAN PACI

1969 geboren in Shkodër, Albanien,
lebt und arbeitet in Mailand, Italien
**1969 born in Shkodër, Albania,
lives and works in Milan, Italy**

2009 10th Biennale de Lyon –
Le spectacle du quotidien
2006 15th Biennale of Sydney –
Zones of Contact
2006 Busan Biennale – *Everywhere*
2005 51st International Art Exhibition /
La Biennale di Venezia – *The Experience
of Art; Always a Little Further*
2000 Manifesta 3, European Biennial
of Contemporary Art, Ljubljana

www.galleriafrancescakaufmann.com
www.peterblumgallery.com
www.peterkilchmann.com

Dem Panorama einer idyllischen Landschaft folgt eine Reihe von Nahaufnahmen, Kinder blicken schweigend in die Kamera. Die Kamera zoomt weg, gibt das Szenario zu erkennen: Die Kindergruppe ist ein Spiegelbild. Ein Junge spannt eine Steinschleuder und zielt auf den Spiegel, der klirrend zerspringt. In den folgenden Einstellungen jagen die Kinder über eine Wiese, sitzen in einer Baumkrone und reflektieren mit Spiegelscherben die Sonne. Wieder zoomt die Kamera von Detailansichten zur Totale, bis nur mehr ein Baum mit blinkenden Lichtpunkten zu erkennen ist.

Der Film *Per Speculum* (2006) von Adrian Paci ist eine Allegorie künstlerischen Arbeitens: Durch die Dekonstruktion existierender Bilder entstehen neue Bilder von großer emotionaler Dichte. Zugleich markiert *Per Speculum* in Pacis Werk eine Hinwendung zu größerer formaler Strenge – weg von einem eher narrativ-dokumentarischen Stil, der direkten Bezug auf die soziale und politische Realität Albaniens und die persönliche Erfahrung der Migration nimmt. In *Klodi* (2005) schildert ein albanischer Emigrant seine Erfahrungen in der Illegalität der Flucht.

Bereits das in Pacis Heimatstadt Shkodër gedrehte Video *Turn on* (2004), eine Parabel auf ein Leben im Wartezustand in einem Land, das seit dem Ende des Kommunismus seinen Weg in die Zukunft sucht, lässt Pacis Kraft zu ikonisch verdichteten Bildern erkennen. Die Grenzen zwischen den Medien sind fließend. So wird das Schlussbild von *Turn on* – eine Gruppe von Männern, jeder mit einer leuchtenden Glühbirne, die aus einem Generator gespeist wird – gewissermaßen zum Standbild; umgekehrt dienen bewegte Bilder immer wieder als Vorlage für Malerei, etwa in *Facade* (2007), einem Fresken-Zyklus auf freistehenden Wänden, der Skulptur, Theaterarchitektur und Projektionsfläche in einem ist.

Auch im Video *Centro di Permanenza Temporanea* (2007) gewinnt die Schlusssequenz fast skulpturale Präsenz. Auf einem Flugfeld, einem Knotenpunkt globaler Mobilität, stehen Menschen dicht gedrängt auf einer Gangway, die Kamera wandert von einem Gesicht zum nächsten. Im Hintergrund starten und landen Flugzeuge, doch die Reise dieser Menschen scheint vorerst beendet, wie auch der Titel, die italienische Bezeichnung für temporäre Aufnahmelager illegaler Einwanderer, nahe legt. Denn die Gangway führt ins Nichts. Es ist ein Moment existenziellen Ausgesetztseins, den Paci in Szene setzt; zugleich schafft er ein Gegenbild zu gängigen Darstellungen illegaler Einwanderer als gesichtslose Masse.

A panorama shot of an idyllic landscape is followed by a series of close-ups; children silently look into the camera. Zooming out, the camera reveals the scenario: the group of children is a mirror image. A boy pulls back a slingshot and aims at the mirror, which shatters loudly. In the next shots, the children chase across a meadow, sit in a treetop, and use mirror shards to reflect the sun. Once again, the camera zooms out from close-up shots of details to a long shot until all we see is a tree in which points of light flash up.

Adrian Paci's film *Per Speculum* (2006) is an allegory of the work an artist does: the deconstruction of existing images engenders new images of great emotional density. At the same time, *Per Speculum* marks a turn in Paci's oeuvre toward greater formal rigour – away from a more narrative and documentary style that makes direct reference to the social and political reality of Albania and to Paci's personal experience of migration. In *Klodi* (2005), an Albanian emigrant describes his experiences of life as an illegal refugee.

Turn on (2004), a video shot in Paci's hometown of Shkodër, a parable about life on standby in a country searching for its path into the future after the end of communism, already demonstrates the artist's talent for iconic and condensed imagery. The boundaries between the media are fluid. The final image in *Turn on* – a group of men, each holding a light bulb set aglow by a generator – becomes a still of sorts; while moving images conversely often serve as models on which paintings are based, thus in *Facade* (2007), a cycle of frescoes on freestanding walls that is at once a sculpture, a piece of theatrical architecture, and a projection screen.

In the video *Centro di Permanenza Temporanea* (2007), the final sequence similarly gains an almost sculptural presence. On an airfield, a hub of global mobility, a crowd of people stands packed on a gangway. The camera pans from one face to the next. In the background, airplanes take off and land, but for these people, the journey seems to have come to a preliminary end, as the title, the Italian term for a temporary holding camp for illegal immigrants, suggests. For their gangway leads nowhere. What Paci stages is a moment of existential exposure; at the same time, he creates an image to counter the widely circulating representations of illegal immigrants as a faceless mass.

Astrid Wege

Centro di Permanenza Temporanea, 2007
Video, colour, sound
5:30 min

Facade 1, 2007
Tempera, plaster, cement,
brick, wood
250 × 300 × 250 cm

Facade 2, 2007
Tempera, plaster, cement,
brick, wood
250 × 300 × 250 cm

Electric Blue, 2009
HDV (Blu-ray), colour, sound
15:30 min

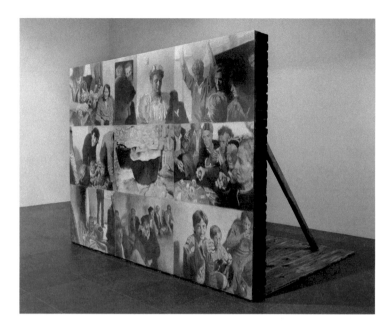

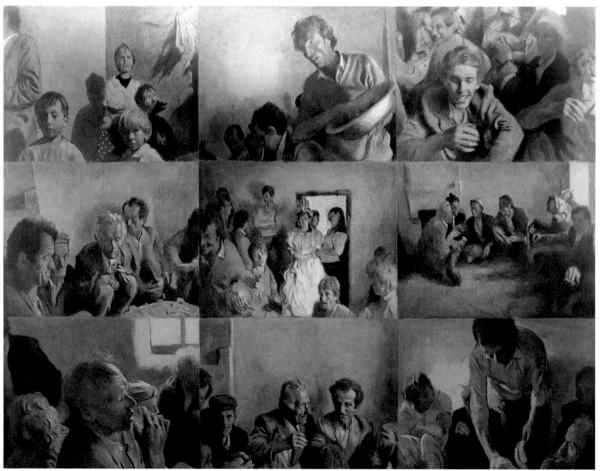

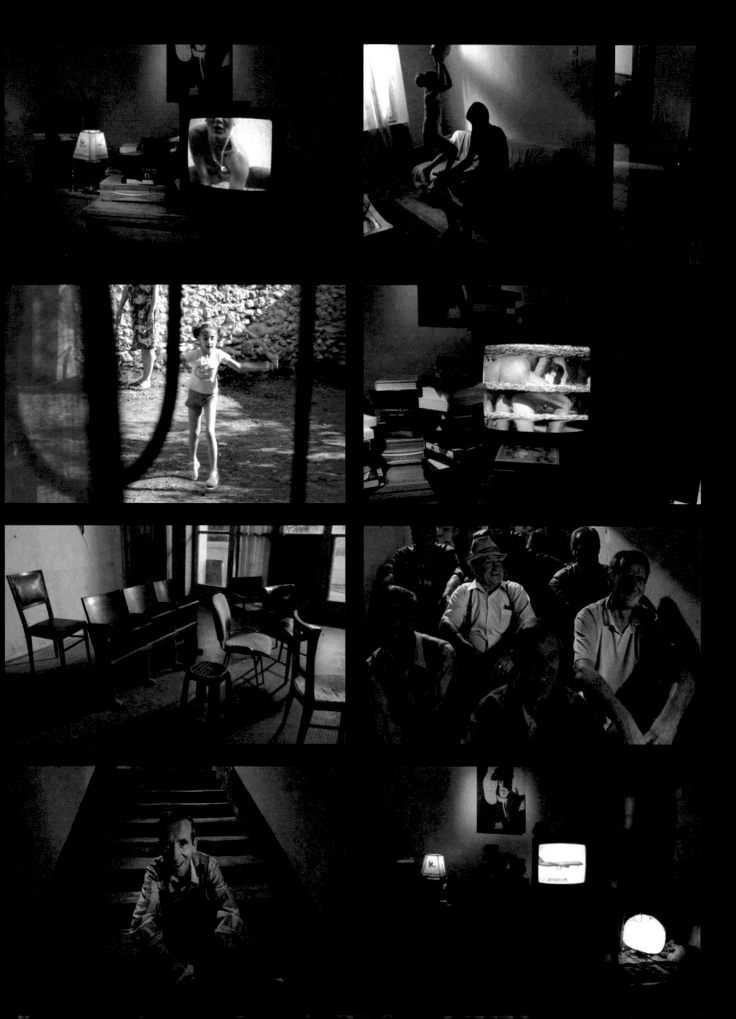

MAI-THU PERRET

1976 geboren in Genf, Schweiz, lebt und
arbeitet in Genf
**1976 born in Geneva, Switzerland, lives
and works in Geneva**

2007 9th Biennale de Lyon – *00s.
The history of a decade that has not
yet been named*

www.davidkordanskygallery.com
www.francescapia.com
www.galeriebarbaraweiss.de
www.praz-delavallade.com
www.timothytaylorgallery.com

Wenn Mai-Thu Perret ihre Arbeiten in Räumen arrangiert, dann gleicht das Ergebnis auf den ersten Blick zunächst eher einer Gruppenausstellung als einer Solopräsentation: Eine überdimensionierte, begehbare Teekanne enthält kleinformatige Sperrholzbilder in Neo-Geo-Manier. Drumherum tanzen lebensgroße, gesichtslose Puppen aus Pappmaché mit leuchtenden Hula-Hoop-Reifen. Objekte aus Keramik könnten geradewegs aus einer Sammlung von Kunsthandwerk entliehen sein. Gerahmte Schriftstücke wiederum erinnern an die rationale Ästhetik konzeptueller Kunst. Außerdem finden sich Fahnen mit rätselhaften Zeichen sowie Metallskulpturen in ihrem Werk, die an abstrahierte Pflanzenteile denken lassen – von einer Pyramide aus Kaninchenställen ganz zu schweigen.

Zusammengehalten werden diese formal kaum auf einen Nenner zu bringenden Arbeiten durch eine fiktionale Klammer. Tatsächlich gehören alle Stücke von Perret dem Langzeitprojekt *The Crystal Frontier* an, an dem die Künstlerin seit 1999 arbeitet. Dahinter verbirgt sich die Geschichte einer autonomen Frauenkommune, die abgeschieden auf einem Bauernhof in der Wüste von New Mexico lebt. Dort versucht die Kommune, buchstäblich aus dem Nichts heraus eine neue Gesellschaftsordnung jenseits kapitalistischer und patriarchaler Zwänge aufzubauen. Perret, die Literaturwissenschaft studiert hat, schildert das Leben ihrer Protagonistinnen jedoch nicht mittels schriftstellerischer Erzählpraktiken. Der Alltag des Kollektivs zwischen Landarbeit und Meditation, Reiten und kreativen Tätigkeiten vermittelt sich vielmehr über die Kunstwerke. Die Keramikskulpturen könnten etwa von den Frauen angefertigt worden sein, um auf einem regionalen Markt verkauft zu werden. Die Texte ihrerseits enthalten mutmaßliche Archivalien wie Tagebucheinträge, Arbeitspläne, Manifeste oder Gedichte.

Viele ihrer Werke enthalten Anspielungen auf die Avantgarden der 1920er Jahre, vor allem auf die sowjetischen Konstruktivisten, die mit ihren Mitteln gleichfalls ein besseres Leben schaffen wollten, aber von der politischen Wirklichkeit schnell eingeholt wurden. Nach dem Ende der Utopien in Kunst und Gesellschaft zeigt Perrets *The Crystal Frontier* auf, dass heutige Weltveränderungspläne zwar nur noch symbolische Bedeutung besitzen können – ihr Potenzial als Möglichkeitsspiegel haben sie jedoch nicht verloren, auch das macht die Archäologie der Utopien von Perret deutlich.

When Mai-Thu Perret arranges her works in exhibition rooms, the results at first glance suggest a group exhibition rather than a solo show: an oversized walk-in teapot contains small-scale pictures on plywood reminiscent of Neo-Geo painting. Dancing around them are life-sized faceless papier-mâché dolls with luminescent hula-hoops. Ceramic objects look like they could be on loan straight from an arts and crafts collection. Framed documents, on the other hand, recall the rational aesthetic of Conceptual Art. Her work also includes flags bearing enigmatic logos and metal sculptures that suggest abstracted parts of plants – not even to mention a pyramid of rabbit hutches.

It is virtually impossible to discover a formal common denominator in these works; what holds them together is a fiction. All of Perret's pieces are in fact part of the long-term project *The Crystal Frontier*, on which the artist has worked since 1999. The title stands for the history of an autonomous commune of women living in isolation on a farm in the desert of New Mexico. The women try to build a society literally from scratch, a new social order beyond capitalist and patriarchal constraints. Perret studied literature, but she does not employ literary narrative practices to depict her protagonists' lives. Instead, she uses the works of art to convey an impression of the collective's everyday life between farm work and meditation, horse riding and creative activities. For instance, the women might have made the ceramic sculptures in order to sell them at a regional farmer's market. The texts Perret includes are presumably archival documents such as diary entries, work schedules, manifestos, or poems.

Many of her works contain allusions to the avant-gardes of the 1920s, and to the Soviet constructivists in particular, who likewise sought to use their artistic means to contribute to the creation of a better life – although political realities quickly caught up with them. After the demise of artistic and social utopianism, Perret's *Crystal Frontier* points out that contemporary plans to reengineer the world can be of no more than symbolic import; still – and this, too, is something Perret's archaeology of utopias illustrates – they have lost none of their ability to hold up to this world the mirror of its possibilities.

Sven Beckstette

*A White Horse Comes and Enters
the White Reed Flowers,* 2008
Glazed ceramic
74 × 64 × 18 cm

Space-Time Rhythm Modulation –
The Most Difficult Love, 2010
Installation: lacquered double
aluminium plates
Digital video: triple projection,
colour, no sound
Wall piece: foil letters
400 × 640 cm
Installation view,
Haus der Kunst, Munich

Donna Come Me, 2008
Mannequin, wig, uniform, pom-poms,
and acrylic paint on carpet
366 × 198 cm
Installation view,
The Kitchen, New York

The Crystal Frontier, 2008
Pages from the artist's book
Land of Crystal, published by JRP | Ringier,
Christoph Keller Editions

And Every Woman Will Be a
Walking Synthesis of the Universe, 2006
Exhibition view, The Renaissance Society
at the University of Chicago

THE CRYSTAL FRONTIER

The more horses you put to, the faster your progress – not of course in the removal of the corner stone from the foundation, which is impossible, but in the tearing of the harness, and your resultant riding cheerfully into space

Franz Kafka

NEW PONDEROSA YEAR ZERO is the true life story of a group of girls, in their 20s and 30s, who decided to follow the activist Beatrice Mandell and create an autonomous community in the desert country of New Mexico. While the reasons for their discontent with mainstream society were different for each of the girls, they all shared the desire to give this unlikely social experiment a try. The decision to make it all-female did not stem from their personal hatred of men, but from Mandell's conviction that a truly non-patriarchal social organization had to be built from the ground up, starting with a core group of women who would have to learn how to be perfectly self-sufficient before being able to include men in the community. Mandell's theories were a mixture of classic feminist beliefs about the oppression of women, and what could best be described as her psychedelic-pastoral tendencies.

The number of community members oscillated between eight and a dozen, since participants were always free to leave and come back. This openness was of course the cause of a great number of organizational difficulties, but it probably also explains why New Ponderosa managed to last beyond the euphoria of the beginning. The desert can be an exceptionally hostile environment, even if you happen to live by a well, and the enormous amount of work it took to start the first crops and keep the livestock alive explains a lot of the tensions on the ranch. There were also the inevitable

personal conflicts that people experience when living together in isolated environments.

The goal of the participants of New Ponderosa Year Zero was to rely on the crops they grew and the livestock they raised (a few cows and palomino ponies) for their survival. Of course, the income from the first year had to be supplemented by personal money the girls had saved before coming there, and by some donations from a few supporters who had stayed back in the cities. This agrarian lifestyle was also to be supplemented from the profits from their production in the decorative arts, which from the beginning played an essential role in the project.

A True Life Story

MATHIAS POLEDNA

1965 geboren in Wien, Österreich, lebt und arbeitet in Los Angeles, CA, USA
1965 born in Vienna, Austria, lives and works in Los Angeles, CA, USA

2006 Whitney Biennial – *Day for Night*, New York
2004 3rd berlin biennial for contemporary art
2004 Liverpool Biennial of Contemporary Art

www.galeriebuchholz.de
www.meyerkainer.com
www.tellesfineart.com

Mit seiner Arbeit verfolgt Mathias Poledna seit Beginn der 1990er Jahre eine konsequente Strategie, mit der er sich bewusst gleichermaßen auf Praktiken der konzeptuellen Kunst wie institutionskritische Traditionen beruft. Das unbelebte Archivmaterial einiger Arbeiten der 1990er Jahre löste er in den folgenden 16-mm-Filmen wie *Actualité* (2001–2002), *Western Recordings* (2003) und *Version* (2004) durch menschliche Protagonisten ab, Schauspieler, Musiker und Tänzer. Rhetorik und Sprachsystem ihrer jeweiligen Profession nutzt Poledna für eine erstaunliche Neudefinition der Re-Inszenierung von Geschichte mit den Mitteln der darstellenden Künste.

Der 35-mm-Film *Crystal Palace* (2006) besteht aus drei unbewegten, lang andauernden Kameraeinstellungen, die einen Regenwald in Papua-Neuguinea zeigen. Farbe, Tonspur und minimale Bewegung des Films verdichten sich zu einer Reflexion über Natur, postkoloniale Blicke auf das Andere und den Hang des Filmbildes zur Abstraktion. Dabei ist allen seinen Filmen gemeinsam, dass sie in den präzisen Kontext einer kinematografischen Installation eingebunden sind und zumeist durch wenige Gegenstände der Alltagskultur und der angewandten Künste wie zum Beispiel ein Poster flankiert werden, die im Sinne eines Paratextes die filmische Arbeit konterkarieren. In *Double Old Fashion* (2009) erhebt Poledna eine von Adolf Loos gestaltete und erstmals 1929 produzierte Serie von Kristallgläsern zum Gegenstand einer filmischen Reflexion. Das zehnteilige Barset wird im ersten Teil des Films Stück für Stück in Rotation begriffen abgebildet. Dieser typologischen Reihung folgt eine Serie von extremen Nahaufnahmen, die den Lichtbrechungen und Spiegelungen des Materials gewidmet scheinen und über die Demarkationslinien zwischen Abstraktion, historischer Konkretion und hyperästhetischer Produktinszenierung im Bilde sind.

Double Old Fashion mit seinen Anklängen an die symphonische Filmkomposition der frühen abstrakten Films zeigt, dass sich Filme immer auf Filme beziehen und wir, die Zuschauer, mit den Konventionen so vertraut sind, dass wir immer schon Filmbilder aufgerufen wissen wollen, wenn wir eine Filmszene sehen. Er beschreibt das Codierte des Films als Codierung, um deutlich zu machen, dass jede Sequenz eine Bedeutung hat, die über die engen Grenzen einer bestimmten Szene, ja sogar des Mediums selbst hinausgeht.

Since the early 1990s, Mathias Poledna's art has pursued a clearly defined strategy that deliberately invokes both practices of Conceptual Art and traditions in institutional critique. If some works of the 1990s were based on inanimate archival material, the subsequent 16mm films such as *Actualité* (2001–2002), *Western Recordings* (2003), and *Version* (2004) replace it with human protagonists: actors, musicians, and dancers. Poledna employs the rhetorics and linguistic systems of these various professions for an astonishing redefinition of what it means to re-enact history with the means of the performing arts.

The 35mm film *Crystal Palace* (2006) consists of three motionless long shots showing a piece of rainforest in Papua New Guinea. The film's colour and soundtrack and the minute movements onscreen coalesce into a reflection on nature, forms of the postcolonial gaze at the other, and the filmic image's tendency toward abstraction. A feature all his films share is the integration into the precise context of a cinematographic installation, where they are usually flanked by a few objects of everyday culture or applied art, such as a poster, that, serving as paratexts, undercut the filmic work. In *Double Old Fashion* (2009), Poledna turns his filmic reflection to a crystal glassware set designed by Adolf Loos and first produced in 1929. In the first part of the film, the ten elements of the bar set are shown, one by one, in rotation. This typological series is followed by a sequence of extreme close-ups that seem devoted to the refractions and reflections of light on the material and are crystal-clear about the lines of demarcation between abstraction, historical concreteness, and hyper-aesthetic product placement.

With its echoes of the symphonic film composition in early abstract film, *Double Old Fashion* shows that films always refer to films; and that we, the viewers, are so familiar with the conventions that we always already want to recognise filmic images being invoked when we see a scene from a film. Poledna describes the encoded character of film as an encoding in order to illustrate that every sequence has a meaning that transcends the narrow confines of a particular scene and even of the medium itself.

Matthias Mühling

Double Old Fashion, 2009
16mm film, colour, no sound
20 min
16mm frame enlargement

Crystal Palace, 2006
35mm film, colour, sound
28 min
35mm frame enlargement

SETH PRICE

1973 geboren in Jerusalem, Israel, lebt
und arbeitet in New York, NY, USA
**1973 born in Jerusalem, Israel, lives and
works in New York, NY, USA**

2010 8th Gwangju Biennale –
10.000 Lives
2008 Whitney Biennial, New York
2007 9th Biennale de Lyon – *00s.
The history of a decade that has not
yet been named*
2007 2nd Moscow Biennale of Contem-
porary Art – *Footnotes on Geopolitics,
Market and Amnesia*

www.distributedhistory.com

www.bortolozzi.com
www.galerie-capitain.com
www.petzel.com
www.reenaspaulings.com

Vintage Bomber, 2008–2009
Autobody enamel on vacuum-formed
polystyrene
245.5 × 123.5 × 12 cm
Installation view, Isabella Bortolozzi,
Berlin

Information, die sich mit der Geschwindigkeit von vielen Gigahertz pro Sekunde ständig aktualisiert und berichtigt, ist nie an einen Ort gebunden und transformiert sich stets in etwas anderes. Seth Price verortet seine künstlerische Praxis auf diesem veränderlichen Terrain, speist sich selbst in den ausufernden Strom ein und lässt zu, dass dieser Vorgang auf die Form und den Inhalt seiner Arbeit abfärbt. Sein Werk beschäftigt sich mittels geschriebener Texte, CDs, Skulpturen, Malerei, Videos und Filmen mit der zeitgenössischen Produktion von Distributionssystemen und ihren unvermeidlichen und endlosen Kreisläufen der Umverteilung.

In Prices frühen musikalischen Experimenten mit den Soundtracks von Videospielen verwendete er Sampler, ein Vorgang, den er mit *Title Variable* (seit 2001), einer fortlaufenden Serie musikalischer Compilations in verschiedenen Formen, bis heute fortsetzt. Für den 16-mm-Film *Untitled* (2006) kaufte und veränderte er einige Sekunden Filmmaterial aus einer Datenbank – Meereswogen, die normalerweise in Firmenpräsentationen als Hintergrund verwendet werden. Die Entwürfe zu seinen *Calendar Paintings* (2003–2004) stammen aus unterschiedlichen Quellen, übernehmen jedoch die standardisierte Ästhetik gewöhnlicher Computergrafiken.

Price erinnert uns daran, dass Computer das Gerümpel des Lebens sind: Sie umfassen alles, von unseren brillantesten Romanen bis zu unseren obszönsten Pornos. Dort findet auch die Kunst von Price statt, da sich ein großer Teil seiner Bilder und Quellen aus dem Internet und aus digitalen Effekten herleitet. Plastik ist in Prices Werk nicht nur ein skulpturales Material, es dient zugleich als dessen zentrale Metapher: Als ein zutiefst US-amerikanisches Medium ist Plastik ein unverzichtbarer Bestandteil der gegenwärtigen Welt aus Verpackung, Werbung, Waren, Effizienz, Müll, Geschwindigkeit und Oberflächen. Doch in dieser Feier der digitalen und synthetischen Technologie verbirgt sich auch eine Warnung davor, wie aus Effekten fast automatisch Affekte werden. In einer Welt ohne echte Haut, Körper und Hände sinkt die Kunst zur bloßen Information herab. Price platziert in seinen Skulpturen Bilder von Händen, Mündern, Gesichtern und Brüsten, als wollte er den menschlichen Körper mit den Effekten/Affekten von Computern und Kunststoff in Kontakt bringen. Doch in all diesen Arbeiten versucht der Körper, zu verschwinden und sich von sich selbst zu befreien und zieht es vor, sich aus dem Prisma von Kunststoff und Kapital herauszuhalten.

Constantly updating and adjusting itself at the frenzied speed of many gigahertz per second, information is always on its way somewhere else, and becoming something else. This shifting ground is where Seth Price situates his artistic practice, squeezing himself into this flow of dispersion and allowing the very process to rub off and provide the form and content of his artworks. With written texts, CDs, sculptures, paintings, videos, and films, his body of work confronts the contemporary production of distribution systems along with their inevitable and endless cycles of re-distribution.

Price used samplers in his early musical experiments with video game soundtracks, a process he continues today with *Title Variable* (since 2001), an ongoing series of music compilations taking different forms. For the 16mm film *Untitled* (2006), he bought and altered a few seconds of stock film – rolling waves normally used as background in corporate presentations. In *Calendar Paintings* (2003–2004), his designs came from a mixture of sources, but take on the standardised aesthetic of generic computer graphics. Computers, as Price reminds us, are the lumber of life: everything else passes through them, from our most brilliant novels to our most obscene porn. Price's art happens there too, with so much of his imagery and sources coming from the Internet and digital effects.

More than just a sculptural material, plastic serves as a central metaphor for Price's work: a quintessentially US American medium, plastic belongs to a contemporary world of packaging, advertising, commodity, efficiency, garbage, speed, and surfaces. But hidden within this celebration of digital and synthetic technology is a warning about the way effects almost automatically become affects. In a world without any real skin, bodies, and hands, art sinks into being nothing but information. As if he were rubbing the human body up against the effect/affect of computers and plastic, Price places images of hands, mouths, faces, and breasts in his sculptures. In each piece, however, the body is trying to disappear, trying to get rid of itself, preferring to remain outside the prism of plastic and capital.

Anthony Huberman

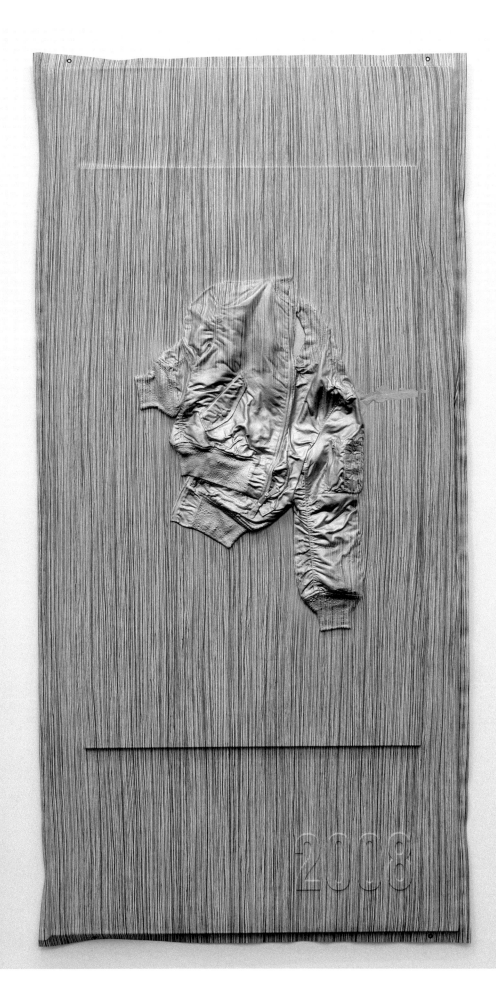

Film/Right, 2006
16mm film, colour, sound
14 min

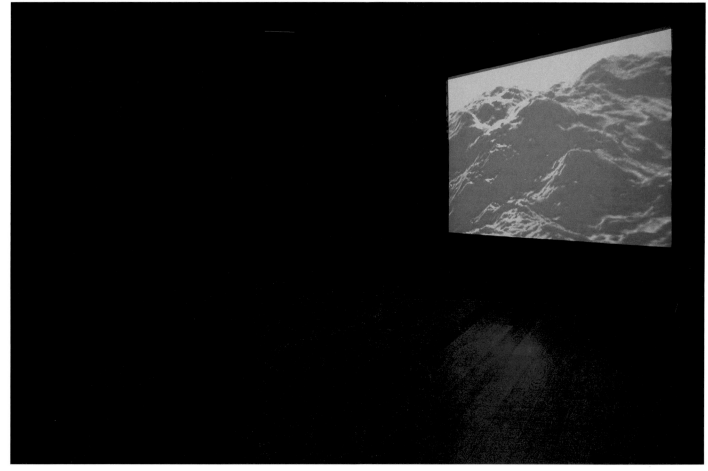

Untitled, 2009
Walnut burl wood and acrylic plastic,
laser-cut from jpeg
137 × 159 × 2 cm

Untitled, 2009
Carpathian elm wood and acrylic plastic,
laser-cut from jpeg
94 × 137 × 2 cm

Untitled, 2008
Iroko wood and diamond acrylic plastic
239 × 142 cm

Untitled, 2008
Enamel on dibond
119 × 117 cm

RAQS MEDIA COLLECTIVE

1992 gegründet in Neu-Delhi, Indien
1992 founded in New Delhi, India

Jeebesh Bagchi
1965 geboren in Neu-Delhi
1965 born in New Delhi
Monica Narula
1969 geboren in Neu-Delhi
1969 born in New Delhi
Shuddhabrata Sengupta
1968 geboren in Neu-Delhi
1968 born in New Delhi

2010 29th Bienal de São Paulo – *Há sempre um copo de mar para o homem navegar / There is always a cup of sea to sail in*
2007 10th International Istanbul Biennial – *Not Only Possible, But Also Necessary: Optimism in the Age of Global War*
2006 15th Biennale of Sydney – *Zones of Contact*
2005 51st International Art Exhibition / La Biennale di Venezia – *The Experience of Art; Always a Little Further*
2004 Liverpool Biennial of Contemporary Art
2003 50th International Art Exhibition / La Biennale di Venezia – *Dreams and Conflicts. The Dictatorship of the Viewer*

www.raqsmediacollective.net

www.bosepacia.com
www.frithstreetgallery.com
www.naturemorte.com

Das Raqs Media Collective beschäftigt sich mit breit gefächerten Recherchen, die in unterschiedlichen Formen wie Lecture/Performance, urbaner Intervention, Text, Installation und Video präsentiert werden. 2002 erlangte die Gruppe auf der Documenta11 internationale Aufmerksamkeit mit dem Projekt *Co-Ordinates 28.28″ N/77.15″ E*. Dazu gehörte eine raumfüllende Videoinstallation, die umstrittene Orte in Delhi (die Stadt, auf die der Titel verweist) erforschte. Eine Serie farbiger Aufkleber mit paranoiden autoritären Slogans wie „Who is the stranger next to you?" (Wer ist der Fremde neben dir?), die auf Schilder in Delhi zurückgehen, wurde in türkischer, deutscher und englischer Sprache gedruckt und in der ganzen Stadt Kassel an Wänden angebracht. In jüngeren Arbeiten liefert Raqs oft spekulative Neuinterpretationen von Dokumenten, Artefakten und Ruinen. *The Reserve Army* (2008) beschäftigt sich mit den Statuen des modernen Bildhauers Ram Kinkar Baij, die vor der Reserve Bank of India, der indischen Zentralbank, Wache stehen. *The Surface of Each Day is a Different Planet* (2009) erzählt eine Geschichte über Reisen und Identität anhand von Fotografien des Anthropologen Francis Galton, der im 19. Jahrhundert versuchte, eine auf der äußeren Erscheinung von Menschen beruhende Typologie zu schaffen.
Viele Forschungsaktivitäten des Medienkollektivs lassen sich nicht einfach als Kunstwerke einordnen. Im Jahr 2000 gründete Raqs zusammen mit Ravi Vasudevan und Ravi Sundaram die Sarai Initiative. Die ursprünglichen Sarais (oder Karawansereien) waren an Straßen gelegene Unterkünfte, die während der Mughal-Ära die Handelsnetzwerke förderten. Sarai entwickelt diese Tradition weiter und bildet einen Knotenpunkt in einem Netzwerk weit verstreuter Mitarbeiter. Es ist bis heute aktiv, veröffentlicht kritische Texte, bietet Stipendien an und recherchiert zu Themen wie neue Medien, kritische Theorie und die Stadt Delhi. Raqs behauptet, der Name stehe für „rarely asked questions" (selten gestellte Fragen), eine Anspielung auf das Kundenservice-Kürzel FAQs. Das Kollektiv beschreibt Raqs aber auch als das Wort, das auf Persisch, Arabisch und Urdu den Zustand bezeichnet, in den ein wirbelnder Derwisch verfällt. Alt und neu, Osten und Westen: Ebenso wie die Künstler selbst, schließt auch der Name Raqs die Kluft zwischen scheinbar unvereinbaren Gegensätzen.

Raqs Media Collective engage in wide-ranging research that is expressed through diverse forms: lecture-performance, urban intervention, text, installation, video. They earned international attention in 2002 with the project *Co-Ordinates 28.28″ N/77.15″ E* at Documenta11. It included an immersive video installation exploring contested spaces in Delhi (the location referred to by its title). A series of colourful stickers based on paranoid authoritarian slogans found on actual signs in Delhi, such as 'Who is the stranger next to you?' were printed in Turkish, German, and English and affixed to walls throughout Kassel. In their recent work, Raqs frequently offer speculative re-readings of documents, artefacts and ruins. *The Reserve Army* (2008) re-imagines statues by modernist sculptor Ram Kinkar Baij that stand guard outside the Reserve Bank of India. *The Surface of Each Day is a Different Planet* (2009) weaves a narrative of travel and identity around photographs by the nineteenth-century anthropologist Francis Galton, who attempted to create a typology of humans based on physical appearance.
Many of Raqs's research activities are not easily categorised as artwork. In 2000, they co-founded the Sarai Initiative with Ravi Vasudevan and Ravi Sundaram. The original sarais (or caravansarais) were rest areas that supported trade networks during the Mughal era. Extending this tradition, Sarai is a node in a network of far-flung collaborators. Still active today, it publishes critical texts, offers fellowships, and conducts research on topics such as new media, critical theory, and the city of Delhi. Raqs suggest that their name stands for 'rarely asked questions', a riff on the customer service shorthand FAQs. They also describe it as a Persian, Arabic and Urdu word for 'the state that whirling dervishes enter into when they whirl'. Old and new, East and West: like the artists themselves, the name Raqs closes the gap between seemingly irreconcilable binaries.

Michael Connor

On the Other Hand, 2009
Inkjet print on archival paper
61 × 41 cm

Co-Ordinates 28.28" N/77.15" E, 2002
Projections, soundscape, slide projection,
print elements (including broadsheet,
floor mat and 18 kinds of stickers)
Dimensions variable

The Reserve Army, 2008
Life size sculptures in fibre glass with sand
finish, cash and barbed wire ornaments
Dimensions variable
Installation view, MuHKA, Antwerp

PIETRO ROCCASALVA

1970 geboren in Modica, Italien, lebt und arbeitet in Mailand, Italien
1970 born in Modica, Italy, lives and works in Milan, Italy

2009 53rd International Art Exhibition / La Biennale di Venezia – *Fare Mondi / Making Worlds*
2008 Manifesta 7, European Biennial of Contemporary Art, Trentino-Alto Adige

www.galerieartconcept.com
www.galleriazero.it
www.iets.be
www.johnengalerie.com

The Skeleton Key, 2006
Soft pastel on paper on Forex
48,5 × 58 cm

The Skeleton Key II, 2007
Soft pastel on paper on Forex
70 × 50 cm

The Skeleton Key III, 2007
Pastel on paper on Forex
147 × 189 cm

The Skeleton Key IV, 2007
(part of the installation
The Silent Woman, 2007)
Acrylic on paper on Forex
39 × 50 cm

Pietro Roccasalva versteht sich in erster Linie als Maler, doch das Werk des Künstlers folgt kaum den üblichen Regeln der Malerei oder des Kunstmachens im Allgemeinen. Um eine Vorstellung von seiner Arbeitsweise zu bekommen, stelle man sich am besten eine Art rhizomatischer Matrjoschka-Puppe vor, die sich öffnen und deren Inhalt sich in alle erdenklichen Richtungen ausdehnen kann. Es ist verführerisch, seine Praxis als „intuitiv" bezeichnen, doch das wäre irreführend. Sie folgt vielmehr einer beinahe schwindelerregenden, sich ständig weiterentwickelnden inneren Logik, die von einem veränderlichen Bild im Bild zum nächsten schreitet. Wenn er also bekannt dafür ist, neben der Malerei unterschiedslos auch mit den Medien Installation, Skulptur, Fotografie, Film, Performance und Zeichnung zu arbeiten, dann deshalb, weil die eingangs erwähnte Logik auf unvorhersehbare Weise den nächsten Schachzug des Künstlers bestimmt, der oft sehr wenig mit der Aufgabe zu tun hat, Farbe auf Leinwand aufzutragen.

So bestand die Arbeit *Jockey Full of Bourbon* (2006) beispielsweise aus einer Installation in einem Badezimmer; dieses wies ein Guckloch auf, durch das man einen exakten Nachbau des Badezimmers auf der anderen Seite sehen konnte, jedoch mit einer Eule auf einer Stange vor dem Spiegel, die den Blick des Betrachters erwiderte. Die Idee zu *Jockey Full of Bourbon* ging ursprünglich auf ein rundes Fenster in einer früheren Multimedia-Installation in einer Kirche zurück und entwickelte sich, durch eine Pirouette der persönlichen Logik, zu einem Tableau vivant, *The Oval Portrait. A Ventriloquist at a Birthday Party in October 1947* (2005). Dieses bestand aus einem Paar, einer Frau und einem Kind, die vor einem Foto des ursprünglichen Kirchenfensters saßen, das nun ein Bild der Eule in dem Badezimmer zeigte, wie man es durch das Guckloch sehen konnte. Was Roccasalvas Malerei betrifft, die stark von seinem Interesse an frühchristlichen Ikonen und dem zeichnerischen, linearen Stil seiner italienischen Vorfahren wie Gino de Dominicis beeinflusst ist, so entspricht ihr figurativer Charakter seiner seltsamen, einzigartig organischen Praxis und macht sie zu einer beinahe mystischen Angelegenheit.

Pietro Roccasalva thinks of himself primarily as a painter, and yet the artist's work hardly abides by any of the usual laws of painting or even art-making. Picture, if you can, a kind of rhizomatic Matryoshka doll, whose contents are liable to open up and progressively flow out in any given direction, and you begin to get a sense of how Roccasalva works. It is tempting to refer to his practice as 'intuitive', but that would be misleading. Rather, it is a question of an almost dizzying, continually evolving internal logic that proceeds in one mutational mise-en-abyme after another. Thus, if he is known to work indiscriminately with installation, sculpture, photography, film, performance and drawing, in addition to painting, that is because the above-mentioned logic unpredictably determines the artist's next move, which often strays far beyond the remit of mere paint on canvas.

Take, for example, the work *Jockey Full of Bourbon* (2006), which consisted of an installation in a bathroom featuring a peephole that looked out onto an exact replica of the bathroom on the other side, with, however, an owl perched on a stick in front of the mirror staring back at the viewer. Originally inspired by a circular window from an earlier multi-media installation inside a church, *Jockey Full of Bourbon* itself went on, by some pirouette of personal logic, to mutate into the tableau vivant *The Oval Portrait. A Ventriloquist at a Birthday Party in October 1947* (2005), which consisted of a couple, a woman and a child, sitting in front of a photo of the original church window, which now featured an image of the owl in the bathroom as seen through the peephole. As for Roccasalva's paintings, which are heavily influenced by an interest in early Christian icons and the graphic linear style of such compatriot forebears as Gino de Dominicis, their figurative nature complements his strange and inimitably organic practice, making it a quasi-mystical affair.

Chris Sharp

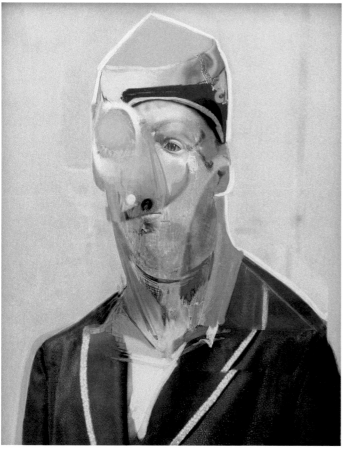

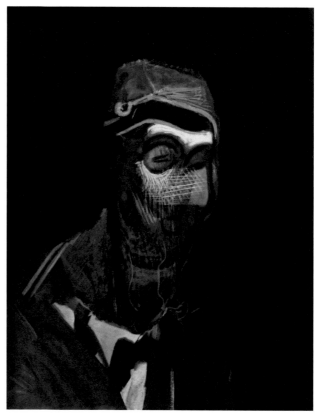

Jockey Full of Bourbon II, 2006
Neon, resin and haindpainted
feathers, microphone pole, acrylic
on paper on Forex, mirror
290 × 680 × 580 cm
Installation view, Johnen + Schöttle,
Cologne

Jockey Full of Bourbon, 2006
Pastel on paper on Forex
33 × 45 cm

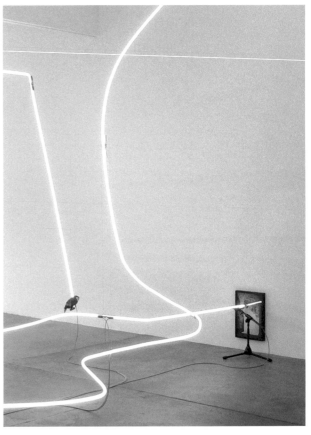

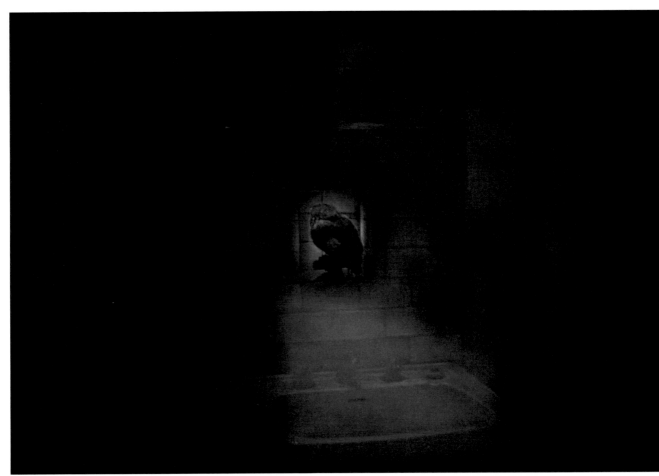

Z, 2008
Tableau vivant, offset print on paper,
fried rice ball, oil on canvas, neon
Dimensions variable
Installation view,
Park Avenue Armory, New York

*The Oval Portrait. A Ventriloquist at a
Birthday Party in October 1947*, 2005
Soft pastel on paper on panel
91 × 150 cm

EVA ROTHSCHILD

1971 geboren in Dublin, Irland, lebt und arbeitet in London, Großbritannien
1971 born in Dublin, Ireland, lives and works in London, Great Britain

2006 The Tate Triennial – *New British Art*, London

www.francescakaufmann.com
www.modernart.net
www.presenhuber.com
www.themoderninstitute.com

Einem Objekt die Fähigkeit zu verleihen, über sein Material und seine Form hinaus etwas auszudrücken, kommt Zauberei oder einem Voodoo-Ritual gleich. Es erfordert aber auch die Fähigkeit vorauszuahnen, welche Formen, Farben und Oberflächen solch eine beunruhigende Energie ausstrahlen könnten. Eva Rothschild ist Bildhauerin, nicht Spiritistin, doch sie stattet ihre reduzierten Arbeiten mit unzähligen Dimensionen jenseits von molekularer Abstraktion und Neominimalismus aus und beschwört die Geister der mittelalterlichen oder viktorianischen Gotik, von Aleister Crowleys „Magick" sowie Anspielungen auf das Okkulte herauf. Zudem bedienen sich Rothschilds Arbeiten mit ihren spinnennetzartigen Linien im Raum, angedeuteten Torsi oder Rümpfen und spitzen oder ovalen Formen auf Stelzen auch der Symbole der amerikanischen Ureinwohner sowie Psychedelia der 1970er Jahre, um vertikale, totemartige Strukturen zu schaffen, die ihre Instabilität und Unsicherheit in der Welt offenzeigen. Ihre Museumsinstallation *Cold Corners* (2009) – ein monumentales Gitter von ineinandergreifenden schwarzen Rauten oder eine gigantische zickzackförmige Kritzelei im Raum – bewies Rothschilds Raumbeherrschung im großen Maßstab; sie erlaubte den Besuchern, einen eigenen Weg durch die Arbeit zu finden, und bot zugleich neue Ansichten und Blickachsen in den scheinbar nicht dazu passenden neoklassischen Räumen der Duveen Galleries in der Tate Britain. Kleinere, ungefähr lebensgroße Arbeiten wie *Stalker* (2004) oder *Mr Messy* (2007) weisen ähnlich komplizierte Strukturen auf, die visuelle Feedback-Schleifen innerhalb der Arbeit erzeugen und ebenfalls Bewegung oder ein Fließen andeuten, wo tatsächlich Stillstand herrscht. In ihren unsauberen, schwärmerischen Interpretationen älterer, für gewöhnlich männlicher Bildhauer wie Anthony Caro, David Smith oder Constantin Brancusi verwendet Rothschild an den Tastsinn appellierende Materialien wie geflochtenes Leder, Plexiglas oder Gewebe aus Kordeln, aber auch grelle Spritzer fluoreszierender Sprayfarben, die ihre streng formalen Vorfahren nachahmen und aktualisieren. Schwarz ist jedoch immer noch ihre Erkennungsfarbe; dies zeigt sich nicht nur in Titeln wie *Nefertiti* (2009) oder *Black Mountainside* (2001), sondern auch in ihrer fortgesetzten Verwendung von glänzendem Kunstharz, pulverbeschichtetem Aluminium, Reifen und Lackfarbe. Die Dunkelheit lässt an schwarze Löcher, Schattenspiele und psychische Leere denken.

To imbue an object with the power to speak beyond its materials and form is to perform a sort of charm or voodoo ritual, but also requires the ability to divine which shapes, colours and textures create such uneasy energy. Eva Rothschild is a sculptor, not a spiritualist, but she gives her pared-down work any number of additional dimensions beyond molecular abstraction and neo-Minimalism, summoning up ghosts of medieval or Victorian Gothic, Aleister Crowley's branch of magick, and references to the occult. Characterised by spidery lines in space, tentative torsos or trunks, spiky or egg-like forms on stilts, Rothschild's art also mines Native American symbology and 1970s psychedelia to create upright, totemlike structures that flaunt their instability and uncertainty in the world.
A monumental grid of interlocking black diamond frames, or a giant zigzagging doodle in space, the public installation *Cold Corners* (2009) showed Rothschild's spatial control on a grand scale by allowing visitors to create their own paths through the piece while also suggesting new vistas and sightlines within the seemingly incongruous neo-classical interior of Tate Britain's Duveen Galleries. Smaller, roughly human-scaled pieces, such as *Stalker* (2004) or *Mr Messy* (2007), have similarly complicated structures that create visual feedback loops within themselves, again suggesting movement or flow where there is none. Her dirtied, romanticised take on previous, usually male sculptors, such as Anthony Caro, David Smith, or Constantin Brancusi, sees Rothschild introducing tactile materials such as plaited leather, Perspex, or woven cord, as well as gaudy dashes of fluorescent, spray-painted colour that mock and update her strictly formal forebears. Black, however, is still her signature theme, evident not only in titles such as *Nefertiti* (2009) or *Black Mountainside* (2001), but also in her continued use of shiny resin, powder-coated aluminium, tyres, and lacquer. The darkness is suggestive of black holes, shadow play, and psychological voids.

Ossian Ward

Someone and Someone, 2008
Aluminium, enamel paint
450 × 400 cm

Exhibition view, 2007
South London Gallery

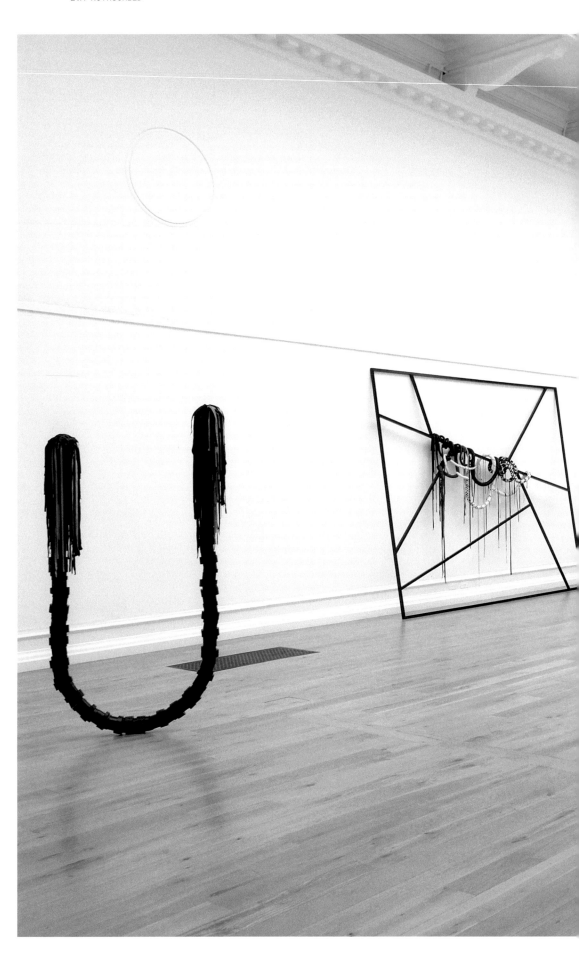

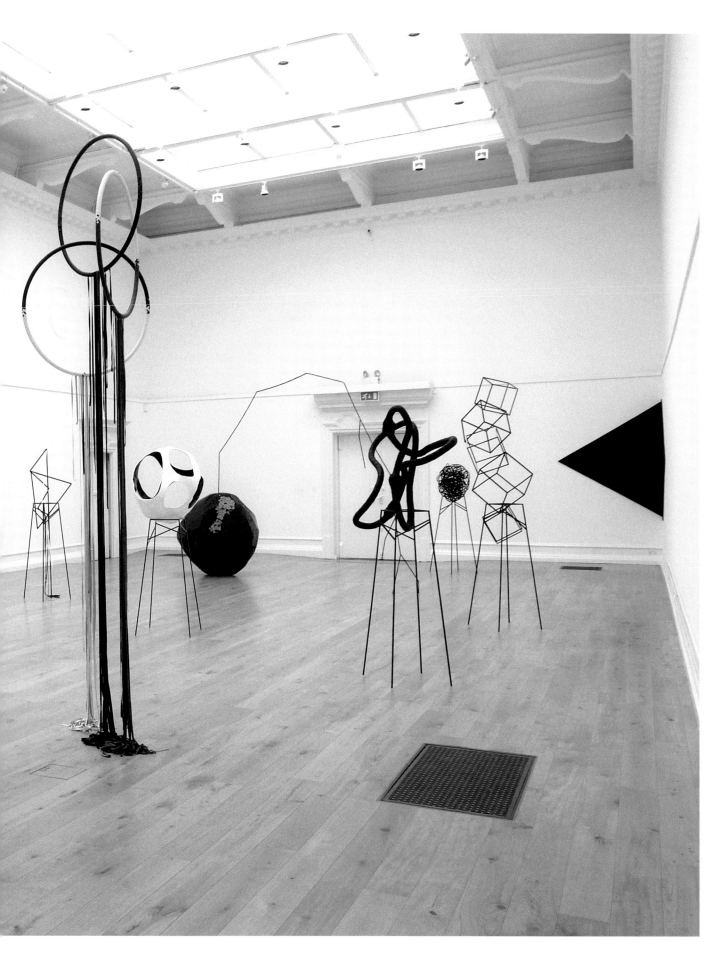

STERLING RUBY

1972 geboren in Bitburg, Deutschland,
lebt und arbeitet in Los Angeles, CA, USA
**1972 born in Bitburg, Germany,
lives and works in Los Angeles, CA, USA**

2007 2nd Moscow Biennale of Contemporary Art – *Footnotes on Geopolitics, Market and Amnesia*

www.foxyproduction.com
www.marcfoxx.com
www.spruethmagers.net
www.thepacegallery.com
www.xavierhufkens.com

„Finish Architecture/Kill Minimalism/Long Live the Amorphous Law!" – die Slogans auf den *Anti-Prints* (2005) von Sterling Ruby klingen wie eine Kriegserklärung. Er ist der wohl radikalste und facettenreichste Protagonist einer jungen Generation von US-Künstlern, die das Formenvokabular der Minimal Art kritisch neuinterpretieren. Versuchten Künstler wie Eva Hesse oder Paul Thek bereits in den späten 1960er Jahren, die aseptische Minimal Art mit Themen wie Körperlichkeit, Sexualität und Tod zu infizieren, geht Ruby in seiner Verunreinigung sehr viel weiter. Neben tumorartig wuchernden Keramiken gehört die Serie der *SUPERMAX*-Skulpturen (seit 2005) zu seinen bekanntesten Arbeiten. Sie ist von den Architekturen der gleichnamigen US-Hochsicherheitsgefängnisse inspiriert: gigantische Urethan-Gebilde, die wie blutrote Stalagmiten oder futuristische Knast-Türme aus Science-Fiction-Filmen anmuten. Im Kontrast dazu stehen die *Inscribed Monoliths* (2006): Resopal-Quader, die mit Kritzeleien, Fingerspuren und Flecken oder mit Farb-Graffiti bedeckt sind. Die Skulpturen wirken, als wären sie im öffentlichen Raum vandalisiert worden. Hintergrund dieser Arbeiten ist sowohl die Auseinandersetzung mit den Schriften Donald Judds als auch die Beschäftigung mit der Gang-Kultur in L. A., wo Ruby als Student Mike Kelley assistierte. In seinen Augen ähneln sich die Heroen der Minimal Art und die Gangster – es geht um Hierarchien, die Verteidigung von Territorium, männliche Dominanz. Ruby sieht das Dogma der Minimal Art, dass alles Persönliche unterdrückt werden soll, als symptomatisch für eine repressive Kultur, für die der Kunstbetrieb ein weiteres Mittel der Überwachung, Konditionierung und Bestrafung darstellt. So kann man seine Ausstellungstrilogie von 2008, *Zen Ripper* (Emi Fontana, Mailand), *Grid Ripper* (GAMeC, Bergamo) und *Spectrum Ripper* (Sprüth Magers, London), nicht nur als formales, sondern auch als institutionskritisches Statement betrachten: Die aufeinandergestapelten Hartfaser-Monolithe evozieren Barrikaden und urbanen Aufruhr – mit ihrem vibrierenden All-over aus Sprühfarbe zerfetzen sie die minimalistischen Ordnungssysteme von Geometrie und Raster regelrecht. Dass Ruby sich selbst nicht klar einordnen lässt, bewies er mit der umstrittenen Videoinstallation *The Masturbators* (2009), für die er neun Pornodarsteller vor der Kamera masturbieren ließ: Kunst als Akt männlicher Selbstbefriedigung.

'Finish Architecture/Kill Minimalism/Long Live the Amorphous Law!' – the slogans in Sterling Ruby's *Anti-Prints* (2005) sound like a declaration of war. Ruby is probably the most radical and most multi-faceted protagonist among a generation of young US American artists who subject the formal vocabulary of Minimal Art to a critical reinterpretation. As early as the late sixties, artists such as Eva Hesse and Paul Thek sought to infect the aseptic art of Minimalism with themes like the human body, sexuality, and death, but Ruby takes such contamination much further. Among his best-known works are ceramic pieces growing uncontrollably like tumours, as well as the series of *SUPERMAX* sculptures (since 2005) inspired by the architecture of the US high-security prisons the title refers to: gigantic urethane structures that suggest crimson stalagmites or futurist jail towers from Science Fiction movies. They contrast with the *Inscribed Monoliths* (2006): formica-lined blocks covered with scrawls, the traces of fingers, and stains or colourful graffiti. These sculptures look as though they had been vandalised while installed in the public space. Behind them stands Ruby's study of Donald Judd's writings as well as his examination of gang culture in L.A., where he was Mike Kelley's assistant during his student years. In Ruby's eyes, the heroes of Minimal Art resemble the gangsters – what matters to them are hierarchies, the defence of territories, male dominance. Ruby considers the dogma of Minimal Art that anything personal must be excluded to be a symptom of a repressive culture in which the art business serves as yet another means of surveillance, conditioning, and punishment. Accordingly, his 2008 exhibition trilogy – *Zen Ripper* (Emi Fontana, Milan), *Grid Ripper* (GAMeC, Bergamo), and *Spectrum Ripper* (Sprüth Magers, London) – can be read not only as a formal statement, but also as an act of institutional critique: the stacked hard-fibre monoliths evoke barricades and urban revolt – with their vibrant spray-paint all-overs, they positively shred the minimalist systems of order, geometry and the grid, to pieces. That Ruby deliberately defies clear categorisation is something he proved with the controversial video installation *The Masturbators* (2009), for which he asked nine porn actors to masturbate in front of the camera: art as an act of male autoeroticism.

SUPERMAX 2008, 2008
Exhibition view, The Museum of
Contemporary Art, Los Angeles

Oliver Koerner von Gustorf

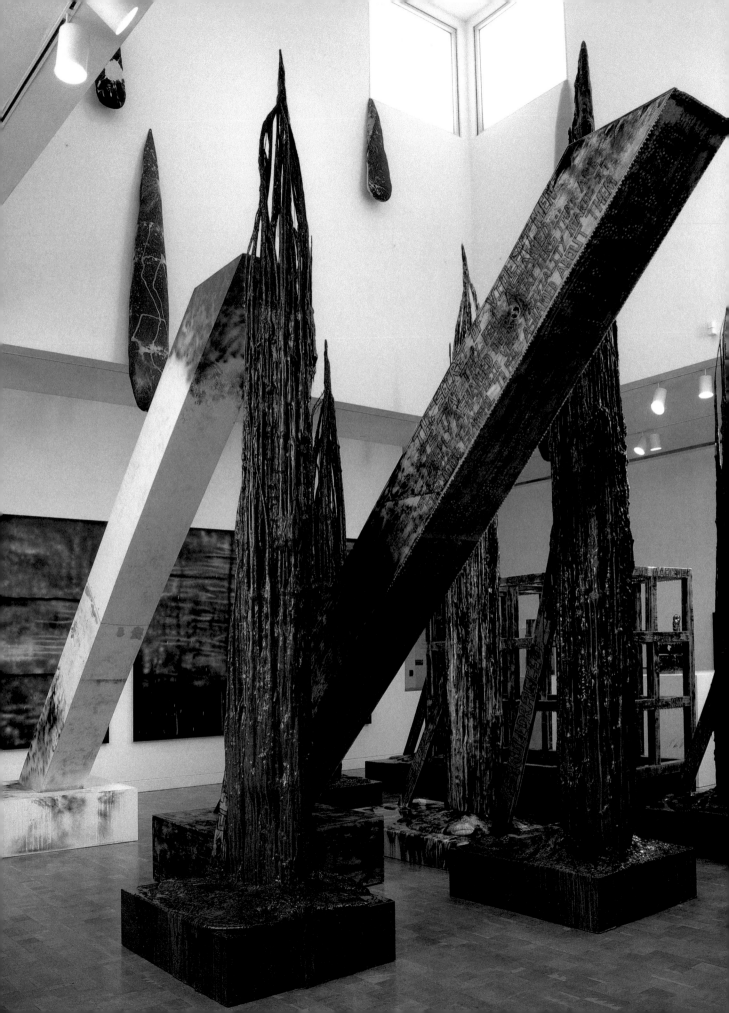

Transcompositional/
Leopard Stance, 2009
Nail polish and collage
on acrylic mirror
127 × 86 cm

The Masturbators, 2009
Exhibition view,
Foxy Production, New York

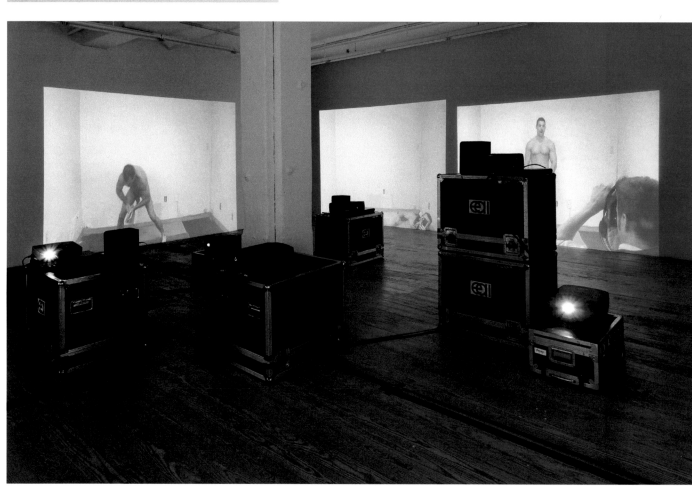

2TRAPS, 2010
Exhibition views,
PaceWildenstein, New York

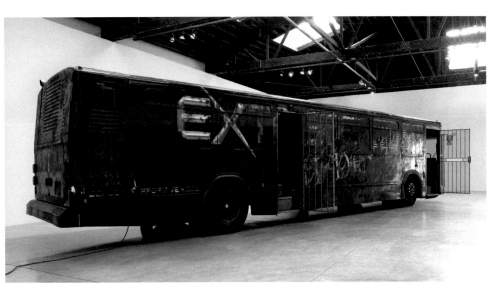

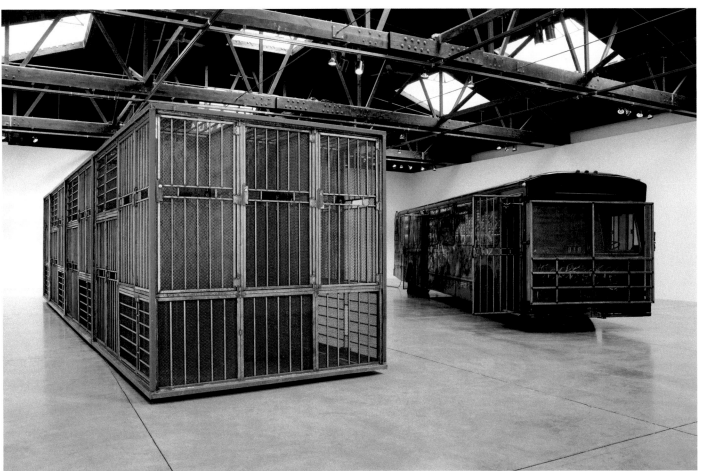

MICHAEL SAILSTORFER

1979 geboren in Velden, Deutschland,
lebt und arbeitet in Berlin, Deutschland
**1979 born in Velden, Germany,
lives and works in Berlin, Germany**

2007 Sharjah Biennial 8 – *Still Life.
Art, Ecology and the Politics of Change*
2007 2nd Moscow Biennale of Contemporary Art – *Footnotes on Geopolitics,
Market and Amnesia*
2004 Biennale of Sydney – *On Reason
and Emotion*
2004 Manifesta 5, European Biennial
of Contemporary Art, San Sebastián
2004 Liverpool Biennial of
Contemporary Art

www.sailstorfer.de

www.fortesvilaca.com.br
www.perrotin.com
www.galleriazero.it
www.johannkoenig.de

Kunst findet bei Michael Sailstorfer mit Vorliebe unter freiem Himmel und in der Natur statt. Einen einsam auf einer Wiese stehenden Obstbaum katapultierte er in die Luft (*Raketenbaum, 2008*), aus einem Segelflugzeug fertigte er ein Baumhaus (*D-IBRB, 2002*), und die Teile einer kleinen Holzhütte am Waldesrand verbrannte er nach und nach in dem Ofen der Behausung, bis am Ende nur noch das Heizgerät selbst übrig blieb (*3 Ster mit Ausblick, 2002*). Abgeschiedene Unterstände an Bushaltestellen, wie sie in dünn besiedelten ländlichen Gebieten anzutreffen sind, stattete er dagegen mit Strom- und Wasseranschluss sowie Mobiliar aus (*Wohnen mit Verkehrsanbindung, 2001–2008*). Vom Kosmischen fühlt sich der Künstler magisch angezogen und begeistert sich dafür, mit den ungewöhnlichsten Fluggeräten zu experimentieren: Seinen alten Mercedes transformierte er beispielsweise in eine Abschussrampe für eine Straßenlaterne und ließ auf diese Weise eine „Sternschnuppe" entstehen. Aus einem Bus und einer weiteren Lampe baute er einen sich drehenden Globus samt Satellit, für dessen Antrieb erneut sein Auto zuständig war.

Gegenstände auf eine charmante und humorvolle Art umzufunktionieren, bis sie auf den ersten Blick völlig nutzlos erscheinen, gelingt Sailstorfer aber auch im Innenraum. Für *Zeit ist keine Autobahn* (seit 2005), das in verschiedenen Versionen existiert, lässt der Künstler mit einem Motor unter großem Getöse Autoreifen an der Wand abschleifen, bis nur noch ein schwarzer Abrieb, feine Späne und ein penetranter Gummigeruch übrig sind. Fast wie eine wissenschaftliche Versuchsanordnung erscheint demgegenüber *Reaktor* (2005): In einem Betonklotz steckten zahlreiche Mikrofone, die über ein Mischpult mit Lautsprechern verbunden waren. Dadurch wirkte der Kubus wie ein Tonabnehmer, der sämtliche Schwingungen des Hauses registrierte und verstärkte: Sowohl die leisesten Tritte auf der Treppe als auch die Vibrationen des Verkehrs manifestierten sich in wahrnehmbaren Schallwellen. Eine Arbeit, die Sailstorfers Faszination für Materie und schwebende Teilchen, den Himmel mit dem Ausstellungsraum verbindet, stellt die *Unendliche Säule* (2006) dar. In Anspielung auf Constantin Brancusis bekannte Skulptur entstanden, besteht sie aus einem Hochleistungsscheinwerfer, der, sobald die Nacht anbricht, durch das Dach der Galerie hindurch in die Weite des Himmels strahlt.

Michael Sailstorfer likes it best when his art takes place outdoors and in nature. He took a lonely fruit tree in a meadow and catapulted it into the air (*Raketenbaum*, 2008); made a tree house out of a glider (*D-IBRB*, 2002); and burned a little wooden cabin on the edge of a forest, feeding it, piece by piece, into the building's stove until all that remained was the heating device itself (*3 Ster mit Ausblick*, 2002). On the other hand, he equipped remote bus stop shelters of the sort found in sparsely populated rural areas with electricity and water connections as well as furniture (*Wohnen mit Verkehrsanbindung*, 2001–2008). The artist feels magically attracted by the cosmic, and so he enthusiastically experiments with the most outlandish aircraft: for instance, he transformed his old Mercedes into a launching pad for a streetlight in order to create a 'shooting star'. Out of a bus and another lamp he built a rotating globe featuring a satellite; his car once again had to power the arrangement.

Yet repurposing objects in charming and humorous ways until they appear at first glance to be perfectly useless: that is something Sailstorfer also accomplishes in interior spaces. For *Zeit ist keine Autobahn* (since 2005), which exists in various versions, the artist runs a motor to wear car tires down by grinding them against a wall, a wildly noisy operation, until nothing is left but black abrasion marks, finely ground shavings, and an overwhelming smell of rubber. A work that in comparison looks almost scientific, like an experimental arrangement, is *Reaktor* (2005): stuck into a block of concrete were numerous microphones connected, via a mixing desk, to speakers. This turned the block into a sort of sound pick-up that registered and amplified any vibration in the building: both the softest steps on the stairs and the vibrations of traffic became manifest in perceptible sound waves. One work that combines Sailstorfer's fascination with matter and floating particles and the sky to the exhibition space is his *Unendliche Säule* (2006). An allusion to Constantin Brancusi's well-known sculpture, it consists of a high-powered floodlight that, as soon as night falls, pierces the gallery's roof to send a ray of light into the vast open sky.

Sven Beckstette

Zeit ist keine Autobahn – Frankfurt, 2008
Tyre, electronic motor, iron
Dimensions variable
Installation view, Schirn Kunsthalle
Frankfurt

Anna, 2004
Hairdryer, microphone,
microphone stand, speaker
165 × 120 × 150 cm

*Wohnen mit Verkehrsanbindung –
Großkatzbach,* 2001–2008
Bus stop, bed, kitchen, table,
chair, shelf, toilet, door, light,
electricity, water
255 × 259.5 × 191.5 cm

Reaktor, 2005
Concrete, microphones, mixer,
amplifier, speaker
210 × 225 × 225 cm
Installation view, Akademie der
Bildenden Künste München, Munich

Unendliche Säule, 2006
Aluminium, searchlight
85 × 100 cm

TOMÁS SARACENO

1973 geboren in San Miguel de Tucumán, Argentinien, lebt und arbeitet in Frankfurt am Main, Deutschland
1973 born in San Miguel de Tucumán, Argentina, lives and works in Frankfurt/Main, Germany

2009 53rd International Art Exhibition / La Biennale di Venezia – *Fare Mondi / Making Worlds*
2008 Liverpool Biennial of Contemporary Art
2007 9th Biennale de Lyon – *00s. The history of a decade that has not yet been named*
2006 27th Bienal de São Paulo – *Como viver junto / How to Live Together*
2003 50th International Art Exhibition / La Biennale di Venezia – *Dreams and Conflicts. The Dictatorship of the Viewer*

www.andersen-s.dk
www.pinksummer.com
www.tanyabonakdargallery.com

Galaxies Forming along Filaments, like Droplets along the Strands of a Spider's Web, 2009
Elastic ropes
Dimensions variable
Installation view, 53rd International Art Exhibition / La Biennale di Venezia

Tomás Saraceno bewegt sich nicht nur thematisch an der Grenze zwischen Wissenschaft und Kunst, sondern er benutzt tatsächlich wissenschaftliche Methoden, um seiner Vision näherzukommen: Der ausgebildete Architekt plant schwebende Städte. Dabei bedient er sich für seine Forschungen in vielen Disziplinen wie der Biologie, der Architektur und der Materialforschung.

In gewisser Weise sind Saracenos künstlerische Interventionen Studien, Ergebnisse in kleinem Maßstab auf dem Weg zur großen Idee, der Cloud-City. Seine in bis zu 15 Metern Höhe schwebenden, transparenten Blasen aus Folie sind Prototypen für künftige Wohneinheiten. Die verknüpften Seile, mit denen die perfekt kugelförmigen Sphären an Boden, Wänden und Decke gehalten werden, sollen einmal in der Lage sein, die schwebenden Module der Cloud-City zusammenzubringen und gegebenenfalls am Boden zu verankern. Spinnen, von denen einige Arten auch die Technik des „Ballooning" beherrschen, sind die konstruktiven Vorbilder für Saraceno. Zusammen mit internationalen Spinnenforschern fertigte er erstmals eine dreidimensionale Rekonstruktion eines kompletten Spinnennetzes. Installiert im Ausstellungsraum, kann diese Intervention einerseits als wissenschaftliche Leistung gelten, andererseits entfaltet sie eine ästhetische Wirkung abseits aller wissenschaftlich korrekten Daten und Koordinaten.

Saracenos Ansatz, sich selbst versorgende bewohnbare Einheiten zu entwickeln, die jenseits von Ländergrenzen und Regierungen existieren können, beruft sich auf interdisziplinäre utopische Konzepte moderner Vordenker wie R. Buckminster Fuller. Doch macht Saraceno seine Pläne nicht nur anschaulich, sondern auch greifbar und begehbar. Das Wort Utopie scheint hier auf den zweiten Blick gar nicht angemessen, denn er geht fest von der Machbarkeit aus und beweist das mit jedem neuen Schritt. Eine große Stärke der Arbeit Saracenos ist die unideologische Haltung. Er mag an einem Zukunftsmodell arbeiten, das die Antwort auf viele gegenwärtige Fragen sein könnte, doch er verzichtet auf die Sprache politischer Propaganda und gesellschaftlicher Programme. Dabei ist das Besondere an seinen Installationen, dass ihre Form auf einer – wenn auch bisher nur hypothetischen – Anwendbarkeit beruht: Statt um ästhetische Fragen geht es um Leichtigkeit, Flugfähigkeit, Stabilität oder Materialeffizienz. Erstaunlicherweise ergibt sich daraus eine Formensprache, die nicht nur funktional, sondern auch höchst poetisch und erzählerisch ist.

Tomás Saraceno not only explores issues that straddle the boundary between science and art, he actually employs scientific methods to approach his vision: a trained architect, he plans floating cities. In his investigations, he has drawn on many disciplines, including biology, space architecture, and materials research.

Saraceno's artistic interventions are studies of sorts, microscale results en route to the grand idea of Cloud-City. His transparent membrane bubbles, floating up to 15 m (50 ft) above the ground, are prototypes of future residential units. The interconnected ropes that attach the perfectly spherical pillows to floors, walls, and ceilings shall one day be capable of holding the floating city modules together and, if necessary, anchor them to the ground. Saraceno's constructions are inspired by spiders, some of which have likewise mastered the technique of 'ballooning'. In collaboration with international arachnologists, the artist created the first three-dimensional reconstruction of a complete spider web. Installed in the exhibition space, this intervention can be considered a scientific accomplishment, but it also has an aesthetic impact beyond scientifically correct data and coordinates.

Saraceno's project of developing self-sustaining habitable units that can exist independently of national borders and governments invokes interdisciplinary utopian concepts developed by modern masterminds such as R. Buckminster Fuller. Yet the artist, rather than merely illustrating his plans, makes them tangible and walkable. Upon closer inspection, the word 'utopia' seems altogether inadequate – Saraceno firmly aims at actual feasibility, which he demonstrates at each new step. One great strength of Saraceno's work is its unideological position. He may be working on a model for the future that might provide answers to many questions of the present, but he does without the languages of political propaganda and social engineering. What is truly special about his installations is that their form is derived from their application, however hypothetical the latter may still be: the focus is not on questions of aesthetics but on lightness or the ability to fly, on stability or the efficient use of materials. Astonishingly enough, this focus leads to a formal vocabulary that is not only functional, but also highly poetical and narrative.

Silke Hohmann

Untitled, 2008
C-print
26.5 × 40 cm

Hydrogen Cloud Explosion, 2008
Elastic thread, plexiglass glue,
vacuum cups
Approx. 170 × 140 × 90 cm

Cumulonimbus/Air-Port_City, 2006
Pillows filled with pressurised air, net,
spiral stairs, weight, entrance, exit,
and social behaviour of the visitors
Height: 1500 cm, ∅ 700 cm
Installation view, 27th Bienal de São Paulo

BOJAN ŠARČEVIĆ

1974 geboren in Belgrad, Jugoslawien,
lebt und arbeitet in Berlin, Deutschland,
und Paris, Frankreich
**1974 born in Belgrade, Yugoslavia,
lives and works in Berlin, Germany,
and Paris, France**

2004 3rd berlin biennial for
contemporary art
2003 50th International Art Exhibition /
La Biennale di Venezia – *Dreams and
Conflicts. The Dictatorship of the Viewer*

www.bojansarcevic.net

www.bqberlin.de
www.modernart.net
www.pinksummer.com

Bojan Šarčević legt in seiner Arbeit Verbindungen zwischen Ost und West, Süd und Nord, zwischen gotischen Kathedralen, dem kufischen Ornament und dem russischen Konstruktivismus, zwischen verschiedenen Formen von Produktion, zwischen der eigenen Existenz und den Schichten, die sich räumlich und zeitlich um sie herum anlagern. Dazu nutzt er unterschiedliche Medien: architektonische Skulpturen aus Kupfer, Holz oder Glas, Videos, in denen jemand mäandernd unterwegs ist, Blaupausen, Readymades, 16-mm-Film-Installationen, Künstlerbücher und Mixed-Media-Vitrinen.

Immer macht das gleichzeitige Interesse an Inhalt und Form, die Betonung der Bedeutung der Form, Šarčevićs Arbeit aus. So erinnert die Skulptur *Replace the Irreplaceable* (2006) an die gerundeten Fassaden des Architekten Erich Mendelsohn, dessen elegante Streamline-Moderne seit den 1920er Jahren weltweit Nachahmung fand. Im „Ersetzen des Unersetzbaren" wird der mit der Stromlinie verbundene Optimismus wieder aufgegriffen, aber mit dem paradoxen Bewusstsein über etwas unwiederbringlich Verlorengegangenes.

Viele von Šarčevićs Arbeiten sind letztendlich Zeichnungen, Spuren, die einen Grundriss oder Aufriss bilden, ornamentale Strukturen, räumliche Lineamente, die eine zarte Kontur in den Raum schreiben, Kerben, die tiefere Schichten freilegen, oder Flecken, die eine Geschichte erzählen. Programmatisch ist das Video *Miniatures* (2003), das einen Autofahrer zeigt, der durch eine große Stadt fährt und dabei mit dem Finger ein Linienraster auf die beschlagene Windschutzscheibe malt: Zeichnet er die Konturen der Häuser nach, den gefahrenen Weg oder vielleicht ein islamisches, in der Region bedeutendes Ornament?

Das Imaginäre, das in dieser temporären Zeichnung aufblitzt, steht in komplexer Beziehung zum Realen der Bewegung und Ortsveränderung in der Stadt, die von der fixierten Kamera aufgezeichnet wird. Hier zeigt sich eine Medienreflexivität, die stark auch die abstrakteren, neueren Arbeiten bestimmt, vor allem die Filminstallationen, die erstmals in *Only after Dark* 2007 gezeigt wurden. *The Breath-Taker Is the Breath-Giver* (2009) deutet auf eine abhängige Closed-Circuit-Situation, die den skulpturalen Ort der Projektion und den skulpturalen Ort im Film – zugleich Hauptfigur und Motiv – zusammenspannt. Trotz dieser formalen Stringenz sind die Filmbilder fantastisch offen und deuten ein Reich des Möglichen an.

Bojan Šarčević's work draws connecting lines between East and West, South and North; between Gothic cathedrals, Kufic ornamentation, and Russian Constructivism; between different forms of production; between his own existence and the layers that aggregate around it in space and time. The artist uses a variety of media: architectonic sculptures made from copper, wood, or glass; videos in which someone follows a meandering trajectory; blueprints, readymades, 16mm film installations, artist's books, and mixed-media display cases.

In each instance, Šarčević's work is characterised by a simultaneous interest in content and form, by an emphasis on the meaning of form. The sculpture *Replace the Irreplaceable* (2006), for instance, recalls the rounded façades designed by the architect Erich Mendelsohn whose elegant Streamline Moderne was emulated by architects all over the world since the 1920s. By 'replacing the irreplaceable', Šarčević takes up the optimism associated with Streamline, but fuses it with a paradoxical awareness that something has been lost forever.

Many of Šarčević's works are ultimately drawings, traces that form a floor plan or elevation, ornamental structures, spatial lineaments that inscribe a delicate contour into space, grooves that reveal deeper layers, or spots that tell a story. The video *Miniatures* (2003) is programmatic: it shows someone who, driving through a large city, uses a finger to draw a grid of lines on the fogged windshield – is he tracing the contours of buildings, his own trajectory through the city, or perhaps an Islamic ornament that has special meaning to the area?

The imaginary that becomes recognisable for a brief moment in this temporary drawing is related in complex ways to the reality of movement and translocation in the city as recorded by the fixed camera. What emerges is a media-reflective approach that profoundly shapes the more abstract recent works as well, especially the film installations first shown in 2007 as part of *Only after Dark. The Breath-Taker Is the Breath-Giver* (2009) points toward a dependent closed-circuit situation that ties the sculptural site of the projection to the sculptural site in the film, at once its protagonist and a motif. Despite their formal concision, the filmic images are of fantastic openness, suggesting a realm of possibility.

Rita Kersting

Replace the Irreplaceable, 2006
Pear wood, brass
230 × 360 × 80 cm

Vitrine (Film 5), 2009
Cardboard, stones, silicone,
paper, oak, glass
187 × 125 × 80 cm

Keep Illusion for the End, 2005
Aluminium, oak, concrete,
brass, copper
250 × 140 × 216 cm

*Untitled (Only After Dark series,
film 2)*, 2007
16mm film (2:56 min), colour, sound
Site-specific pavilion (white-painted
wood, plexiglass)

MARKUS SCHINWALD

1973 geboren in Salzburg, Österreich,
lebt und arbeitet in Wien, Österreich,
und Los Angeles, CA, USA
**1973 born in Salzburg, Austria,
lives and works in Vienna, Austria, and
Los Angeles, CA, USA**

2010 Liverpool Biennial of Contemporary
Art
2006 4th berlin biennial for contemporary art – *Of Mice and Men*
2004 Manifesta 5, European Biennial
of Contemporary Art, San Sebastián
2003 50th International Art Exhibition /
La Biennale di Venezia – *Dreams and
Conflicts. The Dictatorship of the Viewer*

www.georgkargl.com
www.giomarconi.com
www.yvon-lambert.com

Dictio pii, 2001
35mm film transferred to DVD,
colour, sound
16 min

Ten in Love, 2006
35mm film transferred to DVD,
colour, sound
4:37 min

Ten in Love, 2006
35mm film transferred to DVD,
colour, sound
4:37 min

Körper, Kleidung, Möbel, Architektur und Geschichte sind die sich überlagernden Interessengebiete von Markus Schinwald, aber in seiner Arbeit durchdringt er sie alle mit heimtückischer Komplizenschaft. Kleidung verbirgt nicht nur, sie behindert; Einrichtungsgegenstände geben ein verstörendes Echo auf die emotionalen Zustände des Körpers, und Architektur besteht eher aus durchlässigen Grenzen als aus tektonischen Strukturen. In einer fortlaufenden Serie verwendet Schinwald Porträtgemälde des 19. Jahrhunderts und überarbeitet sie: So verhüllt nun ein sinnliches Halstuch den ganzen Kopf oder die Hinzufügung einer kunstvollen Prothese betont eine starre Körperhaltung. In vielen seiner Installationen und Filme treten lebensgroße Marionetten in Anzügen auf; sie wirken wie Agenten des Unheimlichen, die die Lebenden durch schwerfällige Kopien ersetzen. Derweil spreizen sich suggestive Anordnungen antiker Stuhlbeine lüstern wie menschliche Gliedmaßen und verleihen dem Leblosen eine außergewöhnliche Ausdruckskraft.

Schinwald arbeitet mit einem Vokabular der Verdrängung, um zu hinterfragen, was natürlich, wesenhaft oder äußerlich ist; es enthüllt das Verborgene oder verbirgt das Offenliegende und suggeriert eine konspirative Übereinstimmung von körperlichen und psychischen Zuständen. In seinen Zeichnungen von Gerippen mit knöchernen Vorsprüngen oder strukturellen Deformationen lässt sich ein Interesse an Skelettstrukturen erkennen, ebenso wie in den baulich überflüssigen Anordnungen von senkrechten Trägern, die in Ausstellungsräume eingefügt werden. Er lässt die Idee von körperlichen Normen fragwürdig erscheinen mit maßgefertigtem Schuhwerk, dessen fehlende Absätze oder verbundene Zehen Bewegung beeinträchtigen, oder mit Fotografien, in denen Schlangenmenschen in alltäglichen Umgebungen sich in unwirklichen Haltungen verbiegen.

Vanishing Lessons (2009), eine Ausstellung auf drei Stockwerken im Kunsthaus Bregenz, bot eine Mischung aus Theater, Film und Installation. Auf jeder Etage präsentierten Schauspieler auf einer aus zwei Räumen bestehenden Bühne vor Publikum Stücke mit zusammenhanglosen Geschichten, visuellen Dopplungen und unerwarteten Bewegungen. Die Aufführungen wurden gefilmt, und die geschnittenen Fassungen wurden auf hängenden Flatscreens vor einem nun leeren Bühnenbild für ein Ersatzpublikum wiedergegeben – was ein melodramatisches Verschwinden der ursprünglichen Akteure und Betrachter nahelegte.

Bodies, clothing, furniture, architecture, and history are all overlapping fields of interest for Markus Schinwald, but his work infuses each with a malevolent complicity. Clothing does not merely conceal but constrains, furnishings provide disturbing echoes of the body's emotional state, and architecture consists of permeable boundaries rather than tectonic structures. In an ongoing series, Schinwald takes oil portraits from the nineteenth-century and reworks them so that a voluptuous neck-scarf now completely envelops the whole head, or an elaborate prosthetic device is added to accentuate a stiffly held posture. Life-size marionettes dressed in suits appear in many of his installations and films, like agents of the uncanny replacing life with an inert replica. Meanwhile, suggestive arrangements of antique chair legs straddle libidinously like human limbs, granting extraordinary expressive capabilities to the inanimate.

Schinwald's work employs a vocabulary of repression to question what is natural, intrinsic, or external, revealing what is hidden or hiding what is revealed, and suggesting a conspiratorial alignment between physical and mental states. A recurring interest in skeletal structures can be seen in his drawings of skeletons with bony protrusions or structural deformities as much as in structurally superfluous arrangements of perpendicular beams inserted into gallery spaces. He casts doubt on the notion of physical norms with customised footwear whose missing heels or joined toes decidedly compromise movement, or photographs where contortionists in everyday settings bend themselves into improbable postures.

Vanishing Lessons (2009), a three-floor exhibition at Kunsthaus Bregenz, presented a hybrid of theatre, film and installation. On each floor, actors performed scripted scenarios full of disjointed narrative, visual doublings, and unexpected movements in a two-room stage set before a live audience. The performances were filmed, and edited versions were played back on hanging screens before now empty film sets to a replacement audience, suggesting a melodramatic vanishing of both original actors and spectators.

Kirsty Bell

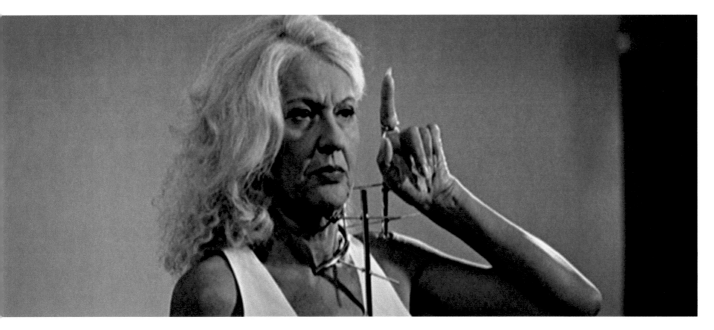

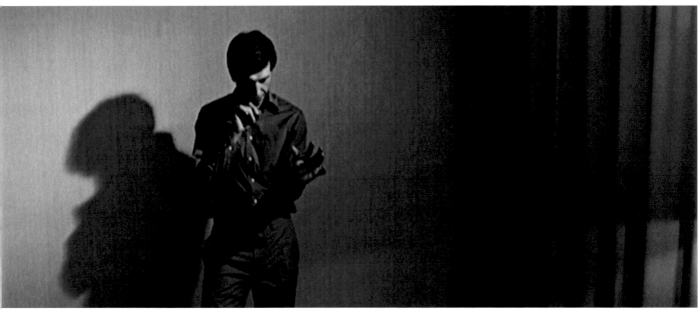

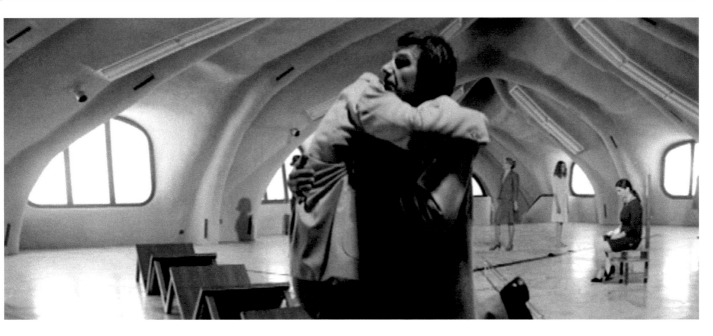

Louise, 2008
Pigment print
140 × 100 cm

Lena, 2010
Oil on cardboard
50.5 × 41 cm

Madeleine, 2009
Oil on canvas
70 × 53 cm

Lavinia, 2007
Oil on canvas
37 × 29 cm

Vanishing Lessons, 2009
Exhibition views,
Kunsthaus Bregenz

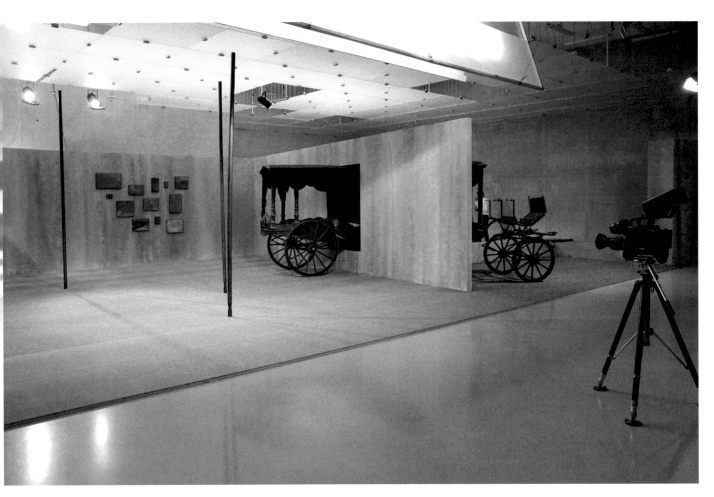

DIRK STEWEN

1972 geboren in Dortmund, Deutschland, lebt und arbeitet in Hamburg, Deutschland
1972 born in Dortmund, Germany, lives and works in Hamburg, Germany

www.gerhardsengerner.com
www.maureenpaley.com
www.tanyabonakdargallery.com

Dirk Stewen negiert Aspekte der Fotografie wie Autorschaft, Bildgehalt und Repräsentation, indem er fotografische Verfahren gegen den Strich bürstet. Zum Beispiel verwendet er handelsübliche Fotopapiere und färbt sie unter Lichteinfluss mit mehreren Schichten schwarzer Tinte ein. Das Bild entsteht aus dem destruktiven Akt, der Beschädigung durch „unsachgemäße" Belichtung, während die Tinte mit der fotoaktiven Schicht in einem unvorhersehbaren Prozess amalgamiert. Die Begegnung chemisch unverträglicher Substanzen bringt schlierige Oberflächen mit informeller Anmutung hervor, die schillernd unbestimmte Tiefe suggerieren und deren Valenzen je nach Lichteinfall von Tiefschwarz über Dunkelbraun bis zu metallischem Blau reichen. Das Verfahren, buchstäblich die Auslöschung von Autorschaft und Bildgehalt, bringt eine neue, imaginative Form von Repräsentation hervor. Stewen fügt die dunklen Blätter mit der Nähmaschine zum großen Format zusammen und überzieht sie – kompositorisch kalkuliert und nicht zu dicht – mit farbigem Konfetti, setzt mit Nähten oft weitere Linien und lässt überstehende Fäden im Bild oder über den Bildrand herabhängen. Das Leuchten der farbig filigranen Kreise und Linien erinnert an die Musikalität Kandinskys, die fragil bleiben will und stets knapp unterhalb von Komposition rangiert.

Eine weitere Werkgruppe bilden lichte Aquarelle, Figuren und Kreisformen, die Stewen rasch und einfach aus der Kontur heraus aufs Papier bringt. Auch hier sucht er amorphe Form und Nähe zur Fotografie: Es geht um den „entscheidenden Moment". Ähnlich wie bei fotografischer Belichtung ist hier in nur einem Moment das Entscheidende getan, ab dem Änderungen nur möglich sind durch behutsames Bewegen des Papiers wie im Entwicklungsbad. Als Träger verwendet Stewen Material mit sichtbarer Geschichte: Vergilbte Papiere aus antiquarischen Kunstmappen etwa, oft mit aufgedruckten Titelzeilen, die er zur Dekontextualisierung eigener malerischer Setzung nutzt wie in *Orangen, Hamburg* (2007). Teils kombiniert er solche Aquarelle mit Fotografie wie in *Ohne Titel, Hamburg* (2007), die er ebenfalls auf alten Papieren druckt, um sie historisch wirken zu lassen. Doch Stewen fotografiert durchweg selbst: Die charakteristische Atmosphäre seiner Bilder, die diskrete Opulenz der Arrangements verdanken sich präzisen bildstrategischen Manövern und raffinierter Konzeptualität.

Dirk Stewen negates aspects of photography such as authorship, pictorial content, and representation by putting photographic procedures to cross-purposes. For instance, he dyes sheets of commercially available photo paper with several layers of black ink while exposing them to light. The resulting image is the product of a destructive act, of the damage done by 'improper' exposure, while the ink unpredictably amalgamates with the photoactive layer. The meeting of chemically incompatible substances engenders streaky surfaces that recall the Informel, an iridescence suggestive of indefinite depth; depending on the lighting conditions, the hues range from jet black across dark browns to metallic blues. The procedure, a literal effacement of authorship and pictorial content, generates a new imaginative form of representation. With a sewing machine, Stewen assembles the dark folios into large-format works, spattering them with colourful confetti (not too densely and with precise compositional calculation), often placing further lines by adding sutures and letting loose ends of thread hang into the picture or off its edge. The luminescence of the colourful and delicate circles and lines recalls the musical qualities of Kandinsky's art, which seeks to remain fragile and always ranges just below composition proper.

Another group of works consists of bright watercolours, figures and circles Stewen quickly and lightly casts onto the paper based on a sense of contour. Here, too, he seeks out amorphous forms and the proximity of photography: what counts is the 'decisive moment'. As with photographic exposure, the decisive act takes only a moment, after which alterations can be made only by carefully moving the paper, not unlike in the developing bath. Stewen paints his watercolours on materials with a visible history: yellowed papers from antiquarian art portfolios, for example, often bearing printed titles, which he uses to decontextualise his own contribution; thus in *Orangen, Hamburg* (2007). Sometimes he combines such watercolours with photographs, thus in *Ohne Titel, Hamburg* (2007), which he likewise prints onto old papers to give them a historic appearance. Yet Stewens always takes his own photographs: the characteristic atmosphere of his pictures, the discreet opulence of the arrangements are the fruit of precisely executed manoeuvres of pictorial strategy and a subtle Conceptualism.

Jens Asthoff

Untitled, 2007
Ink, confetti, and cotton
on photo paper, steel pins
183 × 152.5 cm

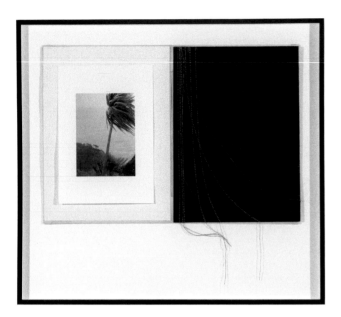

Untitled (Rechtsrum), 2006
Inkjet print, ink, and cotton on paper
60 × 67 cm (framed)

Untitled, 2008
Vintage paper, wooden rods, steel
rings, ink, confetti, and cotton on
photo paper, inkjet print on vinyl,
C-prints, and glassine
137 × 477.5 cm

Paul's Mate, 2010
Ink, tape, offset print on clip frame,
confetti and thread on satin ribbon
Dimensions variable

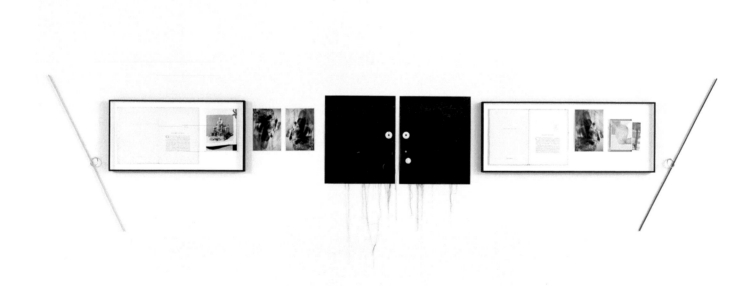

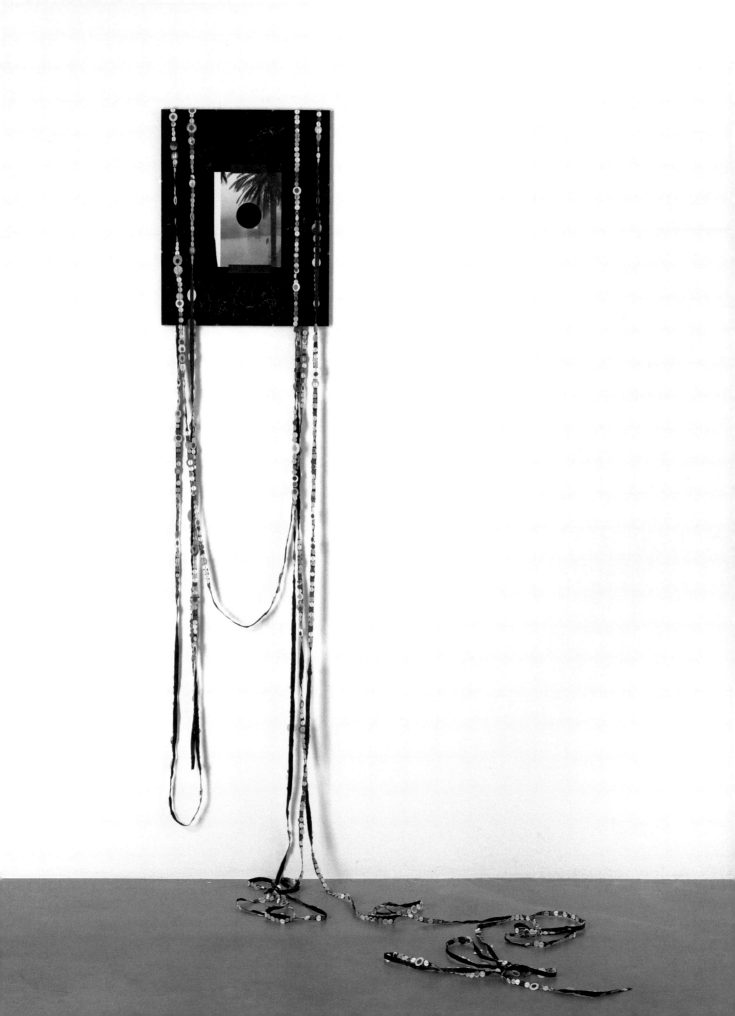

TATIANA TROUVÉ

1968 geboren in Cosenza, Italien, lebt und arbeitet in Paris, Frankreich
1968 born in Cosenza, Italy, lives and works in Paris, France

2010 29th Bienal de São Paulo – *Há sempre um copo de mar para o homem navegar / There is always a cup of sea to sail in*
2008 Manifesta 7, European Biennial of Contemporary Art, Trentino-Alto Adige
2007 52nd International Art Exhibition / La Biennale di Venezia – *Think with the Senses – Feel with the Mind*
2003 50th International Art Exhibition / La Biennale di Venezia – *Dreams and Conflicts. The Dictatorship of the Viewer*

www.gagosian.com
www.perrotin.com
www.johannkoenig.de
www.alminerech.com

Die Türen sind grundsätzlich zu niedrig; um einen Blick hinter die Glasscheiben zu werfen, muss man in die Knie gehen, und die Rohre und Leitungen scheinen unter Strom oder kurz vor dem Bersten zu stehen. Mit wenigen Mitteln erzeugt die Künstlerin Tatiana Trouvé Räume, die an versteckte Versorgungstrakte erinnern, aber gleichzeitig eigenartig dysfunktional wirken. Lässt man sich auf diese latente Beunruhigung ein, die von Trouvés Zeichnungen, Rauminterventionen und Skulpturen ausgehen, wird man bald zum Spurenleser: An der rußgeschwärzten Stelle einer Kupferleitung gab es offenbar Funkenschlag, ein Bettgestell aus Metall könnte elektrisch geladen sein, und es ist unklar, wie auf ihren mit schwarzen Lederpolstern ausgestatteten Möbeln eigentlich Platz zu nehmen wäre.

Trouvé lässt Stromkabel zu steif aufgerichteten Skulpturen werden, die sich – den Stecker in der eigenen Dose – offenbar selbst vollkommen genügen. Ein Felsbrocken, der mit zahlreichen glänzenden Messingschlössern beschlagen ist, wird zur Tautologie, einem „weißen Schimmel" der Verschlossenheit. Größere Geräte verweigern die Erklärung, ob sie der körperlichen Ertüchtigung dienen oder einer dunklen Obsession – und schon fragt man sich, welcher Details es bedürfte, um das eine vom anderen zu unterscheiden. Trouvé gibt diese Informationen mit großer Präzision nicht heraus. Sie ist eine Meisterin der punktgenauen Deplatzierung. Dabei ist die Mehrdeutigkeit ihrer Objekte verwirrend, sehen ihre Skulpturen doch so ungemein zwangsläufig aus. Sie sind von großer Eleganz und beherrschen den Raum wie hocheffiziente Apparaturen, deren Funktion man bloß nicht versteht. Wenn sie etwa das metallene Gebiss-Stück einer Pferdetrense in eine ihrer Skulpturen einbaut, geht das Objekt in seiner reinen formalen Schönheit, aber auch als Bedeutungsträger von Macht und Gefügigmachung in der Arbeit auf. Modelabels wie Hermès und Gucci wissen schon lange um den ambivalenten und darin höchst dekorativen Charme des Zaumzeugs – Fetischfreunde auch. Es geht Trouvé um Spannung, die Gleichzeitigkeit widersprüchlicher Empfindungen wie Gehorsam und Widerstand. *Double Bind* hieß ihre erste große Ausstellung im Pariser Palais de Tokyo – der Begriff beschreibt die unauflösbare Situation, einer in sich paradoxen Botschaft gehorchen zu wollen.

The doors are always too low; to take a look behind the glass panes, we have to get on our knees. The pipes look like they are about to burst, and the wires seem to be live. With spare means, the artist Tatiana Trouvé creates spaces that recall hidden supply rooms while appearing strangely dysfunctional. If we immerse ourselves in the latent disconcertment evoked by Trouvé's drawings, spatial interventions, and sculptures, we soon become sleuths: sparks must have flown where a copper wire is black with soot, a metal bed frame might carry an electric charge, and it is unclear how anyone could actually sit down on her furniture with its black leather upholstery.

Trouvé turns power cables into stiffly erect sculptures that are obviously quite self-sufficient once they are plugged into their own sockets. A rock studded with numerous gleaming brass locks becomes a tautology, a 'black darkness' of taciturnity. Larger devices refuse to declare whether they are implements of physical training or a dark obsession – and there we are, asking ourselves which details would be required to distinguish one from the other.

Trouvé withholds this information with great precision. She is a master of highly exact misplacement. The polyvalence of her objects is rendered even more confusing by the fact that these sculptures look so immensely inevitable. Exceptionally elegant, they command the room like highly efficient apparatuses whose function we merely fail to understand. When Trouvé, for instance, incorporates a metal horse bit into one of her sculptures, the object becomes part of the work in its purely formal beauty, but also as a vehicle of meaning that signifies power and subjugation. Fashion labels like Hermès and Gucci have long known about the ambivalent and yet highly decorative charm of horse-gear – and so have fans of fetishism. Trouvé is interested in the tension, in the simultaneity of contradictory emotions such as obedience and resistance. *Double Bind* was the title of her first grand exhibition at the Palais de Tokyo in Paris – the term describes the irresolvable situation that arises when we attempt to comply with an intrinsically paradoxical message.

Silke Hohmann

Untitled, 2007
Metal, rubber
215 × 268 × 240 cm
Installation view, 52nd International Art
Exhibition / La Biennale di Venezia

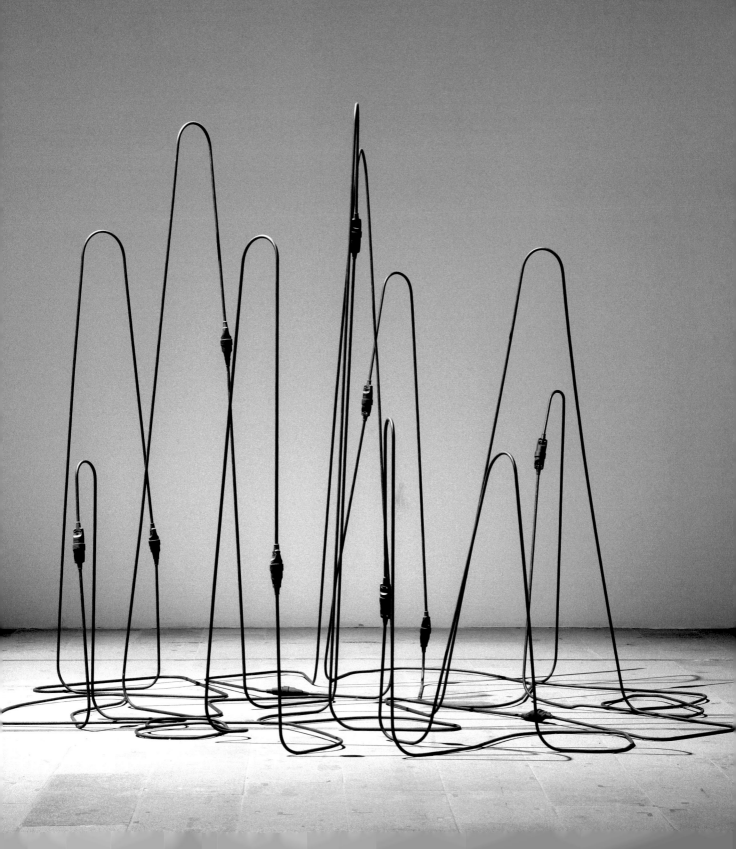

Untitled (from the series
Intranquility), 2010
Pen on paper mounted
on canvas
153 × 240 × 3 cm

Rock, 2010
Stone, bronze
53 × 79 × 74 cm
Installation view,
Gagosian, New York

The Antechamber, 2009
Metal, rubber, neon, acrylic paint,
varnish, bronze
450 × 625 × 570 cm
Installation view, migros museum
für gegenwartskunst, Zurich

350 Points Towards Infinity, 2009
Plumb lines, magnets, metal
450 × 950 × 950 cm
Installation view, migros museum
für gegenwartskunst, Zurich

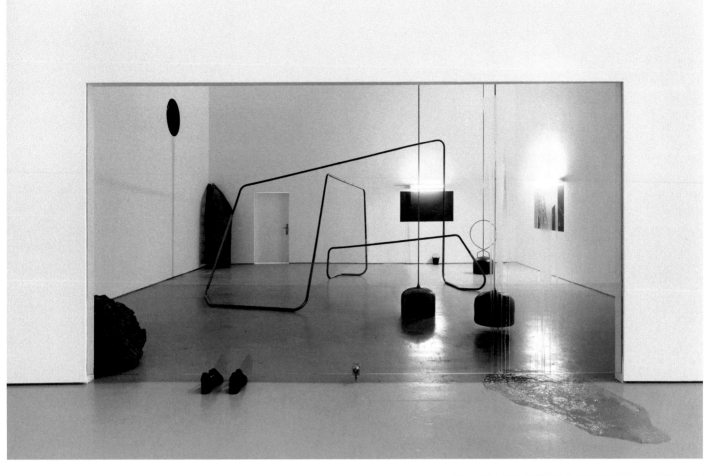

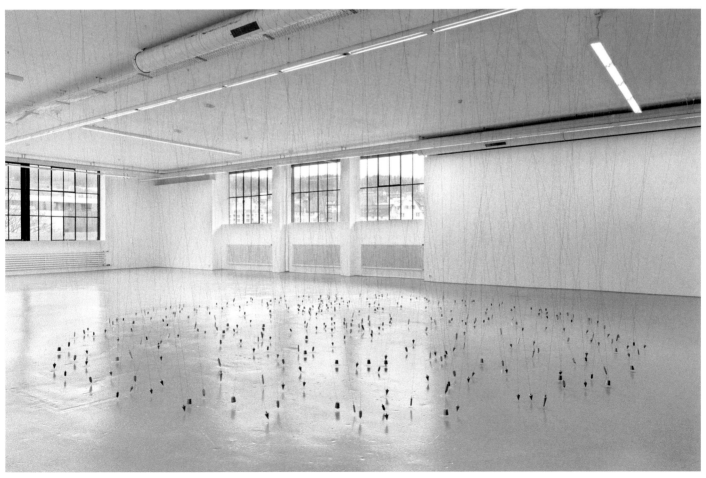

DANH VO

1975 geboren in Saigon, Vietnam, lebt und arbeitet in Berlin, Deutschland
1975 born in Saigon, Vietnam, lives and works in Berlin, Germany

2010 6th Berlin Biennale for Contemporary Art – *what is waiting out there*
2010 8th Gwangju Biennale – *10.000 Lives*
2008 Manifesta 7, European Biennial of Contemporary Art, Trentino-Alto Adige

www.bortolozzi.com
www.galeriebuchholz.de

Danh Vo showering in his bathroom, decorated with tiles depicting:
Flowering branch, fruiting branch and fruit of Rosa souliana; fruiting branchlet of Salix souliei; fruiting branches of Prunus tomentosa var. souliei; distal portion of flowing plant of Lilium souliei; basal leaves, fruit, carpel and flowering plant of Anemone coelestina var. souliei; cauline leaves of Aconitum souliei; fruiting branch of Berberis soulieana, 2010
These plants were discovered by the French missionary Jean-André Soulié along the river of Mekong. In 1905, conflict arose between Tibet and China. Caught by the Tibetan monks at Batang while trying to escape, Soulié was tortured for fifteen days and then shot.

If you were to climb the Himalayas tomorrow, 2005
Vitrine: Rolex watch, Dupont lighter, American military class ring (property of my father)
53 × 63 × 45 cm
Installation view, 6th Berlin Biennale for Contemporary Art

Danh Vo verortet seine Kunst programmatisch in einer Zone zwischen Fakt und Fiktion. In seinen Installationen, die um Fragen kultureller Zugehörigkeit und sexueller Identität kreisen, bringt Vo autobiografische Fragmente, Verweise auf die Kolonialgeschichte seines Geburtslandes und Reverenzen an die postminimalistische Kunst in affektgeladene Konfigurationen. Oftmals dienen Vo dabei die eigene Familie und persönliche Gegenstände – die häufig als Totem oder Talisman auftreten – als Ausgangspunkt und Material. In der Ausstellung *Where the Lions Are* (2009) zeigt sich Vos konzeptuelle Praxis paradigmatisch: Er verknüpft Fundstücke, angeeignete wie eigene Fotografien und historische wie erfundene Dokumente miteinander. Vo installierte im Hauptsaal der Kunsthalle Basel den Kronleuchter, der in dem Raum des Pariser Hotels Majestic hing, in dem 1973 der Friedensvertrag für Vietnam unterzeichnet wurde. Auf dem Boden lag eine Grabplatte für die Großmutter des Künstlers; ein Kruzifix auf der marmornen Nachbildung der Front von Haushaltsgeräten, die sie nach ihrer Ankunft in Deutschland von einer katholischen Hilfsorganisation erhalten hatte. Ähnlich wie Felix Gonzalez-Torres, dessen Retrospektive 2010 Vo auf ihrer Station in Brüssel kuratorisch mitverantwortete, öffnet er die Prinzipien des Readymades und der minimalistischen Skulptur konsequent für ihre identitätspolitischen wie anthropomorphen Dimensionen.

In einem Raum der Basler Ausstellung hatte Vo neben einer Vitrine, in der er auf die Geschichte christlicher Missionare in Asien u. a. mit einer Reliquie Bezug nahm, ein Bündel von Ästen an die Wand gelehnt, die von einem Baum stammen, der als Markierung für die Stelle dient, an der Danh Vos unmittelbar vor der Flucht nach Europa verstorbener jüngerer Bruder begraben liegt. In ihrer kalkulierten Kargheit kann diese archaische Skulptur zum Sinnbild sowohl einer traumatischen Erfahrung als auch des Begehrens des globalisierten Kunstbetriebs nach kultureller Differenz werden.

Mit verwandtem Sinn für die materiellen Wert und Funktionalität übersteigende Aura von Objekten, die durch erlebte Historie von stummen Waren zu sprechenden Dingen werden, zeigte Vo auf der 6. Berlin Biennale eine Auslage mit einer Rolex, einem Feuerzeug und einem Ring: allesamt Gegenstände, die der Vater nach der Flucht erworben hat und die der Sohn nun ausstellt, um fortwährend die tückische Frage nach der Grenze zwischen Kunst und Leben zu stellen.

Danh Vo programmatically situates his art in a zone between fact and fiction. In his installations, which revolve around questions of cultural membership and sexual identity, the artist arranges autobiographical fragments, references to the colonial history of his native country, and acts of homage to post-Minimalist Art in highly affective configurations. In many cases, Vo's own family history and personal objects, which often appear as totems or talismans, serve as points of departure and materials for his work.

The exhibition *Where the Lions Are* (2009) exemplifies Vo's conceptual practice: he combines found objects with appropriated photographs as well as pictures he has taken himself and historic and invented documents. In the main hall at Kunsthalle Basel, Vo installed the chandelier that used to illuminate the room at the Hotel Majestic in Paris where the 1973 Peace Accords for Vietnam were signed. On the floor rested a tomb slab for the artist's grandmother; a crucifix lay on a marble reproduction of the front of household appliances she had received from a Catholic relief organisation after her arrival in Germany. Not unlike Felix Gonzalez-Torres – Vo was a co-curator on his 2010 retrospective in Brussels – the artist forcefully opens up the principles of the readymade and of minimalist sculpture toward the dimensions of identity politics as well as anthropomorphism implicit in them.

One room of the Basel show contained a display case with materials, including a relic, relating to the history of the Christian mission in Asia; next to it, Vo had set a sheaf of branches against the wall that were taken from a tree marking the place where his younger brother, who died immediately before the family fled for Europe, is buried. In its calculated austerity, this archaic sculpture may be read as symbolising both a traumatic experience and the desire for cultural difference in the globalised art business.

Vo's keen sense for the aura of objects beyond their material value and the function they serve, for how mute commodities become eloquent objects by virtue of their association with our own histories, was similarly in evidence in his contribution to the 6th Berlin Biennale: a display featuring a Rolex, a lighter, and a ring – all objects the artist's father acquired after their escape; the son now exhibits them in order to relentlessly raise the question of the boundary between art and life.

André Rottmann

France, Vietnam War, 1973
The four delegations sit at the table during the
first signing ceremony of the agreement to end
the Vietnam War at the Hotel Majestic in Paris,
Jan. 27, 1973. Clockwise, from foreground, de-
legations of the Unites States, the Provisonal
Revolutionary Government of South Vietnam,
North Vietnam and South Vietnam.

Documentation of the chandelier's transport,
Hotel Majestic, Paris, 2009
Documentation of the exhibition set-up,
Kunsthalle Basel, 2009

08:03:51, 28.05.2009, 2009
Late 19th-century chandelier from the ballroom
of the former Hotel Majestic, Avenue Kléber, Paris
Tombstone for Nguyen Thi Ty, 2009
Marble, granite, bronze and wood relief
Installation view, Kunsthalle Basel

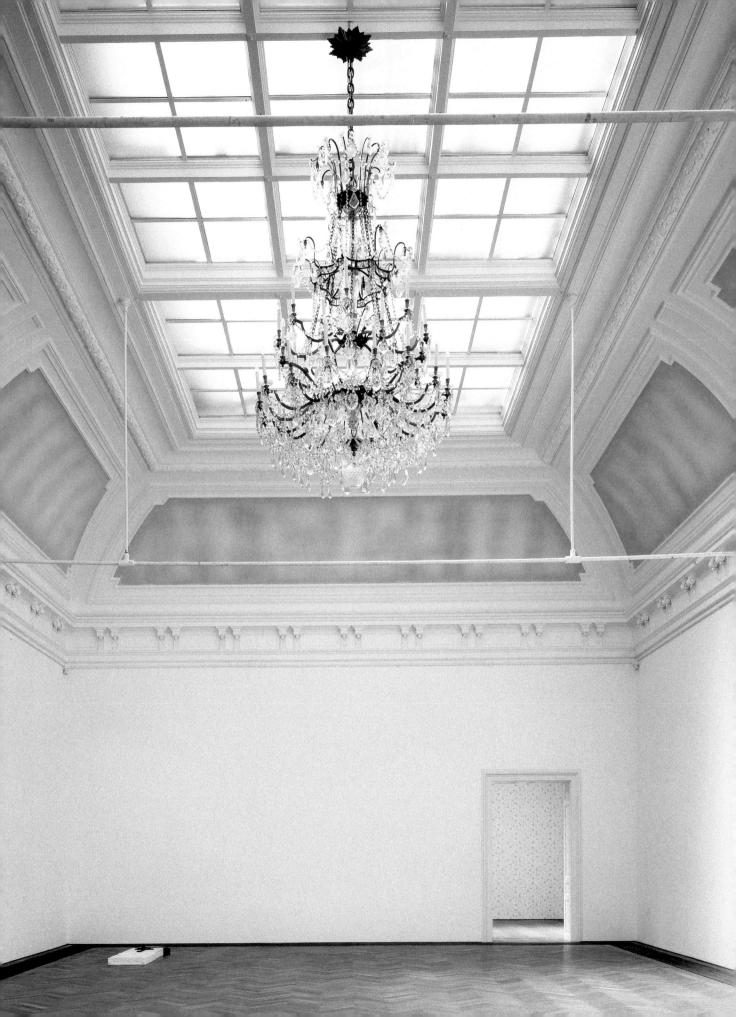

TRIS VONNA-MICHELL

1982 geboren in Southend-on-Sea, Großbritannien, lebt und arbeitet in Stockholm, Schweden
1982 born in Southend-on-Sea, Great Britain, lives and works in Stockholm, Sweden

2009 The Tate Triennial – *Altermodern,* London
2008 5th berlin biennial for contemporary art – *When things cast no shadow*

www.cabinet.uk.com
www.capitainpetzel.de
www.janmot.com
www.t293.it

Der Titel *Tall Tales and Short Stories* fasst nicht nur die künstlerische Praxis des reisenden Barden und alternativen Historikers Tris Vonna-Michell zusammen; er ist zu einer Formulierung geworden, die seine zahlreichen fortlaufenden Projekte und Performances umfasst, und ist auch der Name auf dem Label einer 7-Zoll-Vinyl-Aufzeichnung seiner am häufigsten geprobten Geschichte, *Finding Chopin* (2005–2009). In dieser Arbeit beginnt der künstlerische Griot, seinen eigenen Ursprungsmythos zu enträtseln, indem er zunächst seinen Vater fragt, warum er in der britischen Küstenstadt Southend-on-Sea zur Welt kam. Die Antwort lautet schlicht: „Frag Henri Chopin – alles was du wissen musst, ist, dass er Wachteleier liebt, in Paris lebt und 82 Jahre alt ist." Ausgehend von diesen bruchstückhaften Anhaltspunkten begibt sich Vonna-Michell auf die Suche nach diesem Freund der Familie – ausgerechnet ein Vertreter der Konkreten Poesie –, wobei er die Geschichten und Symbole dekonstruiert, die er unterwegs hervorbringt. In seinen kargen Installationen, die für gewöhnlich aus einem Tisch, einem Diaprojektor und einigen anderen kleinen Requisiten bestehen, ist der Künstler oft selbst anwesend, um die Geschichte zu erzählen, dabei stößt er die Worte mit halsbrecherischer Geschwindigkeit aus wie die Salve eines Maschinengewehrs, in einem ununterbrochenen Monolog, der so lange dauert, wie die Eieruhr auf dem Tisch vorgibt.
Vonna-Michell klopft auch den deutschen Zweig seiner Familie mütterlicherseits auf Anregungen ab, und dies nicht nur, indem er etwas von dem schamanischen Charisma eines Joseph Beuys mit dem bewusstseinsstromartigen Vortragsstil und der Wortgymnastik von John Bock verbindet. Er imitierte die Art und Weise, wie die Stasi Informationen vernichtete, und zerstörte zahlreiche Dokumente seiner eigenen Geschichte, wie etwa Kinderfotos, um die Überbleibsel zu neuen Arbeiten, *Puzzlers* und *Papierstau* (beide 2007–2008) zusammenzusetzen. Vonna-Michell bewertet seine Identität durch unzählige, abschweifende Untersuchungen immer wieder neu – er lotet die Potenziale von Archivmaterialien aus, widerlegt jedoch deren Verlässlichkeit durch seine sich stets verändernden Darstellungen in der Ich-Form.

The title *Tall Tales and Short Stories* not only sums up the practice of travelling bard and alter-historian Tris Vonna-Michell, it has also become a phrase that encompasses his many ongoing projects and performances, as well as being the name on the label of a 7-inch vinyl recording he made of his most well-rehearsed narrative, *Finding Chopin* (2005–2009). In this work the artistic griot begins to unravel his own origin myth, first by asking his father why he was born in the British coastal town of Southend-on-Sea. The reply simply comes: 'Ask Henri Chopin – all you need to know is that he loves quail eggs, lives in Paris, and is eighty-two years old.' From these scraps of evidence Vonna-Michell goes on a quest to find this family friend, a concrete poet of all things, while deconstructing the narrative and symbols he builds up along the way. In his sparse installations, usually involving a desk, a slide projector, and some other small props, the artist is often present himself to narrate the story; only he does so at break-neck speed, spitting out words like machine-gun fire, in an unceasing monologue that lasts as long as the egg-timer on the table demands.
Vonna-Michell also taps his mother's German side of the family for further inspiration, and not just by channelling something of the shamanic charisma of Joseph Beuys alongside the stream-of-consciousness-style delivery and verbal gymnastics of John Bock. Aping the way that information was shredded by the Stasi, East Germany's secret police, the artist erased much of his personal history – childhood photographs and the like – only to reconfigure the strips into new works, *Puzzlers* and *Papierstau* (both 2007–2008). Vonna-Michell is constantly re-evaluating his own identity through any number of meandering investigations – mining the potentialities of archive material but refuting its reliability in his ever-changing first-person accounts.

Ossian Ward

hahn / huhn, 2008
Performance still
from the work *hahn / huhn,* 2003 ongoing
Performance at Vienna Art Week,
Museum Moderner Kunst Stiftung Ludwig

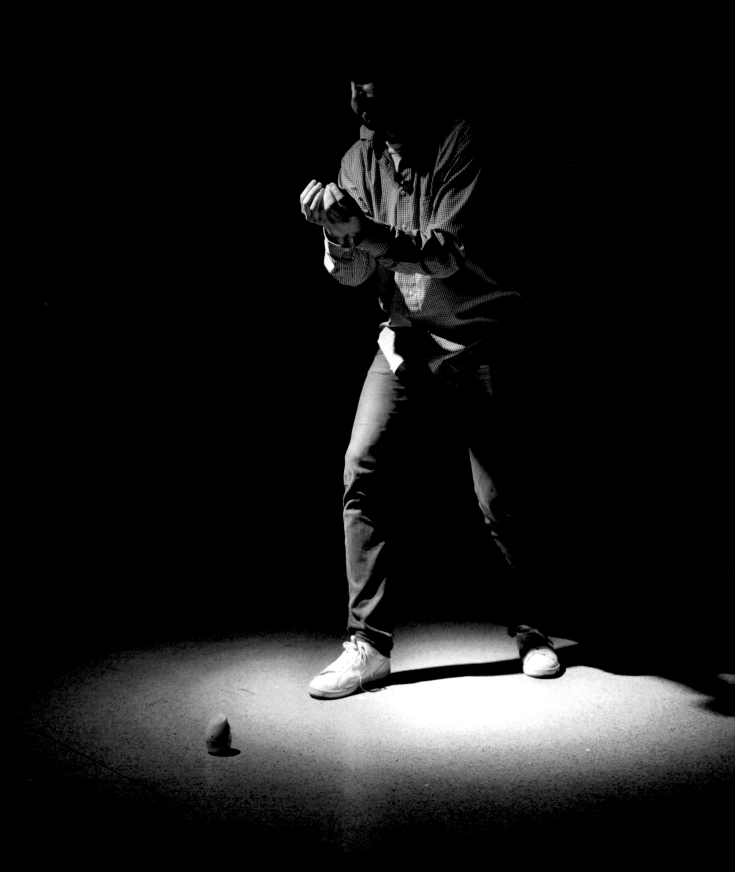

Finding Chopin, 2008
Performance and installation
from the work *Finding Chopin*, 2005–2009
Mixed media
Dimensions variable
Installation views at Art 39 Basel,
Art Statements (with T293, Naples)

hahn/huhn, 2006–2007
Installation
from the work *hahn/huhn,* 2003 ongoing
Mixed media
Dimensions variable
Installation view at Art Cologne, Open Space
(with Schnittraum, Cologne)

Seizure, 2007–2008
Installation
from the work *hahn/huhn,* 2003 ongoing
Mixed media
Dimensions variable
Installation view, Kunsthalle Zürich, Zurich

X: Monumental Detours/Insignificant Fixtures,
2009
Installation
Mixed media
Dimensions variable
Installation view, X Initiative, New York

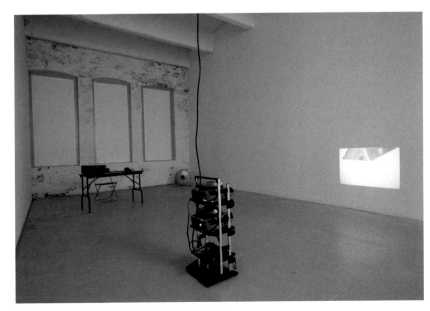

KELLEY WALKER

1969 geboren in Columbus, GA, USA,
lebt und arbeitet in New York, NY, USA
**1969 born in Columbus, GA, USA,
lives and works in New York, NY, USA**

2007 9th Biennale de Lyon – *00s.
The history of a decade that has not
yet been named*
2006 Whitney Biennial – *Day for Night*,
New York
2005 Sharjah Biennial 7 – *Belonging*

www.airdeparis.com
www.capitainpetzel.de
www.paulacoopergallery.com

Bose, 2007
Digital print and gold leaf
on laser-cut steel
Ø 147 × 3 cm
*Schema; Aquafresh plus Crest with
Whitening Expressions (Kelis)*, 2006
Digital print on adhesive vinyl
from CD-ROM
Dimensions variable
Installation view, Le Magasin, Grenoble

Die eindrucksvollen großformatigen Drucke und Installationen von Kelley Walker verwenden Bilder aus dem Fernsehen und der Werbung, aus Musikvideos, den Titelseiten von Zeitschriften und verschiedenen anderen popkulturellen Quellen. Diese Aneignung bildet den Ausgangspunkt für einen komplexen Veränderungsprozess – darunter Schnitte, Siebdrucke, Überlagerungen und das Beschmieren mit Materialien wie (weißer, dunkler und Vollmilch-) Schokolade –, der zu einem widersprüchlichen Ergebnis führt: Die Bilder werden verwischt, während zugleich ihre Bedeutung in den Fokus gerät. Walkers Arbeit, die oft mit der amerikanischen Pop-Art verglichen wurde, unterscheidet sich von ihr dadurch, dass sie auf das facettenreichere Universum heutiger Medien reagiert. Er ist nicht nur sensibilisiert für die Unterscheidung zwischen Kunst und Werbung, sondern auch für die vielfältigen Kontexte, die kulturelle Bilder durchlaufen und die ihrerseits die Interpretationen dieser Bilder beeinflussen.
Bilder aus der Zeit der amerikanischen Bürgerrechtsbewegung sind ein wiederkehrendes Sujet seiner Arbeiten. So zeigt *Black Star Press: Black Star, Star Press Star* (2004) Demonstranten, die von der Polizei festgenommen werden, und verweist damit auf die unterschiedlichen Formen, in denen die politische Wirklichkeit dieses aufgeladenen historischen Moments zum Ausdruck kam. In ähnlicher Weise spürt Walker dem medialen Leben von Berühmtheiten, Models und Musikern nach. *Whitney Houston 1984–85* (2008) zeigt die junge R&B-Sängerin, die neben dem Titel ihres Songs „How Will I Know" posiert. Die Arbeit funktioniert wie ein trauriger Popsong, wobei das wiederholte Bild von Houston einen Refrain bildet, der auf die tragische Wirklichkeit ihres Lebens anspielt – eine klassische amerikanische Geschichte über den Ruhm, deren menschlichere Seite ein aggressiv zuckersüßes, unschuldiges Lächeln in die Kamera ist.
In einem Interview beschreibt Walker seine erste Begegnung mit der Popkultur als positiv. Er erinnert sich an Gefühle der Isolation als Jugendlicher und daran, dass die Populärkultur Möglichkeiten bot, neue und andere Wirklichkeiten zu erforschen. Seine Arbeiten bewegen sich auf dem Gebiet von Pop-Genealogien und zeigen auf, wie sich Bilder in der Geschichte verfangen: Sie werden von ihr produziert und tragen dazu bei, sie wieder und wieder aktiv zu erzählen.

Kelley Walker's striking large-scale prints and installations lift imagery from television, advertising, music videos, magazine covers, and various other pop-culture sources. This appropriation is the start of a complex process of alteration – variously including cutting, screenprinting, layering, and smearing with substances like chocolate (white, dark, and milk) – that produces a contradictory effect: it blurs the images and, at the same time, throws their trajectory of meaning into focus. Often compared to American Pop Art, Walker's work is set apart in that it responds to the more multifaceted media universe of today. He is sensitive not only to the line between commercial and fine art, but to the multiple contexts that cultural images pass through and that, in turn, shape the way they are understood.
American Civil Rights-era imagery is a recurring subject in his work. For instance, *Black Star Press: Black Star, Star Press Star* (2004), which features protestors apprehended by police, points to the competing ways in which political realities were articulated during this charged historical moment. Similarly, Walker traces the media lives of celebrities, models, and musicians. *Whitney Houston 1984–85* (2008) features the young R&B singer posing next to the title of her song 'How Will I Know'. The work itself plays like a sad pop song, with the repeated image of Houston appearing like a refrain hinting towards the tragic realities of her life – a classic American story of fame where the more human reality consists in aggressively candy-coated innocent smiles towards the camera.
In an interview, Walker describes his first exposure to pop culture as positive. He recalls adolescent feelings of isolation and how pop was a means to explore new and different realities. His works traffic in the terrain of pop genealogy, demonstrating how images are caught up in history: both produced by it and involved in the active and continual retelling of it.

Lauren Cornell

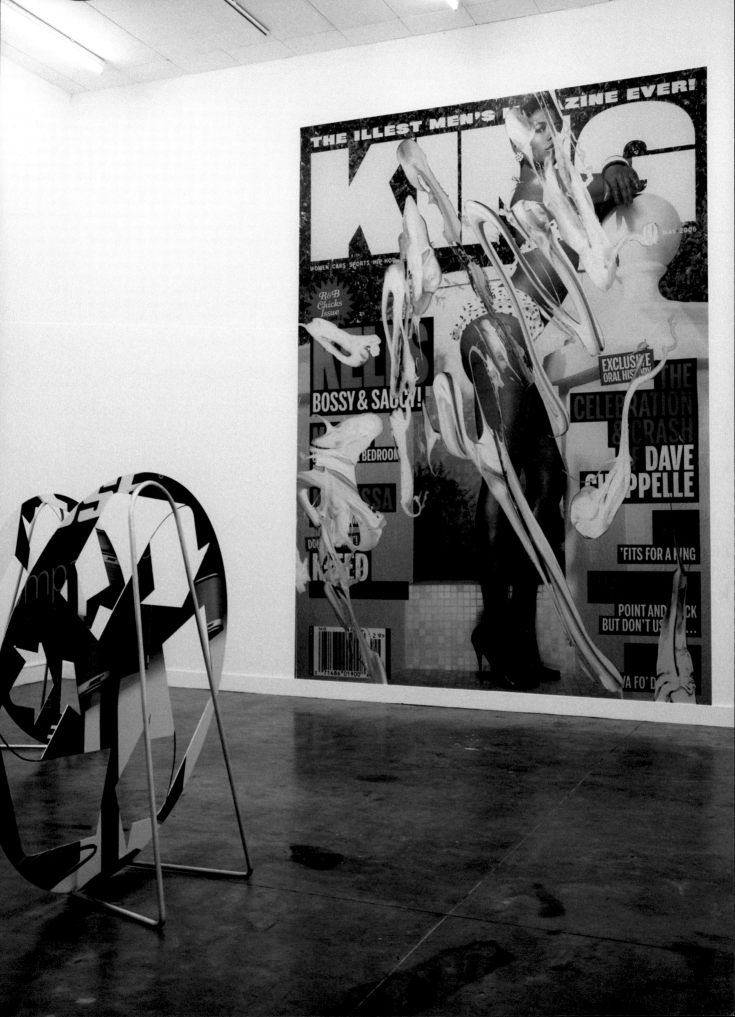

Exhibition view, 2009
Capitain Petzel, Berlin

*Whitney The Greatest Hits – How Will
I Know: Arista 2000, 2006, 2007, 2008
and 2010* (details), 2008
Aluminium stands, Mylar, mirror,
Epson prints, disco ball with chain,
wood, fluorescent tubes, framed
record, canvas with magazine and
newspaper
Dimensions variable
Installation view, Capitain Petzel,
Berlin

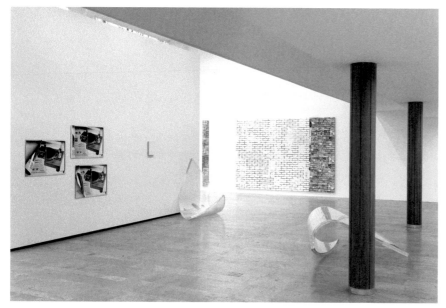

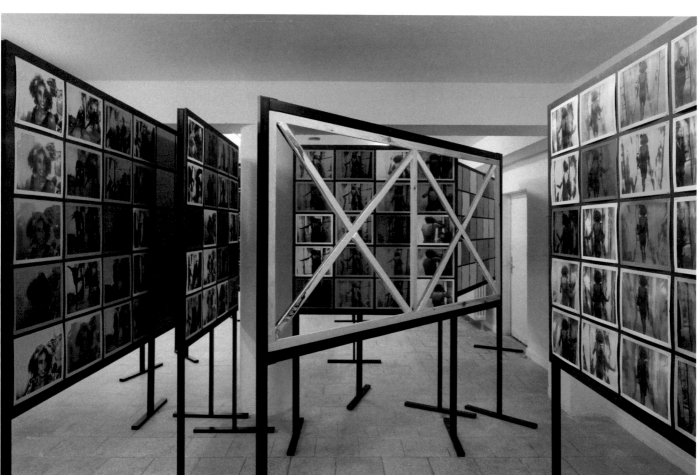

APICHATPONG WEERASETHAKUL

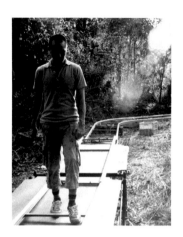

1970 geboren in Bangkok, Thailand, lebt und arbeitet in Chiang Mai, Thailand
1970 born in Bangkok, Thailand, lives and works in Chiang Mai, Thailand

2010 29th Bienal de São Paulo – *Há sempre um copo de mar para o homem navegar / There is always a cup of sea to sail in*
2006 Liverpool Biennial of Contemporary Art
2004 Busan Biennale – *Chasm*
2001 7th International Istanbul Biennial – *Egofugal – Fugue from Ego for the Next Emergence*

www.kickthemachine.com

www.scaithebathhouse.com

Im Jahr 2008 reiste der Regisseur Apichatpong Weerasethakul in den Nordosten von Thailand, um dort nach seinem Onkel Boonmee zu suchen, einem Mann, der sich an seine früheren Leben erinnern konnte. Weerasethakuls Nachforschungen führten ihn in die Kleinstadt Nabua. Dort hatte die thailändische Armee, die seit den 1960er Jahren in der Stadt stationiert war, um kommunistische Aufstände niederzuschlagen, jahrelang Gewalttaten an der örtlichen Bevölkerung verübt. Zum Zeitpunkt von Weerasethakuls Ankunft waren diese traumatischen Erinnerungen verdrängt oder vergessen worden. Weerasethakul sah in Boonmee ein Bindeglied zu den Geistern von Nabuas Vergangenheit. Während seines fünfmonatigen Aufenthalts arbeitete er mit den Bewohnern des Ortes zusammen, um ein Raumschiff zu entwerfen und zu bauen. Als futuristische Verbindung zu fernen Welten wurde das Fluggerät für die Jugendlichen des Ortes bald zu einem Treffpunkt. Als Auftragsarbeit für das Haus der Kunst in München, FACT (Foundation for Art and Creative Technology) in Liverpool und Animate Projects in London dokumentierte Weerasethakul den Bau, die surreale Präsenz und die Nutzung des Raumschiffs in seiner Mehrkanal-Installation *Primitive* (2009). Zusätzlich entstand eine Reihe weiterer Arbeiten, darunter zwei Kurzfilme und ein Künstlerbuch.

Eine zentrale Rolle nimmt die Beziehung zwischen Ort und Erinnerung auch in Arbeiten wie *Syndromes and a Century* (2006) ein. Der Film spielt auf dem Land in einem Krankenhaus, das auf das Vorbild von Weerasethakuls Elternhaus zurückgeht. Die Charaktere des Films beruhen auf seinen Eltern, die Ärzte waren. Der Film ist eine Landschafts- und Architekturstudie: Während man grüne Felder betrachtet, hört man aus dem Off Gespräche; intime Situationen werden aus einer gewissen Distanz gezeigt, die es dem Betrachter ermöglicht, das institutionelle Umfeld zu erfassen. Das Krankenhaus in *Syndromes and a Century* liegt am Stadtrand, wird jedoch mit Geldern aus dem Zentrum finanziert. Es ist ein Treffpunkt von Moderne und Tradition, wo buddhistische Mönche in safrangelben Gewändern eine medizinische Behandlung im westlichen Stil suchen. Und es hat eine Beziehung zur Mutter und zum Vater. Solche Dualismen werden nicht als Widersprüche, sondern als sympathische Unstimmigkeiten präsentiert, die Weerasethakuls gesamtes Werk prägen.

In 2008, director Apichatpong Weerasethakul travelled northeastern Thailand searching for his uncle Boonmee, a man who who can recall his past lives. Weerasethakul's search brought him to the small town of Nabua. Beginning in the 1960s, the Thai army – stationed there to suppress Communist insurgents – had committed acts of brutality against the locals which had lasted for many years. By the time of Weerasethakul's arrival, these traumatic memories had been repressed or forgotten. Weerasethakul saw Boonmee as a link to the ghosts of Nabua's past. During the five months he stayed in Nabua, Weerasethakul worked with local people to design and build a spaceship. A futuristic link to distant worlds, this structure was soon occupied as a hangout by local teenagers. The spaceship's construction, its surreal presence and its subsequent use are documented in Weerasethakul's multi-channel installation *Primitive* (2009), commissioned by Haus der Kunst, Munich, FACT (Foundation for Art and Creative Technology), Liverpool, and Animate Projects, London. In addition to the installation, he created a series of works including two short films and an artist's book.

The link between memory and place is also central to works such as *Syndromes and a Century* (2006), which is set in a rural hospital modelled after Weerasethakul's childhood home and features characters based on his parents, who were doctors. The film is a study of landscape and architecture: conversations take place offscreen while we contemplate verdant fields; intimate exchanges are filmed from a slightly aloof distance, allowing us to take in this institutional setting. The hospital in *Syndromes and a Century* exists at the periphery, but is funded with money from the urban centre. It is a meeting place of modernity and tradition, where Buddhist monks in saffron robes seek Western-style medical treatment. And it is linked to both mother and father. Dualities like these are not presented as contradictions, but as friendly incongruities, and they can be found throughout Weerasethakul's work.

Michael Connor

Faith, 2006
Two-channel video installation, colour, sound
11:05 min

Primitive, 2009
Seven installation videos (in vario
combinations)
Installation view, Haus der Kunst
Munich

A Dedicated Machine, 2009
Digital (HD), colour, no sound
1:35 min

A Letter to Uncle Boonmee, 2009
Digital (HD), colour, sound
17:40 min

Nabua, 2009
Digital (HD), colour, sound
9 min

Only tribes and villages.

Judging from the number of lights

ANDRO WEKUA

1977 geboren in Sochumi, UdSSR, lebt und arbeitet in Zürich, Schweiz, und Berlin, Deutschland
1977 born in Sukhumi, USSR, lives and works in Zurich, Switzerland, and Berlin, Germany

2010 8th Gwangju Biennale – *10.000 Lives*
2008 Busan Biennale – *Expenditure*
2006 4th berlin biennial for contemporary art – *Of Mice and Men*

www.gladstonegallery.com
www.peterkilchmann.com

Gott ist tot aber das Mädchen nicht, 2008
Wax, hair, aluminium, coloured plexiglass, brass, bricks
150 × 203 × 103 cm
Installation view, Kunsthaus Zürich, Zurich

Er fühle mitten im Kunstboom auch große Einsamkeit, sagt Andro Wekua in einem 2008 geführten Gespräch. Tatsächlich haftet seinen bühnenartigen Installationen etwas Abgekapseltes, beinahe Autoerotisches an. Die gesichtslosen androgynen Figuren, die auf Podesten strammstehen, in riesigen Vitrinen warten oder rücklings auf glänzenden Motorrädern posieren, scheinen in einem beunruhigenden Traum ewiger Adoleszenz gefangen – in sich versunken, eingesperrt in ihren Körpern aus Wachs oder Keramik; ihre Münder und Augen wurden versiegelt, maskiert oder verstümmelt. Sie haben keine Augen, betont Wekua, weil sie den Blick des Betrachters nicht erwidern, sondern lediglich der Projektion dienen sollen. Wekua fetischisiert diesen unerwiderten Blick mit allen Mitteln: Er erklärt den Zuschauer zum Voyeur, der in verlockende, abgründige Gefühls- und Erinnerungsräume blickt, die vermeintlich nicht für ihn bestimmt sind.
Get Out of My Room heißt seine rätselhafte Installation aus dem Jahr 2006: Im Zentrum eines azurblauen Raumes rekelt sich ein halbbekleideter Junge an einem Schreibtisch, das Gesicht zur clownesken Maske geschminkt. An den Wänden um ihn herum hängen Collagen, die an surreale Filmstills erinnern – Bilder, die sich in seinem Inneren abspielen könnten. Offen bleibt dabei, ob Wekuas Protagonisten narzisstisch oder traumatisiert sind. Sein Vater wurde in den georgischen Unabhängigkeitskriegen getötet. Anfang der 1990er Jahre musste der 15-Jährige mit seiner Mutter aus seiner Heimatstadt Sochumi emigrieren.
In Wekuas Arbeiten verschmelzen mythologische Anspielungen auf die eigene Kindheit und Jugend mit einem latent gewalttätigen Trip durch die unterschiedlichsten Stile und Strömungen von Moderne und Gegenwart. So wandelt sich der museale Ausstellungsraum in den verschiedenen Varianten seiner Installation *Wait to Wait* (2006) in eine Mischung aus Peepshow, Todeszelle, Dan-Graham-Zitat und existenzialistischem Theater. Wekuas Figuren gleichen Reisenden, die auf der Stelle verharren, während die eigentliche Bewegung etwas Innerliches, Seelisches ist: In der Installation *My Bike and Your Swamp (6 p. m.)* (2008) hält die futuristische Bikerin die Augen geschlossen, ganz so als ob der in gleißendes Gelb getauchte Raum um sie herum nichts als ein Nachbild auf ihrer Netzhaut wäre. Sie selbst scheint bereits Lichtjahre entfernt. Die Galerie bleibt als Mausoleum ihrer Träume zurück – angefüllt mit Artefakten, Bildern und Surrogaten eines Lebens, das sich nur noch in Relikten andeuten, aber nicht mehr nachvollziehen lässt.

In the middle of an art boom, Andro Wekua said in conversation in 2008, he sometimes felt very lonely. And indeed, there is something introverted, even autoerotic to his stage-like installations. The faceless androgynous figures standing at attention on pedestals, waiting in gigantic glass cases, or posing recumbent on gleaming motorcycles seem caught in a disconcerting dream of eternal adolescence – lost in thought, imprisoned in their own waxen or ceramic bodies; their mouths and eyes have been sealed, masked, or mutilated. They have no eyes, Wekua emphasises, because rather than returning the beholder's gaze, they are to serve as pure projection screens. Wekua does everything to fetishise this unreturned gaze: he installs the viewer as a voyeur who peers into alluring and abysmal spaces of feeling and memory allegedly not intended for him.
Get Out of My Room is the title of an enigmatic installation created in 2006: at the centre of an azure room, a half-naked boy lounges by a writing desk, his face a painted clownish mask. Mounted on the walls around him are collages that recall surreal film stills – images that might be playing before his inner eye. It remains unclear whether Wekua's protagonists are narcissists or traumatised. The artist's father was killed in the Georgian wars of independence. In the early 1990s, the fifteen-year-old boy and his mother were forced to emigrate from their hometown of Sukhumi.
Wekua's works fuse mythological allusions to his own childhood and youth with a journey, charged with latent violence, through the most diverse modern and contemporary styles and movements. The different versions of his installation *Wait to Wait* (2006), for instance, transform the museum's exhibition space into a mixture of peep show, death chamber, Dan Graham quote, and existentialist theatre. Wekua's characters resemble travellers who remain stuck in one place while the true movement takes place inside, in the soul: in the installation *My Bike and Your Swamp (6 p.m.)* (2008), the biker keeps her eyes closed as though the room around her, bathed in blinding yellow light, were nothing but an afterimage on her retina. She herself already seems light years away. The gallery is left behind as the mausoleum of her dreams – filled with the artefacts, images, and surrogates of a life that, while hinted at in its relics, can no longer be truly understood.

Oliver Koerner von Gustorf

Get Out of My Room, 2006
Table, wood, wax, figure, artifical
hair, fabrics, leather, wax
colour, chair, bronze, email paint,
eight silk screen prints, etching
Variation 1:
Table: 75 × 195 × 100 cm
Chair: 115 × 115 × 71 cm
Installation view, Kunstmuseum
Winterthur

Landscape, 2007
Oil on canvas
63 × 53 cm

My Bike and Your Swamp (6 p. m.), 2008
Black polyurethane rubber, wax,
aluminium, wood, cloth, artificial hair
202 × 86 × 186.5 cm
Installation view, Camden Arts Centre,
London

CATHY WILKES

1966 geboren in Belfast, Nordirland, lebt und arbeitet in Glasgow, Großbritannien
1966 born in Belfast, Northern Ireland, lives and works in Glasgow, Great Britain

2006 4th berlin biennial for contemporary art – *Of Mice and Men*
2004 Manifesta 5, European Biennial of Contemporary Art, San Sebastián

www.nourbakhsch.de
www.themoderninstitute.com

Splash (detail), 2006
Mixed media
Dimensions variable
Installation view, 4th berlin biennial for contemporary art

>>
I Give You All My Money, 2008
Mixed media
Dimensions variable
Installation view, Turner Prize 08,
Tate Britain, London

Cathy Wilkes, die Weiblichkeit und die gesellschaftlichen Rollen von Frauen gleichzeitig preist und auf die Schippe nimmt, ist eine viel zu geschickte und ausweichende Künstlerin, als dass sie ihr Werk als genderspezifische Kunst abstempeln ließe. In der Multimedia-Installation *Non-Verbal* (2005) verwendete sie die für sie charakteristischen halbnackten Schaufensterpuppen, deren leblose Gesichter von abstrakten Leinwänden bedeckt waren, und suggerierte so einen Zusammenbruch der Kommunikation durch expressive Mittel wie etwa Kunstwerke – vor allem angesichts der Ungeheuerlichkeit und des alltäglichen Chaos, die diese Figuren umgeben: ein Maclaren-Kinderwagen, ein LCD-Fernseher und eine Salatschüssel. Auch das Konsumverhalten gerät in diesen Arbeiten in die Kritik, in anspruchsvollen mehrteiligen Installationen wie *Prices* und *I Give You All My Money* (beide 2008), die ganze Supermarktkassen und Förderbänder zeigen – allerdings nur insofern, als Wilkes möchte, dass wir darüber nachdenken, welche Beziehung wir zu den ständig wachsenden Bergen persönlicher Gegenstände haben und ob diese wirklich noch etwas bedeuten, nachdem wir sie erworben haben.

Ähnlich zwiespältige Perspektiven entwickelt sie mit Blick auf die nicht voneinander zu trennenden Belastungen und Freuden der Mutterschaft in Arbeiten wie *She's Pregnant Again* und *Most Women Never Experience* (beide 2005); oft verwendet sie auch die symbolische Figur der Krankenschwester, deren Fähigkeit zu heilen und zu pflegen von ihrer unterwürfigen, fetischisierten Form scheinbar untergraben wird. Wilkes inszeniert mitfühlende Reaktionen auf diese einsamen Gestalten, macht jedoch im Allgemeinen jede rührselige Sentimentalität durch die Verwendung klappriger Readymades wett, um eine verwahrloste und unmonumentale Ästhetik zu erzeugen. Und dies, obwohl ihre „Tableaux vivants" häufig kunsthistorische Vorgänger haben, sei es in einem Gemälde von Walter Sickert oder in einer Skulptur von Umberto Boccioni.

Die Begegnung mit Wilkes' Arbeiten findet zwangsläufig in drei Dimensionen statt – man muss um sie herumgehen und mit ihnen interagieren –, und letztlich strebt sie danach, Kunst zu machen, die das wirkliche Leben durchdringt, indem sie die Bedingungen und Situationen des Dialogs zwischen Menschen imitiert. Wilkes treibt ihr Spiel – teils Puzzle, teils Performance – mit uns und lässt uns im Ungewissen.

An artist who simultaneously lauds and lampoons femininity and the role of women in society, Cathy Wilkes is also far too dexterous and evasive to allow her work to be labelled as gender-specific art. Her multimedia installation *Non-Verbal* (2005) featured her trademark use of semi-naked shop mannequins, only with abstract canvases covering their inanimate faces, suggesting a breakdown in communication through expressive means such as art – especially when faced with the enormity and mess of everyday life that surrounds the figures: a Maclaren pushchair, an LCD television, and a salad bowl. Consumerism comes under fire in these works, too, in ambitious multi-partite installations featuring entire supermarket checkouts and conveyor belts such as *Prices* and *I Give You All My Money* (both 2008), but only insofar as Wilkes wants us to consider our relationship to our ever-expanding personal hoards of objects and whether they hold any real meaning once purchased.

She gives similarly conflicting perspectives on the twinned burden and joy of motherhood in pieces such as *She's Pregnant Again* and *Most Women Never Experience* (both 2005), also often employing the symbolic figure of the nurse, whose healing and nurturing abilities are seemingly undermined by her subservient, fetishised form. Wilkes stages empathetic responses to these lonely characters, but generally offsets any mawkish sentimentality through her use of decrepit readymades, creating a squalid and unmonumental aesthetic. This is despite the fact that her 'tableaux vivants' are often deeply rooted in art-historical precedents, whether sparked by a painting by Walter Sickert or a sculpture by Umberto Boccioni.

The encounter with Wilkes's work is necessarily three-dimensional – it is to be walked around and interacted with – and ultimately her quest is to create art that can penetrate real life while mimicking the conditions and situations of human dialogue. Part performance, part puzzle, Wilkes's art leaves us guessing while leading us on a merry dance.

Ossian Ward

XU ZHEN

没顶公司
MadeIn

1977 geboren in Schanghai, China, lebt
und arbeitet in Schanghai
**1977 born in Shanghai, China, lives and
works in Shanghai**

2007 10th International Istanbul
Biennial – *Not Only Possible, But Also
Necessary: Optimism in the Age of
Global War*
2005 51st International Art Exhibition /
La Biennale di Venezia – *The Experience
of Art; Always a Little Further*
2001 49th International Art Exhibition /
La Biennale di Venezia – *Plateau der
Menschheit*

www.jamescohan.com
www.longmarchspace.com
www.shanghartgallery.com

Xu Zhen gehört zu den maßgeblichen Per-
sönlichkeiten der aufstrebenden Kunstszene
Schanghais. Seine künstlerische Arbeit um-
fasst ein breites Spektrum von Disziplinen
und erforscht ein umfangreiches Repertoire
von Themen, Gegenständen und Tropen. Die-
se reflektieren auf scharfsinnige Weise das
hohe Bewusstsein des Künstlers angesichts
der zahlreichen Ambivalenzen, die mit Chinas
Aufstieg zu einer globalen politischen, wirt-
schaftlichen und kulturellen Vormachtstel-
lung einhergehen.

Xus frühe Arbeiten sind tief verwurzelt in
der Performance/Video-Tradition, durch die
viele chinesische Künstler, die in der Post-
Tiananmen-Ära aufwuchsen, versuchten,
sich von den starken Einschränkungen der
herrschenden künstlerischen Konventionen
zu befreien; Arbeiten wie die mit dem trüge-
rischen Titel *Rainbow* (1998, dargestellt wird
ein nackter Torso, der unter dem Druck wie-
derholter Schläge die Farbe wechselt) und
The Problem of Colourfulness (2000, gezeigt
wird, wie aus einem männlichen Schritt Blut
rinnt) offenbaren ein Interesse am Körper als
politischem Minenfeld realer Gefühle und Er-
fahrungen; *Shouting* (1998) hingegen themati-
siert auf direktere Weise die Atmosphäre der
Unterdrückung des Gemeinwesens als Faktor
des öffentlichen Lebens – es zeigt Massen
von Menschen, die in die gleiche Richtung lau-
fen und deren alltägliche Routine (Arbeiten,
Einkaufen, Pendeln) für einen Moment unter-
brochen wird durch ein kurzes Trommelfeuer
von Rufen und Schreien. Im Lauf der Jahre
wurden die Versuche des Künstlers, seine
Stimme zu erheben, jedoch unbeschwerter,
weniger selbstgewiss und durch ihre Überein-
stimmung mit der Bildsprache chinesischer
Macht letztlich auch ironischer. Dies bestä-
tigt sich in Projekten wie *8848-1.86* (2005) und
18 Days (2006), einem Film, der zeigt, wie Xu
und seine Mitarbeiter China mit einer Armee
aus ferngesteuertem Kriegsspielzeug berei-
sen, mit dem sie eine Invasion in Russland,
der Mongolei und Myanmar planen.

2009 führte das programmatische Interes-
se des überaus produktiven Künstlers an der
Nähe der Kunst zur Realität des „Geschäfts"
zur Einführung des Pseudonyms „MadeIn";
ein Spitzname, unter dem er unter anderem
„Gruppenausstellungen" zeitgenössischer
Kunst aus dem Mittleren Osten produziert hat:
ein bissiger Kommentar auf den unstillbaren
Hunger der (westlichen) Kunstwelt nach dem
angesagten neuen „anderen", das vor nicht
allzu langer Zeit chinesisch war und jetzt nur
noch „made in China" ist.

Xu Zhen is one of the leading lights of the
burgeoning Shanghai art scene. His work en-
compasses a wide variety of disciplines and
explores a rich repertoire of themes, topics,
and tropes that acutely reflect the artist's
keen awareness of the many ambiguities
that complicate China's rise to global politi-
cal, economic, and cultural dominance.

Xu's early work is squarely rooted in the
performance/video tradition by means of
which many Chinese artists coming of age
in the post-Tiananmen era sought to liberate
themselves from the rigid constraints of rul-
ing artistic conventions; works such as the
deceptively titled *Rainbow* (1998, depicting a
naked torso changing colour under the pres-
sure of repeated slapping) and *The Problem
of Colourfulness* (2000, showing trickles of
blood running from a male crotch) reveal an
interest in the body as a political minefield of
real emotions and experiences, while *Shout-
ing* (1998) addresses the oppressive atmos-
phere of the body politic as a factor of public
life more directly – it depicts throngs of peo-
ple all heading in the same direction whose
daily routine (working, shopping, commut-
ing) is momentarily disrupted by a brief bar-
rage of shrieks and shouts. Over the years,
however, the artist's attempts at raising his
voice have grown more light-hearted, less
self-assured, and ultimately more ironic in
their alignment with the imagery of Chinese
power, as is attested by such projects as
8848-1.86 (2005) and *18 Days* (2006), a film
tracing Xu and his associates' travels around
China with an army of remote-controlled
military toys with which they plan to invade
Russia, Mongolia, and Myanmar.

In 2009, the prolific artist's programmatic
interest in art's proximity to the reality of
'business' has led to his adoption of the
pseudonym 'MadeIn', a moniker under which
he has produced, among other things, 'group
shows' of contemporary art from the Middle
East: an acrid comment on the (Western) art
world's unquenchable thirst for the hot new
'other', Chinese not so long ago, now only
'made in China'.

Dieter Roelstraete

8848-1.86, 2005
Resin, glass, video, photo,
mountain climbing equipment
Dimensions variable

Madeln
In mass exercise, the greater the conflict
between theory and reality, the stronger its
eagerness to impose beliefs on others., 2010
Wax, military caps
300 × 800 × 300 cm (installation)
262.5 × 150 cm (photo)

Madeln
The people is a beast of muddy brain.
It does not know its own force; it only
knows absolute obedience., 2010
Marble
70 × 60 × 50 cm (sculpture)
212 × 150 cm (photo)
70 × 60 × 50 cm (sculpture)
157 × 150 cm (photo)

Madeln
A real subjection is born mechanically
from a fictitious relation., 2010
Steel
650 × 300 × 400 cm (installation)
200 × 150 cm (photo)

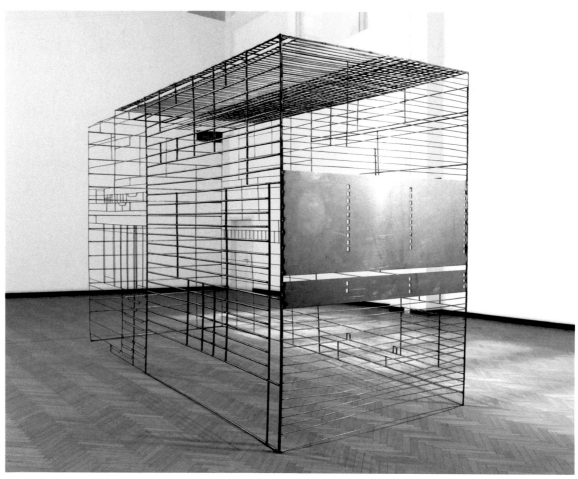

HAEGUE YANG

1971 geboren in Seoul, Südkorea, lebt und arbeitet in Berlin, Deutschland, und Seoul
1971 born in Seoul, South Korea, lives and works in Berlin, Germany, and Seoul

2010 8th Gwangju Biennale – *10.000 Lives*
2009 53rd International Art Exhibition / La Biennale di Venezia – *Fare Mondi / Making Worlds*, Korean Pavilion
2006 27th Bienal de São Paulo – *Como viver junto / How to Live Together*
2004 Busan Biennale – *Chasm*
2002 Manifesta 4, European Biennial of Contemporary Art, Frankfurt / Main

www.heikejung.de

www.barbarawien.de
www.kukje.org

Series of Vulnerable Arrangements – Domestic of Community, 2009
Clothing rack and shoe rack on casters, light bulbs, cable, knitting yarn, rope, socks, hammock net, aluminium venetian blinds, stainless steel strainer, paint grill, fish grill, plastic tube, plastic packages, plastic funnel, tin, buttons, metal ring, metal sponge, silver tinsel, mardi grass bits, toy spring, garden supply, sea shells
Dimensions variable
Installation view, 53rd International Art Exhibition / La Biennale di Venezia

In der zwischen 2004 und 2006 entstandenen Filmtrilogie von Haegue Yang sind die Unterschiede zwischen den Schauplätzen Amsterdam, Berlin, London, Seoul und Frankfurt am Main nicht wahrnehmbar. Sie verweigert sich dem Exotischen und konzentriert sich stattdessen auf Aufnahmen von Menschen an ungenannten, unbedeutenden Orten. In Verbindung mit den introspektiven Stimmen in Ich-Perspektive aus dem Off, die über Gefühle von Einsamkeit und Entfremdung sprechen, entsteht der Eindruck von Isolation als kollektivem und zugleich individuellem Phänomen. Yangs 2006 begonnene *Series of Vulnerable Arrangements* umfasst Anordnungen aus Lampen, Heizkörpern, Ventilatoren, Klimaanlagen oder Beduftungsgeräten, die durch die Präsenz des Betrachters aktiviert werden und bei ihm unmittelbare sensorische Reaktionen auslösen. Obwohl dies der Betonung der Entfremdung in den Filmen entgegenzuwirken scheint, wird durch das Vertrauen auf einen zeitweiligen Teilnehmer die Vorstellung von der Vergänglichkeit und Flüchtigkeit der Erfahrung noch verstärkt. Manche Elemente in Yangs Installationen sind zu Erkennungszeichen geworden: Origami-Faltungen in leuchtenden Farben, Lampengruppen mit wild verschlungenen Kabeln auf beweglichen Gestellen oder herabhängende Jalousien, die weder Objekt noch Architektur sind und vorgeblich den Raum aufteilen, während sie bedeutungsvolle Schatten werfen. Die Alltäglichkeit dieser Gegenstände wird aufgewogen durch die subtilen Beziehungen, die zwischen ihnen entstehen.
Sound, Farbe und Licht werden eingesetzt, um abstrakte Porträts von so radikalen Persönlichkeiten wie der französischen Autorin Marguerite Duras oder des koreanischen Freiheitskämpfers Kim San herzustellen, bei denen die sichtbare öffentliche Person oftmals eine tragische Lebensgeschichte verbirgt. Obwohl hier das dramatische Potenzial von Licht und Schatten ausgeschöpft wird, untergräbt die Fragmentierung des Arrangements das vage Angebot einer Erzählung und der Betrachter wird mit zahlreichen möglichen Bedeutungen konfrontiert. Die abwesenden Protagonisten dieser Installationen machen die Betrachter hingegen zu ihren Stellvertretern; diese werden vom Licht angestrahlt, das durch den Raum fällt, oder durch Jalousien abgeschirmt. Yang erschafft Zonen jenseits der üblichen Kategorien von Arbeit oder Erholung, Heimat oder Ausland, privatem oder öffentlichem Raum, Präsenz oder Abwesenheit, wo die Sinne in Alarmbereitschaft sind und jede Erfahrung für Interpretationen offen ist.

In the trilogy of films Haegue Yang made between 2004 and 2006, the distinctness of their locations Amsterdam, Berlin, London, Seoul and Frankfurt/Main remains imperceptible. Refusing the exotic, they focus instead on footage of people in anonymous, insignificant locations. This, coupled with the films' introspective first-person voiceovers expressing feelings of solitude and alienation, lets a sense of isolation as a collective as well as an individual phenomenon emerge.
Yang's *Series of Vulnerable Arrangements,* which began in 2006, comprises arrangements of lamps, heaters, fans, air conditioning units, or scent-emitting machines which are activated by the viewer's presence to directly engage his sensory responses. Though this may seem to counteract the films' insistence on alienation, their reliance on a transitory participant in fact reinforces notions of the transience and ephemerality of experience. Certain forms have become signature elements in Yang's installations: brightly coloured origami shapes, clusters of lamps with wildly tangled cords on moveable stands, or hanging Venetian blinds which operate somewhere between object and architecture, proposing nominal divisions of space while casting evocative shadows. The ordinariness of these objects is counterbalanced by the subtle interrelations that arise between them.
Sound, colour, and light are employed to produce abstract portraits of radically-minded individuals such as French author Marguerite Duras or Korean freedom fighter Kim San, where the visible public persona often masks a tragic personal narrative. While the dramatic potential of light and shadow is utilised here, the vague offer of narrative is fraught by the arrangements' fragmentation, confronting the viewer with multiple possible meanings. The absent protagonists in these installations cast the viewers instead as their substitutes, spotlit by lights traversing the space or shaded by blinds. Yang seeks out zones beyond the usual categories of work or rest, home or abroad, private or public space, presence or absence, where senses are on the alert and every experience is left open to interpretation.

Kirsty Bell

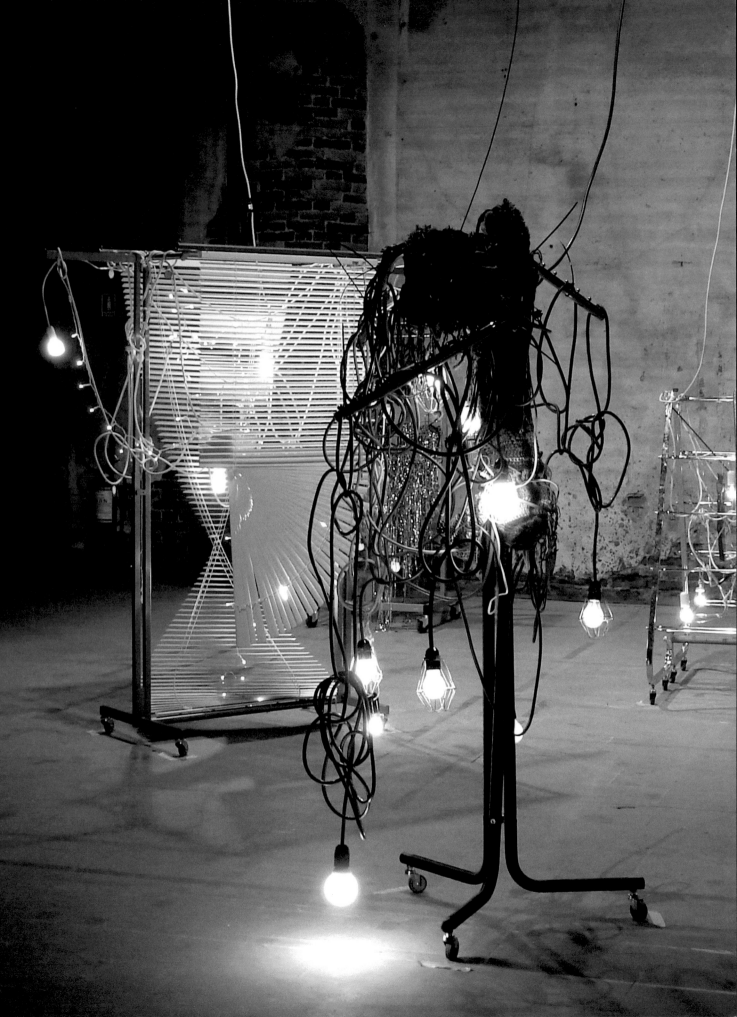

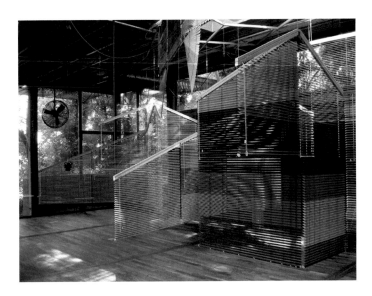

Series of Vulnerable Arrangements – Voice and Wind, 2009
Aluminium venetian blinds, aluminium frame, industrial electric fan, wind machine, scent emitter (Buddha Temple, Musty, Fresh Cut Grass, Earth, Rainforest, Ocean Mist)
Dimensions variable
Installation view, 53rd International Art Exhibition / La Biennale di Venezia, Korean Pavilion

Storage Piece, 2004
Various works (mixed media)
Dimensions variable
Installation view, 27th Bienal de São Paulo

Series of Vulnerable Arrangements – Blind Room, 2006
Black aluminium venetian blinds, three video essays (video trilogy, 2004–2006), MDF, spotlight, mirror, humidifier, infrared heater, air ventilator, origami, photocopies, found objects, seating, scent emitters (Wood Fire and Fresh Linen)
Dimensions variable
Installation view, Walker Art Center, Minneapolis

THE ART OF TOMORROW

THE ART OF TOMORROW

HERAUSGEBER UND AUTOREN

Jens Asthoff (geb. 1962), freier Autor und Kritiker, lebt in Hamburg. Er studierte Philosophie, Literatur und Linguistik und schreibt über Kunst, u. a. für „Artforum", „Camera Austria", „Kunstforum", „Kultur & Gespenster", „Texte zur Kunst" sowie für Kataloge und Kunstpublikationen wie etwa „ART NOW 3" oder „The ART of Anselm Reyle".

Sven Beckstette (geb. 1974), promovierter Kunsthistoriker, arbeitet seit einigen Jahren als freier Kunst- und Musikkritiker für u. a. die „Frankfurter Allgemeine Zeitung", „Texte zur Kunst", „artnet", „Spike" und „Spex". Von November 2009 bis September 2010 war er wissenschaftlicher Volontär am Lenbachhaus in München. Seit Oktober 2010 ist er Chefredakteur des Magazins „Texte zur Kunst" und lebt in Berlin.

Kirsty Bell hat in Cambridge Englisch und Kunstgeschichte studiert, als freie Kuratorin in London und als Gallery Director in New York gearbeitet. Sie lebt seit 2001 als Autorin in Berlin und schreibt regelmäßig u. a. für „frieze", „Mousse" und „Camera Austria" und hat zahlreiche Beiträge für Künstlermonografien, darunter kürzlich Nick Mauss, Carroll Dunham, Susanne M. Winterling und Alicja Kwade, verfasst.

Michael Connor ist Autor und Kurator und lebt in New York; er interessiert sich insbesondere für die Schnittmengen zwischen Politik, Technologie und Kunst. Er arbeitete als Kurator bei FACT und als Ausstellungsleiter am BFI Southbank. Connor kuratierte die ICI-Wanderausstellung „The New Normal" (2008–2010) und war Co-Kurator der Dauerausstellung „Screen Worlds" am ACMI in Melbourne. 2009 gründete er Marian Spore, ein Kunstmuseum in Industry City, Brooklyn, dessen Sammlung sich im Aufbau befindet.

Lauren Cornell ist geschäftsführende Direktorin von Rhizome und Adjunct Curator am New Museum in New York. Sie managt und entwickelt die Programme von Rhizome, deren Aufgabe es ist, Kunst zu fördern und zu kontextualisieren, die sich mit Technologie beschäftigt. Davor arbeitete Cornell als Kuratorin und Autorin in London und New York. Ihre nächste Ausstellung, „Free", eröffnet im Oktober 2010 im New Museum.

Yilmaz Dziewior (geb. 1964), ist Kunsthistoriker, Autor und Kurator. Seine Texte erschienen regelmäßig in „Artforum", „Camera Austria" und „Texte zur Kunst". 2001–2008 war er Direktor des Kunstvereins in Hamburg. Parallel unterrichtete er 2003–2009 als Professor Kunsttheorie an der Hochschule der Bildenden Künste in Hamburg. Seit Oktober 2009 ist er Direktor des Kunsthaus Bregenz.

Uta Grosenick hat als Ausstellungsorganisatorin an den Hamburger Deichtorhallen und der Bundeskunsthalle in Bonn gearbeitet und war Kuratorin am Kunstmuseum Wolfsburg. Sie ist Herausgeberin von u. a. „Art at the Turn of the Millennium", „Women Artists", „ART NOW", „ART NOW Vol 2", „CHINA ART BOOK", „PHOTO ART" und „Tobias Rehberger 1993–2008". Von 2006 bis 2009 war sie Programmleiterin beim DuMont Verlag. Seit 2010 ist sie Verlegerin von DISTANZ in Berlin.

Silke Hohmann (geb. 1972) ist seit 2005 Redakteurin beim Berliner Kunstmagazin „Monopol", wo sie sich u. a. den Kunstszenen entlegener Orte widmet, junge Talente entdeckt, Ausstellungen rezensiert und Essays verfasst.

Laura Hoptman ist Kraus Family Senior Curator am New Museum of Contemporary Art in New York. Von 1995 bis 2001 war sie Kuratorin für Papierarbeiten am Museum of Modern Art, New York. Sie hat zahlreiche Ausstellungen und Projekte mit Gegenwartskünstlern realisiert. Am New Museum hat sie u. a. die Eröffnungsausstellung „Unmonumental" (2007) und „The Generational: Younger Than Jesus" (2009) organisiert. Neben einer Vielzahl von Ausstellungskatalogen schreibt sie regelmäßig für Kunstmagazine wie „Parkett" und „frieze".

Anthony Huberman (geb. 1975) ist Kurator und Autor und lebt in New York. Er organisierte Ausstellungen als Chief Curator am Contemporary Art Museum St. Louis, als Kurator des Palais de Tokyo in Paris und als Kurator am SculptureCenter in New York und realisierte zudem eine Vielzahl freier Projekte. Er hat in Zeitschriften wie „Artforum", „Afterall", „Dot Dot Dot" und „Mousse" veröffentlicht. Derzeit ist er Distinguished Lecturer am Hunter College und Direktor des Artist's Institute in New York.

Rita Kersting (geb. 1969) ist Kunsthistorikerin. Von 2001 bis 2006 war sie Direktorin des Kunstverein für die Rheinlande und Westfalen, Düsseldorf, seit 2006 ist sie u. a. am Aufbau der Sammlung Stadtsparkasse Düsseldorf im museum kunst palast beteiligt,

berät die Staatskanzlei Nordrhein-Westfalen für ihre Förderankäufe und ist Mitglied der Jury der Villa Massimo.

Oliver Koerner von Gustorf lebt und arbeitet als freier Kunstjournalist in Berlin, wo er 2007 die Galerie September eröffnet hat. Als Redakteur betreut er „ArtMag", das Online-Kunstmagazin der Deutschen Bank. Er schreibt für Publikationen wie „taz", „Spex", „artnet" und „Monopol" und hat zahlreiche Beiträge für Kataloge und Kunstpublikationen verfasst.

Matthias Mühling (geb. 1968), promovierter Kunsthistoriker, ist Sammlungsleiter und Kurator an der Städtischen Galerie im Lenbachhaus und Kunstbau in München. Er realisierte zahlreiche Ausstellungen und Publikationen: u. a. zu Monica Bonvicini, Angela Bulloch, Tom Burr, Maria Lassnig, Sarah Morris oder Cerith Wyn Evans. Zurzeit arbeitet er an Ausstellungen über De Stijl und Marcel Duchamp.

Lauren O'Neill-Butler (geb. 1980) ist leitende Redakteurin von „Artforum.com". Sie schreibt regelmäßig für „Artforum" und hat auch für „Bookforum.com", „Paper Monument" und „Time Out New York" geschrieben, ebenso wie Essays für Ausstellungskataloge. Sie unterrichtet an der Rhode Island School of Design und an der School of Visual Arts und war als Kritikerin u. a. Gastdozentin bei Parsons The New School for Design und an der New York Foundation for the Arts.

David Riedel (geb. 1982) studierte Kunstgeschichte und Dänische Philologie in Münster und Paris. Dem studentischen Volontariat bei „skulptur projekte münster 07" folgte 2008–2010 ein wissenschaftliches Volontariat an der Staatlichen Kunsthalle Baden-Baden mit Ausstellungsprojekten zu den Themen Kunst/Design und Selbstporträt im späten 20. Jahrhundert. Seit Oktober 2010 kuratorische Assistenz an der Kunsthalle Bielefeld.

Dieter Roelstraete (geb. 1972) studierte Philosophie an der Universität von Gent und arbeitet als Kurator am MuHKA Museum van Hedendaagse Kunst Antwerpen. Er ist Redakteur von „Afterall" und „F. R. David" sowie Contributing Editor der Zeitschrift „A Prior" und unterrichtet am De Appel in Amsterdam sowie am Piet Zwart Institute in Rotterdam. Roelstraete hat zahlreiche Beiträge zur zeitgenössischen Kunst und zu verwandten philosophischen Themen veröffentlicht.

André Rottmann (geb. 1977), Studium der Kunstgeschichte, Neueren deutschen Literatur, Politikwissenschaft, Philosophie, Allgemeinen und Vergleichenden Literaturwissenschaft. Von 2005 bis 2010 war er Chefredakteur von „Texte zur Kunst"; seit 2007 ist er Berlin-Korrespondent für „Artforum International"; außerdem verfasst er regelmäßig Katalogbeiträge.

Chris Sharp ist Autor und freier Kurator und lebt in Paris. Seine Texte sind in „Art Review", „frieze", „Kaleidoscope", „Art Monthly" und anderen Zeitschriften erschienen. Derzeit kuratiert er zusammen mit Gianni Jetzer „Under Destruction", einen Überblick über die Zerstörung in der zeitgenössischen Kunst (2010–2011 im Museum Tinguely in Basel und im Swiss Institute, New York) und bereitet die Textsammlung „A Necessarily Incomplete Anthology of Withdrawal" vor, die 2011 erscheinen wird.

Ali Subotnick ist seit 2006 Kuratorin am Hammer Museum. 2009 kuratierte sie „Nine Lives: Visionary Artists from L.A."; außerdem kuratierte sie mehrere Hammer Projects-Ausstellungen. 2006 co-kuratierte sie mit dem Künstler Maurizio Cattelan und dem Kurator Massimiliano Gioni die 4. berlin biennale für zeitgenössische kunst (zusammen gründeten sie The Wrong Gallery & die Zeitschrift „Charley"). Sie hat für „frieze", „Parkett", „Art News" und „Art Review" sowie für andere Veröffentlichungen geschrieben.

Ossian Ward ist Visual Arts Editor für „Time Out London" und schreibt über zeitgenössische Kunst. Er hat in „Art in America", „Art + Auction" und „Monopol" publiziert, für Zeitschriften wie „Esquire" und „Wallpaper*" sowie für Zeitungen, darunter der „Guardian", „The Times" und der „Independent", geschrieben. Er arbeitete für „The Art Newspaper" und gab von 2005 bis 2010 auch „The Artists' Yearbook" heraus.

Astrid Wege, Publizistin und Kuratorin, ist Herausgeberin und Autorin zahlreicher Publikationen zur zeitgenössischen Kunst und schreibt regelmäßig für „Artforum" und „Texte zur Kunst". Kuratorin von Ausstellungen wie Charlotte Posenenske (2005), „Resonances" (2006–2007) oder „Transforming Memory" (2007). Von 2008 bis 2010 war sie Programmleiterin der European Kunsthalle, Köln. Sie lehrt an der Ruhr-Universität Bochum und der Universität zu Köln.

EDITORS AND AUTHORS

Jens Asthoff (b. 1962) is a freelance author and critic and lives in Hamburg. He studied philosophy, literature, and linguistics. His writings on art have appeared in 'Artforum', 'Camera Austria', 'Kunstforum', 'Kultur & Gespenster', and 'Texte zur Kunst', as well as in catalogues and books on art such as 'ART NOW 3' and 'The ART of Anselm Reyle'.

Sven Beckstette (b. 1974) holds a doctorate in art history and has been a freelance art and music critic for the past few years. His writings have appeared in 'Frankfurter Allgemeine Zeitung', 'Texte zur Kunst', 'artnet', 'Spike', and 'Spex'. He was a scholarly intern at the Lenbachhaus, Munich, from November 2009 to September 2010; since October 2010, he has been managing editor at the journal 'Texte zur Kunst'. He lives in Berlin.

Kirsty Bell studied English and Art History in Cambridge, worked as a freelance curator in London, a gallery director in New York and has been based in Berlin and writing about art since 2001. She is a regular contributor to 'frieze', 'Mousse', and 'Camera Austria', a.o., and has written numerous monographic catalogue essays about artists including recently Nick Mauss, Carroll Dunham, Susanne M. Winterling, and Alicja Kwade.

Michael Connor is a writer and curator based in New York with an interest in the intersections among politics, technology, and art. He worked as curator at FACT and Head of Exhibitions at BFI Southbank. Connor curated the ICI touring exhibition 'The New Normal' (2008–2010) and co-curated the permanent exhibition 'Screen Worlds' at ACMI in Melbourne. In 2009, he founded Marian Spore, an accumulative art museum in Industry City, Brooklyn.

Lauren Cornell is Executive Director, Rhizome, and Adjunct Curator, the New Museum in New York. She oversees and develops Rhizome's programs, all of which serve to promote and contextualise art engaged with technology. Previously, Cornell worked as a curator and writer in London and New York. Her upcoming exhibition 'Free' will open at the New Museum in October 2010.

Yilmaz Dziewior (b. 1964), is an art historian, author, and curator. His texts have been published regularly in 'Artforum', 'Camera Austria', and 'Texte zur Kunst'.

From 2001–2008, he was the Director of the Kunstverein in Hamburg. Parallel to this, he also taught art theory at the University of Fine Arts in Hamburg 2003–2009. He has been the Director of the Kunsthaus Bregenz since October 2009.

Uta Grosenick worked as Exihibition Manager at Deichtorhallen, Hamburg, and the Bundeskunsthalle in Bonn, and was curator at the Kunstmuseum Wolfsburg. She has edited a.o. 'Art at the Turn of the Millennium', 'Women Artists', 'ART NOW', 'ART NOW Vol 2', 'CHINA ART BOOK', 'PHOTO ART', and 'Tobias Rehberger 1993–2008'. From 2006 to 2009, she was Editorial Director at DuMont publishers, Cologne. Since 2010 she has been publisher of DISTANZ in Berlin.

Silke Hohmann (b. 1972) has been an editor at the Berlin-based art journal 'Monopol' since 2005. Her mission includes the discovery of art scenes in places off the beaten path and the discovery of young talent. She also reviews exhibitions and writes essays.

Laura Hoptman is the Kraus Family Senior Curator at the New Museum in New York. From 1995 to 2001, she was a curator of drawing at The Museum of Modern Art, New York. She realised numerous exhibitions and projects by contemporary artists. At the New Museum, she organised the opening exhibition 'Unmonumental' (2007) and 'The Generational: Younger Than Jesus' (2009), a.o. In addition to various exhibition catalogues she has written frequently for magazines including 'Parkett' and 'frieze'.

Anthony Huberman (b. 1975) is a curator and writer based in New York. He has organised exhibitions as Chief Curator of the Contemporary Art Museum St. Louis, curator of the Palais de Tokyo in Paris, and curator of SculptureCenter in New York, as well as a variety of independent projects. He has written for magazines such as 'Artforum', 'Afterall', 'Dot Dot Dot', and 'Mousse'. He is currently a Distinguished Lecturer at Hunter College and Director of The Artist's Institute in New York.

Rita Kersting (b. 1969) is an art historian. From 2001 to 2006, she was Director at the Kunstverein für die Rheinlande und Westfalen, Düsseldorf. Since 2006, she has helped build the collection of the Stadtsparkasse Düsseldorf at museum kunst palast; advised the office of the Minister-

President of North Rhine-Westphalia's emerging artists acquisitions program; and served on the Villa Massimo jury.

Oliver Koerner von Gustorf is a freelance art journalist living and working in Berlin, where he opened the gallery September in 2007. He is managing editor at 'ArtMag', the online art magazine produced by Deutsche Bank. His writings have appeared in 'taz', 'Spex', 'artnet', and 'Monopol'; he has also written numerous contributions to catalogues and books on art.

Matthias Mühling (b. 1968) holds a doctorate in art history. He is Director of collections and curator at the Städtische Galerie im Lenbachhaus und Kunstbau, Munich. He has produced numerous exhibitions and publications about Monica Bonvicini, Angela Bulloch, Tom Burr, Maria Lassnig, Sarah Morris, and Cerith Wyn Evans, a.o. He is currently working on exhibition projects about De Stijl and Marcel Duchamp.

Lauren O'Neill-Butler (b. 1980) is Managing Editor of 'Artforum.com'. A frequent contributor to 'Artforum', she has also written for 'Bookforum.com', 'Paper Monument', and 'Time Out New York', in addition to exhibition catalogue essays. She teaches at the Rhode Island School of Design and the School of Visual Arts, and has been a visiting critic at Parsons The New School for Design, and the New York Foundation for the Arts, a.o.

David Riedel (b. 1982) studied art history and Danish philology in Münster and Paris. After a student internship with 'skulptur projekte münster 07', he was a scholarly intern at the Staatliche Kunsthalle Baden-Baden from 2008 to 2010, working on exhibition projects about art/design and the self-portrait in the late twentieth century. Since October 2010, he has been a curatorial assistant at Kunsthalle Bielefeld.

Dieter Roelstraete (b. 1972) trained as a philosopher at the University of Ghent and works as a curator at MuHKA Museum van Hedendaagse Kunst Antwerpen. He is an editor of 'Afterall' and 'F. R. David' as well as a contributing editor to 'A Prior' magazine, and a tutor at both De Appel in Amsterdam and Piet Zwart Institute in Rotterdam. Roelstraete has published extensively on contemporary art and philosophical issues.

André Rottmann (b. 1977) studied art history, early modern and modern German literature, political science, and comparative literature. Between 2005 and 2010, he was Managing Editor at 'Texte zur Kunst'; since 2007, he has reported from Berlin for 'Artforum International'. He has also frequently contributed to catalogues.

Chris Sharp is a writer and independent curator based in Paris. His writing has appeared in 'Art Review', 'frieze', 'Kaleidoscope', 'Art Monthly', among other magazines. He is currently co-curating with Gianni Jetzer 'Under Destruction', a survey of destruction in contemporary art (2010–2011 at Museum Tinguely, Basel, and at the Swiss Institute, New York), and preparing 'A Necessarily Incomplete Anthology of Withdrawal', to be published in 2011.

Ali Subotnick has been a curator at the Hammer Museum since 2006. In 2009 she curated 'Nine Lives: Visionary Artists from L.A.', she has also curated several Hammer Projects exhibitions. In 2006, along with artist Maurizio Cattelan and curator Massimiliano Gioni (together they created The Wrong Gallery & 'Charley' magazine) she co-curated the 4th berlin biennial for contemporary art. She has written for 'frieze', 'Parkett', 'Art News' and 'Art Review' among other publications.

Ossian Ward is Visual Arts Editor for 'Time Out London' and a writer on contemporary art. As well as contributing to 'Art in America', 'Art + Auction', and 'Monopol' he has written for magazines such as 'Esquire' and 'Wallpaper*', as well as newspapers including the 'Guardian', 'The Times', and the 'Independent'. He has worked at 'The Art Newspaper' and also edited 'The Artists' Yearbook' from 2005 to 2010.

Astrid Wege is a writer and curator. She has written and edited numerous publications on contemporary art, and regularly writes for 'Artforum' and 'Texte zur Kunst'. Her curatorial work included an exhibition on Charlotte Posenenske (2005) and the shows 'Resonances' (2006–2007) and 'Transforming Memory' (2007). Between 2008 and 2010, she was Programming Director at the European Kunsthalle, Cologne. She teaches at the Ruhr University Bochum and the University of Cologne.

CREDITS

Jennifer Allora & Guillermo Calzadilla,
18–21 Courtesy Allora & Calzadilla;
Gladstone Gallery, New York/Brussels;
Copyright Allora & Calzadilla; Temporäre
Kunsthalle, Berlin (19); Lisson Gallery,
London (20, top); Haus der Kunst, Munich
(20, bottom); Photos: Jens Ziehe (19); Giorgio
Boata (20, top); Marino Solokov (20, bottom)

Ei Arakawa, 22 Photo: Sergej Jensen; 23–25
Courtesy Ei Arakawa; Galerie Neu, Berlin (23);
Amy Sillman (24); Reena Spaulings Fine Art,
New York (24); Taka Ishii Gallery, Tokyo/Kyoto
(25); Design: Issay Kitagawa, GRAPH, Tokyo
(25, top); Photos: Yuki Kimura (23); Paula
Court (24); Naoko Tamura (25, bottom)

Fikret Atay, 26 Photo: Franz Fischer;
27–29 Courtesy Fikret Atay; Galerie Chantal
Crousel, Paris; Photos: Fikret Atay

Nairy Baghramian, 30 Photo: Simon Vogel;
31–33 Courtesy Nairy Baghramian; Galerie
Daniel Buchholz, Cologne/Berlin; Photos:
Raphael Hefti (31); Steven Decroo (32, top);
Andy Keate (32, bottom); Simon Vogel (33)

Yael Bartana, 34–37 Courtesy Yael Bartana;
Annet Gelink Gallery, Amsterdam; Sommer
Contemporary Art, Tel Aviv

Walead Beshty, 38–41 Courtesy Walead
Beshty; Regen Projects, Los Angeles;
Wallspace, New York; Thomas Dane Gallery,
London; Galerie Rodolphe Janssen, Brussels;
Photos: Fredrik Nilsen (38); Hugh Kelly (40/41)

Johanna Billing, 42–45 Courtesy Johanna
Billing; Hollybush Gardens, London

Alexandra Bircken, 46 Photo: Thomas
Brinkmann; 47–49 Courtesy Alexandra
Bircken; BQ, Berlin; Herald St, London;
Photos: Lothar Schnepf, Cologne (48, right;
49, bottom); Horst Kolberg (49, top)

Karla Black, 50 Courtesy Alex Frost; Sorcha
Dallas, Glasgow; 51–53 Courtesy Karla
Black; Mary Mary, Glasgow; Galerie Gisela
Capitain, Cologne; migros museum für
gegenwartskunst, Zurich (51); Modern Art
Oxford (52/53); Photos: A. Burger, Zurich (51);
Andy Keate (52/53)

Carol Bove, 54–57 Courtesy Carol Bove;
Maccarone, New York; Kimmerich, New York

Kerstin Brätsch, 58 Courtesy Kerstin
Brätsch; Photo: DAS INSTITUT; 59–61
Courtesy Kerstin Brätsch; DAS INSTITUT;
Balice Hertling, Paris

Fernando Bryce, 62 Photo: Galerie Barbara
Thumm, Berlin; 63–65 Courtesy Fernando
Bryce; Galerie Barbara Thumm, Berlin

Andreas Bunte, 66–69 Courtesy Andreas
Bunte; Galerie Ben Kaufmann, Berlin

Mircea Cantor, 70 Photo: Mircea Cantor;
71–73 Courtesy Mircea Cantor; Galerie Yvon
Lambert, Paris/New York; Dvir Gallery,
Tel Aviv (73, bottom); Photos: Mircea Cantor
(72; 73, top)

Cao Fei, 74 Photo: Judy Zhou; 75–77
Courtesy Cao Fei; Vitamin Creative Space,
Guangzhou; Lombard-Freid Projects,
New York (76)

Paul Chan, 78–81 Courtesy Paul Chan;
Greene Naftali, New York; Photos:
Jason Mandella (79); Gil Blank (81, top);
Maurizia Elia (81, bottom)

Claire Fontaine, 83–85 Courtesy Claire
Fontaine; Galerie Chantal Crousel, Paris;
Metro Pictures, New York (84); Reena
Spaulings Fine Art, New York (84); Galeria
T293, Naples (85)

Peter Coffin, 86–89 Courtesy Peter Coffin;
Galerie Emmanuel Perrotin, Paris/Miami

Minerva Cuevas, 90 Photo: Alejandro
Castillo; 91–93 Courtesy Minerva Cuevas;
kurimanzutto, Mexico City

Aaron Curry, 94 Photo: Amy Bessone; 95–97
Courtesy Aaron Curry; David Kordansky
Gallery, Los Angeles; Michael Werner Gallery,
New York (96; 97, left)

Keren Cytter, 98–101 Courtesy Keren Cytter;
Pilar Corrias, London (99); Galerie Christian
Nagel, Cologne/Berlin (100/101)

Enrico David, 102–105 Courtesy Enrico David;
Galerie Daniel Buchholz, Cologne/Berlin

Simon Denny, 106 Photo: Derek Henderson; 107–109 Courtesy Simon Denny; Galerie Daniel Buchholz, Cologne/Berlin; Michael Lett, Auckland

Nathalie Djurberg, 110 Photo: Juliane Eirich; 111–113 Courtesy Nathalie Djurberg; Gió Marconi, Milan; Zach Feuer Gallery, New York; Photo: Hans Berg (111)

Jason Dodge, 114 Photo: Christine Roland; 115–117 Courtesy Jason Dodge; Kadist Art Foundation, Paris (117, right)

Trisha Donnelly, 118–121 Courtesy Trisha Donnelly; Casey Kaplan, New York; Air de Paris, Paris; Photos: Cary Whittier (120)

Geoffrey Farmer, 122–125 Courtesy Geoffrey Farmer; Catriona Jeffries, Vancouver

Omer Fast, 126–129 Courtesy Omer Fast; gb agency, Paris; Arriata Beer, Berlin; Postmasters, New York

Christian Frosi, 130–133 Courtesy Christian Frosi; Zero..., Milan

Cyprien Gaillard, 134 Photo: Marcus Gaab; 135–137 Courtesy Cyprien Gaillard; Bugada & Cargnel (Cosmic Galerie), Paris

Ryan Gander, 138 Photo: Bedwyr Williams; 139–141 Courtesy Ryan Gander; Lisson Gallery, London; gb agency, Paris; Annet Gelink Gallery, Amsterdam; Tanya Bonakdar Gallery, New York; Taro Nasu, Tokyo; Photos: Aurélien Mole (140, top)

Mario García Torres, 142–145 Courtesy Mario García Torres; Jan Mot, Brussels

Manuel Graf, 146 Photo: Sarah-Jane Hoffmann; 147–149 Courtesy Manuel Graf; Johann König, Berlin; Van Horn, Düsseldorf; Photos: Roman März (148; 149)

Amy Granat, 150 Photo: Jason Schmidt; 151–153 Courtesy Amy Granat; Galerie Eva Presenhuber, Zurich; Photo: Stefan Altenburger Photography, Zurich (153, bottom)

Wade Guyton, 154 Photo: Wade Guyton Studio; 155–157 Courtesy Wade Guyton; Friedrich Petzel Gallery, New York

Rachel Harrison, 158 Photo: Jean Vong; 159–161 Courtesy Rachel Harrison; Greene Naftali, New York; Photos: Jean Vong (159); A. Morin (160); Rachel Harrison, *Haycation,* Portikus, Frankfurt am Main, 2009–2010, Copyright Katrin Schilling (161)

Sharon Hayes, 162 Photo: Andrea Geyer, documentation of Sharon Hayes' performance *I March In The Parade Of Liberty But As Long As I Love You I'm Not Free,* 2007–2008; 163–165 Courtesy Sharon Hayes; Tanya Leighton Gallery, Berlin; Photos: Andrew Clark Photography (165, top); Gene Pittman for the Walker Art Center (165, bottom)

Diango Hernández, 166 Photo: Anne Pöhlmann; 167–169 Courtesy Diango Hernández; Galerie Michael Wiesehöfer, Cologne; Alexander and Bonin, New York; Paolo Maria Deanesi Gallery, Rovereto; Photos: Wolfgang Träger (168, bottom); Lorenz Oeventrop, Cologne (169)

Runa Islam, 170 Photo: Juergen Teller; 171–173 Courtesy Runa Islam; White Cube, London

Luis Jacob, 174–177 Courtesy Luis Jacob; Birch Libralato, Toronto

Jesper Just, 178–181 Courtesy Jesper Just; Galleri Christina Wilson, Copenhagen

Annette Kelm, 182 Photo: Sabine Reitmaler; 183–185 Courtesy Annette Kelm; Johann König, Berlin

Gabriel Kuri, 186 Photo: Ivo Corrá; 187–189 Courtesy Gabriel Kuri; kurimanzutto, Mexico City; Sadie Coles HQ, London (189)

Robert Kuśmirowski, 190 Photo: artist's archive; 191–193 Courtesy Robert Kuśmirowski; Foksal Gallery Foundation, Warsaw; Barbican Art Gallery, London (191); Photo: Eliot Wyman (191)

Tim Lee, 194 Photo: Jonathan Middleton; 195–197 Courtesy Tim Lee; Johnen Galerie, Berlin; Lisson Gallery, London

Manuela Leinhoß, 198–201 Courtesy Manuela Leinhoß; Galerie Micky Schubert, Berlin

Tomás Saraceno, 274–277 Courtesy Tomás Saraceno; Andersen's Contemporary, Copenhagen/Berlin; Tanya Bonakdar Gallery, New York; pinksummer contemporary art, Genova; Photo: Tomás Saraceno (277)

Bojan Šarčević, 278–281 Courtesy Bojan Šarčević; BQ, Berlin; Photos: Lothar Schnepf, Cologne (280, left); Studio Schaub, Cologne (280, right); Bernd Borchardt (279)

Markus Schinwald, 282–285 Courtesy Markus Schinwald; Georg Kargl, Vienna; Yvon Lambert, Paris/New York; Gió Marconi, Milan; Kunsthaus Bregenz; Copyright Markus Schinwald; Kunsthaus Bregenz (285); Photos: Markus Tretter (285)

Dirk Stewen, 286–289 Courtesy Dirk Stewen; c/o Gerhardsen Gerner, Berlin (287; 289); Tanya Bonakdar Gallery, New York (288); Photos: Matthias Kolb, Berlin (287; 289); Christopher Burke Studio, New York (288, top); Jean Vong Photography Inc, New York (288, bottom)

Tatiana Trouvé, 290 Photo: J. B. Mondino; 291–293 Courtesy Tatiana Trouvé; Johann König, Berlin (291; 293); Galerie Emmanuel Perrotin, Paris/Miami (291; 293); Galerie Almine Rech, Brussels/Paris (291; 293); Gagosian, New York (292); Photos: Daniele Resini (291); Robert McKeever (292); A. Burger, Zurich (293)

Danh Vo, 294 Photo: David Heerde; 295–297 Courtesy Danh Vo; Isabella Bortolozzi, Berlin (295; 297); Copyright ddp images/AP Photo (296, top); Kunsthalle Basel, 2009 (297); Photos: Nick Ash (295); Danh Vo (296, middle); Serge Hasenböhler (297)

Tris Vonna-Michell, 298 Photo: Baloise Art Prize, 2008; 299–301 Courtesy Tris Vonna-Michell; Jan Mot, Brussels (299; 301); T293, Naples (300); Schnittraum, Cologne (301, top); Photos: Baloise Art Prize (300); Nick Ash (300); Michael Wiesehöfer (301, top); Stefan Altenburger (301, middle); Tom Powel (300, bottom)

Kelley Walker, 302–305 Courtesy Kelley Walker; Paula Cooper Gallery, New York; Capitain Petzel, Berlin (304, 305)

Apichatpong Weerasethakul, 306 Photo: Apichatpong Weerasethakul; 307–309 Courtesy Apichatpong Weerasethakul; Scai the Bathhouse, Tokyo

Andro Wekua, 310 Photo: Ketuta Alexi-Meskhishvili; 311–313 Courtesy Andro Wekua; Gladstone Gallery, New York (311; 313, bottom); Galerie Peter Kilchmann, Zurich (312; 313, top)

Cathy Wilkes, 314–317 Courtesy Cathy Wilkes; Galerie Giti Nourbakhsch, Berlin; The Modern Institute / Toby Webster Ltd, Glasgow (316/317); Photos: Matthias Kolb (315); Andy Keate (316/317)

Xu Zhen, 318–321 Courtesy Xu Zhen (319); Madeln (320, 321)

Haegue Yang, 322–325 Courtesy Haegue Yang; Kukje Gallery, Seoul; Galerie Barbara Wien, Berlin (323); Walker Art Center, Minneapolis, T. B. Walker Acquisition Fund, 2007 (325); Photos: Pattara Chanruechachai (324, top); Juan Guerra (324, bottom); Gene Pittman (325)

COMING SOON